DREAM HOMES

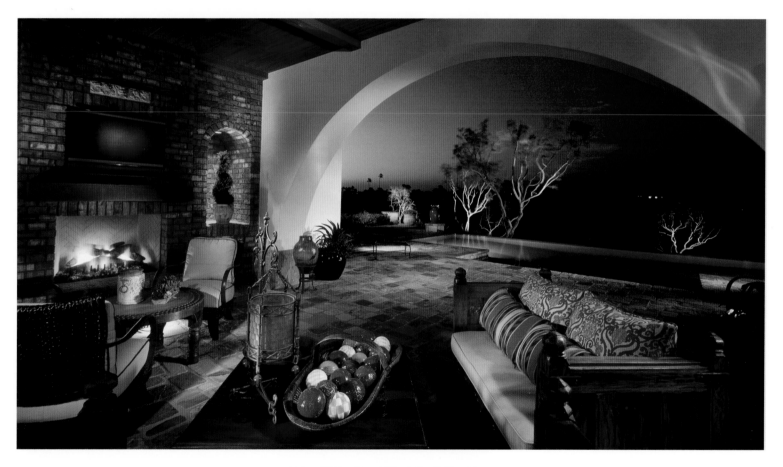

DESERTS

A SHOWCASE OF THE FINEST ARCHITECTS, DESIGNERS & BUILDERS
IN LAS VEGAS, PALM SPRINGS & NEW MEXICO

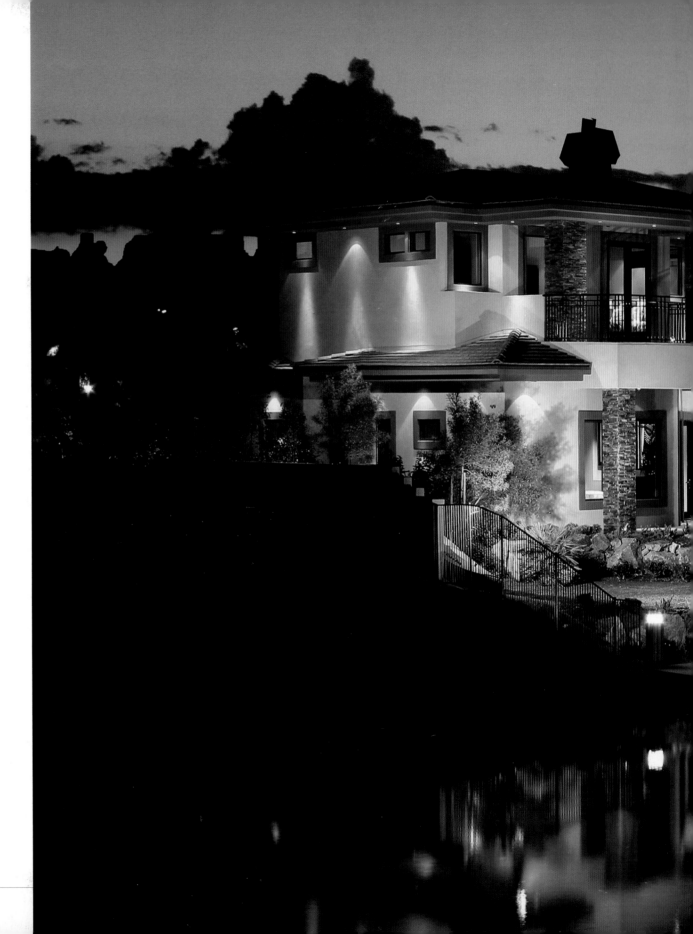

Published by

PANACHE
PANACHE PARTNERS, LLC

13747 Montfort Drive, Suite 100
Dallas, Texas 75240
972.661.9884
f: 972.661.2743
www.panache.com

Publishers: Brian G. Carabet and John A. Shand
Executive Publisher: Steve Darocy
Senior Associate Publisher: Martha Cox
Senior Associate Publisher: Karla Setser
Associate Publisher: Carla Bowers
Art Director: Michele Cunningham-Scott
Editor: Anita M. Kasmar

Printed in Malaysia

Distributed by IPG
800.748.5439

PUBLISHER'S DATA

Dream Homes Deserts

Library of Congress Control Number: 2007930826

ISBN 13: 978-1-933415-28-4
ISBN 10: 1-933415-28-2

First Printing 2007

10 9 8 7 6 5 4 3 2 1

Previous Page: South Coast Architects, Inc., page 151
Photograph by Lance Gordon Photography

This Page: Palm Canyon Development, Inc., page 31
Photograph by Paul Cichocki

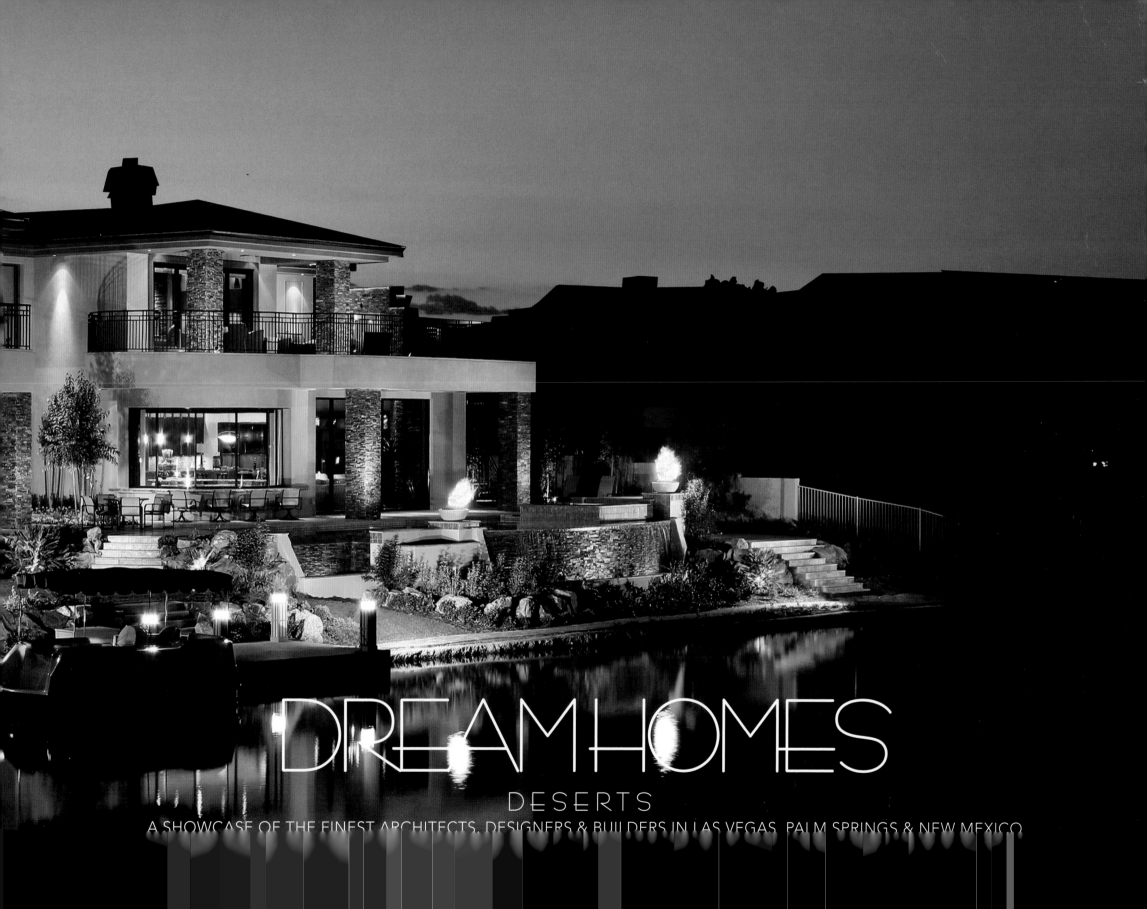

DREAM HOMES

DESERTS

A SHOWCASE OF THE FINEST ARCHITECTS, DESIGNERS & BUILDERS IN LAS VEGAS, PALM SPRINGS & NEW MEXICO

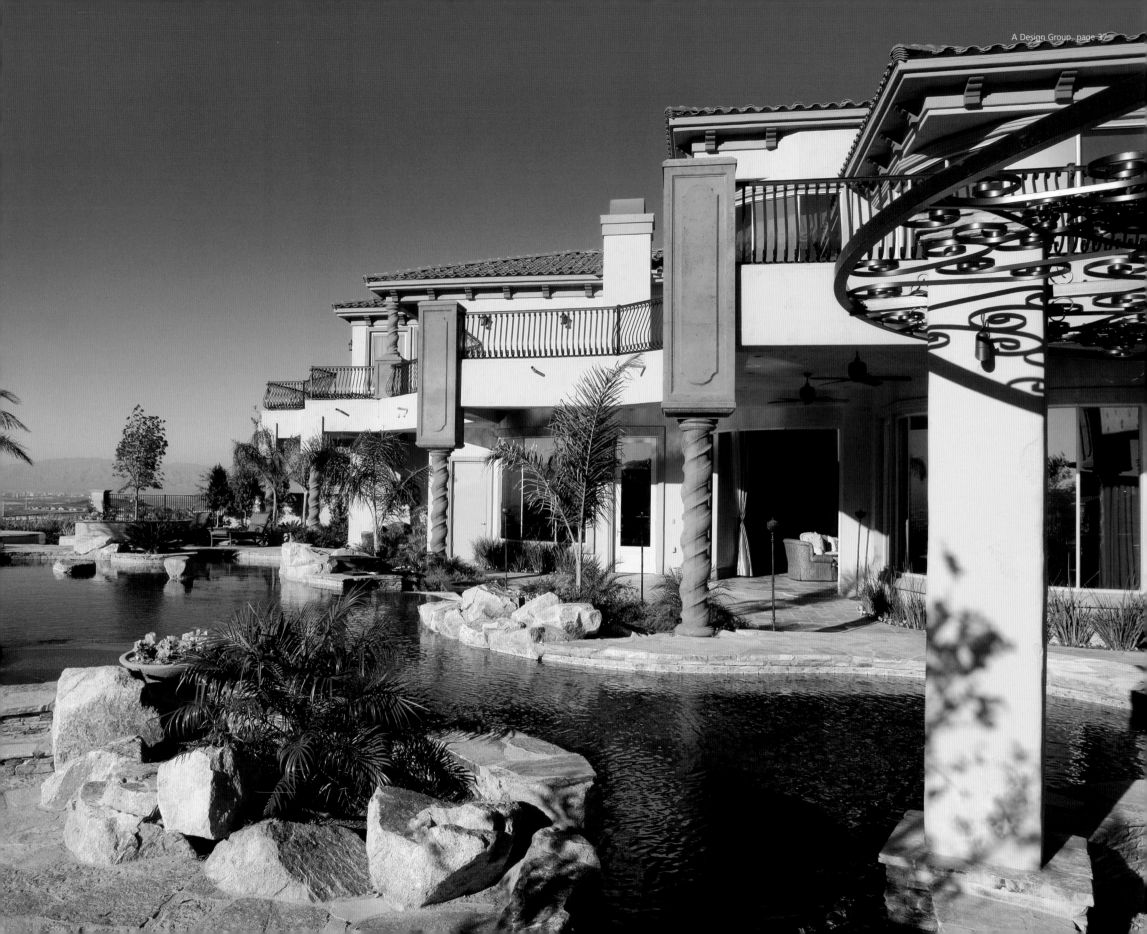

INTRODUCTION

What will unfold on the following pages is not a mirage. It is a true commingling of unbridled talent from some of the deserts' most passionate and committed professional architects, residential designers, custom builders, master developers and ingenious interior designers.

If you have ever visited North America's arid desert regions we are sure you will agree that Mother Nature certainly painted her most dramatic landscapes here—from mysteriously dark mountain ranges to fiery orange skies and unique rocky terrain, cacti and succulents—making an oasis in the desert one of the most hypnotic places to live. These desert homes may be year-round primary residences, but more often than not, many are vacation home retreats to escape the blustery winter months from other parts of the country.

The private custom residences showcased throughout *Dream Homes Deserts* epitomize the diversity of architectural styles and interior designs representative of the desert terrain and prime real estate properties in California, Nevada and New Mexico. Luxury high-rises and master-planned developments of Las Vegas will leave you star-struck. Palm Desert's golf resort communities reflecting luxurious lifestyles will astound you. And the charming homes inspired by the native culture of old Santa Fe, the famed "walking city," will embrace you with their allure. Warm and wonderful Old World Spanish-inspired homes and ecologically conscious construction will leave you wanting more.

Fresh, clean-lined contemporary homes keep things light in this dramatic environment under star-studded skies. Tuscan-inspired and Mediterranean styles with a touch of the exotic will take your breath away. The avant-garde and visionary Green residences created by trailblazing architects and interior designers will open your eyes to new ways of living in the deserts' intense climate.

The scope of the deserts' architecture and design work is vast, just like the land. The vivid and inspiring photographic and editorial content of *Dream Homes Deserts* will captivate your senses and offer you new ideas and possibilities of what a dream home can be. We invite you to escape to these magical places to experience the fine art of dwelling—wandering through the deserts never looked so beautiful.

Warm Regards,

Brian Carabet & John Shand

Prest • Vuksic Architects, page 147

Brian G. Carabet

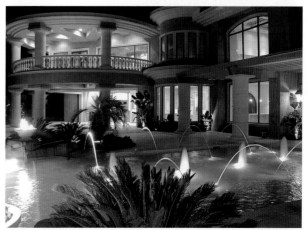

Richard Luke Architects, page 71

John A. Shand

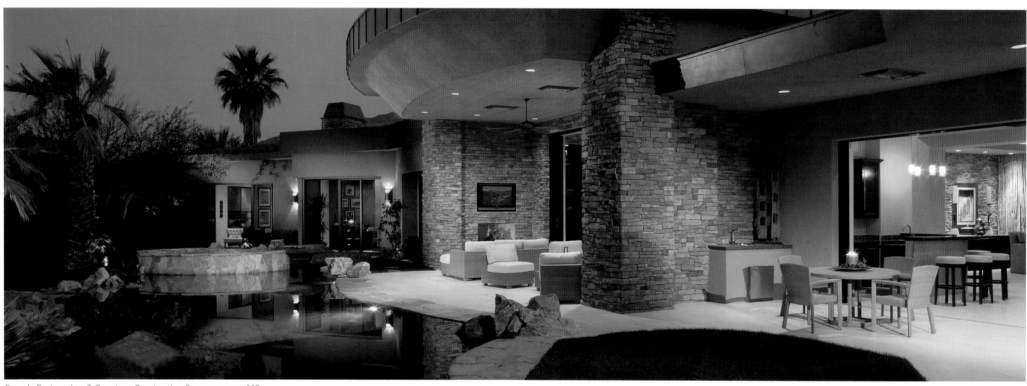

Duende Designs, Inc. & Graystone Construction Company, page 115

Archaeo Architects, page 169

Archi-Scape, page 165

"THE ULTIMATE DESIGN LUXURY IS SPACE."
—AARON BOHRER

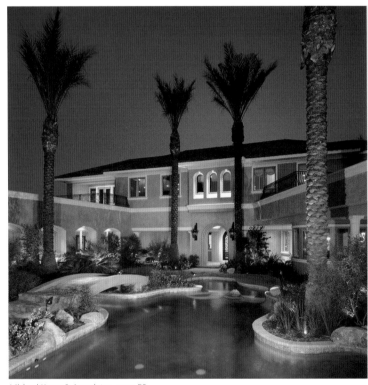

Michael Knorr & Associates, page 53

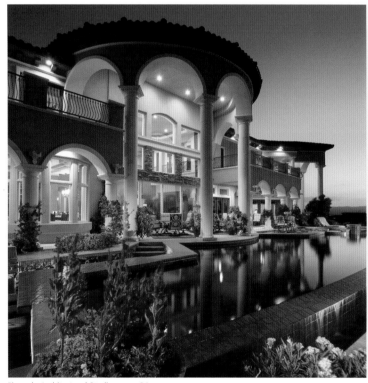

Pinnacle Architectural Studio, page 21

"ARCHITECTURE EMERGES FROM A RECOGNITION OF THE SITE'S INHERENT FEATURES THROUGH THE LENS OF DESIGN."
—*DION MCCARTHY*

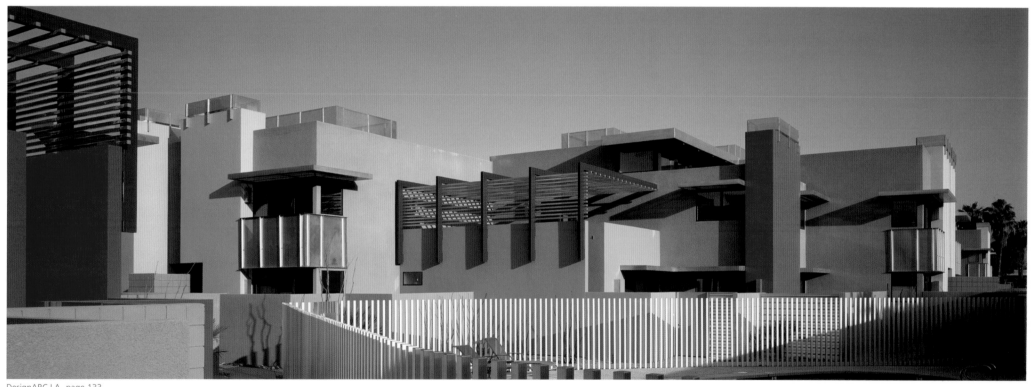

DesignARC LA, page 133

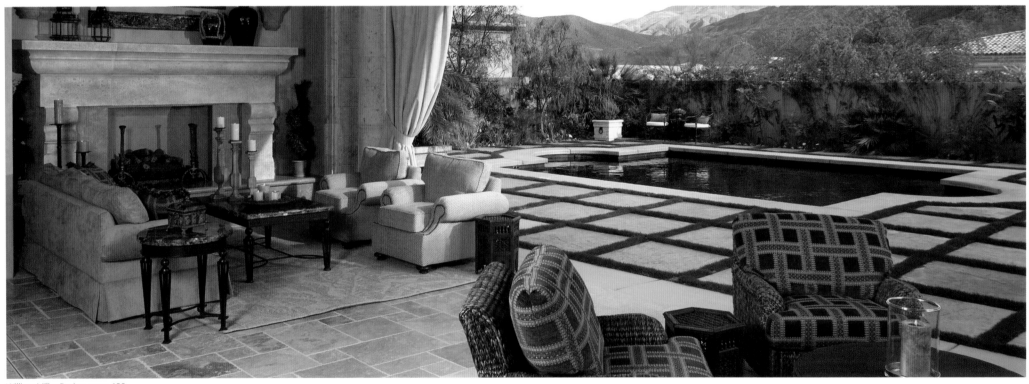

William Miller Design, page 139

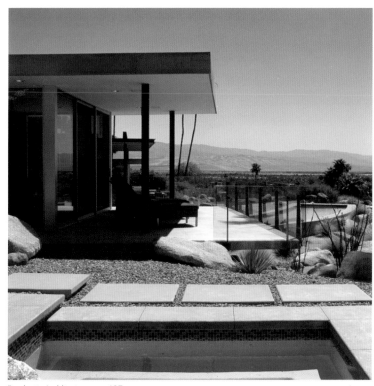

Escalante Architects, page 127

Sherman Architecture, page 103

"THE DESERT AND ITS EXTREME CLIMATOLOGY HAS ALWAYS BEEN A FRONTIER FOR ARCHITECTURAL EXPERIMENTATION AND FREEDOM WITH ITS RAW BEAUTY."
—ANA ESCALANTE

Jon J. Jannotta Architects-Planners, Inc., page 43

Signature Custom Homes, page 93

CONTENTS

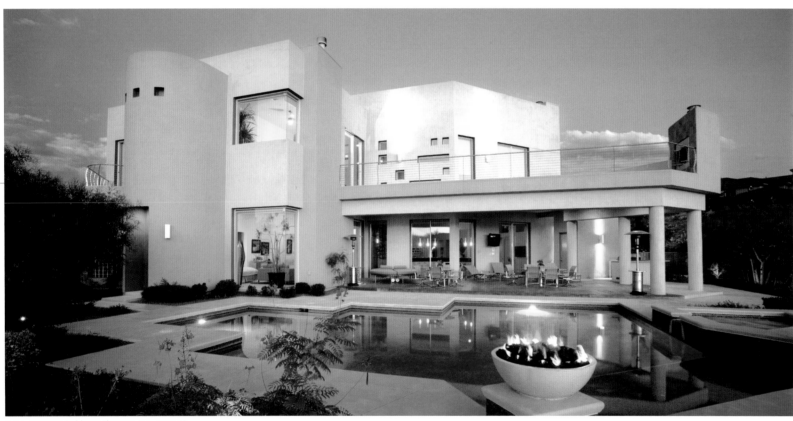

Jon J. Jannotta Architects-Planners, Inc., page 43

De Atelier Design Group, page 81

CHAPTER ONE

LAS VEGAS

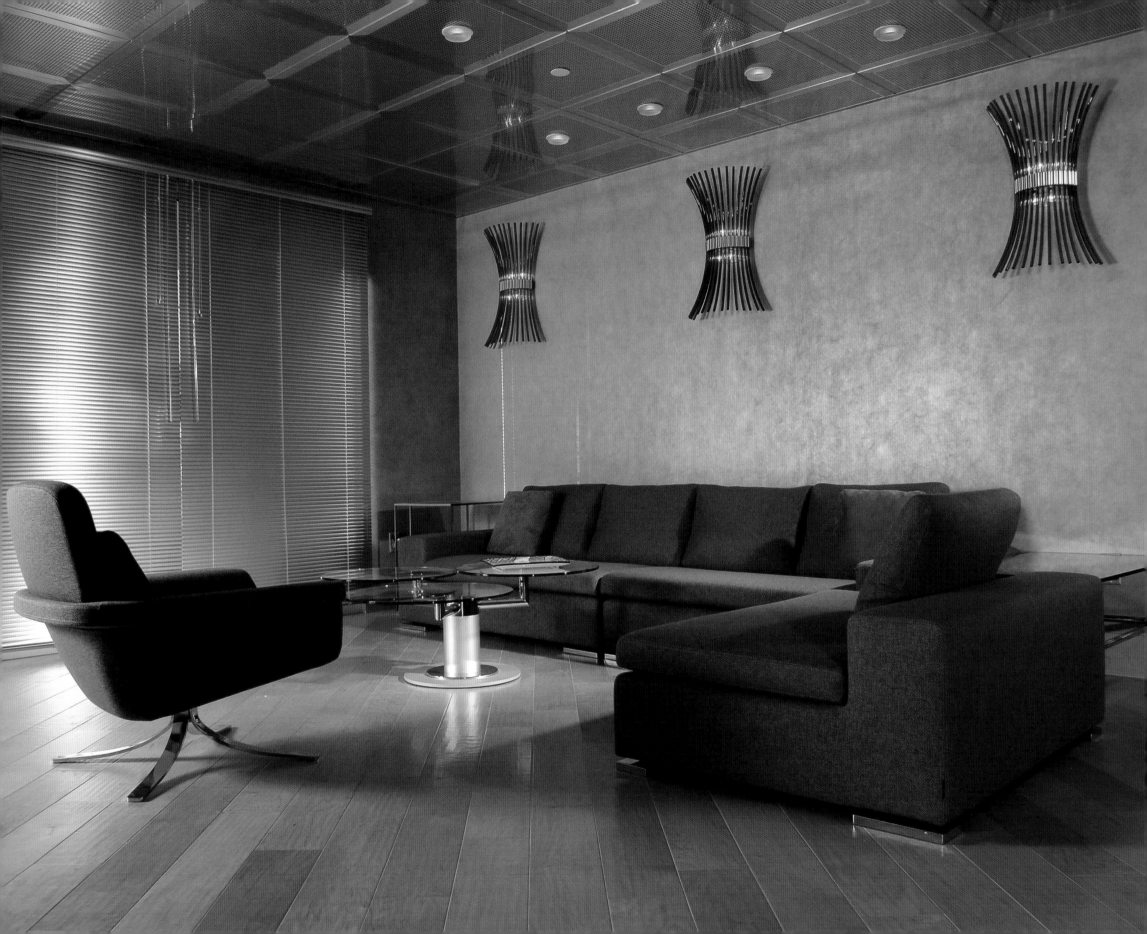

Joy Bell
JOY BELL DESIGN

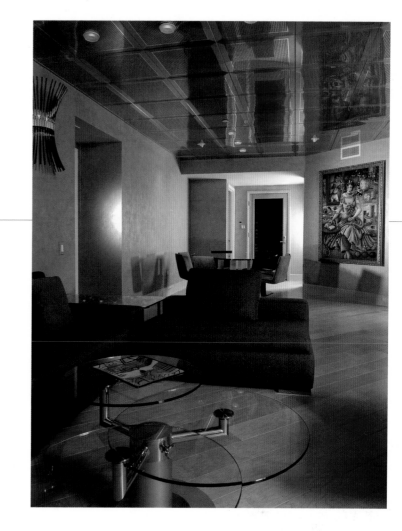

With more than 25 years to her credit as a residential interior designer, Joy Susan Bell was born and raised in Las Vegas and has fond memories of riding her beloved pony on the famed Strip. Riding high on creativity and recognized for her amazing work, she is a nationally registered professional featured in *Who's Who in Interior Design*.

She began her illustrious career learning from established interior designers and mentors, working to design what was the largest home in Nevada at the time. She took to it naturally and enjoyed the process so much that the rest is history. Joy Bell is an active member of IDS and her interiors have been internationally published. From the cover of *Options* magazine to a featured designer in the *Robb Report* and *Home Entertainment Design*, she has also starred on HGTV and was selected as interior designer of choice for Bob Vila's "LasVegas.com" Internet show and dream home project. Her credits read like an entertainer's resume, as she has also been featured on local television shows presenting the newest trends in home interiors as well as an invited guest designer for three annual events in the Street of Dreams home showcase. She is very knowledgeable about new materials and innovative building techniques and created award-winning interior designs for the NextGen Demonstration Home at the International Builder's Show in Las Vegas.

ABOVE:
Sleek Minotti seating and Linea glass tables star in this minimalist environment. A dramatic original oil painting becomes the vibrant focal point on an expansive dining room wall.
Photograph by Dusk Photo

FACING PAGE:
A sophisticated stainless steel ceiling with a brushed, patterned finish and JM Lynne wall coverings envelop a modern Minotti sectional sofa and chair. A pair of wall sconces, by Artemide, glow with a warm lighting effect while natural hardwood flooring brings all of the elements together.
Photograph by Dusk Photo

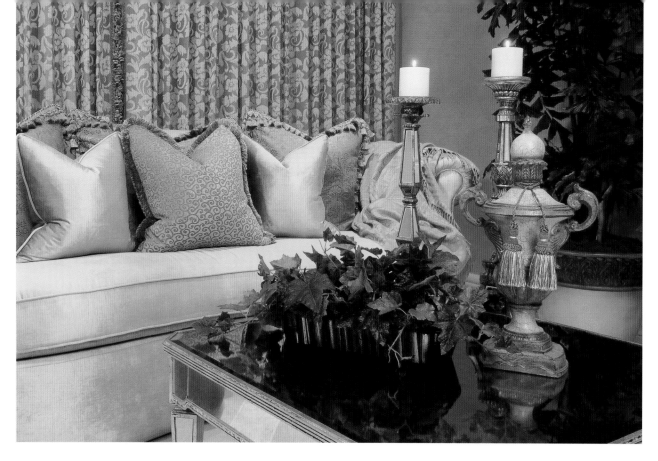

Her name literally rings true with her passion for design ranging from the opulence of Old World Italian to desert contemporary with stainless steel ceilings and minimalist style. She has a design flair for both custom private residences and high-rise condominiums. Joy genuinely loves a wealth of styles and declares herself a chameleon, adapting to new challenges and creating fabulous interiors, whether designing with a fusion of elements, creating organic and industrial statements, or classical traditional and Prairie styles. She appreciates her respected sources and uses her professional connections to provide anything an interior design may call for, from the most lavish elements to the finest finishing touches. With attention to detail, she exhibits finesse and follow-through with each client to achieve stunning interior designs.

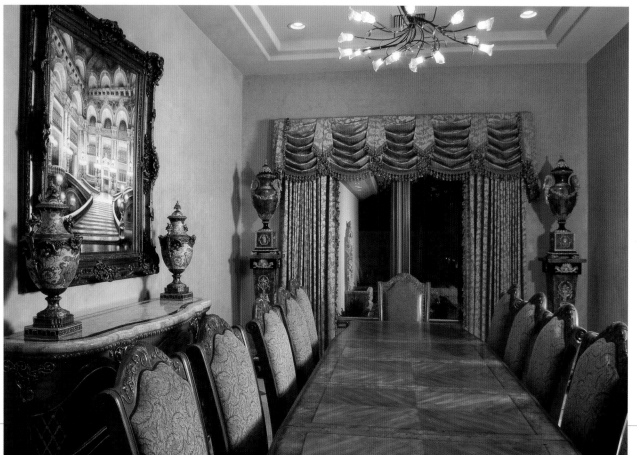

TOP LEFT:
A formal living room, bathed in rich golden and cognac colors, is lavishly furnished with Belgian velvets, silks and chenille fabric combinations. The antiqued, mirrored cocktail table brings a reflective ambience to this classical presentation.
Photograph by Dusk Photo

BOTTOM LEFT:
This opulent formal dining room offers abundant seating and full-window views to the garden courtyard. Tortoise shell pedestals, ornate urns and important appointments adorn the room perfectly without need for further embellishments.
Photograph by Dusk Photo

FACING PAGE:
The textural Pebble Beach-style sage wall covering lends a soft, sensual backdrop for a bold original oil painting and ultra-contemporary Artemide sofa with ottoman. Corner sculptural lighting fixtures from Odyssey create a fresh minimalist setting.
Photograph by Dusk Photo

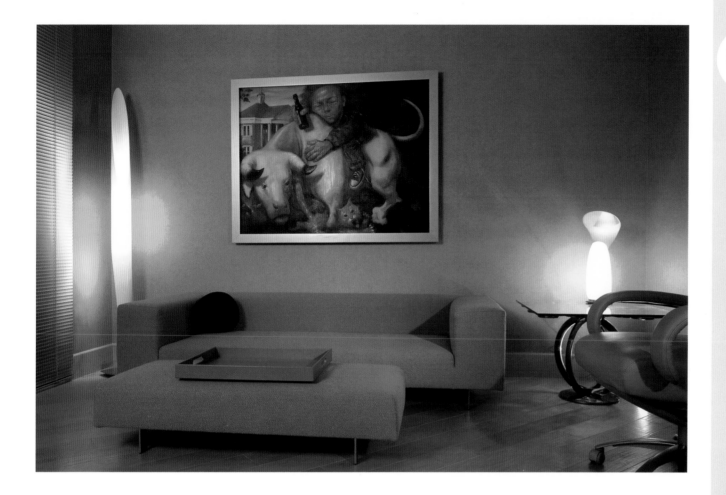

Extravagant spaces are her specialty, and she recently designed a beautiful, Tuscan-inspired home that sports one of the largest in-home gyms, a juice bar, seven full-service kitchens, nine fireplaces, a private salon and spa, and an extraordinary wine cellar with dumbwaiter that ascends to a unique receiving room where staff decants the vintage to serve in the adjacent dining room. A most sought-after interior designer, Joy Bell loves what she does, and it shows ... bellissimo.

Q&A more about joy ...

NAME ONE THING THAT PEOPLE DON'T KNOW ABOUT YOU.
I am an avid writer!

WHAT PERSONAL INDULGENCE DO YOU SPEND THE MOST MONEY ON?
So many indulgences, so little time.

WHAT BOOK ARE YOU READING RIGHT NOW?
I'm a voracious reader from books on design to suspense thrillers by Michael Crichton, motivational and inspirational subjects to best-selling novels.

HOW WOULD WE KNOW YOU LIVE IN YOUR LOCALE?
I'm a desert rat who loves the heat.

WE WOULDN'T KNOW IT, BUT YOUR FRIENDS WOULD TELL US YOU ARE...
Hilarious.

WHAT COLOR BEST DESCRIBES YOU AND WHY?
Beige in the a.m. for comfort. Red late in the day for energy.

JOY BELL DESIGN
JOY BELL, IDS
4870 West Oquendo
Las Vegas, NV 89118
702.873.4342
f: 702.873.4342

750 Rancho Circle
Las Vegas, NV 89107
702.734.7404
f: 702.873.8939
www.joybelldesign.com

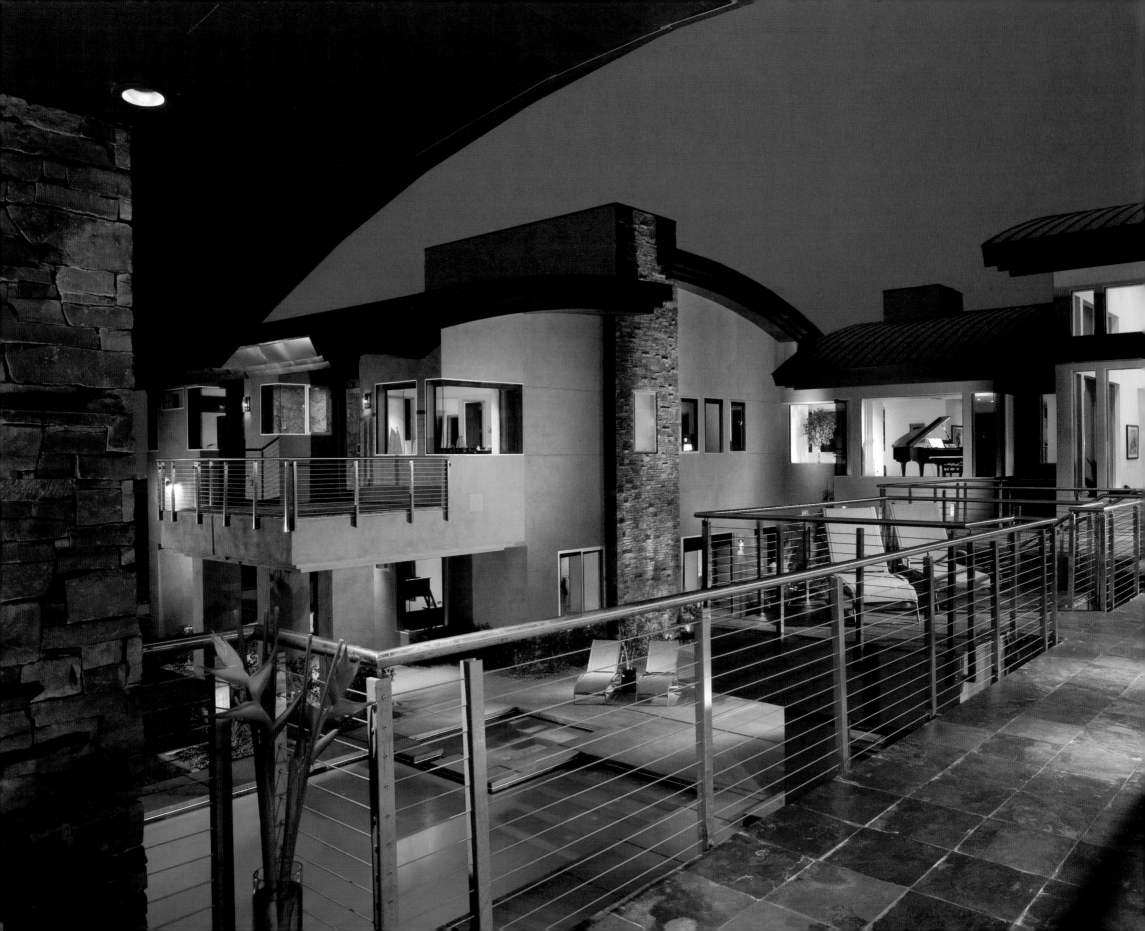

Quinn Boesenecker
Ping To
PINNACLE ARCHITECTURAL STUDIO

When clients meet with Quinn Boesenecker and Ping To for the first time, there are three things that are undeniable: their infectious enthusiasm, their grounded, hands-on approach and their high profile success at a time when most architects their age may just be finding their niche in the craft. With all these serendipitous factors at work, the talented principals at Pinnacle Architectural Studio have been able to envision amazing, spot-on build projects for their eager clients. More than that, they have been able to deliver them—consistently and with glowing acclaim.

Founded by Quinn and Ping in 2001, Pinnacle was formed when the duo, who previously worked together at a local firm, recognized that their unique strengths could benefit and complement one another in this unique Las Vegas environment. Quinn, a Las Vegas native, excels in the planning stage of the process while Ping, a Hong Kong native, is unsurpassed at exterior elevations.

In the beginning, Quinn admits, their "under 40" status forced them to prove themselves a bit more, but ultimately, that push to exceed expectations had an advantageous effect and it continues today. In just a few short years, their bold leap has become such a success that Quinn admits giddy delight but also reflects that when a person loves what he does, and does it well, success follows suit. Case in point, when most business owners call it a day by 6 p.m., Quinn can often be found "extending" his workday until 2 a.m. poring over a sketch pad. "It's my passion and my life," he explains.

LEFT:
Lounging under the covered gazebo at the end of an open bridgeway allows one to appreciate the vastness of this desert contemporary home. The cable rail offers an almost unimpeded view of the spaces below.
Photograph by Eric Jamison

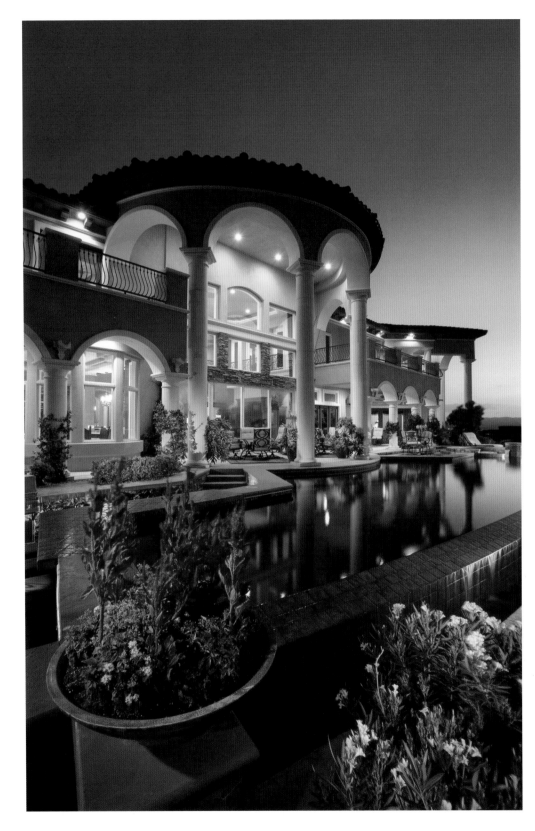

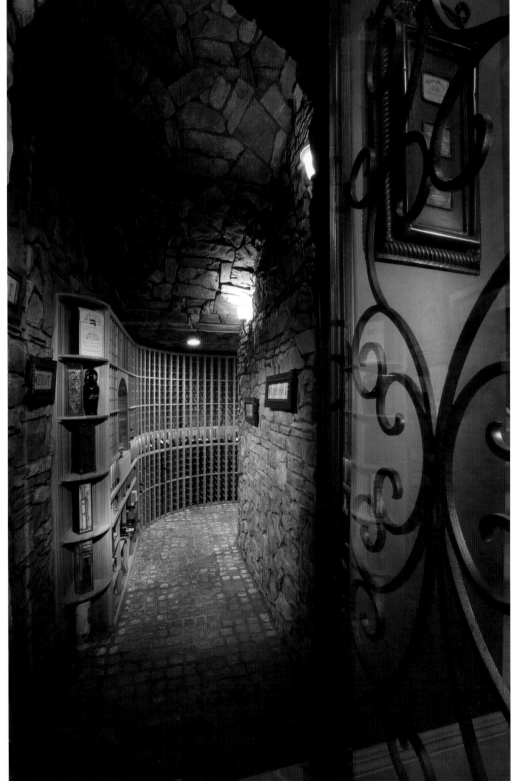

The firm is comprised of 12 people, including five licensed design professionals. The firm handles about 40 to 50 projects a year, heavily residential with a handful of commercial projects as well. Quinn, Ping and the team meet personally with clients, designing and working closely with them throughout the project. Each house they design must be a reflection of each of their clients' unique desires, necessities and lives. Quinn will be the first to tell you "since all of our clients are unique as is each job, Pinnacle always starts each job with a clean sheet of paper. This way, each project starts from scratch and will not pick up design elements of a previous project." From the first rough sketch until the first step through the door of that now-tangible vision, Pinnacle never considers a job complete until its clients do. The team is genuinely committed to the customer service of each project, never passing it off from team member to team member. Because this is the biggest purchase most of their clients will make in their lifetime, the principals make themselves available to meet in person or by cell at any hour and work around their clients' hectic schedules.

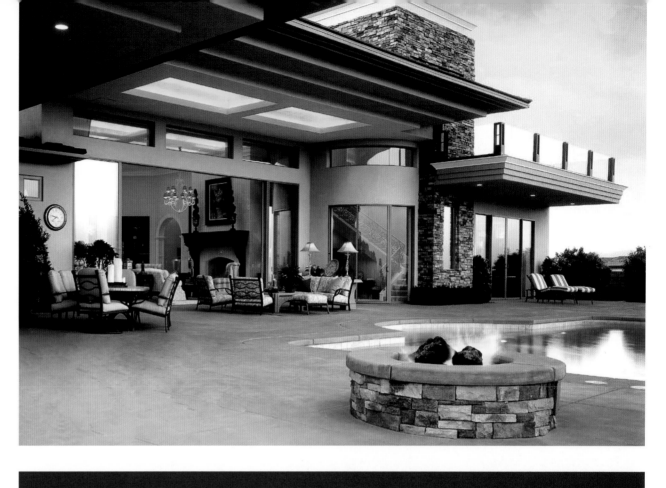

TOP RIGHT:
Without the support of columns below, these ever-reaching overhangs—some up to 20 feet in length—appear to go on forever as they stretch out to protect the furniture below from the brutal Las Vegas sun.
Photograph by Tim Maloney

BOTTOM RIGHT:
As night falls, this house undergoes a chameleon-like change from day to night. Lights gently wash the exterior to show off its subtle changes in material and texture.
Photograph by Dave Smith

FACING PAGE LEFT:
The two-story open patio in this modern-day Mediterranean-style home allowed for a complete split between the master bedroom patio and the kids' patio. It is as breathtaking as it is practical.
Photograph by Eric Jamison

FACING PAGE RIGHT:
In a place under the stairway that is usually forgotten, a wine room that the firm created would rival some of Napa Valley's best.
Photograph by Eric Jamison

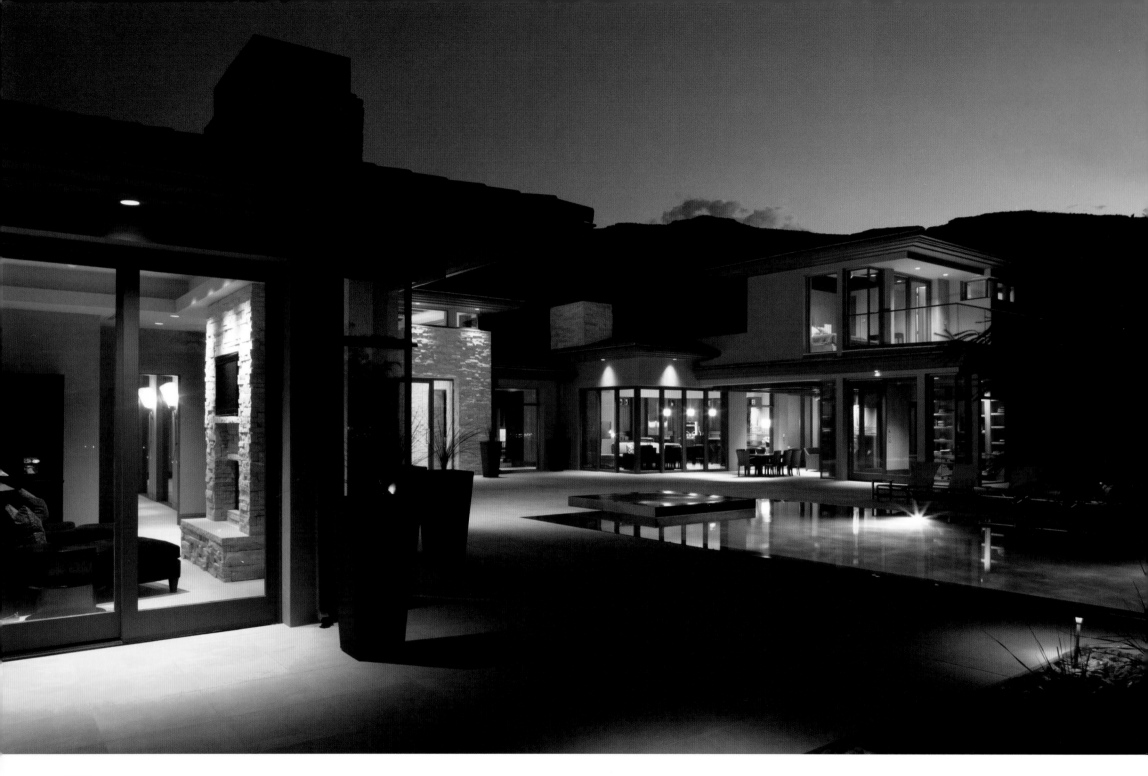

ABOVE:
Each glimmer of light invites you to a new discovery of space and beauty in this contemporary Las Vegas home. Whether it is the soft glow over the carefully stacked stone of the master bedroom fireplace or the ever-changing ripples of the infinity-edge pool, you know that your journey is never ending.
Photograph by Jeff Green

FACING PAGE:
This marriage of simple lines in the kitchen and complex patterns in the ceiling makes for a unique blend of styles that warm up this elegant living space.
Photograph by Jeff Green

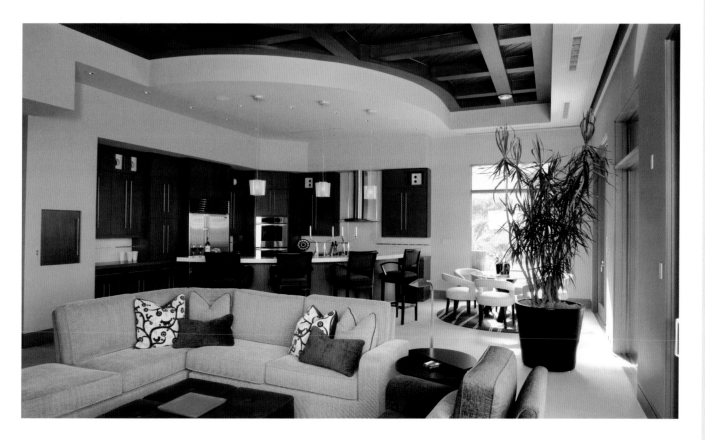

WHAT IS YOUR FAVORITE ARCHITECTURAL STYLE, PERSONALLY?
Contemporary. There seems to be more "room for creativity" in this style.

IS YOUR WORK STILL EVOLVING? WHAT DIRECTION DO YOU SEE YOUR WORK TAKING?
Ever evolving! With so many new products and ever-changing avenues of design, it is important for us to "stay on the cutting edge." We travel quite a bit for our job and it is important for us to stay on this edge and keep ourselves abreast of new products and materials. If we did not do this, we would soon be devoured by the companies that do take the time to keep themselves better educated.

WHAT WOULD BE YOUR IDEAL PROJECT?
I would say that the ideal project is as much the ideal client as the project. We can have a job that would have no budget, the perfect site, optimum conditions, etc. but without the ideal client, this is just another job. Of course, when you have both, you have *our* ideal project!

In a city that has made it to the top of the list of fastest growing cities in the United States since the early 1990s, opportunity is vast and competition is fierce. Never ones to rest atop their success, a move which often lands many architects in a design rut, Quinn and Ping work hard to constantly keep abreast of the latest design trends in order to stay fresh and on the cutting edge. While Las Vegas in general has been known to lean toward a handful of definite styles, Pinnacle is breaking that mold by designing in a wide breadth of styles within all scale ranges. While they tend to appreciate the clean lines of contemporary design and the principles of Frank Lloyd Wright, Pinnacle ultimately looks to its discriminating clientele for its founding cues. Celebrities, businessmen and sports stars alike have called upon the talents of the firm to help bring their dreams to fruition. The firm's spectacular designs can be found in the most prestigious Las Vegas communities, including The Ridges, Southern Highlands, Queensridge, MacDonald Highlands, Lake Las Vegas and more.

Pinnacle has certainly lived up to its name and counts itself among Las Vegas' most influential architectural firms. While constantly abuzz with electricity and excitement, the city of Las Vegas infuses that passionate lifestyle in all of its residents—including the team of Pinnacle. Quinn and Ping offer their clients well-designed havens where they can rejuvenate and appreciate their beautiful surroundings every day. They always strive to continue to be a positive influence over this ever-changing architectural canvas they call Las Vegas. "Because when you set the bar high, everybody will step up."

PINNACLE ARCHITECTURAL STUDIO
QUINN BOESENECKER, AIA
PING TO
9755 West Charleston Boulevard
Las Vegas, NV 89117
702.940.6920
c: 702.278.9494
www.lvpas.com

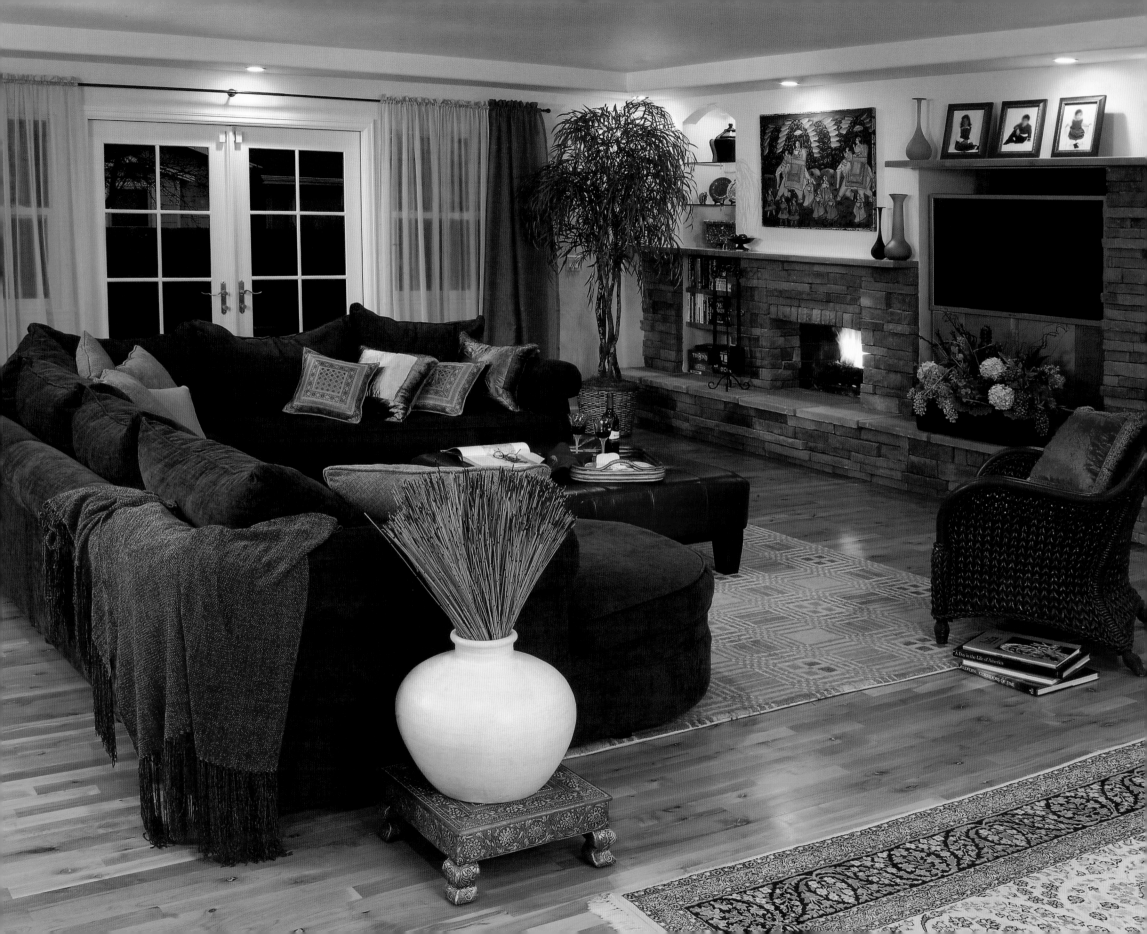

Joyce Clegg
DAYDREAM DESIGNS, LLC

The technology industry and interior design business appear to be worlds apart (an entire brain hemisphere, at least), so it seemed an unlikely transition for Joyce Clegg. But, even though she was designing computer networks, she always knew she had a different sort of inventive streak. She had always enjoyed creating what she could not find, even designing and hand beading her own wedding dress. When Joyce and her husband gutted and restored a historic 1901 home in Los Angeles, doing most of the work themselves, she knew she had found her heart's desire. So after a decade in the computer field, she decided to follow her passion and returned to school to study interior design.

An accomplished designer for more than a decade, Joyce founded Daydream Designs, LLC, in 1999. Using clean lines and keeping environments uncluttered, Joyce designs spaces that are calm and comfortable. Elements of Feng Shui, universal design and accessibility as well as one-of-a-kind details go into nearly every project she does. She loves to create a fresh twist with each room, a little splash of the unexpected, reflecting each client's taste and keeping the eye and the senses interested. "People desire spaces that work, that flow and meld *with* them. So while they may not know it, there are aspects of universal design and energy-management that play a role in good design, always."

ABOVE:
Heated floors, a deep air-therapy tub and views for miles—What more could one want?
Photograph by Ron Ruscio

FACING PAGE:
Four rooms of this 1950s' ranch home were converted into one large, open area perfect for entertaining and enjoying each others' company.
Photograph by Ron Ruscio

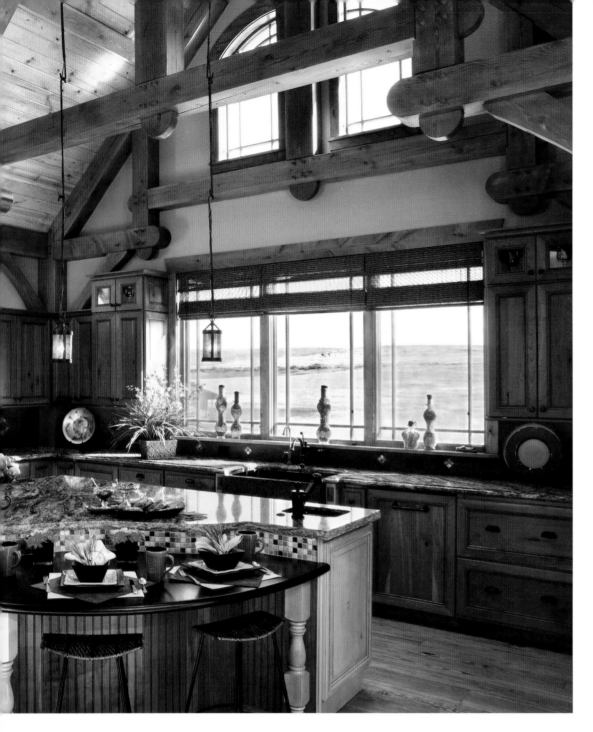

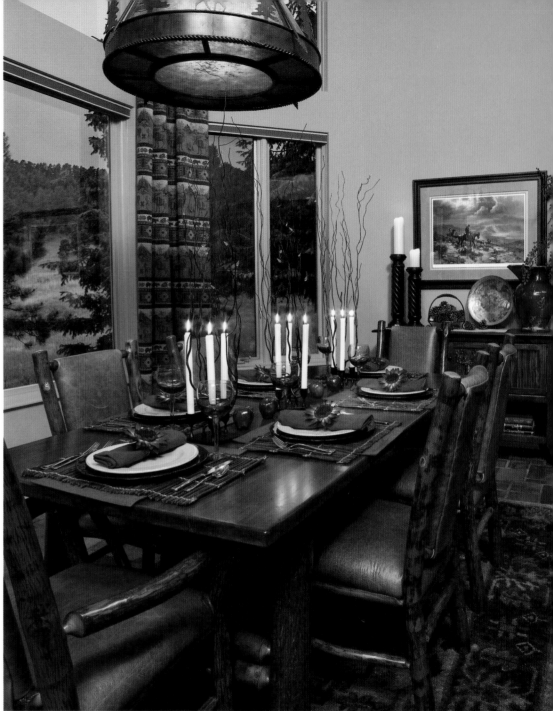

ABOVE LEFT:
This homey, old-fashioned kitchen disguises the fact that the latest and greatest in technology lies within. If you look closely, you can see the touch screen built into the backsplash, which controls the entire home's lighting, security, sound and phones.
Photograph by Ron Ruscio

ABOVE RIGHT:
In a 16-foot-tall room full of windows in the high Sierra, warmth and comfort are created through color, fabric and lighting—dining becomes an hours-long activity.
Photograph by Ron Ruscio

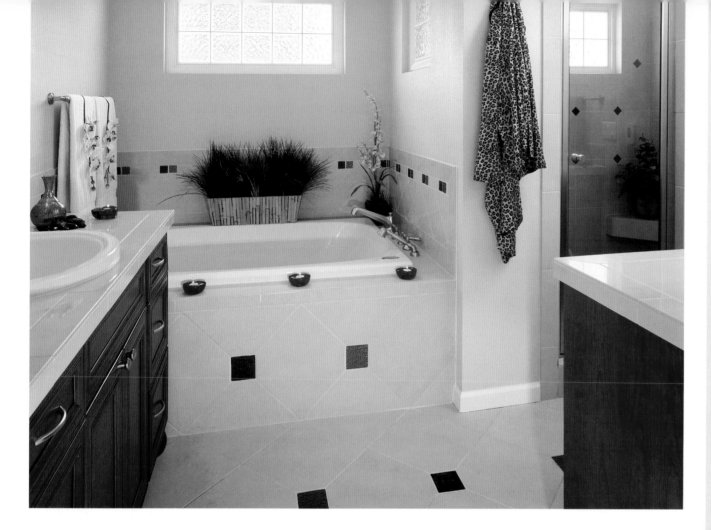

HAS YOUR WORK BEEN PUBLISHED?

Yes, my design work has been featured in *The Denver Post, Luxe Magazine, Architecture & Design of the West, Colorado Homes & Lifestyles* and *NKBA Profiles* magazines. I have also been featured in the book entitled *Spectacular Homes of Colorado*, as well as the HGTV series, "My First Place."

WHAT WOULD YOUR FRIENDS TELL US ABOUT YOU?

I always know the right thing to say and when to say it.

WHAT SETS YOU APART FROM YOUR COMPETITION?

I design custom tiles, which helps me keep each of my projects fresh. They run the gamut in style and price and can add tremendously to an environment.

HOW DO YOU RELAX IN YOUR OFF TIME?

I love to rock climb! It makes me feel strong and empowered and at times it can help me maintain focus. If I'm having a stressful day, I go climb a rock and I'm able to return with my head and heart back in the game.

As a designer, she has had the opportunity to work on many historical restorations and in this has found one more facet of design that suits her. She experiences such a sense of awe by connecting with the past. "Restorations are like renewing one's face while still acknowledging one's age. If it were that easy, we all could have it!"

Continually playing with options, textures, shapes and materials, Joyce keeps each project new and invigorating, especially since she absolutely detests repeating herself. Guiding her clients in making good choices throughout the design process, she transforms their dreams into reality.

Joyce still has her computers; however, instead of designing them, she is now designing *with* them for her clientele.

DAYDREAM DESIGNS, LLC
JOYCE CLEGG
5691 South Harlan Street
Littleton, CO 80123
303.DAYDREAM
f: 303.379.9858
www.daydreamllc.com

ABOVE:
Here, even a small space can be spacious if well planned and appointed. Glass tiles in the floor and walls provide visual interest while keeping the design clean and uncluttered.
Photograph by Ron Ruscio

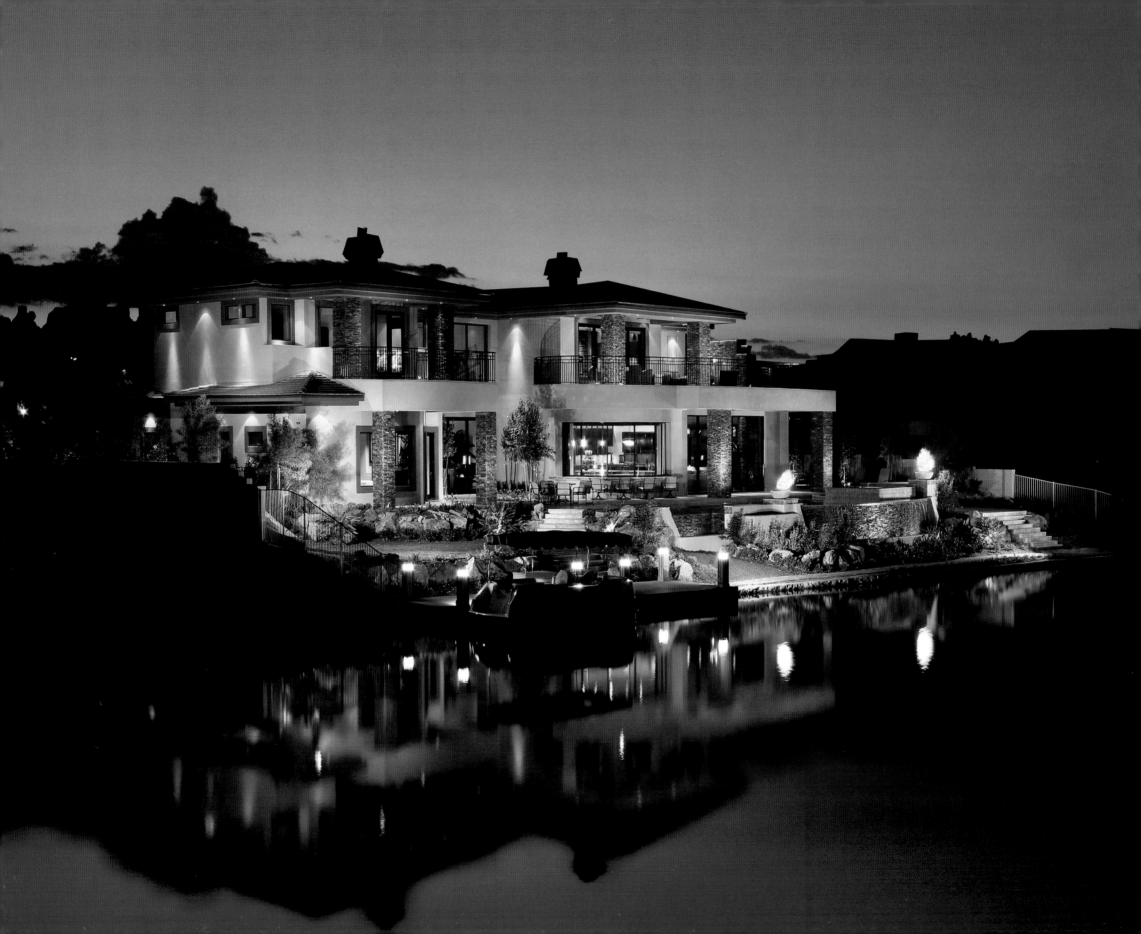

Chris Finlay
PALM CANYON DEVELOPMENT, INC.

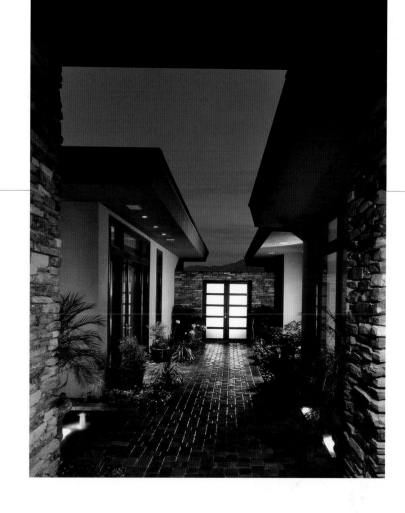

Palm Canyon Development, Inc. is a Las Vegas-based corporation specializing in the design, construction and development of luxury custom homes. Chris Finlay, president, has more than 15 years of experience with multi-award-winning results. He has produced homes in Las Vegas and Palm Springs, and is known for his unmatched attention to detail and quality.

Chris relocated to Las Vegas in 1981 to attend the University of Nevada Las Vegas where he earned his Bachelor of Science degree. He began working in the real estate field in commercial leasing and became interested in building custom homes for himself with the development of a 10-lot cul-de-sac in southwest Las Vegas.

Chris Finlay's expertise in land development, real estate and construction has garnered him prestigious acknowledgements. He was an appointee to Clark County's Planning Commission and a "featured builder" for The Ridges, a Summerlin master-planned community in west Las Vegas. His firm has received six Las Vegas *Luxury* magazine DESI Awards, as well as numerous awards from the 2003 through 2006 Las Vegas Parade of Homes for best architectural design, interior/exterior design, kitchen layout and patio design.

ABOVE:
This inviting entry courtyard is an event on its own. With lush landscape and bubbling water features, Chris Finlay designs a home that is just as comfortable and welcoming outside as it is inside.
Photograph by Paul Cichocki

FACING PAGE:
Rich landscape and a negative-edge pool with roaring fire features bejewel the ground while dramatic exterior lighting showers the house. Both master bedroom and twin guest bedrooms have a personal balcony retreat to take in the lakeside view. At ground level, the home offers four different elevations of patio with private boat dock.
Photograph by Paul Cichocki

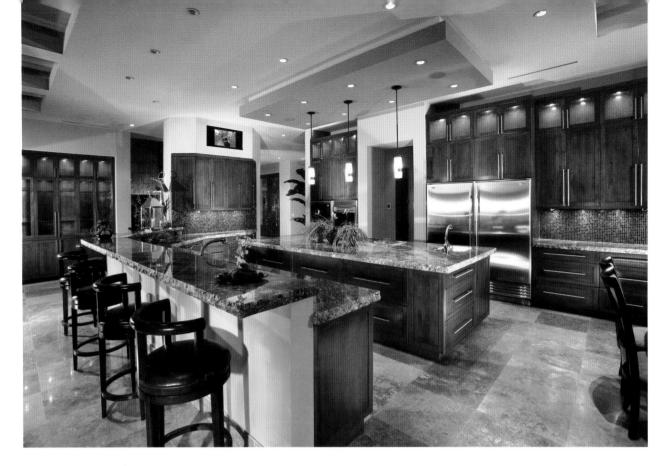

Chris, as creative director of Palm Canyon, incorporates a touch of Frank Lloyd Wright's view on philosophy and life as it relates to design. His most recent creative idea is fusing Desert Contemporary with mid-century architecture. This fusion of styles becomes a home which is livable, spacious and modern—a new twist in luxury living. Palm Canyon was one of the first builders in Las Vegas to incorporate pocketing window walls and indoor/outdoor bars, blurring the line between inside and out. This unique way of building creates the ultimate in entertainment homes. Palm Canyon integrates state-of-the-art electronic and lighting technology to achieve spectacular, fully automated homes without a single sacrifice to the design aesthetic. Keeping the environment in mind, the latest energy-efficient appliances and insulation are also incorporated.

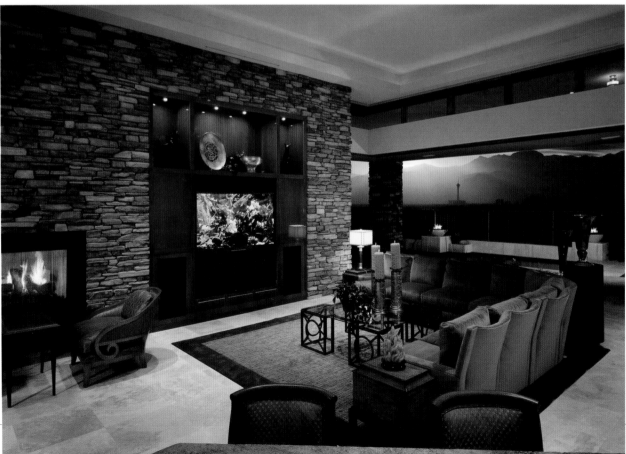

TOP LEFT:
Floor-to-ceiling alder cabinetry with lit rain glass display and down-draft range hood conceals the daily clutter of everyday use while extended hand-chiseled granite tops and copper mosaic backsplash bring sophistication to this kitchen.
Photograph by Paul Cichocki

BOTTOM LEFT:
Pocketing window walls and the use of masonry stone for the interior of the home blur the line between inside and out.
Photograph by Paul Cichocki

FACING PAGE:
A steel-veneered fireplace wall, vertical stone columns and dramatically lit soffits add a new level of formal design.
Photograph courtesy of Palm Canyon Development, Inc.

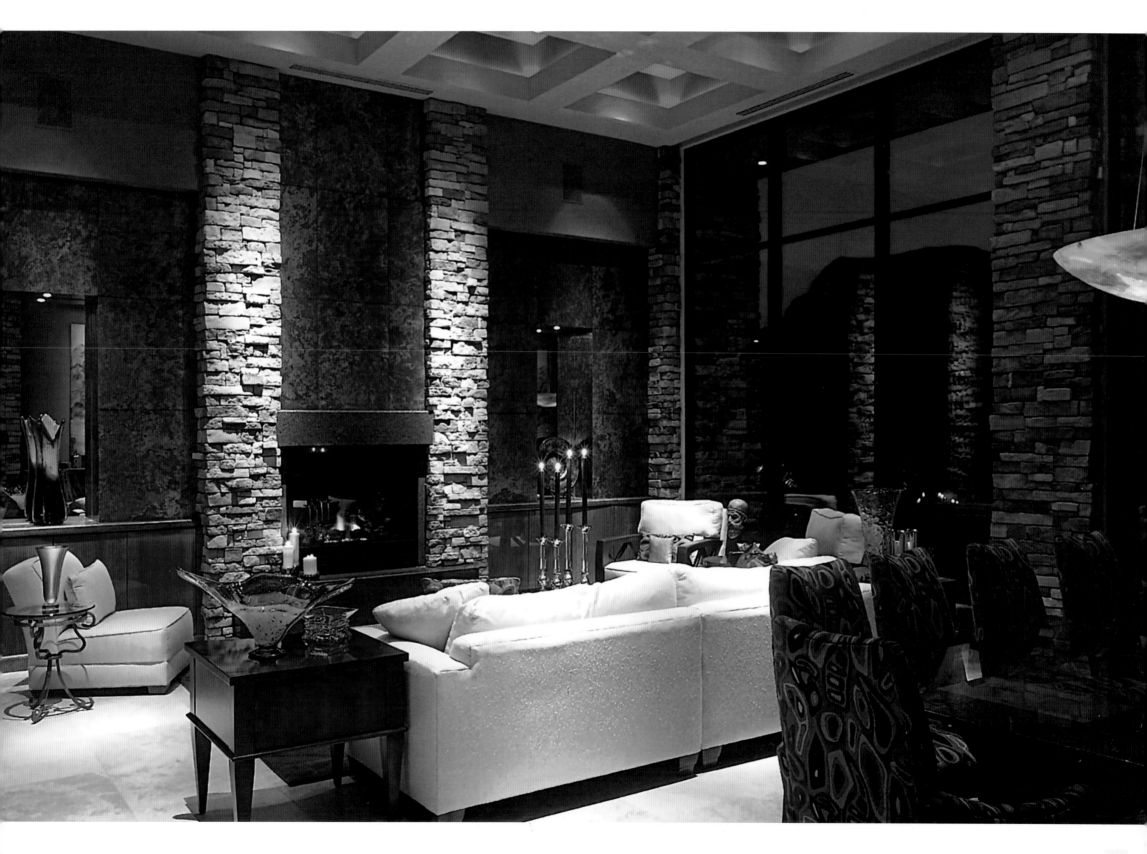

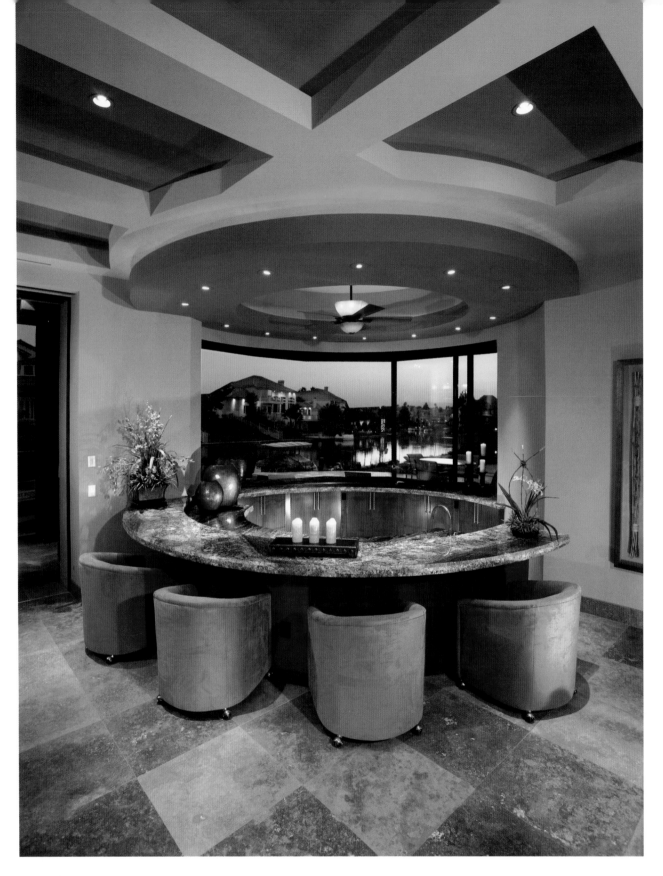

Chris and his team of specialists are always available to personally orchestrate each step of the construction process. Their dedicated hands-on approach along with a superior level of customer service separates Palm Canyon from other developers. It is this responsive way of building that attracts clients to their lavish custom homes. The goal is to make the experience hassle free and, most importantly, enjoyable for the client.

Palm Canyon Development prides itself on blending artistry and lifestyle with engineering and development, bringing each client's dream to reality.

LEFT:
Chris Finlay's most acknowledged design is the indoor/outdoor bar. This bar incorporates the use of a bent pocketing window. The bar itself holds stainless steel appliances, and the circular Rainforest Tan marble counter top is matched above with an impressive ceiling drop—another Palm Canyon trademark.
Photograph by Paul Cichocki

FACING PAGE:
A showstopping backyard integrates a favorite fire-on-water feature along with the latest in pool technology. This lavish landscape with its amazing lighting alone is one of the reasons why Chris Finlay is a multi-award-winning developer.
Photograph by Paul Cichocki

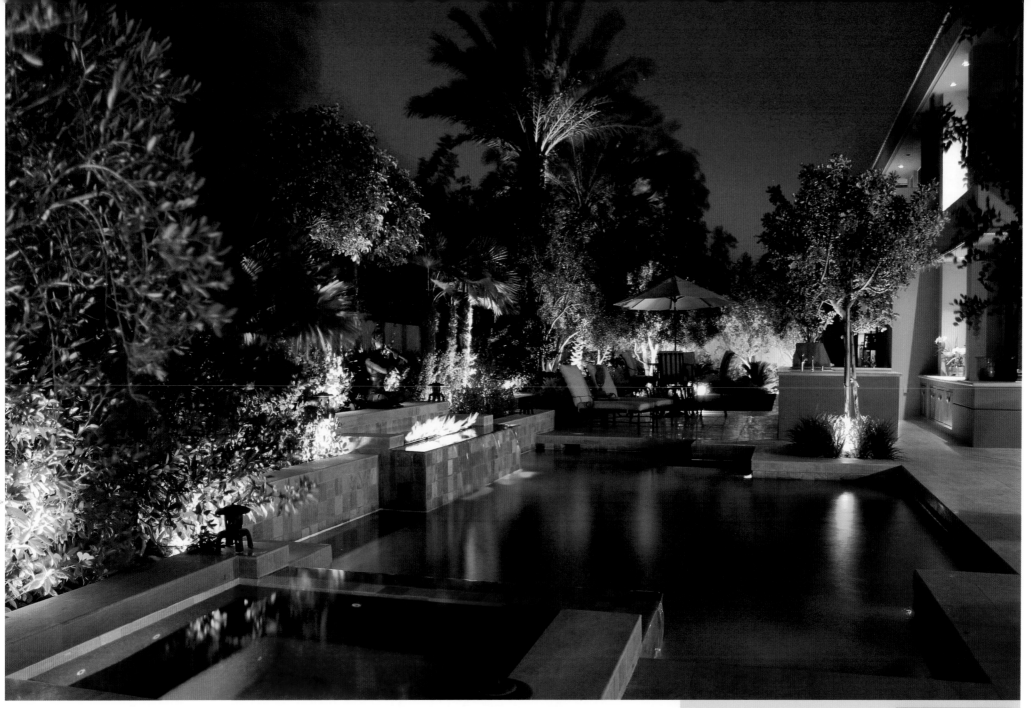

PALM CANYON DEVELOPMENT, INC.
CHRIS FINLAY
10300 West Charleston Boulevard
Suite 13-170
Las Vegas, NV 89135
702.220.8920
f: 702.228.3137
www.palmcanyondevelopment.com

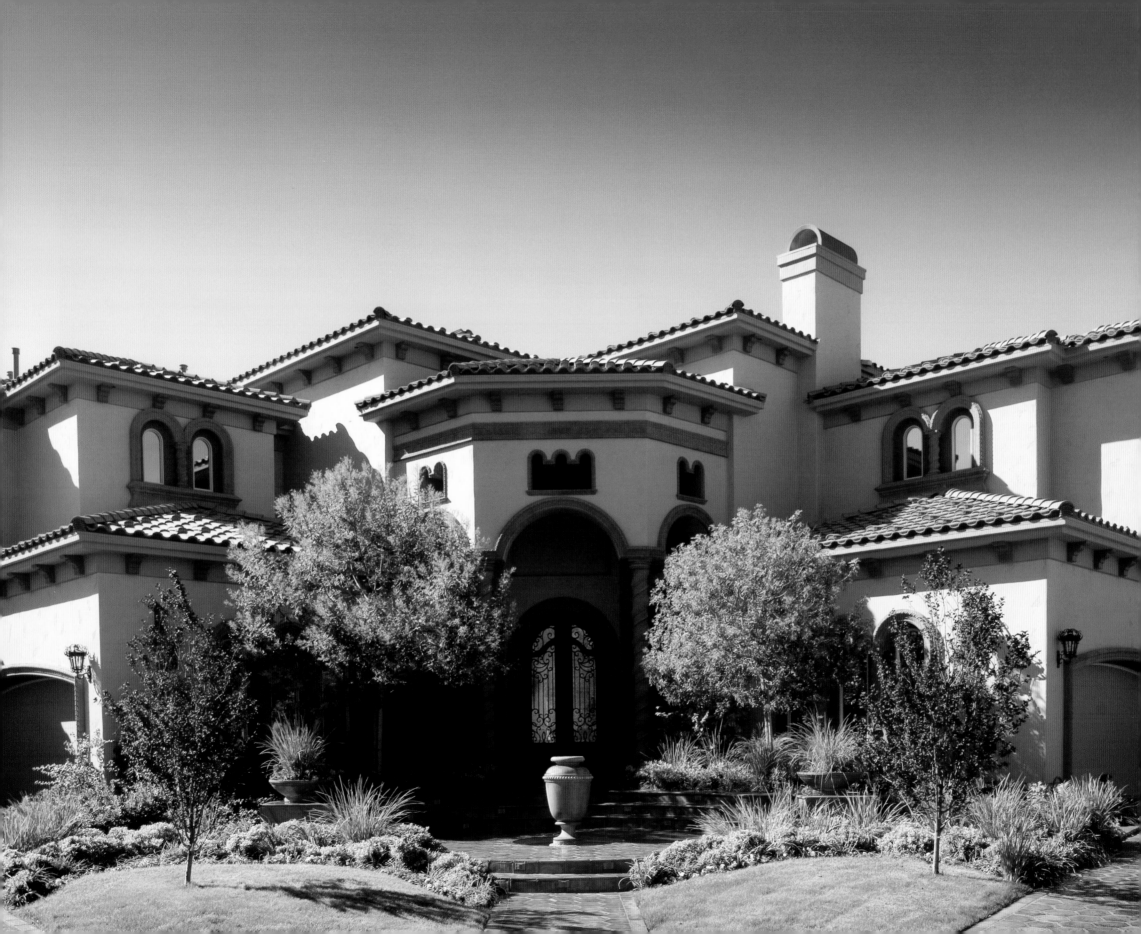

Darrell A. Gardner
Angela K. Gardner
A DESIGN GROUP

A Design Group, formed in 1996, focuses on providing creative, functional architecture while developing long-term client relationships that emphasize the value of their investment. With more than 25 years of combined experience, Darrell Gardner and his wife, Angela Gardner, run the Las Vegas-based architecture firm with a strong emphasis on serving clients and meeting their needs to the fullest extent. Together, they have established A Design Group as a force in the Las Vegas architecture industry through the design of beautiful homes and a continually growing list of absolutely satisfied clientele.

A judicious and enthusiastic design team, Darrell and Angela's innate ingenuity in creating stunning homes has been the cornerstone of their achievements. However, Darrell is quick to tell you that what truly drives their success is their desire to make clients feel completely at ease. "We meet our clients in the comfort of our home or theirs," he says. That uncomplicated but priceless philosophy of putting his clients' needs first, taking into account their desires, and ultimately, their dreams, has created quite a reputation for A Design Group.

ABOVE:
A pool and trellis structure are seamlessly integrated into the design of the residence.
Photograph by Opulence Studios

FACING PAGE:
The beautiful front elevation of a Tuscan-inspired home.
Photograph by Opulence Studios

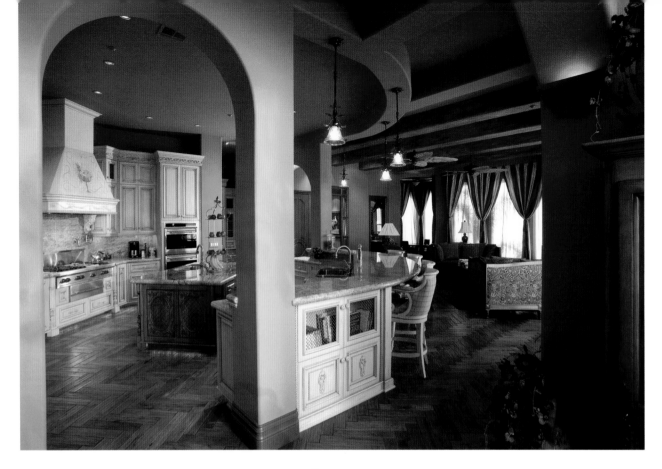

Recently, Darrell and Angela were showcased as featured designers on HGTV's "Designers' Challenge." The Vegas homeowners asked for a bit of whimsy, and A Design Group's playful plan won the honor. It was the Gardners' ability to listen and then skillfully articulate the homeowners' wishes into an environment that reflected their personal style that, yet again, set them above the competition.

Able to easily flow through a range of styles, Darrell finds that one of the perks of his trade is seeing his client's happiness with the completion of each project. Feeling the highest compliment he could receive is the sheer delight of homeowners as they enter their brand new residence for the first time, he never tires of the broad smiles that his designs create. "If I have improved their quality of life, I'm absolutely thrilled!"

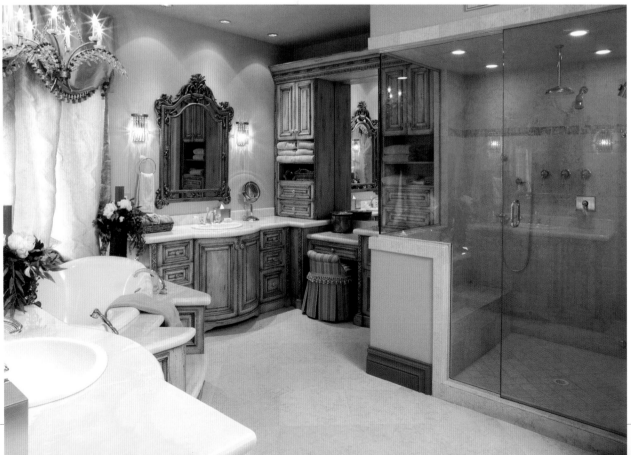

TOP LEFT:
A dramatic ceiling design enhances the gourmet kitchen and leisure room with function and harmony.
Photograph by Opulence Studios

BOTTOM LEFT:
The luxurious master bath and spa emphasize comfort and relaxation.
Photograph by Opulence Studios

FACING PAGE:
The high-volume formal living area with adjacent adult lounge for entertaining features a Juliet-inspired balcony.
Photograph by Opulence Studios

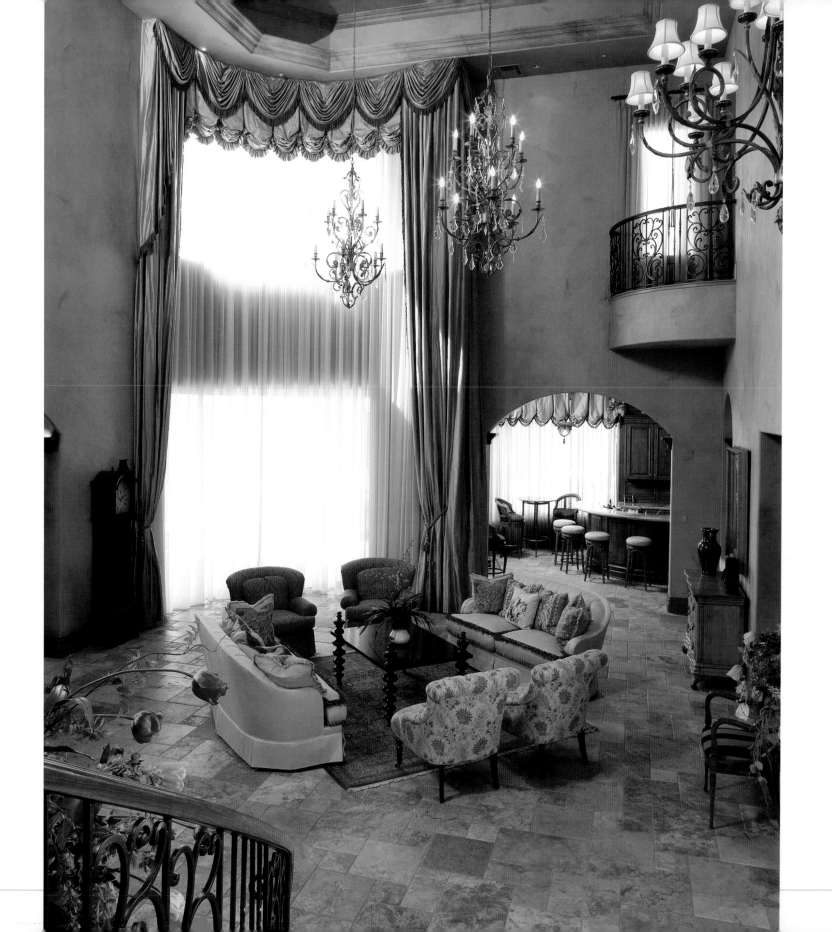

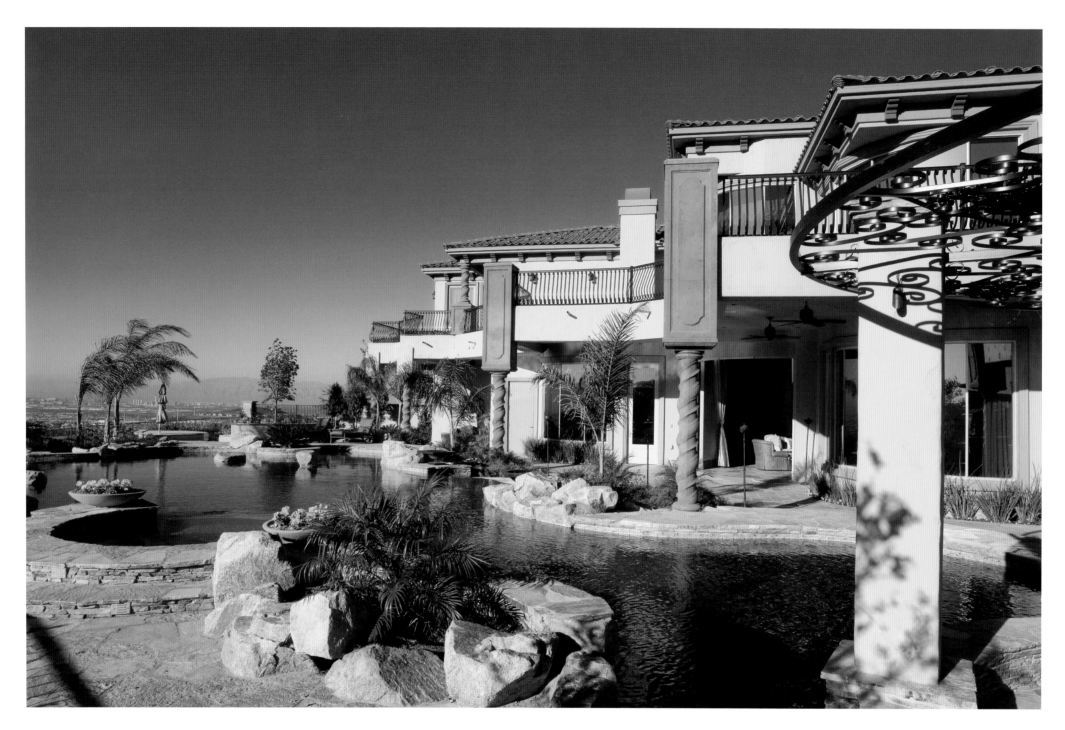

ABOVE:
A backyard paradise overlooks the entire Las Vegas valley and world famous Strip.
Photograph by Opulence Studios

FACING PAGE:
Retractable doors and windows throughout both levels of the residence promote indoor/outdoor living.
Photograph by Opulence Studios

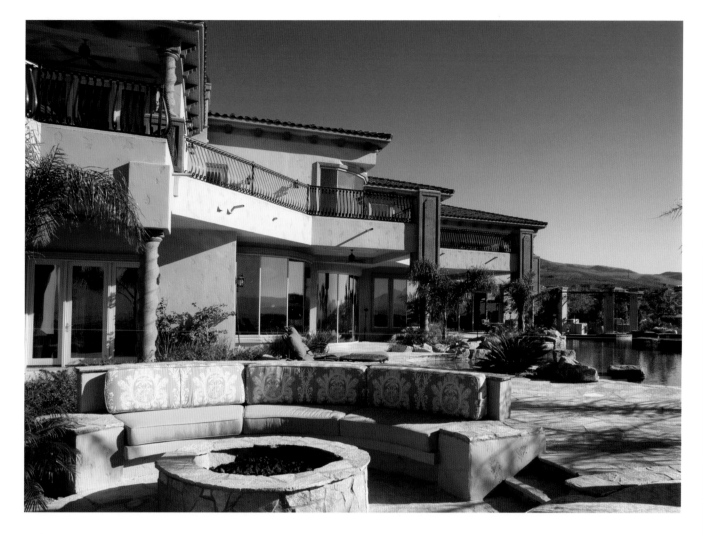

A DESIGN GROUP
DARRELL A. GARDNER, ASSOCIATE AIA
ANGELA K. GARDNER, AIA
3722 Caesars Circle
Las Vegas, NV 89120
702.658.2169
www.adesigngroup.com

Q&A

more about darrell ...

WHAT IS ONE OF THE BEST PARTS OF BEING AN ARCHITECT?
Being able to work with my talented wife.

IF YOU COULD ELIMINATE ONE BUILDING STYLE FROM THE WORLD, WHAT WOULD IT BE?
Tract homes!

WHO HAS HAD THE BIGGEST INFLUENCE ON YOUR CAREER?
Joel Bergman, the architect for The Mirage and Treasure Island casinos.

ON WHAT PERSONAL INDULGENCE DO YOU SPEND THE MOST MONEY?
I love to go saltwater fishing off of the Kohala Coast on Hawaii's Big Island.

Both Darrell and Angela truly love their work and find it genuinely rewarding doing business in Las Vegas with the unmistakable energy that runs through the city and its architecture. One of the fastest growing, hottest communities in the country, it provides them with not only an exceptional backdrop for their spectacular homes, but the unique opportunity to design custom residences on a remarkable level.

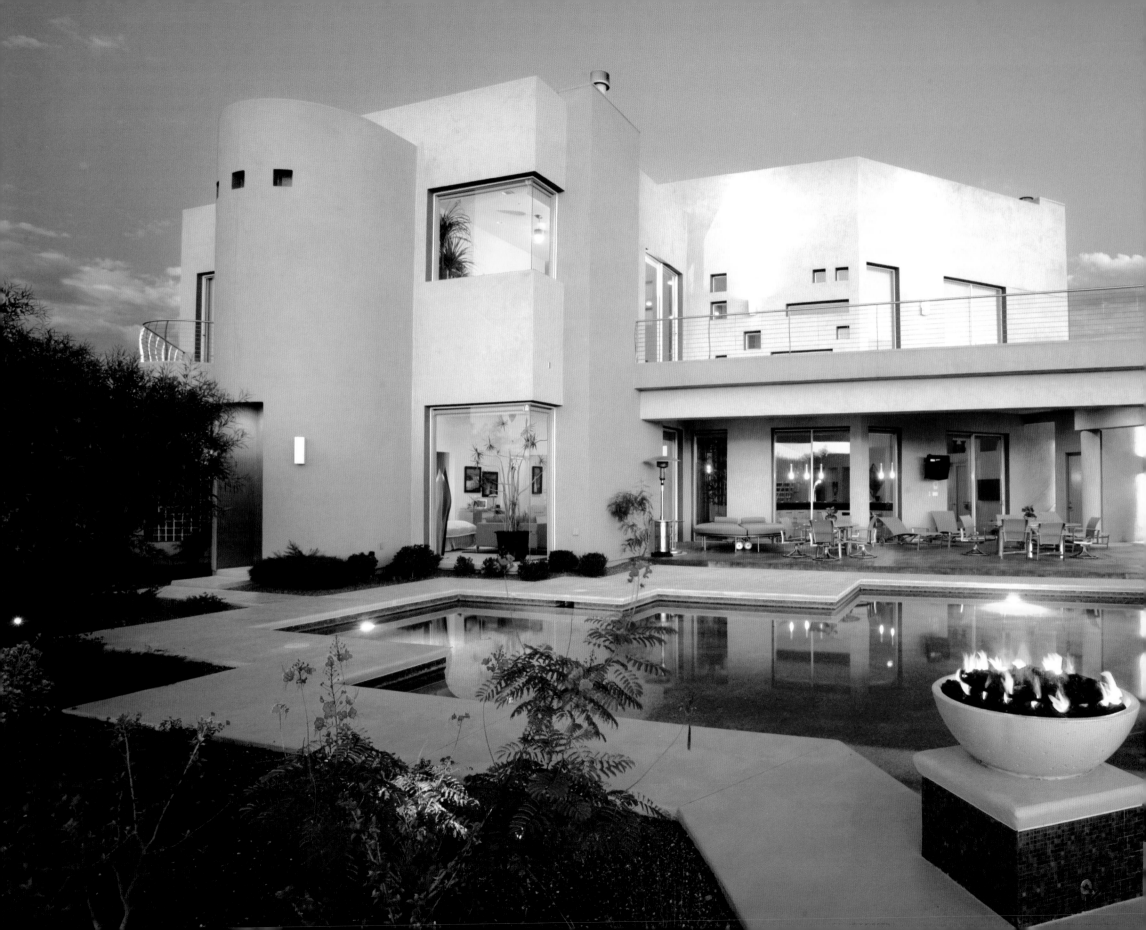

Jon J. Jannotta

JON J. JANNOTTA ARCHITECTS-PLANNERS, INC.

Jon J. Jannotta was destined to be an architect. At age 10, Jon created a model of the Eiffel Tower, though he never knew of or saw the colossus until he was a teenager. Then, designing his first house at the age of 12, Jon had obviously found his calling and followed it with passion and enthusiasm, ultimately becoming one of the most well-respected architects in the West.

Graduating from California Polytechnic State University in San Luis Obispo, California, with a Bachelor of Architecture degree in 1971, Jon went on to further his studies at UCLA, earning his Master of Architecture and Urban Planning in 1978. There is no doubt that Jon's sterling education has been a valuable asset, but his early influences have shaped the essence of his design and his career. While at UCLA, Jon studied under the renowned architects Charles Moore and Rem Koolhaas. Moore's humanistic work and Koolhaas's use of the unexpected are evident in Jon's approach to architecture as well as his ability to physically articulate new visions. Jon is now developing his own projects with his long-time friend and master builder Michael A. Vespi, who has major experience building in his hometown of Toronto, Canada, and presently in Las Vegas, Nevada.

In his quest for new ideas in design, Jon joined forces with Mexican architect Francisco J. Delgadillo. Francisco studied at the School of Architecture at the University of Guadalajara in Mexico, where he was influenced by contemporary Mexican architect Luis Barragan. As they started to work together, they

LEFT:
The Zimmer-Jage residence's rear elevation and pool are spectacularly illuminated at twilight.
Anthem Country Club, Las Vegas, Nevada.
Photograph by Jeff Green

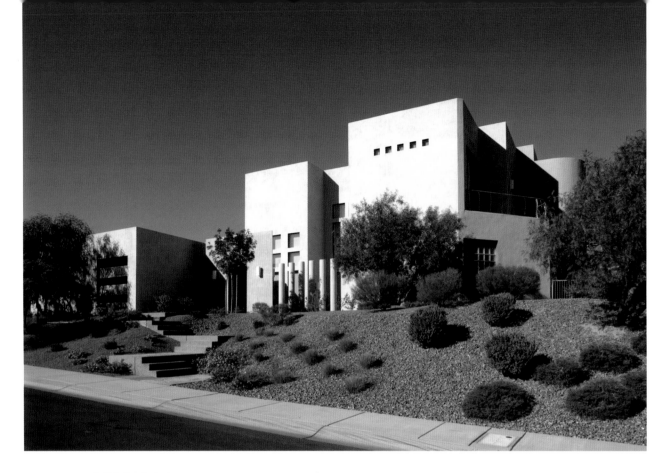

found how similar their designs were even though their backgrounds were so different. With years of experience as an architect and builder in his hometown of Guadalajara, Mexico, Francisco has brought a new design approach to the firm for more than a decade.

Engaging users within a clearly defined spatial environment and an assured, natural philosophy, each project is created by considering the building's surroundings, indigenous material, volume and space. Jon infuses each plan with the sum and substance of himself, engraving the project with his own spiritual awareness and creativity. Though as he builds, it is dollars and cents, rocks and mortar, all planted on the earth, that he focuses upon. He muses that his imagination and inspiration come from somewhere else, somewhere almost ethereal.

Nevertheless, Jon has yet to reach his pinnacle. He continues to change as he grows with age and experience. Over the years Jon has traveled across the entire United States as well as to various countries abroad, and these adventures have also made their mark on his extraordinary work. He is a soulful artist who cares deeply about all life, all people, and whose designs have been greatly shaped by the cultures of the world.

TOP LEFT:
Exterior front elevation of the Zimmer-Jage residence.
Photograph by Jeff Green.

BOTTOM LEFT:
Interior main living space from the kitchen's vantage point. The openness of the floor plan invites ample natural light into the Zimmer-Jage residence.
Photograph by Jeff Green

FACING PAGE TOP:
Exterior front elevation of the Jannotta residence in Anthem Country Club, Las Vegas, Nevada.
Photograph by Jeff Green.

FACING PAGE BOTTOM:
Exterior rear elevation pool area in the evening at the Jannotta residence. Sculpture art by Carlos A. Chavez, Las Vegas, Nevada.
Photograph by Jeff Green

Admittedly, that world has come a long way with many women entering the architectural arts. When Jon graduated, only two of the 500 students accepting their degrees were women. But today, that number has risen significantly and Jon's daughter Gabriella will be following in his footsteps. Though he and his wife Nancy had encouraged her to become a doctor, and even expected she would announce her intent to become a ballerina, at a very young age she declared insistently that she would be an architect just like her father. Soon, she will graduate and join his firm, making one of the few father/daughter teams in the nation, if not the world, and instilling in Jon a stellar sense of pride and appreciation of his daughter's immense creativity, compassion for humanity and talent.

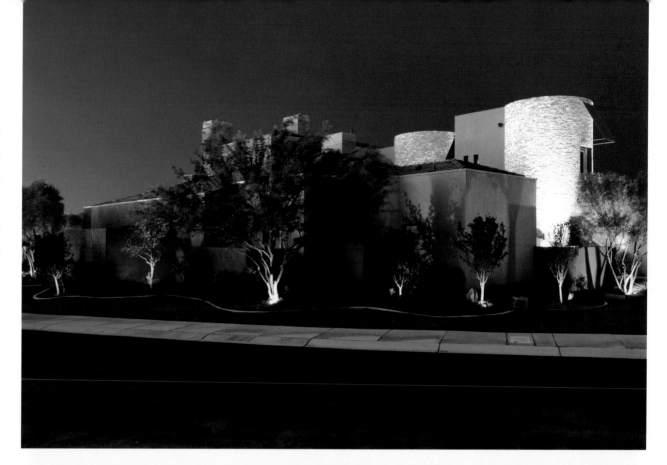

Q&A
more about jon ...

HAVE YOU EVER BEEN PUBLISHED OR RECOGNIZED FOR YOUR WORK?
I have been published in the *Los Angeles Times'* "Home Section," *The Las Vegas Home Book, Architectural Record, Desert Living* and I was featured along with my work on the cable television show "Homes Across America."

WHAT IS THE HIGHEST COMPLIMENT YOU'VE RECEIVED PROFESSIONALLY?
I won several AIA design awards for buildings I completed, but it is also a wonderful compliment and makes me content when clients truly love their buildings.

JON J. JANNOTTA ARCHITECTS-PLANNERS, INC.
JON J. JANNOTTA
2500 Anthem Village Parkway, Suite 200
Henderson, NV 89052
702.804.8034
f: 702.804.9307

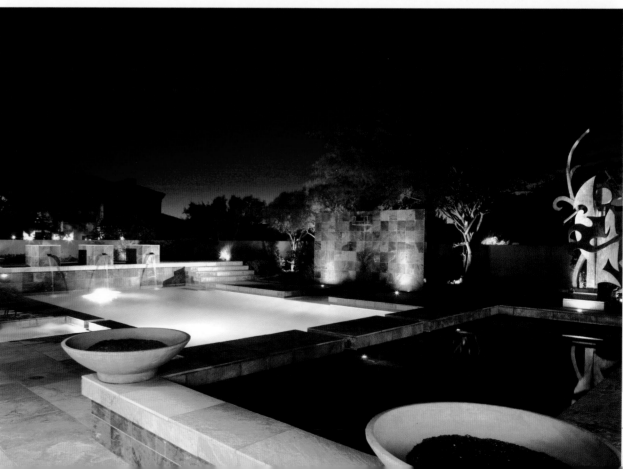

Kara A. Karpenske
KAMARRON DESIGN, INC.

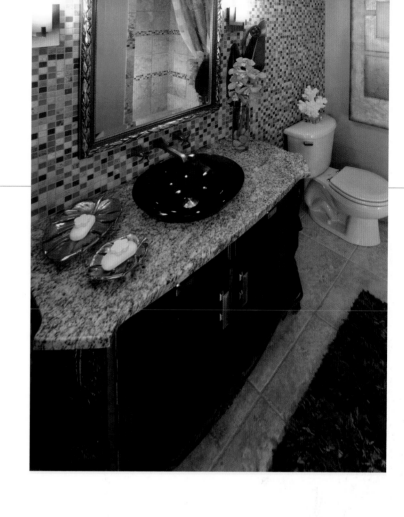

Combine an all-consuming passionate energy for what one does with a service-oriented work ethic derived from a traditional Midwest upbringing and you have interior designer extraordinaire Kara Karpenske, founder and principal of Kamarron Design, Inc., a thriving studio serving loyal clients in the exceedingly upscale Las Vegas residential market. Kara is not new to the interior design arena; she started her reputable firm in 2001 in Minneapolis which she runs with the help of three assistants and a 10-person installation crew. Kara is the consummate professional and her clients ask for her by name, as 95 percent of her business is referral. Clients communicate freely with her on a daily basis, all the while knowing their homes are in the most creative hands as she transforms their spaces into luxurious, sophisticated retreats with her design prowess.

In a city known for its over-the-top image, Kara is a master at creating residential environments that truly mirror the good taste of her homeowner-clients. Whether creating interior designs in spacious contemporary condominiums or in exclusive residences throughout the area's prestigious desert communities, she is notably adept at extensive interior remodeling; updating and revitalizing private residences is her forte. She is equally talented at developing design solutions for a brand new home's blank canvas, creating classically dramatic rooms from start to finish. Kara's innate ability to interpret each client's vision, desires and needs to reflect today's current design look is her calling card. When it comes to color trends and textures, furniture and seating arrangements, innovative products and materials, she is the expert consultant and advisor. She draws from her established contacts and resources from the

ABOVE:
An artistically inspired bathroom is poised for guests: Natural granite contrasts the hand-carved walnut vanity showcased with charcoal-colored glass vessel sink. Modern brushed-nickel fixtures complement the Italian mosaic glass and travertine tiled walls.
Photograph by Bill Diers Photography

FACING PAGE:
Hair-on-hide, stamped, tufted and rustic mahogany leather creates a base for this luxurious living room. Complements of modern amber and cinnamon striped panels flank the grand sofa. Details of beaded pillows, large mercury lamps, crystal candlesticks, modern sculptures and scaled botanical art deliver this as a conversational, yet intimate living space.
Photograph by Bill Diers Photography

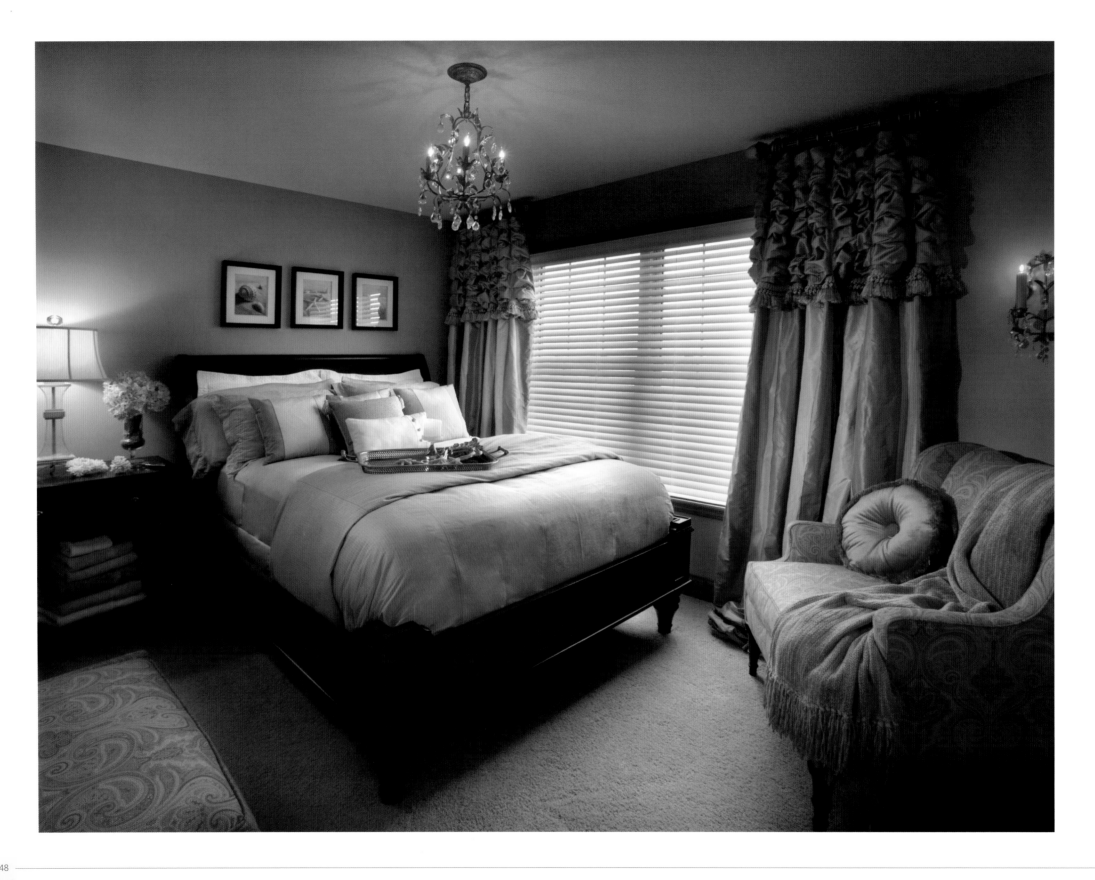

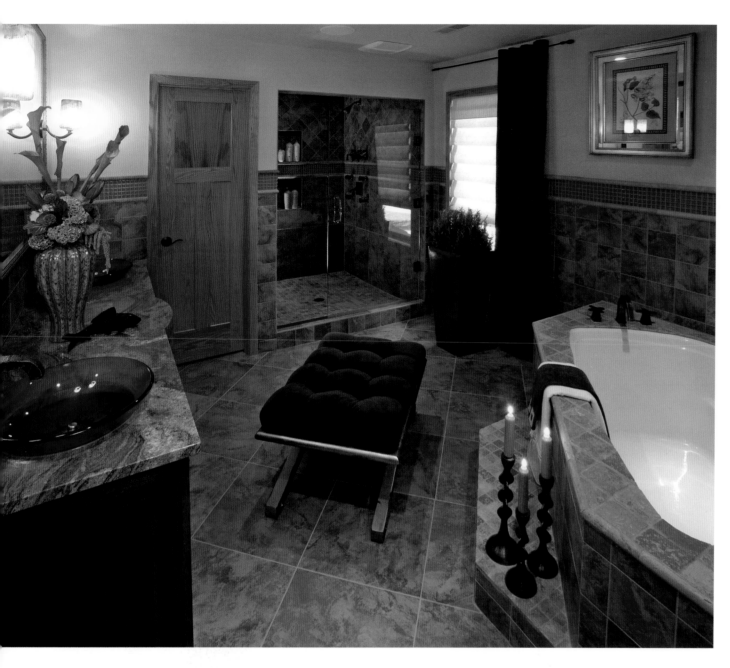

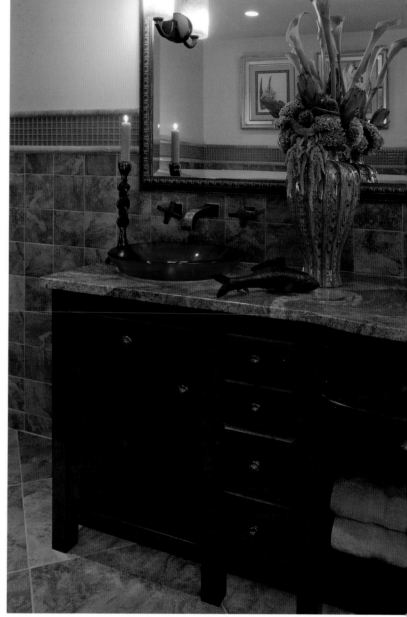

ABOVE LEFT:
A therapeutic approach was taken to this master bathroom: Travertine and natural stone were mixed with modern glass tiles—a perfect backdrop for a sensual spa experience. State-of-the-art bath fixtures were installed in the shower built for two, complete with rain heads that add to this relaxing and rejuvenating space.
Photograph by Bill Diers Photography

ABOVE RIGHT:
A custom vanity becomes the bathroom's signature piece, elegantly accented by the contemporary colored-glass basin, hand-forged wall-mount faucets, and glass tile accents.
Photograph by Bill Diers Photography

FACING PAGE:
Refined, classical opulence is personified in this glamorous guest suite, which is luxuriously appointed with silks and sumptuous linens, soft textures and a historical color palette, creating an elegant sanctuary.
Photograph by Phillip Mueller

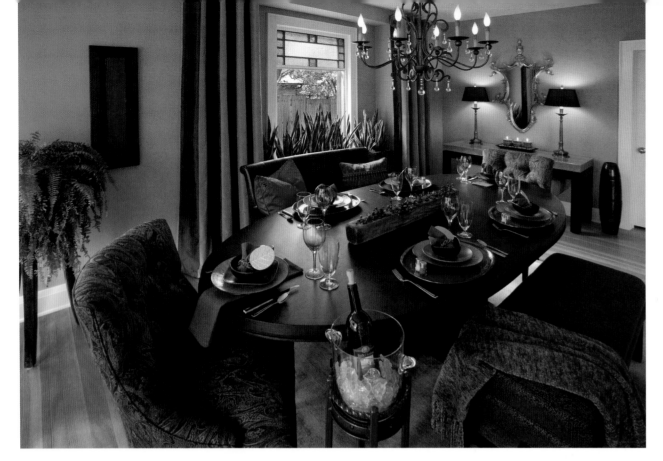

renowned World Market Center as well as handpicked overseas importers to create custom rooms for her clientele.

Basing her business on a high level of quality both in terms of design work and outstanding service, she has attracted a loyal following; clients often become friends in the process of working with Kara. Known for upscale classic and "comfortably lavish" interiors with an impeccable attention to detail, Kara has made her mark devoting the last several years to the design-savvy Las Vegas market. In addition to her work in the deserts, she has maintained a Minnesota presence as well as designed custom interiors in Austin, South Padre Island, New Orleans and Washington, D.C. From original concepts to completion, her main objective is to give clients a home that they absolutely love to live in, one where their every wish is satisfied.

Kara's signature style is expressed in the particular way that she accessorizes a room or angles the furniture, but most of all, how she attends to the unique details that make a house a home. She also includes natural, native materials evocative of the desert culture; design elements and accessories are sometimes dictated by the intense climate. For example, window treatments are selected to keep rooms cool by day but frame spectacular views at night. Gilded furniture, metallic wall glazes, silver antique finishes on mirrors and

TOP LEFT:
Modern elements meet classical form; custom-upholstered chairs, dark woods and fresh green walls create an ambience to impress guests. A sparkling chandelier and ornate reflective mirror add to pure dining pleasure.
Photograph by Bill Diers Photography

BOTTOM LEFT:
Overlooking a lake, this classic kitchen breaks the mold. Black walnut cabinetry finished in a charcoal stain with glass uppers defines the space. Accented by the copper and glass tile backsplash, beautiful granite, top line appliances and contemporary pendant lighting, this kitchen is a family showplace.
Photograph by Bill Diers Photography

FACING PAGE:
Cordovan leather and custom paisley fabric with hues of gold and blue combine to create a classic living room. Attention to detail in the accents, oil painting and aged antiqued mirror formulates this living room into a soothing and sophisticated space.
Photograph by Phillip Mueller

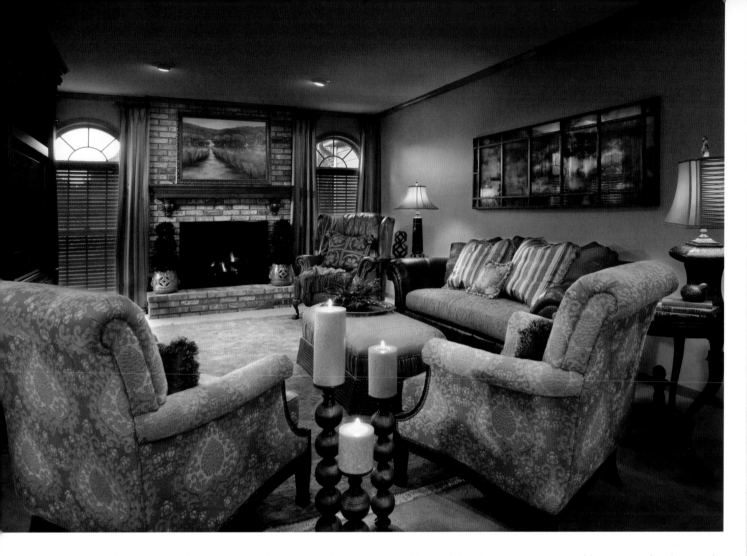

WHAT IS THE HALLMARK OF YOUR DESIGN FIRM?

We are capable of doing a home from start to finish with outstanding service where each client's needs and wants are met.

IS THERE A PHILOSOPHY YOU HAVE STUCK WITH FOR YEARS THAT STILL WORKS FOR YOU TODAY?

Trust, honesty and service are our core values. My Midwest upbringing instilled a solid work ethic, and I operate from the philosophy that the client should consistently receive a high level of quality, good service and respect for budgetary considerations.

WHAT IS YOUR BIGGEST INSPIRATION?

I began my professional life in international business and traveled abroad eight months each year to Mexico, Puerto Rico, Spain and other exotic locations. Travel informs my design work and inspires my selections of furniture pieces, materials, finishes and unexpected accessories.

WHAT IS THE BEST PART OF BEING AN INTERIOR DESIGNER?

Creating a home that my clients love! My clients have confidence in me and many become lifelong friends.

DO YOU HAVE ANY SPECIAL PROFESSIONAL AFFILIATIONS?

Serving on the Board of Directors for the International Furnishings and Design Association, I enjoy being an influential contributor within the design community.

fabulous chandeliers are just some of the important details incorporated in Kara's interior designs. Las Vegas' homes are often large-scale, so to personalize them with the region's flavor Kara incorporates genuine pieces such as an oversized antique wooden wheel or chocolate-brown cowhide chaises. Creating authenticity with interest via natural materials, such as concrete with wood accents, granite and stone finishes and organic details, integrates the desert's outdoor beauty with indoor living.

Kara's studio provides a full range of professional design services—her passion for people and love for design excellence is the perfect combination for successful interior design projects. Las Vegas has met its creative match.

KAMARRON DESIGN, INC.
KARA A. KARPENSKE, IFDA
11814 South Lake Boulevard NE
Blaine, MN 55449
612.396.1840
f: 952.403.6982
f: 763.757.2508
www.kamarrondesign.com

Photograph by Phillip Mueller

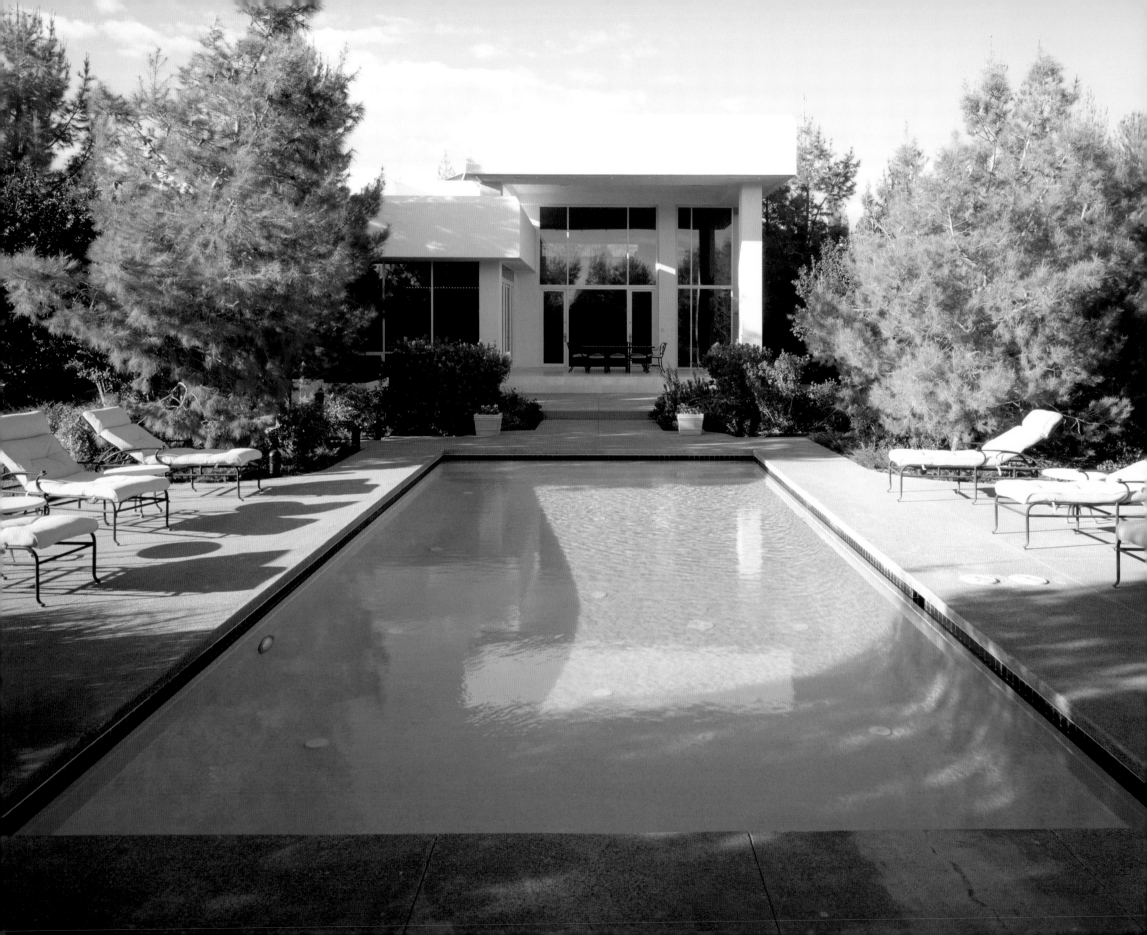

Michael Knorr
MICHAEL KNORR & ASSOCIATES

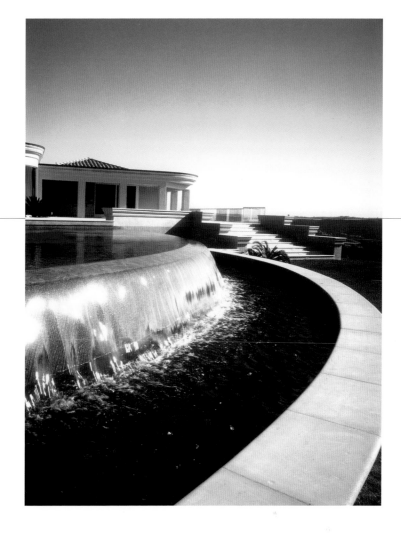

It is said, "architecture is not an art of words, but of experience." In one look, and then upon close inspection, great buildings and homes speak volumes about the architect who designed them and the clients who commissioned them. Michael Knorr, principal architect of Michael Knorr & Associates, is eager to meet this challenge.

Since the age of 12, Michael has focused his life to become an architect. At age 18, while only an intern for a local architect in his hometown of Milwaukee, Wisconsin, Michael designed and built his first house. He went on to earn his Master of Architecture from the University of Oklahoma in 1974, and became founding partner of Michael Knorr & Associates in 1981.

Now with two thriving offices in Denver and Las Vegas, Michael loves the dichotomy between his adopted hometowns. While at home in both places, he feels that "Las Vegas is a city of possibilities." People come to Las Vegas to renew their spirits and passions, and are open to "taking chances." The five associates in Michael's firm love the creativity of this exciting environment, bringing new energy to the design of upscale custom homes, as well as a variety of multi-family and commercial projects.

ABOVE:
An outdoor pool curves to embrace an indoor great room and its wall of glass while multi-level terraces surround this house with an invitation to enjoy the outdoors.
Photograph courtesy of Michael Knorr & Associates

FACING PAGE:
Gracefully balanced contemporary shapes create a serene oasis in the middle of the Mohave Desert.
Photograph courtesy of Michael Knorr & Associates

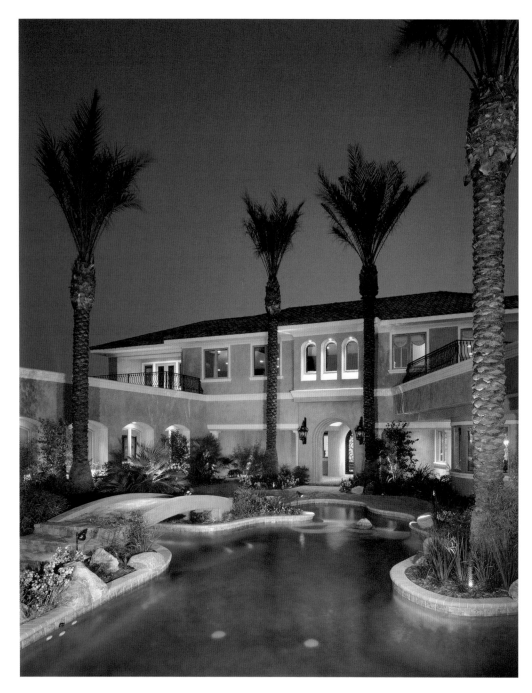

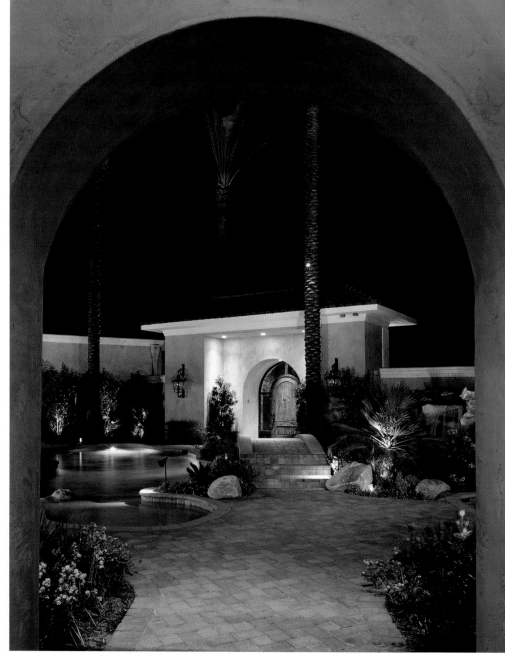

ABOVE LEFT:
Looking from the gatehouse to the main entry reveals an oasis in the desert.
Photograph by Chawla Associates

ABOVE RIGHT:
Passing through the entry gate from the street is like unlocking a treasure box of architectural delights.
Photograph by Chawla Associates

FACING PAGE:
Details and deep shadows add counterpoint and liveliness to bold architectural massing, creating a timeless quality independent of any particular style.
Photograph courtesy of Michael Knorr & Associates

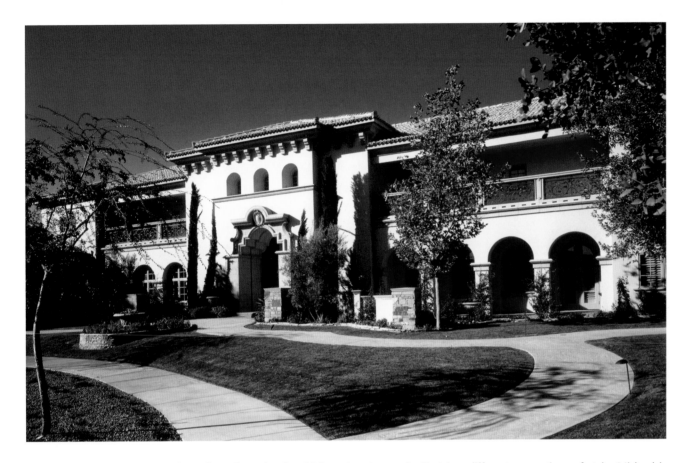

Michael Knorr refers to his style as "non-denominational," knowing that each client has different perceptions of style. Michael is committed to producing architecture that interprets each client's individual taste. Going beyond simple surface treatments, he explores character and individual qualities, and transforms these traits into an original, three-dimensional work of art.

Michael believes that by utilizing space and enhancing movement, architectural details make a home come alive. And by extending lines of sight, expanding or compressing volume, and creating focal points, he sculpts space to meet the needs of the client. His skill brings drama to an entertainment room, serenity to a private bath, or coziness to a bedroom.

In accordance with the principal's vision, Michael Knorr & Associates is rooted in the belief that well-crafted architecture makes a difference. To advance this goal, the firm takes time to know its clients. Rather than projecting a corporate interpretation of style, Michael and his small, select staff listen to their clients, discovering not only the obvious needs but also the intricate passions that define and determine a private living space. Capturing and expressing personality is the beauty of a Michael Knorr design.

Clients such as Las Vegas businessman Irwin Molasky and the celebrated Siegfried and Roy have entrusted the design of their homes to Michael. He is continually surprised by the unique dreams of each and every client and knows that the common goals of living well and being happy can be expressed through the infinite possibilities of architecture.

DESCRIBE YOUR DESIGN PREFERENCES.
I don't want to be identified by any particular style. When working in any given style, we want the spaces to be both comfortable and interesting.

WHAT EXCITES YOU MOST ABOUT BEING PART OF *DREAM HOMES DESERTS?*
Being among peers who also set high standards and deliver a well-designed product.

WHAT PHILOSOPHY HAVE YOU STUCK WITH FOR YEARS THAT STILL WORKS FOR YOU TODAY?
Architecture is about interior space and volume. The outside of a building should be an expression of what's going on inside.

WHAT IS THE MOST UNUSUAL/EXPENSIVE/DIFFICULT DESIGN OR TECHNIQUE YOU'VE USED IN ONE OF YOUR PROJECTS?
Our projects, though unique expressions of our clients' needs, are never intentionally unusual or difficult. We believe simplicity can equal beauty.

WHAT SINGLE THING WOULD YOU DO TO BRING A DULL HOUSE TO LIFE?
Open it up: let in light, knock down walls and raise the roof.

WHAT IS THE HIGHEST COMPLIMENT YOU'VE RECEIVED PROFESSIONALLY?
I enjoy it when our clients tell us that their house is "the best one we've ever designed." This happens a lot, and I think it means we've listened to them and we've seen their inner dreams.

MICHAEL KNORR & ASSOCIATES
MICHAEL KNORR
44 Grand Miramar
Lake Las Vegas, NV 89011
702.233.1947

2131 South Grape Street
Denver, CO 80222
303.744.1887
www.michaelknorr.net

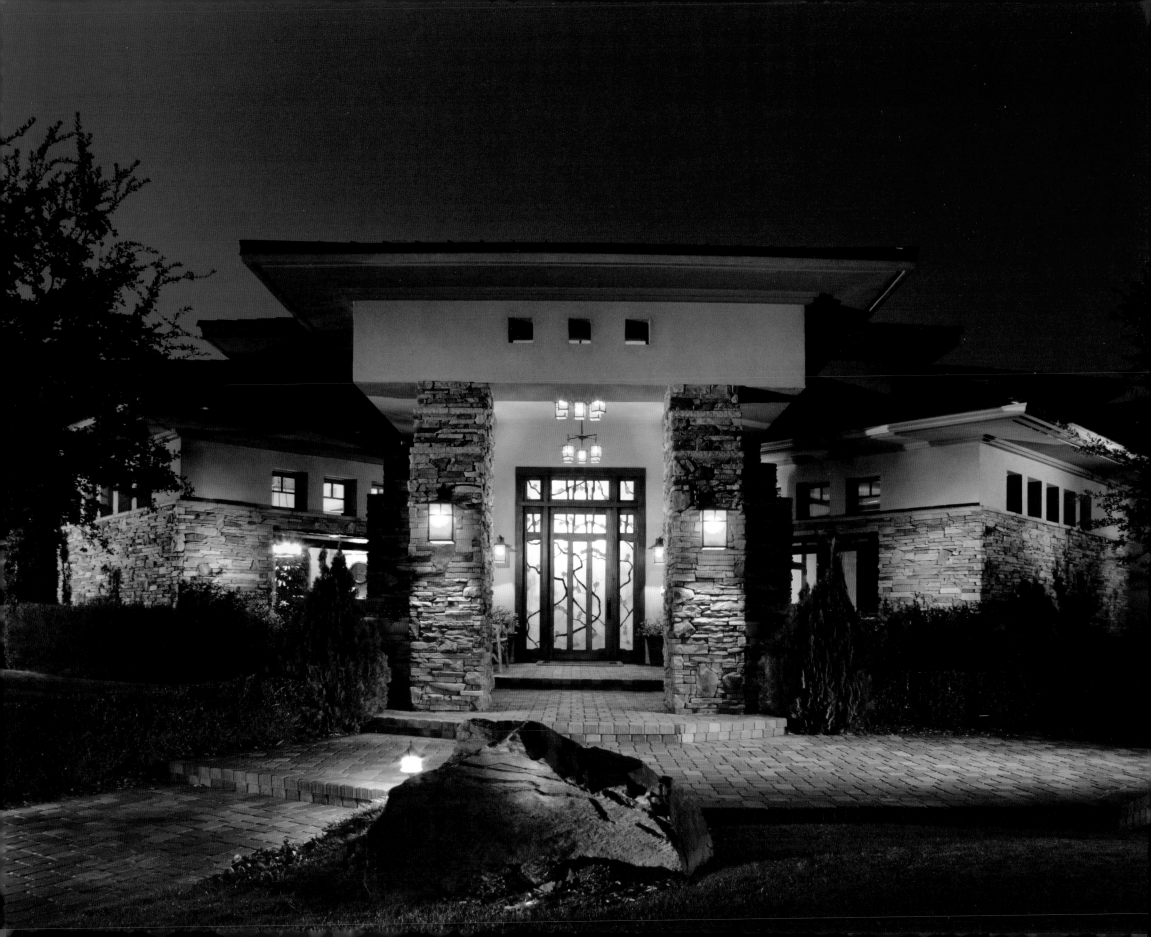

Leroy Loerwald
LOERWALD CONSTRUCTION

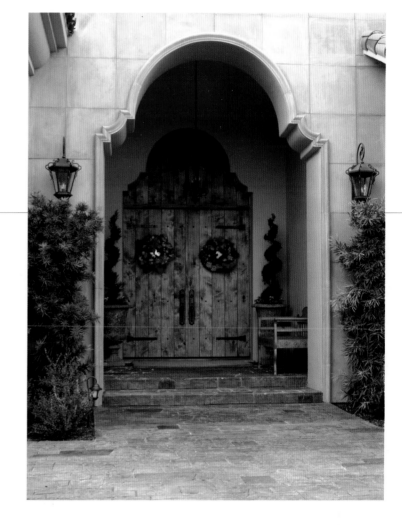

Born and raised in Las Vegas, Leroy Loerwald has been offering clients the competitive edge for 18 years. The founder of Loerwald Construction, Leroy grew up under the influence of an engineer/builder father and always knew that he wanted to be a builder. Years later, he now provides clients a unique offering in the building market: complete turnkey construction with an attention to detail that is not only hard to find in the fast-paced world of building, it is virtually non-existent.

Starting the process with an architect, Leroy and his team provide the whole building process from laying the foundation, to furnishing the home and placing each final detail, right down to minor elements like hanging towels in the guest bath. In fact, Leroy takes his clients to North Carolina for the ultimate in cost effectiveness and furniture selection. Interior designer Robin Barrett expertly guides clients through soft goods selection and entire home design—another rarity in a construction company. Whether the second or third custom home, even the most seasoned clients seek the expertly choreographed start-to-finish, truly one-of-a-kind services Loerwald provides.

Building primarily in Summerlin, Southern Highlands and other upscale Las Vegas suburbs, Loerwald Construction is a "one-stop shop," providing prospective home builders with everything they need to suit their needs. Rather than focus his idea of success on the financial

ABOVE:
A Loerwald signature, each of the company's front doors is customized and entirely unique. The level of attention to this home's façade is displayed in the stone detailing which was carried through to the front door.
Photograph by Jeffrey Green

FACING PAGE:
This Frank Lloyd Wright-style home, located in Promontory at The Ridges in Summerlin, features a beautifully landscaped approach. The custom front door is crafted of alder wood enhanced with artfully leaded glass.
Photograph by Jeffrey Green

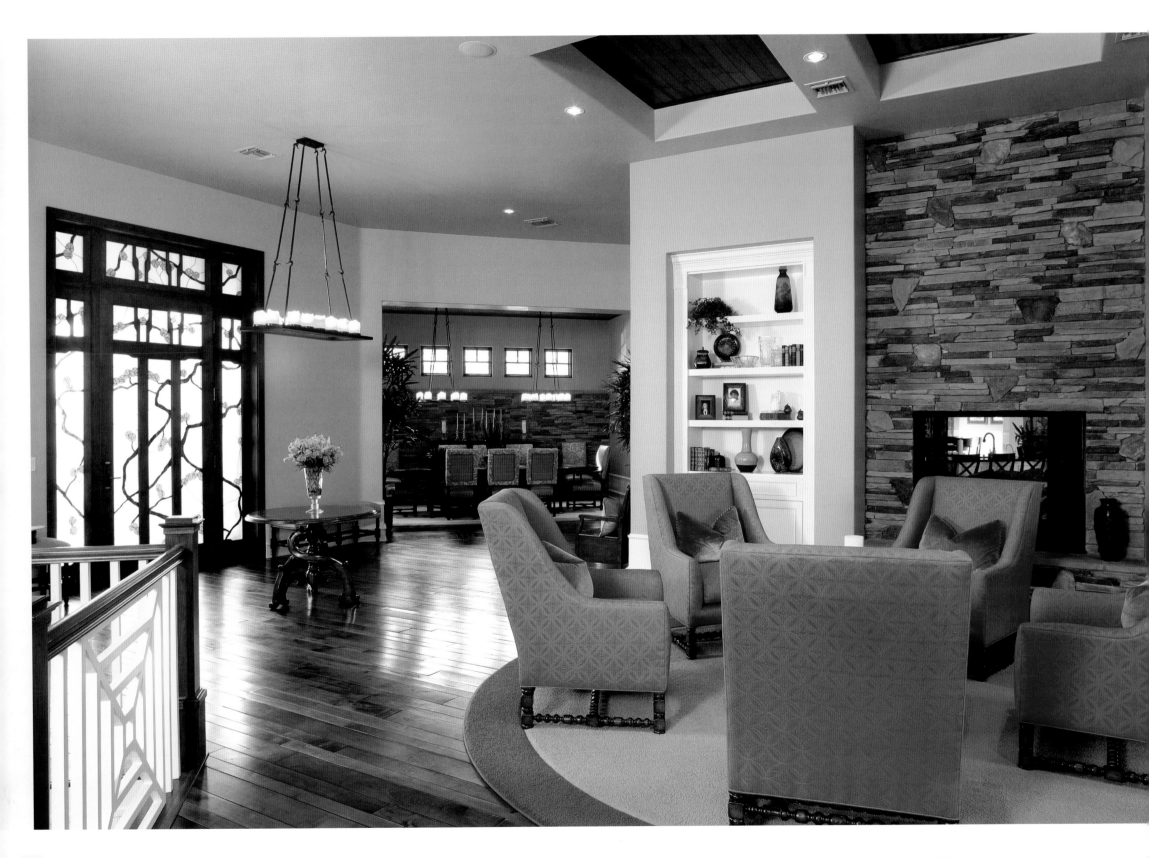

aspects of a project, Leroy is truly satisfied with a project when the design and construction of the home are exactly what both he and the client had in mind; and this is the case in most projects because both Leroy and his clients have followed the vision of the home since its inception.

Largely influenced by Frank Lloyd Wright, Leroy not only admires his renowned design skills, but also his ability to truly understand the people for whom he was building a home. Just as Frank Lloyd Wright would move in with a family for a month to identify what their needs would be in their new home, Leroy endeavors to get to know his clients, fully understanding them and their needs before beginning the build.

"I like to build for people that like to be involved in the building process. Because this process is so intimate, we get to know our clients on such a level that they oftentimes become our closest friends. Many of our clients are repeat customers because we have so much fun building their house. I treat their money as if it was my own. My goal is to create something unique for them while keeping the cost affordable. We also service our homes for life; we are there whenever we are needed," says Leroy.

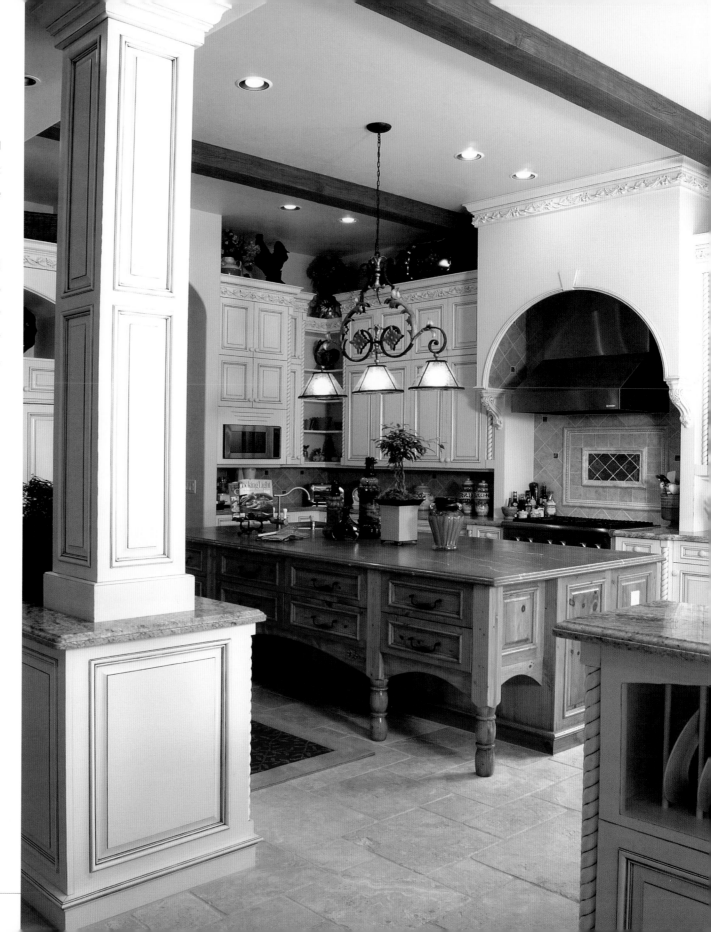

RIGHT:
This cozy French Country kitchen focuses on a lovely alder wood island—topped with honed Rojo Alacante marble—which is an elegant piece of furniture suitable for any room. Perfectly placed built-ins truly make this the heart of the home.
Photograph by Jeffrey Green

FACING PAGE:
Upon stepping into the entryway of this home, one is immediately met by the rich "Old Boards" carved wood flooring and hand-crafted, stacked stone see-through fireplace. Also highlighted are the custom light fixtures throughout.
Photograph by Jeffrey Green

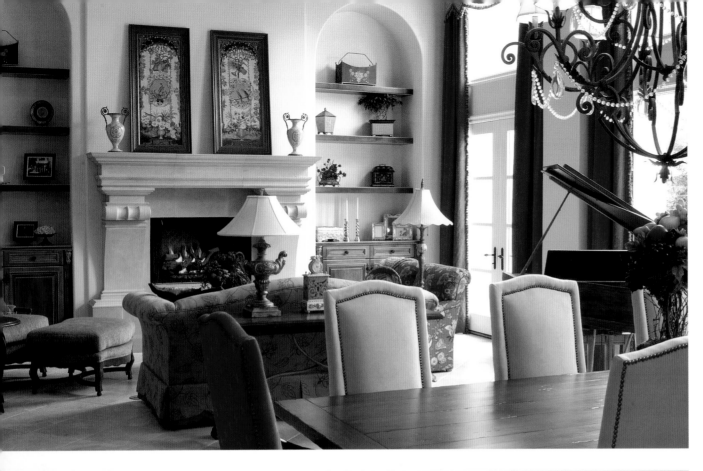

Leroy offers his clients something unique; as a family man himself, he understands what a family needs in a home. In fact, he lives in the community of Summerlin where he does the majority of his business. In addition to being his community's builder, he is also its neighbor. He is presently building a home for his wife Jana and their four children in Redhawk at The Ridges.

Also setting Leroy apart from his competition is the love and passion for building homes instilled in him from a young age by his father, ultimately inspiring both his brother and him to become builders. For more than 40 years, the Loerwald name has been critical to the building evolution of Las Vegas, and although this stellar reputation assists in familiarity, it is the integrity of the final product and turnkey process that keeps clients at their door.

Every day that Leroy goes to work, he is doing something he enjoys, whether it is designing a home or building client relationships. Repeat customers are not the only people who notice and appreciate Leroy's finesse in the home building industry; Loerwald Construction has been profiled in a variety of publications, including *The Magazine of Summerlin*, *Trends*, *Home & Living*, *Las Vegas Sun* and *Las Vegas Review-Journal*.

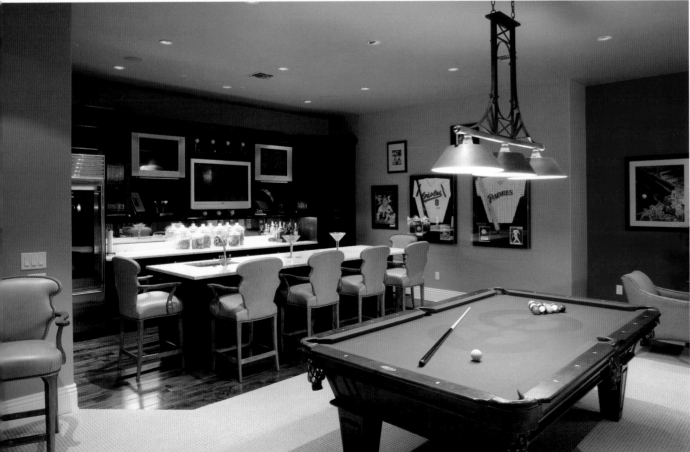

TOP LEFT:
This French Country-style living room, interior design by Loerwald as well, makes the most of expansive windows which fill the area with natural light.
Photograph by Jeffrey Green

BOTTOM LEFT:
This entertainment room is the perfect place to watch the game, play some pool or view the newest movie in the attached theater.
Photograph by Jeffrey Green

FACING PAGE:
This bright kitchen is replete with well-designed elements including the large dark, distressed alder wood island—topped with Carrera marble—and soapstone counters throughout. Details such as the 20-inch-tall baseboards, "Old Boards" flooring, as well as the bead board walls of the nook add character and charm.
Photograph by Jeffrey Green

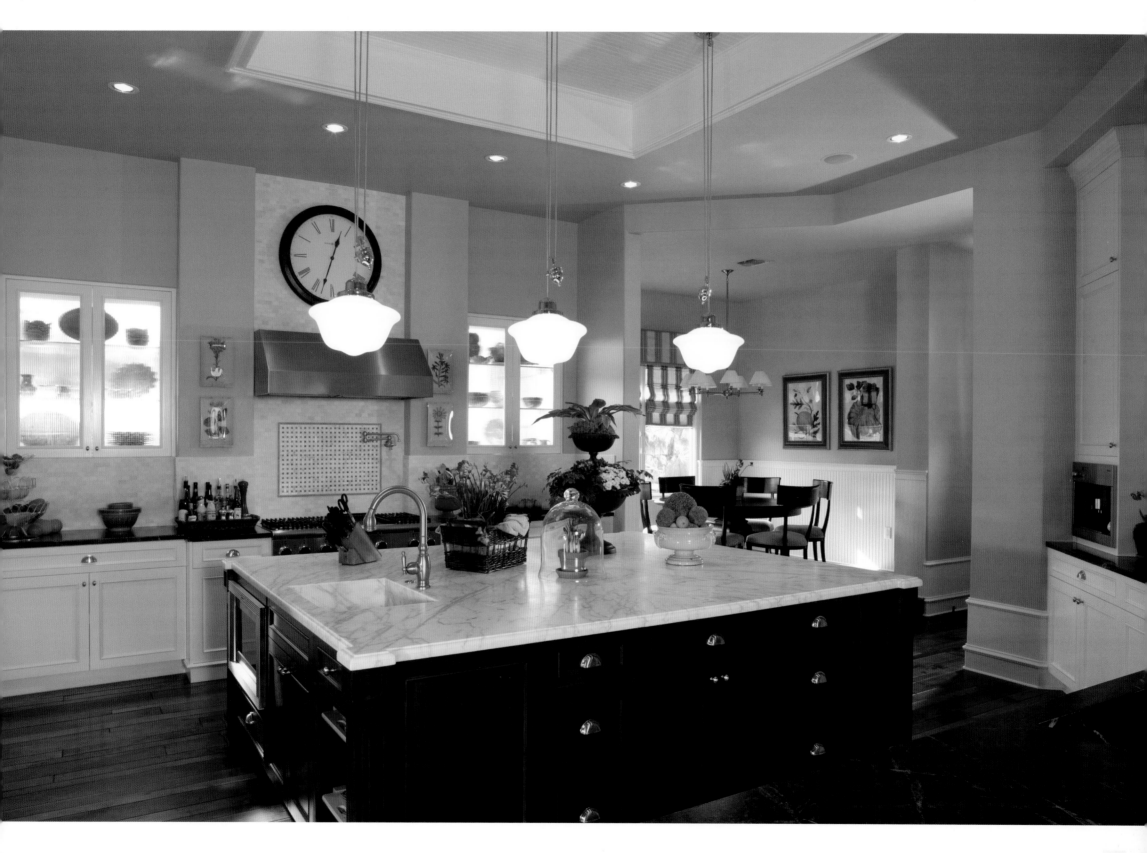

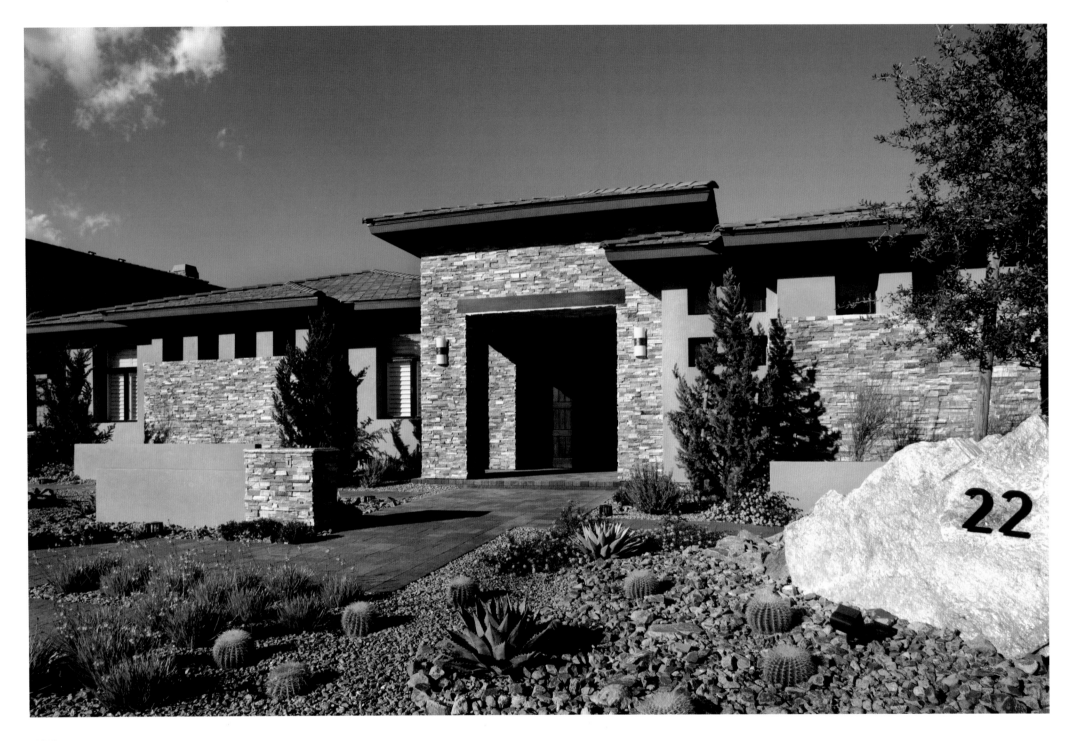

ABOVE:
This Frank Lloyd Wright-style home features a Rox Proe stone façade and beautiful custom landscaping by Loerwald.
Photograph by Jeffrey Green

FACING PAGE:
Loerwald's attention to every last detail is apparent in this bathroom from the small mosaic tiles to the graceful chair.
Photograph by Jeffrey Green

Q&A

more about leroy ...

WHAT IS THE BEST PART OF BEING A BUILDER?

Building a house often becomes like a marriage. I truly enjoy building relationships with my clients. I get excited about building homes and meeting the unique people who are going to live in them.

WHAT KEEPS YOU BUSY WHEN YOU ARE NOT WORKING?

My family: I have four very active children and my wife and I are very involved in our community and church. I spend a lot of time coaching Little League and taking my children to golf and tennis lessons. Time with my family is my first priority, and I believe it makes me a better builder because I understand the needs of my clients and their families.

WE WOULDN'T KNOW IT, BUT YOUR FRIENDS WOULD TELL US ...

I am always thinking about my projects. It is hard to simply leave them when I go home because they become so much a part of my life at that time. I really take every home I build very personally.

HOW CAN WE TELL YOU LIVE IN THIS LOCALE?

I am a rare native of Las Vegas, so I know the building industry here inside and out, having been enmeshed in it from a young age by my father.

LOERWALD CONSTRUCTION
LEROY LOERWALD
1008 Arabian Sand Court
Las Vegas, NV 89144
702.525.9000

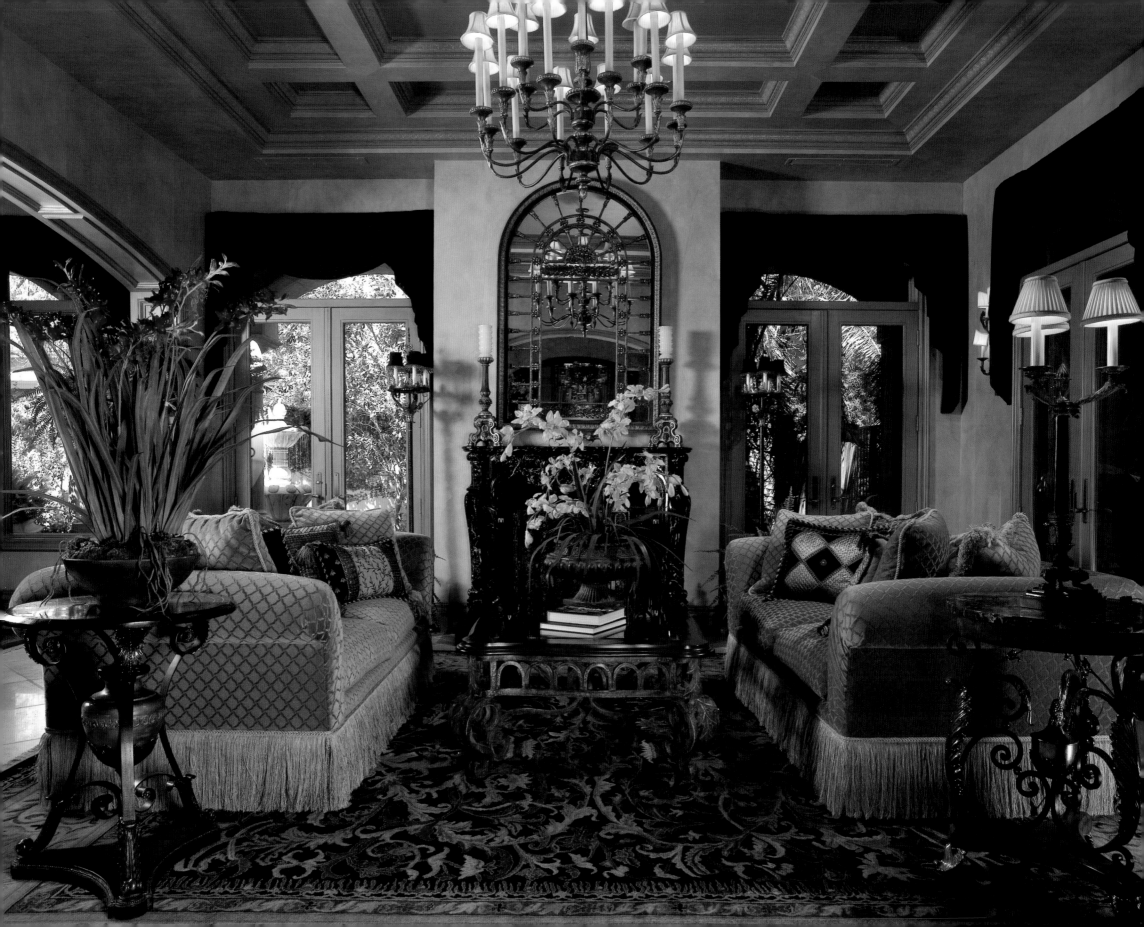

Joanne E. Lucia
JOANNE LUCIA INTERIORS

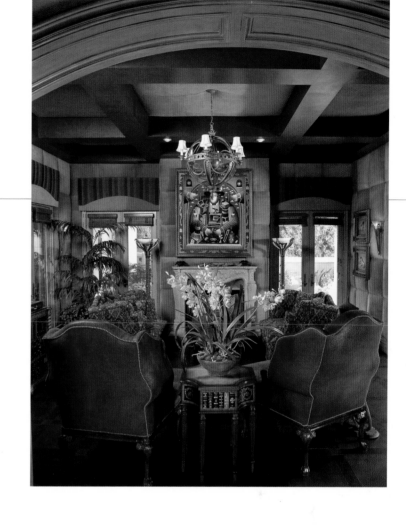

When a home interior makes a dramatic visual impact, everyone in Las Vegas knows it is a room created by Joanne Lucia Interiors. Joanne designs in some of the finest homes throughout Las Vegas, the city that never sleeps and motivates her every day of her life. Born in Canada, she knew she wanted to become an interior designer while growing up in Vancouver. Joanne pursued her profession of choice by attending Woodbury University in Los Angeles, receiving her bachelor of professional arts degree in interior design and continuing her education at Pepperdine University by earning her bachelor's degree in liberal arts. A permanent resident of Las Vegas for more than 11 years, Joanne has made this desert oasis her home.

Joanne first worked after college for a contemporary and Scandanavian furniture retail store, which was a key learning experience. She learned about planning, materials, how to work a space and began to develop management skills from budgeting to understanding fabrics and materials. An outstanding designer for a span of 42 years, she became an independent interior designer and founded her own firm, Joanne Lucia Interiors, in 1970. Joanne is a passionate, artistic person who truly loves her work and her open-minded clients who allow her to use her creativity to the maximum.

Distinguished in "Barron's Who's Who in Interior Design" and an active member of the ASID, Joanne has received recognition from the local press for her impressive projects. Her work has been featured in the *Las Vegas Review Journal* "Home" section,

ABOVE:
Ochre suede-upholstered walls, "crocodile" stenciled leather flooring, burgundy-glazed ceiling inserts and suede wingback lounge chairs complete the handsome "cigar room."
Photograph by Jim Decker

FACING PAGE:
Mohair velvet sofas, shagreen wallcovering, the negro-marguina carved fireplace surround and custom-designed area rug in sage, black and aubergine create the formal living room.
Photograph by Jim Decker

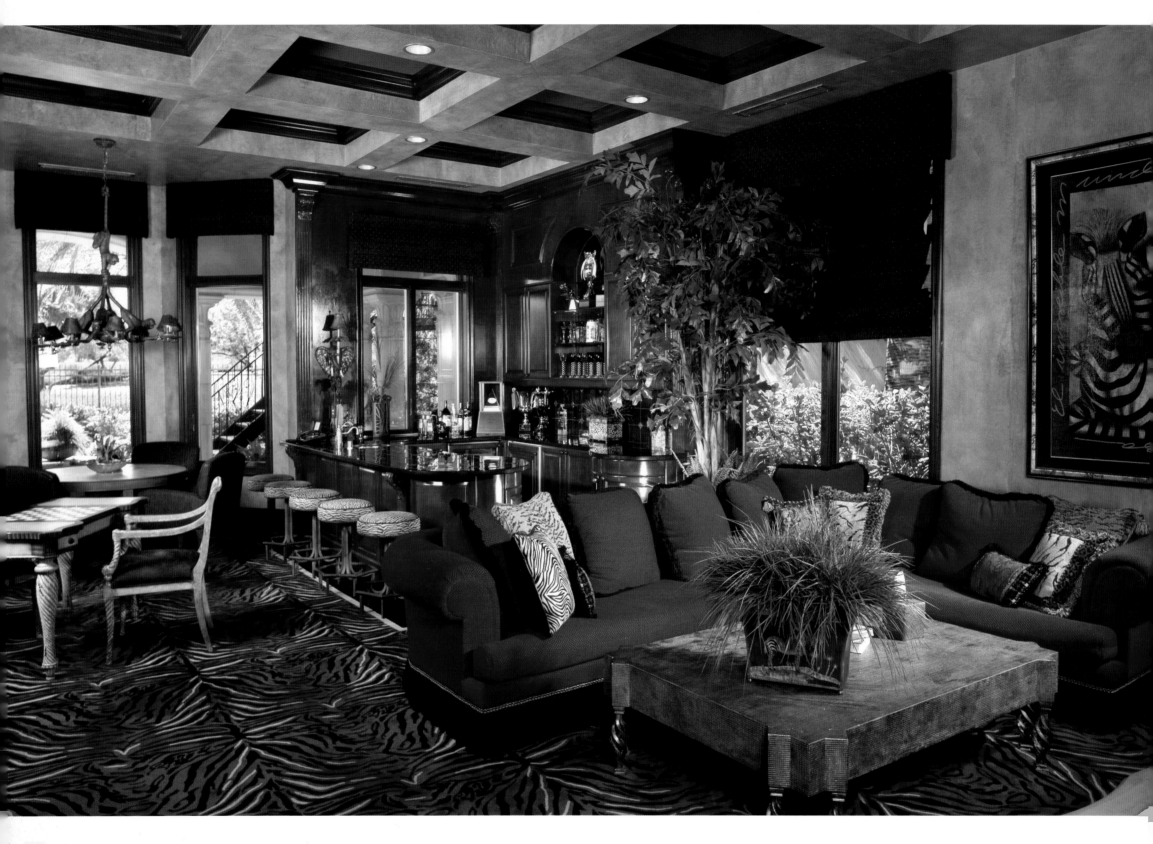

Southern Nevada Homes and Gardens and *Luxury Las Vegas* magazines. She designs primarily in Las Vegas but has also been designing beautiful interiors throughout neighboring California and Colorado for primary and luxury vacation homes.

What separates Joanne's interiors from that of her peers is that she creates interiors unique to the personalities of her clients. She can "read" them and understand their lifestyle needs. Never doing the same design twice, she is an original thinker and abhors imitation. Highly creative and an artist to the core, Joanne designs interiors with the "wow" factor.

She specializes in designing interiors for both new custom homes and existing homes, townhomes and penthouses ranging in size from 2,500 square feet to upwards of 16,000 square feet. Though often designing in large-scale residences, she has made it possible to create intimacy around every corner for her clients. Even if the home is spacious she creates "pockets" where one can be comfortable, so clients fall in love with their personal space and really enjoy living in it. Avoiding pretentious or ostentatious designs, her interiors are all about making her clientele feel right at home with high-end quality and an up-to-the-moment fashionable look in mind.

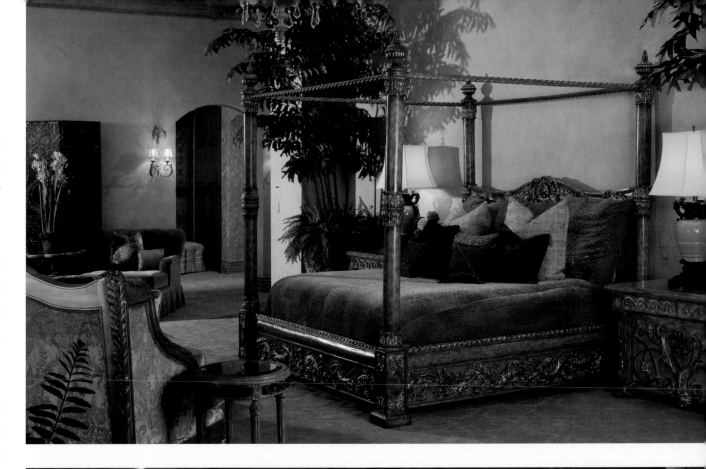

TOP RIGHT:
Richly carved, metallic-glazed finish casepieces with dramatic four-poster bed and softly hand-painted velvet lounge chairs are surrounded by Venetian plaster walls, creating a sumptuous and exotic suite.
Photograph by Jim Decker

BOTTOM RIGHT:
An elegant media room has red-glazed paneling and upholstered cobalt blue velvet walls. The remote-control Austrian "theater" shade of red velvet is framed by blue velvet draperies accented with tassel tiebacks.
Photograph by Jim Decker

FACING PAGE:
Crackle-finish wallcovering, burgundy chenille sofa, red-glazed cabinetry, faux alligator finish cocktail table and daring custom "animal skin" wall-to-wall carpeting evoke a sophisticated, sexy ambience for entertaining.
Photograph by Jim Decker

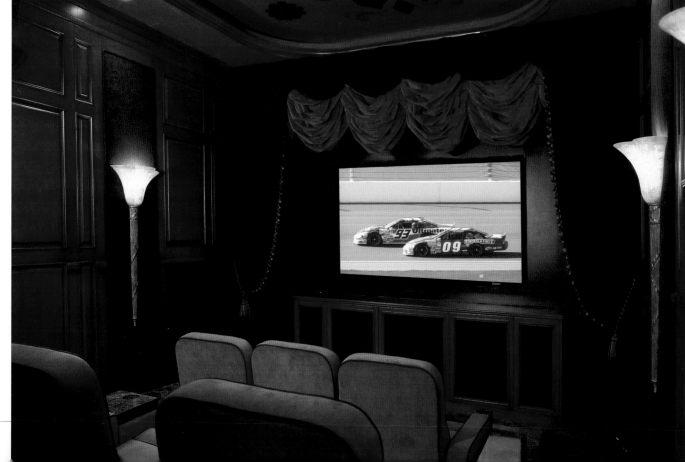

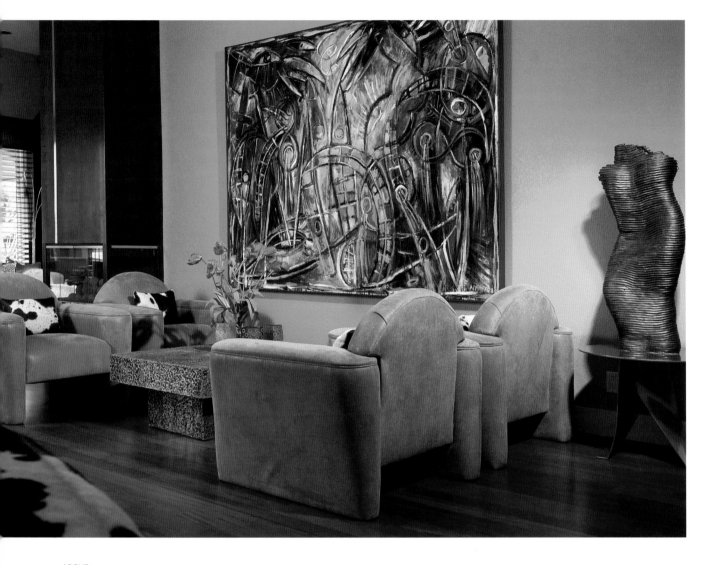

Working with builders, landscape architects and tradespeople while a home is being built offers a team concept and professional synergy by which she is driven. Collaboratively, she designs up to a dozen homes per year and feels that each individual process is like giving birth to a new creation. Simultaneously designing 10 homes at once, she and her talented project coordinator of more than 23 years, Dominic Nardini, accomplish the impossible with amazing results. Her own resource team includes veteran craftsmen and experts from wallpaper installers to carpet layers, faux finishers, drapery people as well as contacts in furniture showrooms and factory-direct sources. A well-orchestrated effort goes into every interior and it shows in the impeccable outcome.

Joanne does not have a signature style, as her work is derived by her clients' desires, tastes and interests. She loves working in all styles from upscale, ultra contemporary to Italian Renaissance, always creating a sophisticated and livable space, warm and welcoming to the owners, their families and friends. She enjoys adding a surprise element to each interior, an accent or unique furnishing to create the unexpected or a touch of whimsy. Joanne has a passion for each project and has the fringe benefit of being blessed to get to know her wonderful clients extremely well—many have become long-term personal friends.

ABOVE:
Amber wild boar suede club chairs complement the hammered metal cocktail table and offset the cherry plank wood floor—the perfect setting for showcasing contemporary art and sculpture.
Photograph by Jim Decker

FACING PAGE:
The plush chenille sectional centers around a woven metal cocktail table anchored on an abstract-patterned wool rug with modern highlights of aubergine and black.
Photograph by Jim Decker

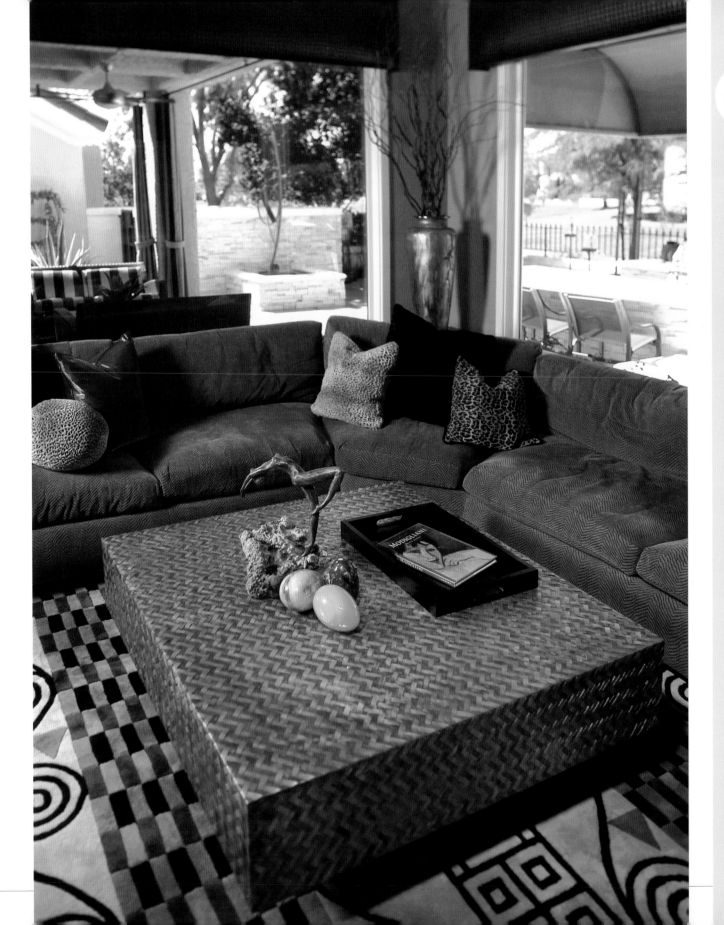

WHAT PERSONAL INDULGENCE DO YOU SPEND THE MOST MONEY ON?
Travel and unique art pieces. I just purchased a beautiful Oriental wood panel screen.

NAME ONE THING MOST PEOPLE DON'T KNOW ABOUT YOU.
I'm a sensitive person.

WHAT COLOR BEST DESCRIBES YOU AND WHY?
Black because it has impact. It is a strong no-nonsense color.

HOW CAN WE TELL YOU LIVE IN THIS LOCALE?
I think Las Vegas is one of the most exciting cities in the world, and I enjoy being a part of its development and growth.

WHAT BOOK ARE YOU READING NOW?
I read all of the time, mostly novels. I love mysteries but never sappy, romantic titles.

WE WOULDN'T KNOW IT BUT YOUR FRIENDS WOULD TELL US ...
I am an animal lover. I rescued my German shepherd from the animal shelter.

JOANNE LUCIA INTERIORS
JOANNE E. LUCIA, ASID
3009 Campbell Circle
Las Vegas, NV 89107
702.889.8676
f: 702.889.8677
www.joannelucia.com

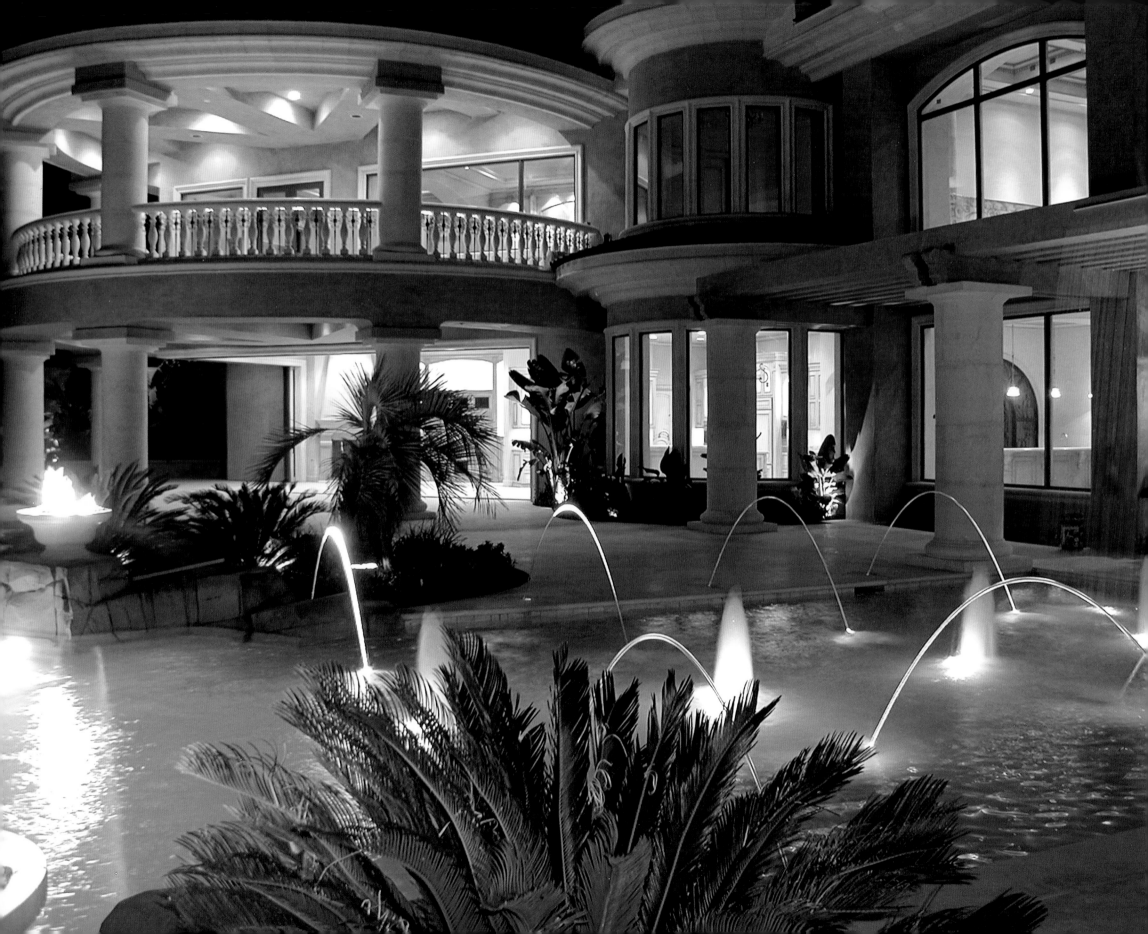

Richard Luke

RICHARD LUKE ARCHITECTS

According to Richard Luke, his success and exemplary professional reputation stems from his ability to not only listen, but to truly hear his clients. Attentively considering the needs, desires, objectives and character of the individual, his designs are based on his clients' fundamental purpose with an emphasis on delivering elegance. The end result is a home that captures their singularity, functions as an extension of their lifestyle and is an exquisite reflection of their unique family.

Crafting a design that is a representation of his clients' ideas, Richard considers feasibility and aesthetics within the scope of the total built environment. Adapting each design to the specific site considerations including space, volume and light, Richard deftly manipulates conceptual elements, softens or enhances proportion, and definitively creates pleasing and functional homes unlimited in style. "I don't confine myself, but tailor each design to the location's ideal, maximizing the view potential, while simultaneously creating a distinctive design that strives to exceed the client's expectations," he explains.

Encompassing all principles, including psychological, Richard strikes a balance among structure, function and aesthetics of a project. With no one element overpowering the others, he is able to construct a home with any tone his clients wish, from Italian villa,

ABOVE:
Galardi residence entry foyer.
Photograph by George Gutenberg 2004

FACING PAGE:
Barnhart residence pool and rear balcony.
Photograph by Bob Barnhart

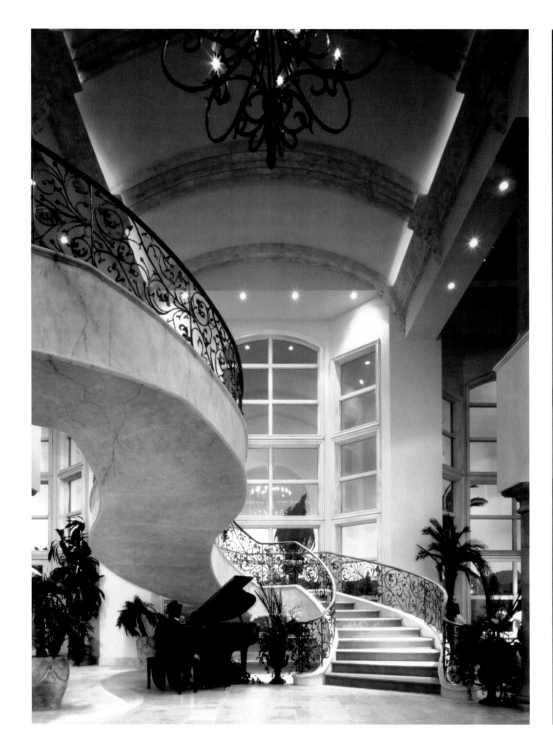

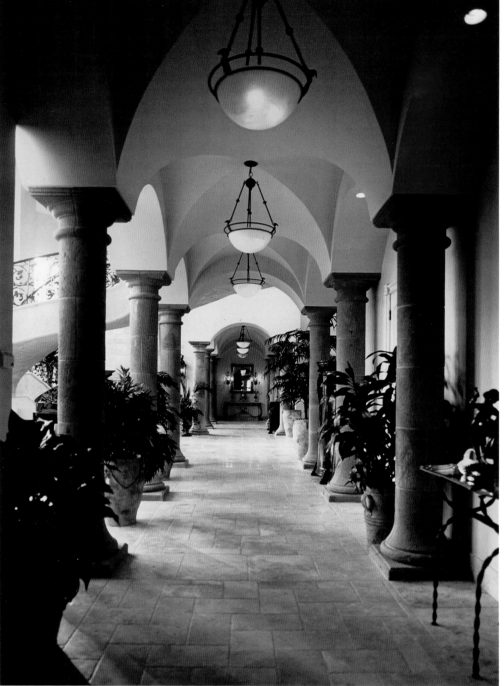

to Mediterranean-influenced residences and eclectic-flavored options to the traditional or contemporary. His objective consistently remains creating the ultimate synthesis of purpose, character, necessity and refined quality while ultimately expressing his clients' sensibilities.

Richard Luke Architects is recognized as one of Las Vegas' leading residential architectural firms, with more than 20 years of experience and numerous design awards to its credit, including the Las Vegas 2000 Street of Dreams Show Award in "Best Architectural Design."

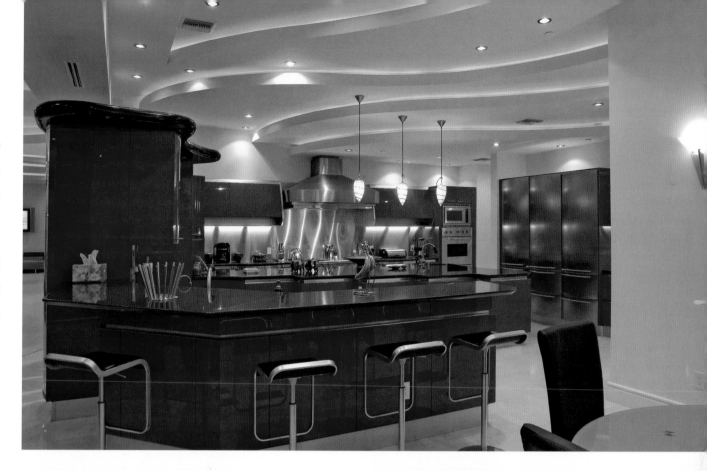

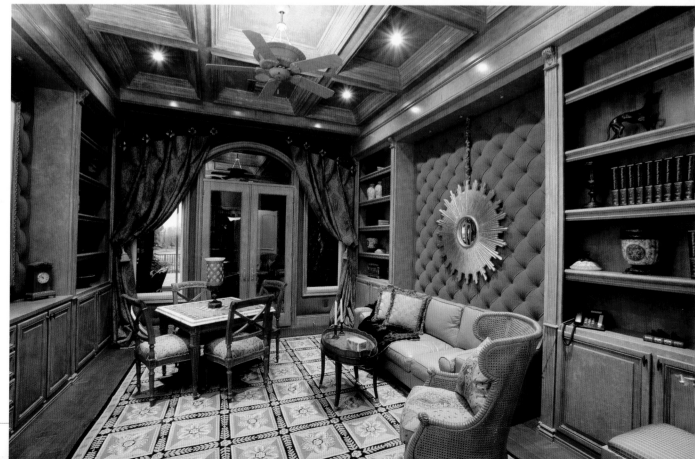

TOP RIGHT :
The Galardi residence's dramatic Ferrari-red kitchen.
Photograph by George Gutenberg 2004

BOTTOM RIGHT:
Varney residence library.
Photograph by Deepak Chawla

FACING PAGE LEFT:
The Karlen residence's floating entry staircase.
Photograph by Deepak Chawla

FACING PAGE RIGHT:
Karlen residence gallery colonnade.
Photograph by Deepak Chawla

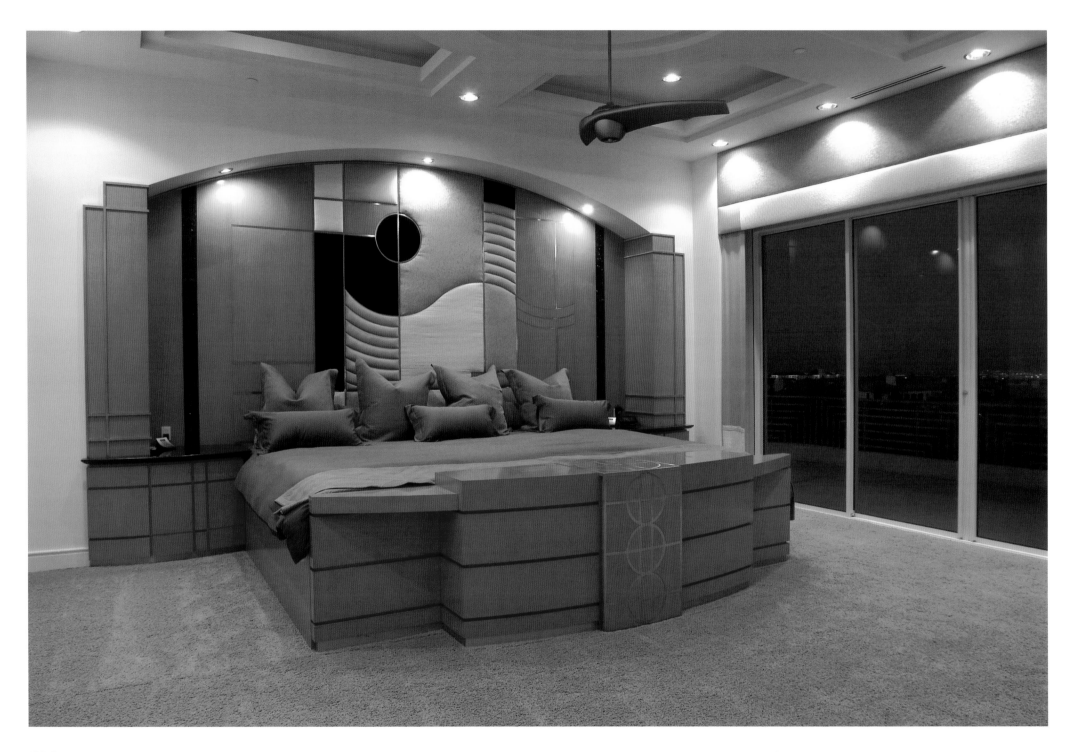

ABOVE:
The Galardi residence's master bed wall.
Photograph by George Gutenberg 2004

FACING PAGE:
The Galardi residence's magnificent master bath.
Photograph by George Gutenberg 2004

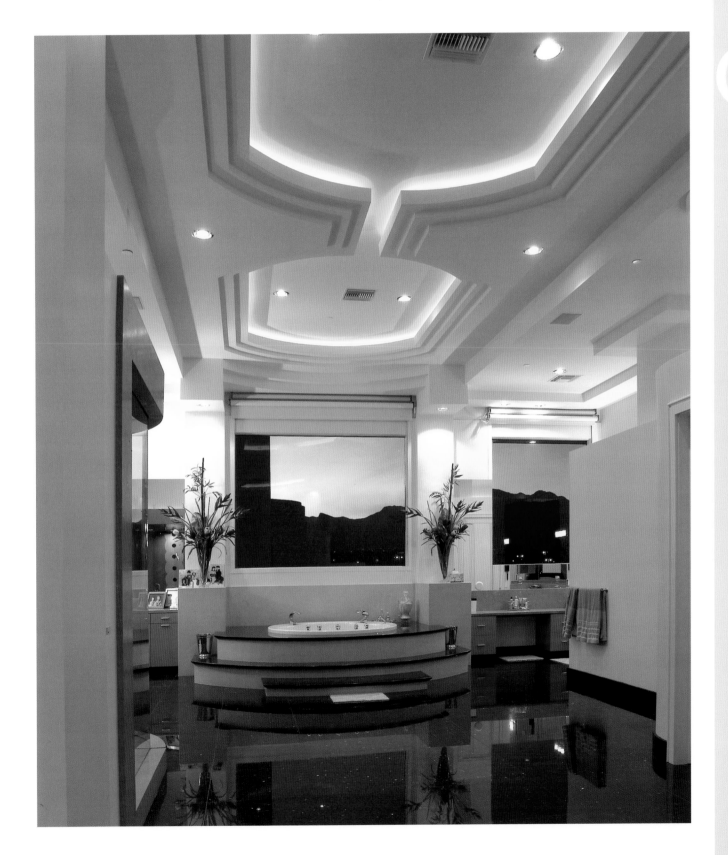

more about richard ...

WHAT PHILOSOPHY DO YOU APPLY TO YOUR WORK?

Whatever tone clients choose for their home, whether it is contemporary, Italian villa-style, Mediterranean-influenced or another eclectic-flavored option, my objective is to listen intently to their wishes and incorporate them into a design that has functionality and flair, drama and practicality. The design should take full advantage of the site, be cost-effective and energy efficient!

DO YOU FOLLOW A PARTICULAR STYLE IN YOUR DESIGNS?

No, I do not limit myself to any one style. I love many different architectural styles and find it rewarding and refreshing to take on a new challenge and adapt to my clients' wishes.

WHAT SEPARATES YOU FROM YOUR COMPETITION?

We have more than 30 years of experience specializing in residential architecture and are currently celebrating our 20th year operating in Las Vegas. Staying on the cutting edge of design and technology with the latest 3-D software, we offer our clients fly-arounds, walk-throughs and photorealistic renderings throughout the design process. We also offer land procurement, interior design and complete construction services.

RICHARD LUKE ARCHITECTS
RICHARD LUKE
9061 West Sahara Avenue, Suite 105
Las Vegas, NV 89117
702.838.8468
f: 702.838.8472
www.richardlukearchitects.com

Jesse Maheu
JAM DESIGN STUDIOS

Jesse Maheu has the distinct honor of being the youngest design professional to ever be licensed in the state of Nevada at just 24. The company he and his identical twin brother manage together, Jam Design Studios, has been producing beautiful designs in the Las Vegas area for 10 years, first as a drafting service and then as a full residential architecture firm specializing in large custom homes. Young and energetic, Jesse creates and oversees the construction of exquisite homes with speed, accuracy and unmatched quality in the time it takes most to simply render a drawing.

Spending three years at the University of Arizona in Tucson, Jesse completed his education with a Bachelor of Science in Architecture from the University of Nevada Las Vegas. Following his graduation, he remained in Las Vegas to take advantage of its unique atmosphere. Because of the constant renewal of the city and its booming economy, Las Vegas presents exceptional opportunities while fostering an environment for inimitable architecture.

An astute and dedicated learner, Jesse's sterling educational background and creativity in designing homes that meet his clients' every need have paved the way for his success. With a simple but invaluable doctrine, Jesse approaches each project with the goal

ABOVE:
A view from the great room looking toward the kitchen.
Photograph by Jesse Maheu

FACING PAGE:
This partial front elevation of a contemporary home blends seamlessly with the desert landscape.
Photograph by Jesse Maheu

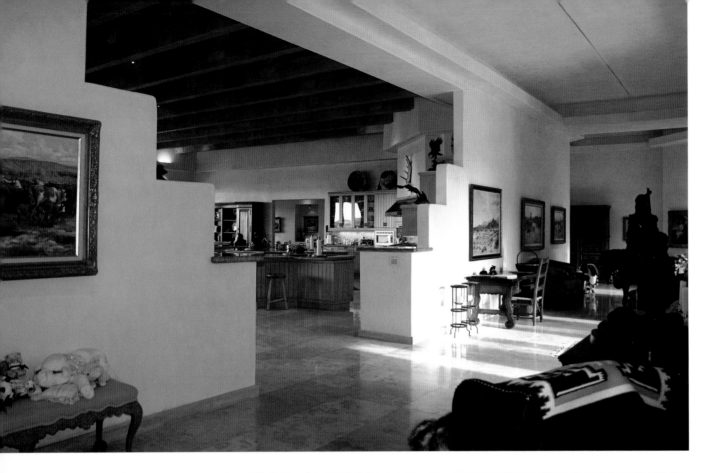

of assisting his clients in articulating their style, preferences and needs and executing a plan with exacting detail. His built environments reflect his clients' personal tastes, accommodating necessity and fulfilling their desires, one of the aspects of being a designer that Jesse finds purely pleasurable.

Though providing his patrons with their ultimate vision is a perk of the trade, Jesse finds the actual construction of a building the most satisfying aspect of his profession. To see a physically tangible structure literally rise from paper to a standing work of art makes him indescribably delighted. There is something quite invigorating about his buildings on paper, but they become simply phenomenal as they are fabricated.

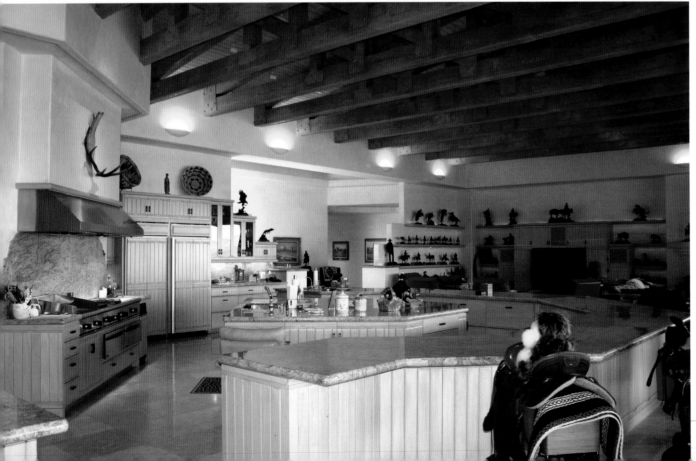

TOP LEFT:
View from the entry gallery looking toward the great room/kitchen.
Photograph by Jesse Maheu

BOTTOM LEFT:
The kitchen with the great room beyond.
Photograph by Jesse Maheu

FACING PAGE:
Spacious master bathroom looking toward "her" side.
Photograph by Jesse Maheu

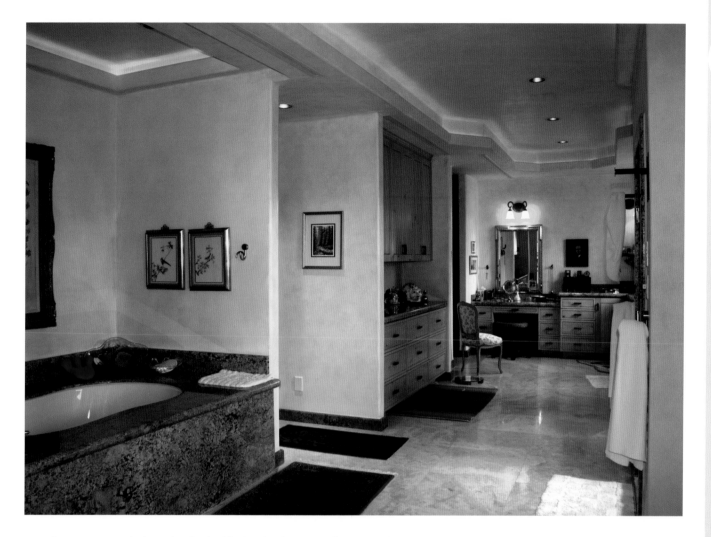

WHAT ARE YOUR PERSONAL DESIGN FAVORITES?
My own preferences are ultra modern and contemporary, but I excel in desert contemporary and Mediterranean.

DO YOU HAVE A PHILOSOPHY THAT YOU HAVE STUCK WITH FOR YEARS THAT STILL WORKS FOR YOU TODAY?
Get the job done right the first time.

WHAT IS THE HIGHEST COMPLIMENT YOU'VE RECEIVED PROFESSIONALLY?
When clients have been living in their home for a while and they are completely satisfied months and months down the road. If they are happy, it makes me feel good because I have done my job. As long as a client is happy, it doesn't get much better than that.

WHO HAS HAD THE BIGGEST INFLUENCE ON YOUR CAREER?
My high-school drafting instructor, Wendell Brezina; he is the reason I am a designer. From the first moment I was in his class at the age of 15, I knew exactly what I wanted to do.

Jesse has most recently been involved with the development of an incredible and very large custom home. It is simple on the outside, but elegantly done and boasts a handsome 16,000 square feet. When guests walk through the doors, they describe feeling as if they are stepping inside a museum or a palace; they are in awe of the beauty of the building. But, what Jesse likes more than the house itself is that his clients are ecstatic about their new, gorgeous home—the result of a job well done.

JAM DESIGN STUDIOS
JESSE MAHEU
5125 West Oquendo, Suite 1
Las Vegas, NV 89118
702.262.7955
f: 702.253.1182

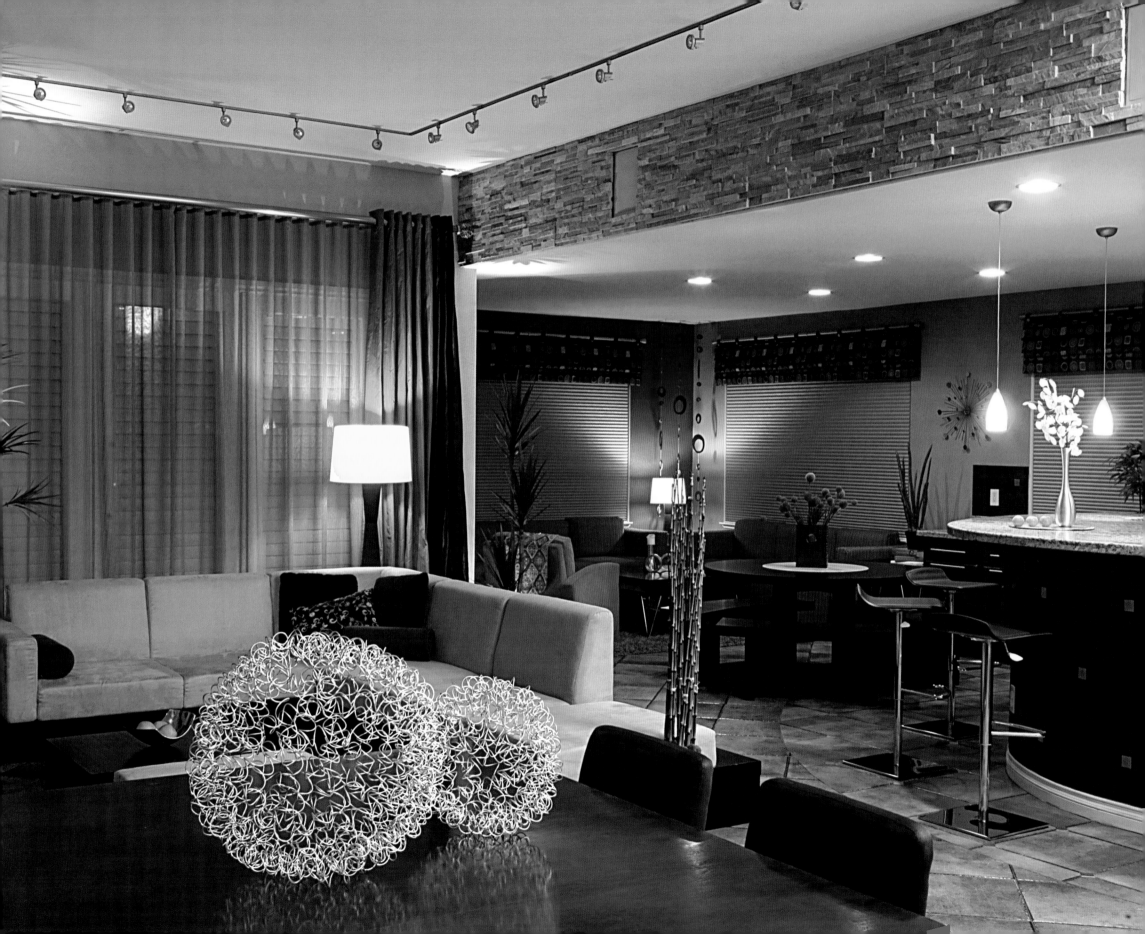

Becky Najafi
DE ATELIER DESIGN GROUP

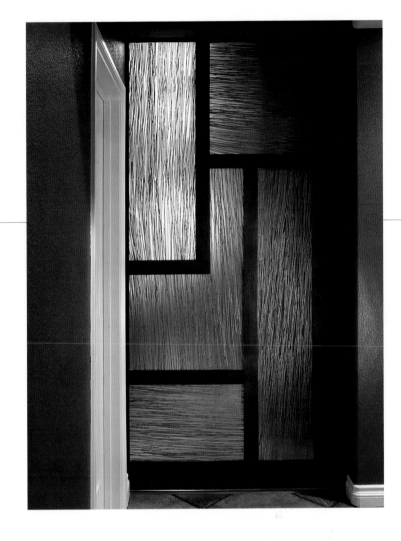

A graduate of Arizona State University with a bachelor's degree in decorative arts, Becky Najafi began her own business more than 20 years ago. Becky, an entrepreneur, fine artist and interior designer, started De Atelier Design Group in 1985 while living in Scottsdale, Arizona. Originally designing residential interiors in Tucson and Scottsdale, she moved her thriving studio to America's entertainment capital of Las Vegas in 1989, where her work has been shining ever since.

Designing both large-scale residential spaces and commercial projects, Becky has established herself as a daring, innovative designer. Passionate about her work, she brings her heightened enthusiasm, self-expression and imagination to each and every client, whether the project is a private residence, condominium home or professional office. To Becky, an empty space presents an opportunity for creative expression just as a blank canvas offers to an artist. She brings a strong design sense to the space through strategic use of intense color, fabric, textures and custom wall treatments creating an unforgettable feeling in a room and dramatic first impression.

Becky believes that there is a psychology to every room within a home. When designing for an entertainment area or dining room, she considers how the room will be used, who will be there and the lifestyle needs of the client. Her vivid imagination takes off and she brings in the personality of her client, sees through their eyes and adds her adventurous spirit with sophistication to achieve their vision. Her style is indeed eclectic, combining elements creatively—a juxtaposition of contemporary with antiques and more traditional objects. Lighting plays an important role in every room and her deliberate use of it enhances the art on the walls to

ABOVE:
A custom-formed resin pocket door becomes a sculptural art piece, combining natural reeds for a zen experience leading to the library.
Photograph by Studio West Photography

FACING PAGE:
This contemporary family living area with custom alder wood dining table, low Ultrasuede® sectional, curved granite bar with chocolate glass and steel tiles creates a modern child-friendly atmosphere.
Photograph by Studio West Photography

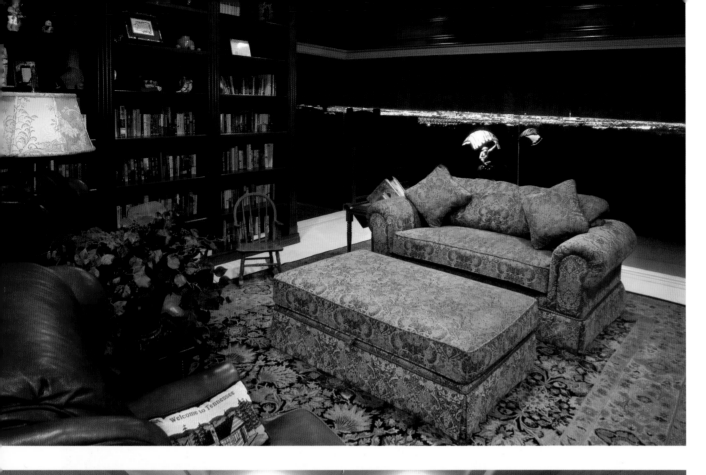

the quiet reading corner. Her final room designs become three-dimensional sculptures in their own right.

De Atelier Design Group interiors have an exciting energy appropriate to the space. Rich use of color on the walls and ceilings attracts clients to her original designs. Becky is a fine artist, and this aspect is evident in every room she "paints" or "sculpts," often with an unexpected color palette and original furniture pieces she designs and has fabricated by local craftsmen. Her stunning creations and interiors have been featured in *Las Vegas Home Book* 2001.

She has a collaborative approach to her work in-person or long-distance and teams with architects, contractors, builders and tradespeople. Involved in the early planning stages, she draws her detailed interior designs and executes them digitally with specifications from creative tile layouts and lighting needs to furniture pods. These exacting plans help avoid costly change orders for clients and speak to her vast experience.

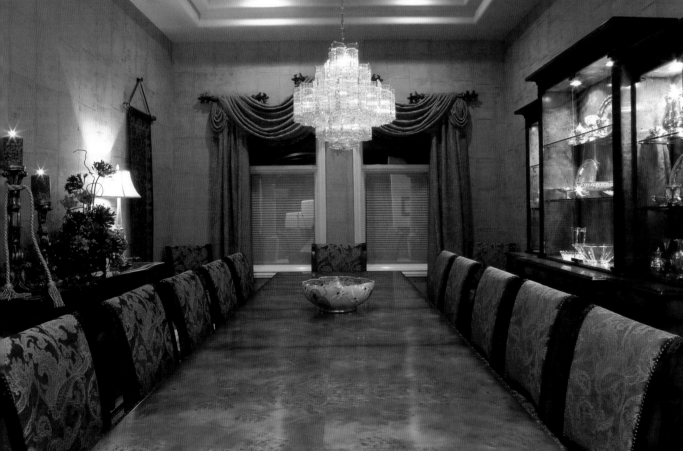

TOP LEFT:
A traditional library with panoramic view features elegantly appointed built-in bookshelves and a custom loveseat with matching ottoman centered on an exquisite antique Oriental rug.
Photograph by Studio West Photography

BOTTOM LEFT:
Venetian plaster walls and a faux bronze ceiling envelop a European dining room graced by an Italian burled wood table, velvet brocade dining chairs and a Schoenbeck crystal chandelier. Hand-painted leather tapestry and formal draperies evoke a Renaissance feel.
Photograph by Studio West Photography

FACING PAGE LEFT:
Asian fabrics and hand-combed plaster walls create a tropical, textural bamboo-lined room in this intimate guest bath.
Photograph by Studio West Photography

FACING PAGE RIGHT:
This sophisticated granite bar comes alive with the handmade paper wall treatment uniquely glazed and crackled for a tortoiseshell effect.
Photograph by Studio West Photography

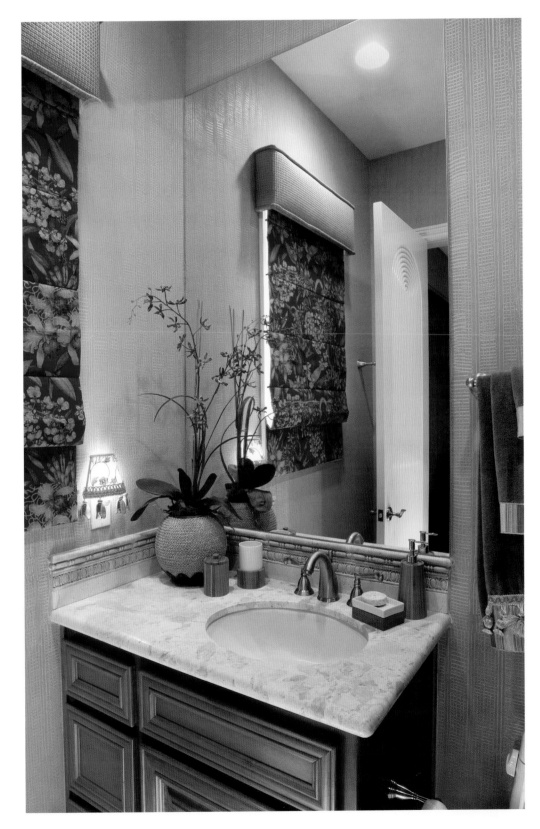
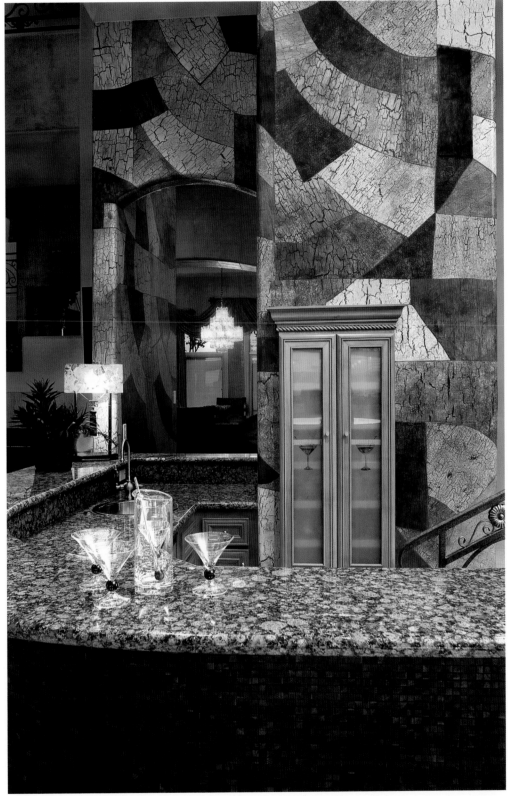

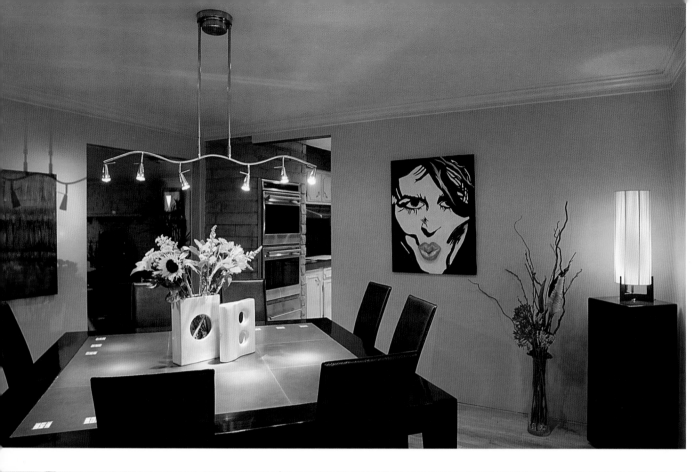

Refined and glamorous, many of Becky's interiors excite with color and express life in an exciting presentation. Above all she is client-sensitive and knows how to interpret their individual lifestyle, designing based on their needs. The age of each client can influence the final look of a room as much as the budget and her firm will work with high-profile clients as well as those who want first-time guidance and consultation.

Passionate about her work, Becky believes she has been given a gift as an artist and interior designer and continues to take professional coursework to advance her skills. She is passionate about giving back to the community where she works and lives, touching and inspiring people's lives inside and out. Voluntarily giving of her time and talents, she has worked with charitable organizations including the Shade Tree Shelter, Family to Family, The Art of the Smile and the Junior League of Las Vegas.

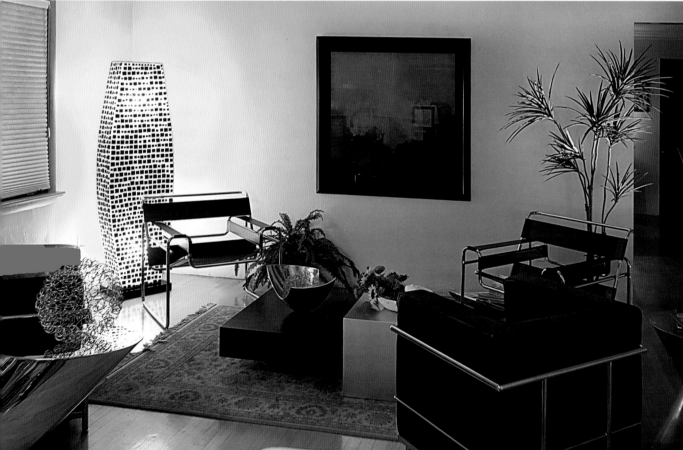

TOP LEFT:
A fresh dining room painted vibrant orange sets the stage for the custom black lacquer and metal tile inlaid table with bold black leather dining chairs. Modern acrylic and cast aluminum portrait by artist Kasondra Najafi.
Photograph by Studio West Photography

BOTTOM LEFT:
A transitional space becomes a serene sitting room with classic Le Corbusier and Wassily leather arm chairs facing brushed aluminum and wood geometric tables. Lighting statements add a restful glow.
Photograph by Studio West Photography

FACING PAGE TOP:
This elegant and uplifting living room is enhanced by hand-tissued, gold and bronze painted walls. Distinctive red-hued, custom furniture crafted and upholstered by local fabricators.
Photograph by Studio West Photography

FACING PAGE BOTTOM:
Daring purple and green tissue paper-textured walls and ceiling add impact to this dining room with smooth marble table and custom jewel-toned upholstered chairs. Commissioned original acrylic painting by Jennifer Main.
Photograph by Studio West Photography

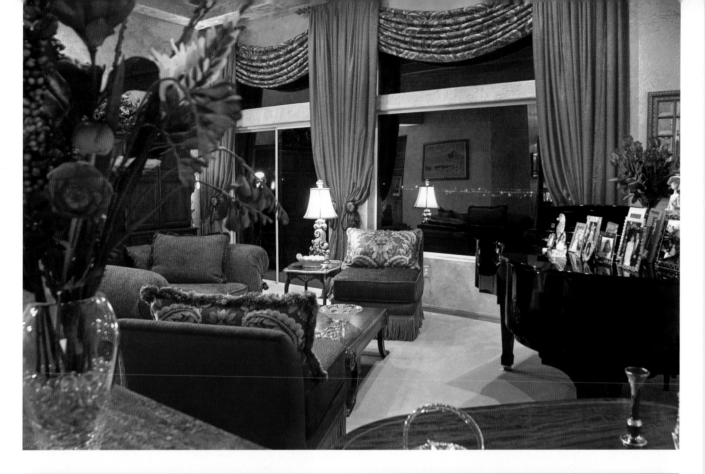

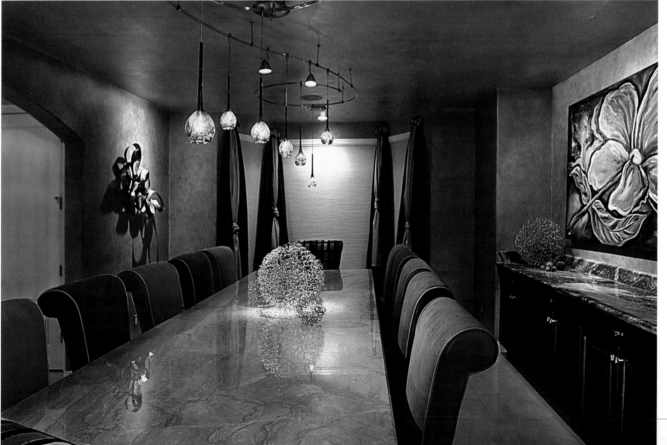

WHAT COLOR BEST DESCRIBES YOU AND WHY?
Red. I love the exciting, vibrant, on-fire feeling of fun it connotes.

WHAT PERSONAL INDULGENCE DO YOU SPEND THE MOST MONEY ON?
Shoes!

WHAT ARE SOME OF YOUR FAVORITE THINGS ABOUT BEING AN INTERIOR DESIGNER?
I would have never come close to fathoming how much of a thrill it was all going to be. I've enjoyed the genuine relationships that I have developed with clients along the way, taking chances and having fun in my career, and learning from one interior masterpiece to another.

WHAT SORT OF PROJECTS DO YOU UNDERTAKE MOST OFTEN?
Past projects have included everything from custom high-end residential and vacation homes, to doctors' offices and business strip malls. I've been involved in creative projects all the way to the exquisite finishing touches such as Christmas trees and window displays, to my personal favorite: children's playrooms.

WHAT DO YOU FEEL IS MOST IMPORTANT FOR PEOPLE TO KNOW ABOUT YOU?
If it wasn't for the solid relationships I have with my family, the strength to follow my ambitions and overcome my fears, and the loyalty to myself in terms of respect and morality, I don't believe I would truly be as happy as I am today. I honor and value every moment and strive to capture the essence of life around me and translate that into my interior design work.

WHAT BOOK ARE YOU READING RIGHT NOW?
The Secret, which is an amazing book!

DE ATELIER DESIGN GROUP
BECKY NAJAFI, IIDA, ALLIED MEMBER ASID
2120 West Oakey Boulevard
Las Vegas, NV 89102
702.366.0180
f: 702.366.1670
www.deatelierdesign.com

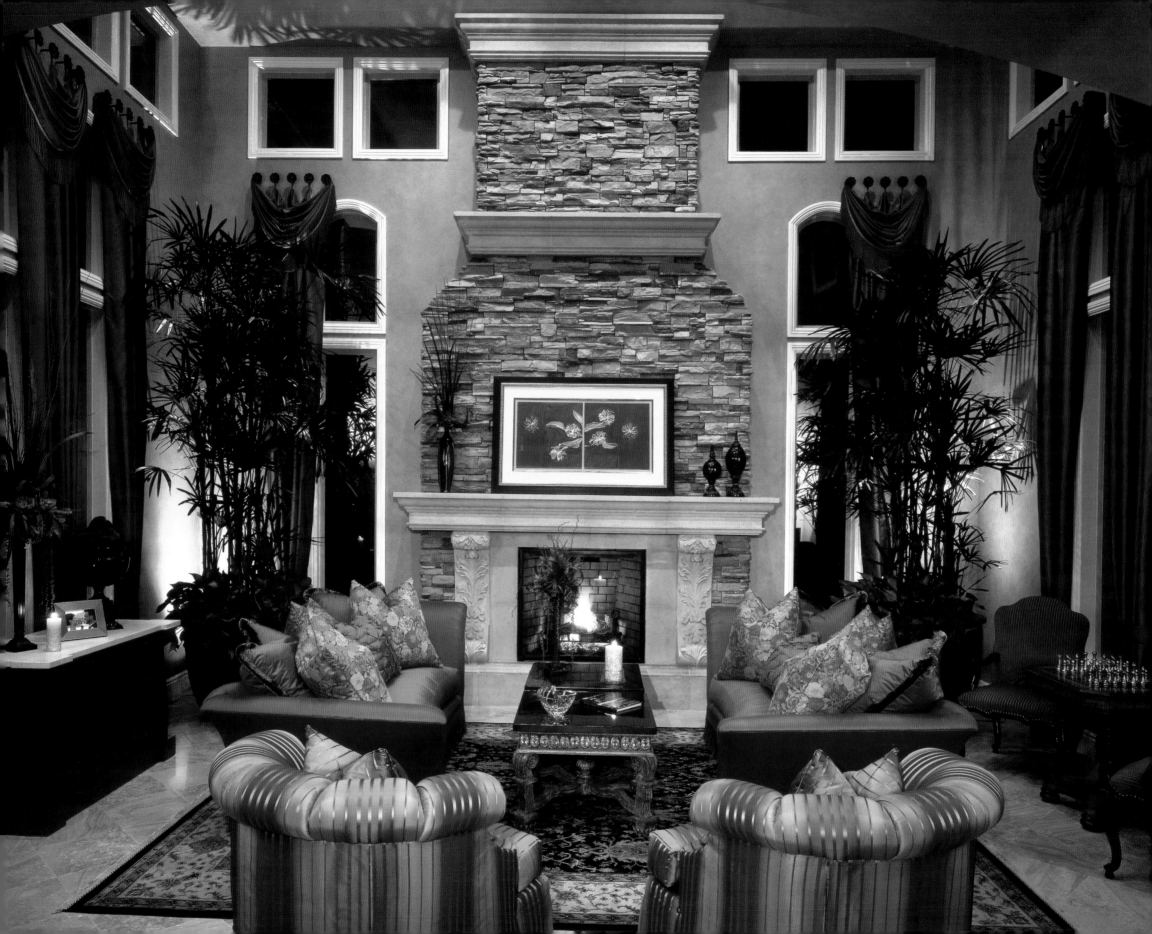

Ron Nicola

RON NICOLA INTERIORS LTD

A master performer thrilling audiences, Ron Nicola had his hand in entertainment working as a dancer and assistant in the legendary Siegfried and Roy stage show. Now in a different kind of show business, Ron is a Las Vegas legend in his own right as a premier residential interior designer.

Making his transition from the glitz of the stage to designing custom home interiors was as natural to him as dancing, and he founded his design firm in 1994. The interior design world is where Ron found his true passion and a place where he could bring his flair for the dramatic. With infinite energy, while doing two shows a night on the Las Vegas Strip, he started his interior design business working first on small remodeling projects with the ultimate dream of working on luxury high-end custom residences.

Ron quickly got his big break and was asked to design an interior for a Caesars Palace executive in a multimillion-dollar home where he could showcase his talents and produce results. This single opportunity catapulted Ron into the realm of high-end residences which he specializes in today throughout the Las Vegas desert region. He designs interiors for larger-than-life homes of up to 18,000 square feet. The secret to Ron's success is his amazing way of making a spacious residence into an intimate experience for the owners. When Ron does his magic on a private home, clients say it is simply spectacular.

ABOVE:
Dramatic custom lighting and stone columns enhance this 50-foot grand gallery and establish the ambience of this transitional-style home. Many of the homeowner's art pieces are showcased here.
Photograph by Chawla Associates

FACING PAGE:
Symmetry, texture and rich warm colors were the driving forces when designing this opulent living area. Ron's attention to proportion and sensitivity to scale complete the equation to make this oversized area an amazing space.
Photograph by Chawla Associates

ABOVE:
The second story loggia outside the master bedroom brings fresh air and natural light to an additional living area for the homeowners. The draperies, fireplace and furnishings make it feel more like an interior space so you do not quite know if you are inside or out.
Photograph by Chawla Associates

FACING PAGE LEFT:
Pakistan imported Honey Onyx flooring looks three-dimensional and provides the foundation for this elegant, contemporary pied-à-terre.
Photograph by Chawla Associates

FACING PAGE RIGHT:
Lacquered walls, polished marble, Venetian chandeliers, and 14-carat-gold trim on low-voltage lighting creates an elegant backdrop for this collection of bronze statues.
Photograph by Chawla Associates

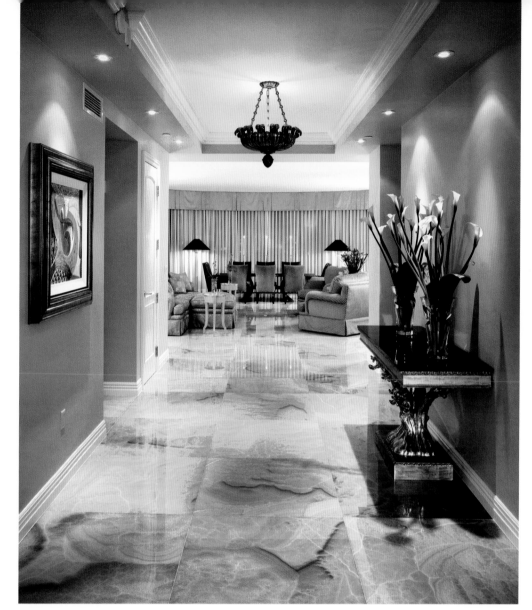

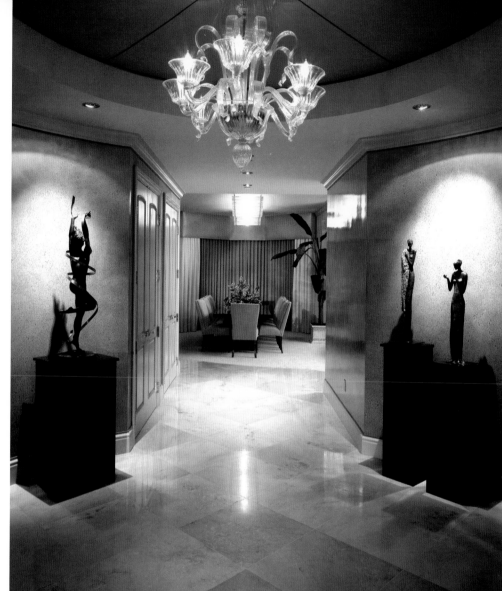

Having a bachelor's degree in psychology Ron has the ability to take a client through the design process with finesse and good communication. His high-profile clients enjoy a genuine trust factor because Ron listens with the intention of appealing to their specific lifestyle and habits. His clients are very precise in their direction and he is willing and able to accommodate the most demanding interior design project. Clients hire Ron and actually get Ron as their lead designer, so this close relationship allows them to be in constant touch along the way. There is never a junior designer assigned to one of his clients. It is this personalized service that makes a difference in the whole process.

Originally from Maryland and having lived in Las Vegas since 1983, Ron brings eclectic ideas to his design work. His sharp eye for detail and flair for the dramatic combined make every corner come alive in his interiors. He enjoys creating spaces in any given style and can design ultra modern, contemporary, traditional, Old World and Italian because he expresses creativity whatever the genre. He embraces the philosophy that even when a style has been done a million times before, he brings his special "gift" and ability to make it unique for each individual homeowner.

Whether a hand-carved chess set accent or custom iron and crystal chandelier, his designs are instantly recognizable as a Ron Nicola-inspired interior. His biggest accolade is when clients enter a room and insist it is the most beautiful place they have ever seen in their lives. His more-than-satisfied clients love their homes for years and refer him regularly.

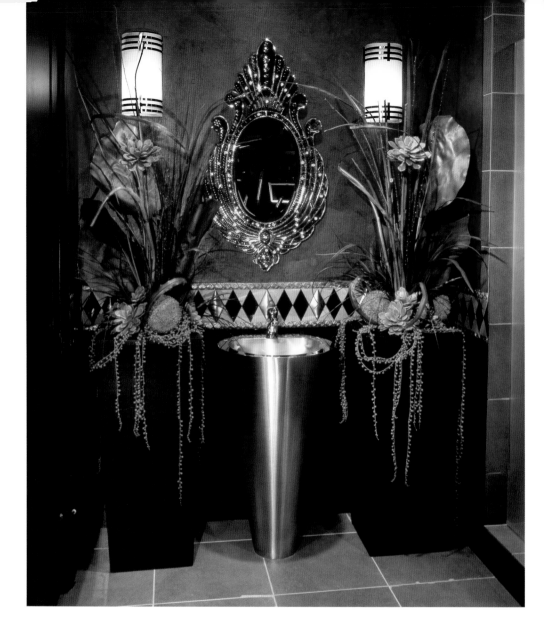

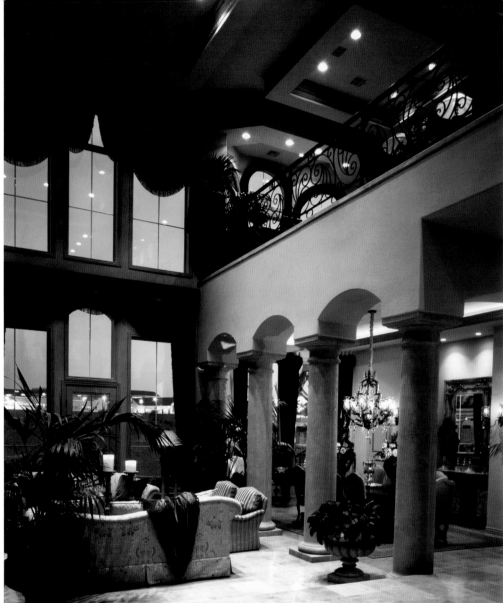

A perfectionist, Ron makes deliberate design decisions and he constantly strives to bring beauty, functionality and, above all, warmth to any interior. His talent can take a huge home that lacks intimacy and transform it into a comfortable place through his artful use of colors, fabrics, textures, plants, furnishings and accessories. He brings a certain harmony to a space, and one can clearly see a common thread throughout a home as the rooms flow into one another. This sense of continuity makes for timeless interior designs that defy anything trendy.

Every single creative project is a new opening night, a new stage show. His signature interiors have been featured on The Travel Channel and in various publications worldwide. A bon vivant, Ron is passionate about all of life from friendship to family, international travel to his tennis game. With a grateful heart and high energy, his work ethic attracts the best clients in Las Vegas. It is Ron's stellar showmanship that shines as he sees every home as a major creative production and is ready to be on stage every day.

ABOVE LEFT:
Custom floral arrangements flank the ultra contemporary brushed-steel sink in this dramatic Art Deco-style theater bathroom. The room features an antique Venetian-style glass mirror. Ron designed this room selecting each piece to be the antithesis of one another.
Photograph by Chawla Associates

ABOVE RIGHT:
There is always a gasp when entering this Old World, Mediterranean residence. Warm neutral tones create a timeless existence for this distinctive "Italian Palazzo."
Photograph by Chawla Associates

FACING PAGE:
Sumptuous woods and finishes combined with extraordinary millwork are a trademark of all the master bathrooms that Ron designs. This transforms an ordinary master bathroom into a luxurious personal retreat.
Photograph by Chawla Associates

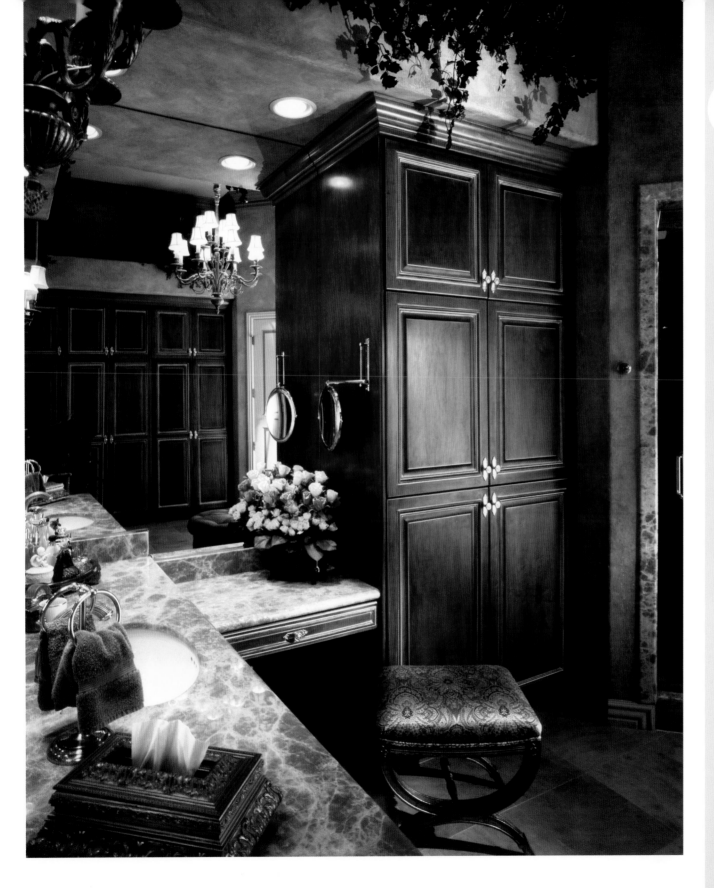

WHAT ONE ELEMENT OF STYLE HAVE YOU STUCK WITH FOR YEARS THAT STILL WORKS FOR YOU TODAY?
Classic design, regardless of the period, never goes out of style. I don't go for trends!

WHAT SEPARATES YOU FROM YOUR COMPETITION?
My attention to detail and God-given talent.

WHAT PERSONAL INDULGENCES DO YOU SPEND THE MOST MONEY ON?
Luxury cars and designer clothing.

WHAT BOOK ARE YOU READING RIGHT NOW?
Lisey's Story by Stephen King.

WHAT IS THE HIGHEST COMPLIMENT YOU'VE RECEIVED PROFESSIONALLY?
Every interior design job I do is spectacular.

HOW CAN WE TELL THAT YOU LIVE IN THIS LOCALE?
I'm tan all year round.

RON NICOLA INTERIORS LTD
RON NICOLA
1820 Glenview Drive
Las Vegas, NV 89134
702.592.1013
f: 702.869.9296

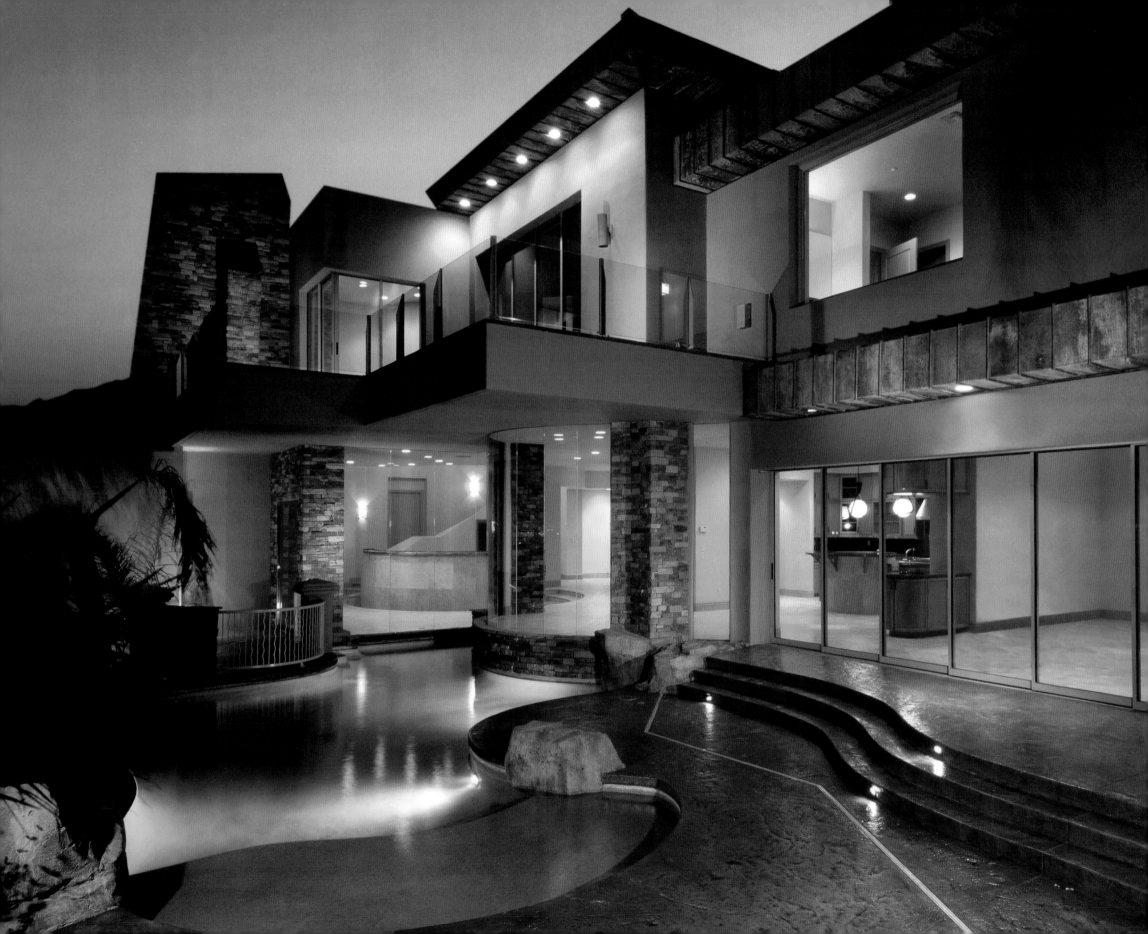

Brian Plaster

SIGNATURE CUSTOM HOMES

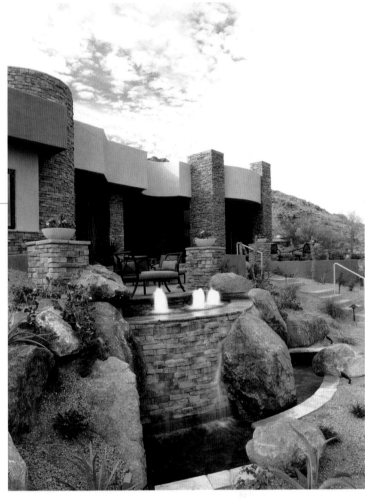

Founded in 1978 by Richard and Wendy Plaster, Signature Homes is one of the largest and most successful privately held home builders in the Las Vegas valley. The company has built more than 12,000 homes, thousands of condominiums and apartments, is a member of the National Association of Home Builders (NAHB), and has been listed in the Top 100 builders nationally.

As a testament to the firm's dedication to customer service, a custom homes division was established within Signature Homes in 1999. Richard's vision was to unite architects and construction development to simplify the custom home building process for clients and everyone involved in the process. Brian Plaster heads up this division, ensuring that every final detail is considered in the process of building a custom home. "Our focus on customer service makes certain that we are always putting the needs of our clients first. There is no stopping point for us; we will continue to provide excellent customer service on a home for years if necessary," says Brian.

Ensuring that customer service remains top priority, Signature Custom Homes develops long-lasting relationships with each client and in many cases, these relationships evolve into friendships. Projecting the family environment of the company forward to customers, the team insists that each client is not just satisfied, but delighted with the end result of each project. Clients enjoy the "family style"

ABOVE:
The curb appeal of this modern-style home is enhanced by an attractive cascading water feature and generous application of stonework in rich contrasting colors.
Photograph by getdecorating.com

FACING PAGE:
This stunning desert contemporary home features sliding glass doors which bring the outside in and copper roof details which accent the warm exterior color scheme.
Photograph by Paul Cichocki

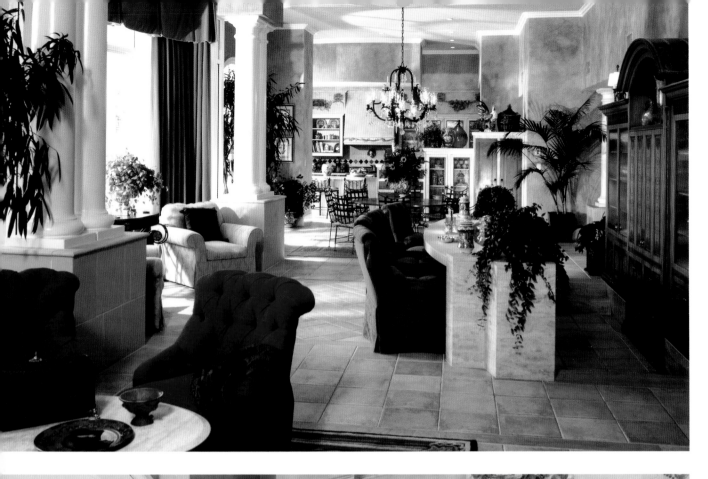

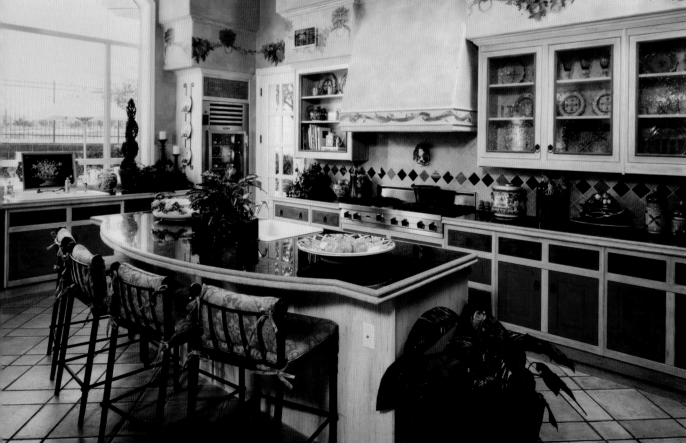

environment of the company and the special attention and service they receive from Brian and his team.

Signature Custom Homes keeps clients thrilled with their homes by offering the constant level of quality for which they have become so highly acclaimed. There is not an occasion when Brian and his team do not think outside the traditional home building box to identify new, innovative ways to build a product, making that product reach its ultimate potential. Always educating himself and his team on new products and ways to implement them into the building process, Brian is now in the process of building a "high-performance" home with the latest energy-saving technology developed from NAHB's Green building program. The home will be extremely energy efficient, built with a multitude of energy saving techniques like radiant heat barriers, high SEER air conditioners, tankless water heaters, solar water heaters, upgraded insulation, solar power, low-flow toilets and low-emittance windows.

Creating energy efficient homes is just one way in which Signature Custom Homes caters to its clients so that they have the best experience possible during the home building process. The company has carried on the tradition of creating homes as unique as the people who live in them. The Signature team of professionals collaborates with each client in designing a custom home that meets the unique needs of his or her distinctive lifestyle. Dedicated to

TOP LEFT:
This elegantly decorated home has a bar that separates the family room from the kitchen, which allows for an ideal traffic flow for entertaining.
Photograph by Opulence Studios

BOTTOM LEFT:
The faux-finished walls which are accented with exquisite hand-painted details add warmth and depth to this inviting Tuscan-style kitchen.
Photograph by Opulence Studios

FACING PAGE:
Winner of numerous Street of Dreams awards including "Best of Show," the exterior design of this spectacular home blends harmoniously into the desert surroundings.
Photograph by getdecorating.com

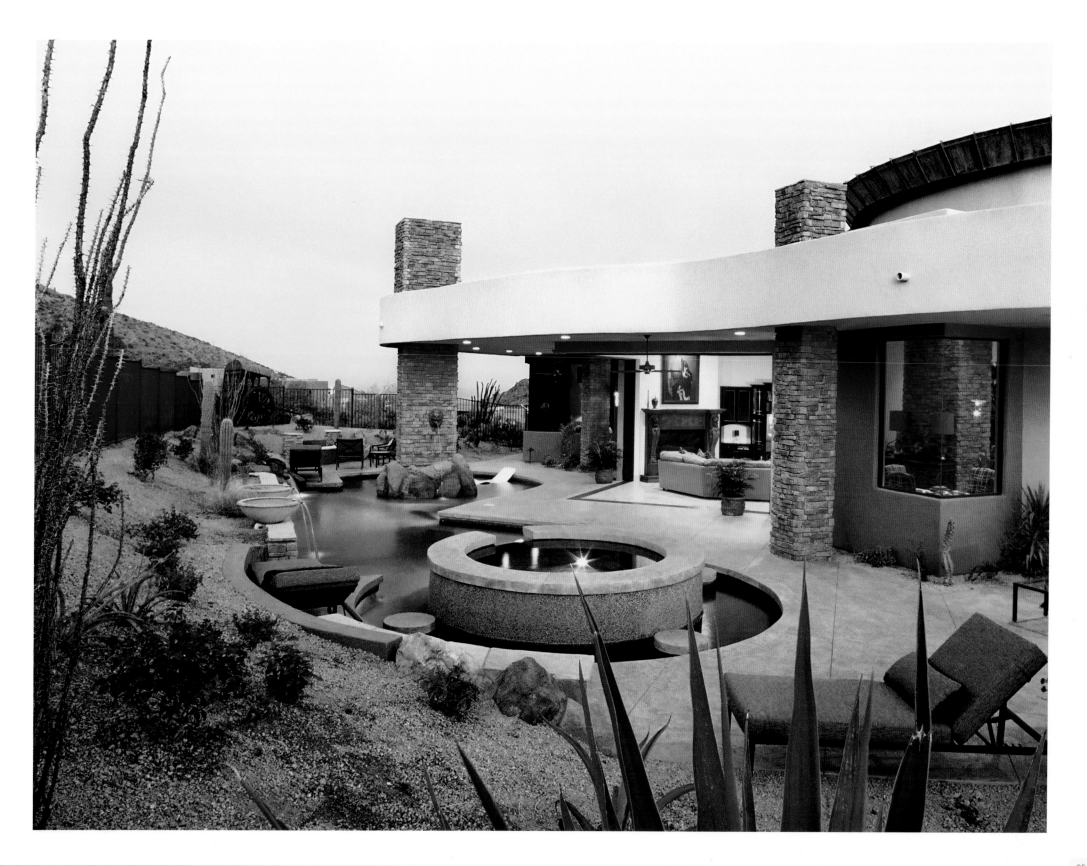

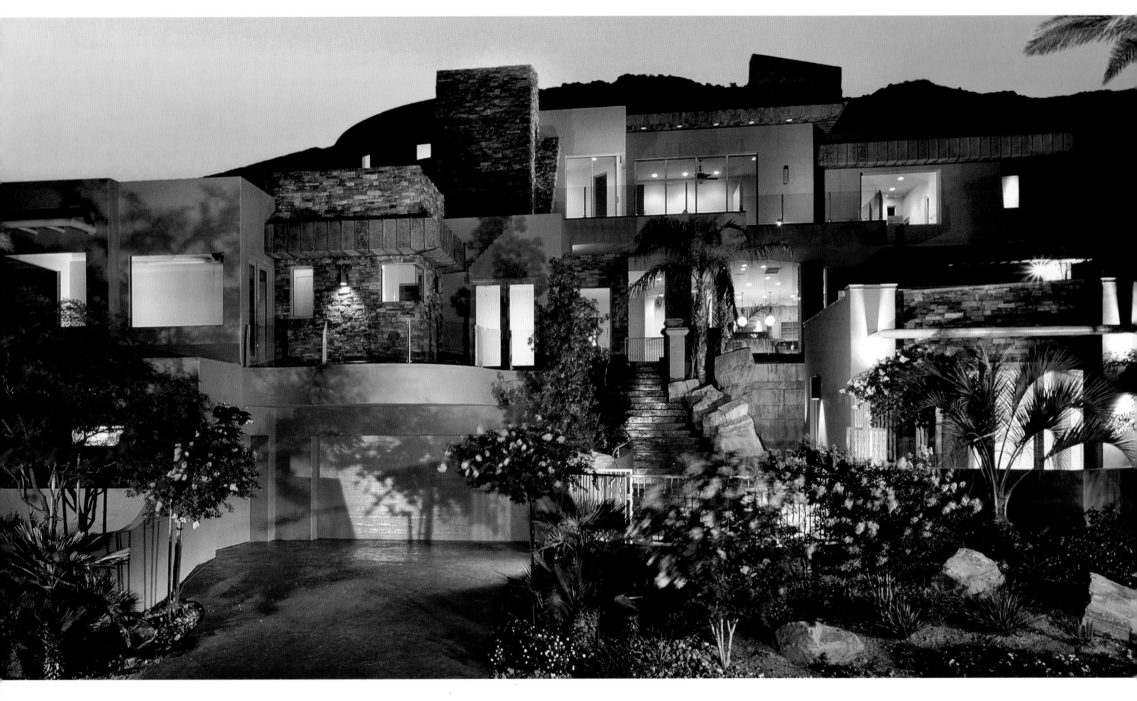

ABOVE:
Winner of DESI awards for "Best Sustainable Design" and "Best Courtyard Design," this spectacular hillside home skillfully showcases
its unique architectural features.
Photograph by Paul Cichocki

FACING PAGE:
Circular turrets and a staircase which trails up to a tranquil sitting area add to the splendor of this old Spanish-style home.
Photograph by Paul Cichocki

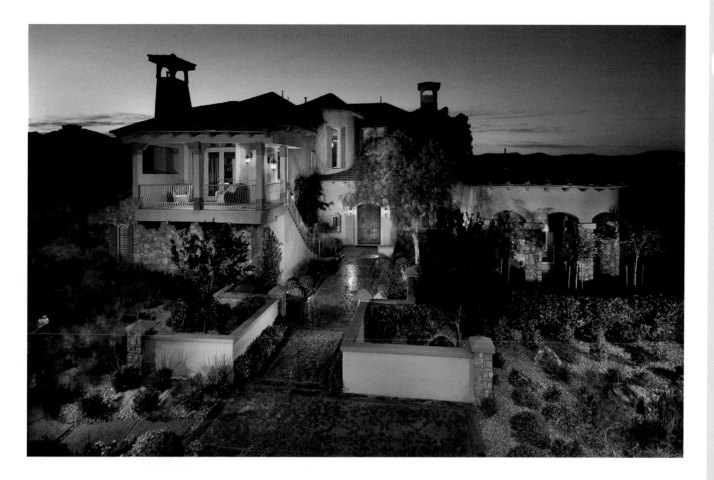

DESCRIBE YOUR STYLE OR DESIGN PREFERENCES:
We offer a wide variety of architectural designs, but since we build primarily in desert communities, our homes tend to be Tuscan or desert contemporary-style homes.

WHAT IS THE BEST PART OF BEING AN ARCHITECT/BUILDER?
Completing the construction of a custom home and knowing that it was built with the highest standards of excellence. Whenever I drive by a home built by Signature Custom Homes, I am proud to have been part of a process which created a quality product with lasting appeal and value.

WHO HAS HAD THE BIGGEST INFLUENCE ON YOUR CAREER?
My parents have had the biggest influence on my career. My mother's attention to detail and interior space planning have led me to focus on design elements throughout custom homes at a variety of different levels. My father's commitment to customer service and building homes with the highest level of quality inspired me to join the family business and begin a fulfilling and exciting career in the home building industry.

providing the highest level of personalized service and maximum value, Signature Custom Homes strives to enhance the quality of each of its clients' lives by creating a one-of-a-kind home which has been specifically designed for its residents.

Clients are not the only ones impressed with Signature Custom Homes; the firm has been published multiple times and received numerous awards and accolades. The company's custom home, "House of Desert Dragon," won six awards including "Best of Show" at the Street of Dreams show in Scottsdale, Arizona. Signature Custom Homes was also presented the "Best Value" award, voted among Realtors® in Las Vegas, for its luxury home, "Villa Trieste," at the Street of Dreams show in Seven Hills. Signature Custom Homes' most recent showcase home, "El Mirador," won DESI awards for "Best Sustainable Design" and "Best Courtyard Design" and has been featured in *Custom Homes and Living* magazine.

SIGNATURE CUSTOM HOMES
BRIAN PLASTER
801 South Rancho Drive, Suite E-4
Las Vegas, NV 89106
702.671.6000
f: 702.385.5036
www.signaturecustom.com

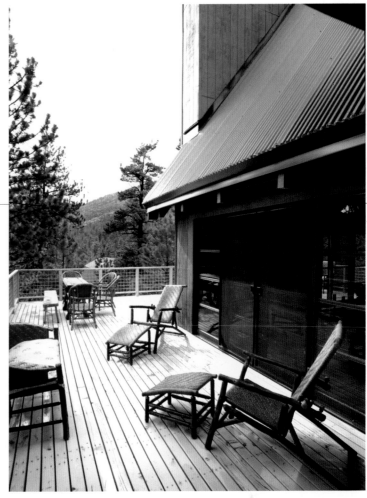

Ted Rexing
ARTECH ARCHITECTURE & PLANNING

Opened in 1994, ARTECH is an intimate firm which dials in the balance of fine art and architecture, both personal loves of the principal, Ted Rexing. All designs are conceived with an artist's attention to detail and beauty combined with an architect's precision and grasp of the built world. Ted free-hands all sketches for artistic freedom, then shifts them to CAD for efficiency. His designs emphasize harmony with the environment. He incorporates a range of Green architecture and energy efficiency that is unique to each client, site and budget. Several projects underway are not only Green but completely "off the grid" for maximum environmental sensitivity. Architecture can join the lead in energy solutions.

One special element in Ted's designs is the use of light—both naturally and artificially derived. He enjoys cultivating a great range of experiences by providing users with many lighting options. Great lighting can showcase art; spill over the shoulders for perfect reading; create drama; or glance across architectural features for texture. It is an art form all its own.

Ted believes style is a unique product of the client's goals and the demands of the environment. For instance, one noteworthy project is a home nestled in Mount Charleston among the majesty of the Bristle Cone Pines, the oldest living things on Earth. It showcases the owner's furniture and art collections, and standing as a serene sanctuary, becomes a counterpoint to the intensity of Las Vegas.

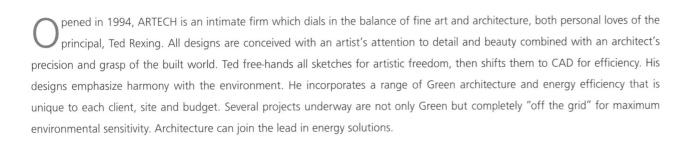

ABOVE:
The house opens to the south for heat and views, while cedar decks and corrugated roofing nod to the Japanese influence of the owner's art collection.
Photograph by Erin O'Boyle Photography

FACING PAGE:
Light turns the kitchen into a stage for entertaining through sliding walls, custom lanterns and carefully concealed illumination.
Photograph by Erin O'Boyle Photography

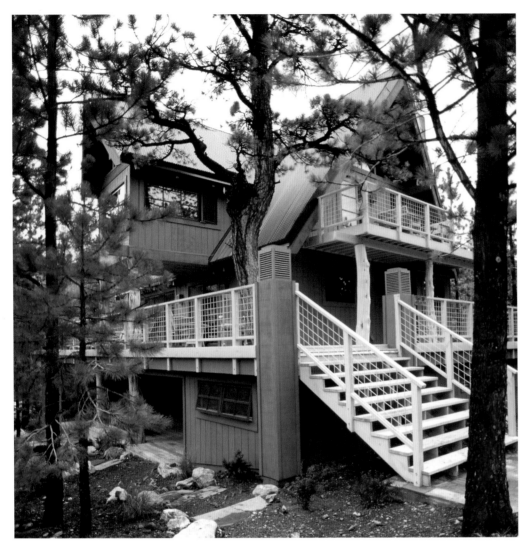

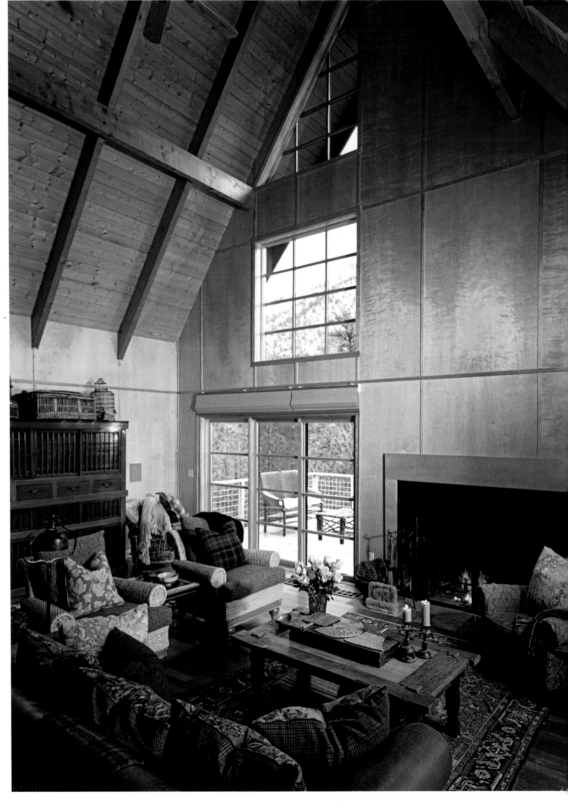

ABOVE:
Wood construction and steep roofs respond to the rugged site among 200-foot pines, some of which curl through the deck to welcome guests.
Photograph by Erin O'Boyle Photography

RIGHT:
The project was inspired by the owner's collection of Asian furniture, which was echoed in environmentally sensitive woods and pattern motifs throughout the interior.
Photograph by Erin O'Boyle Photography

FACING PAGE:
The minimalist details belie the sophisticated technology below the skin to generate power and heat despite no electric utility in the area.
Photograph by Erin O'Boyle Photography

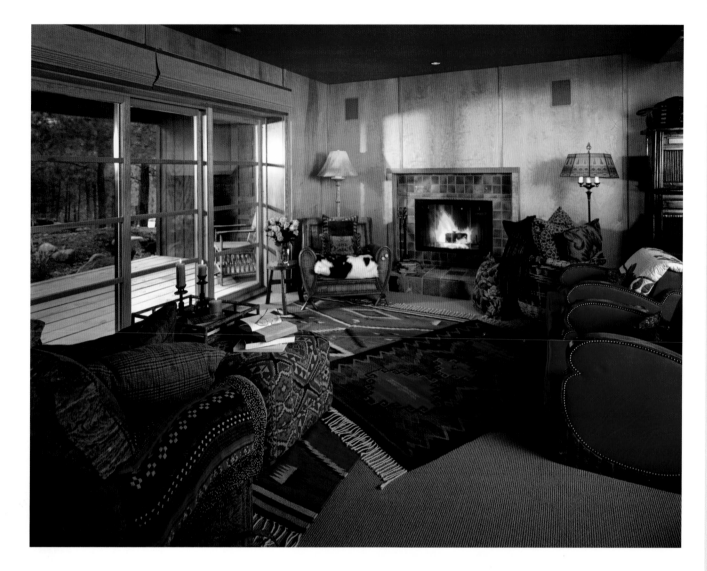

WHAT ONE PHILOSOPHY HAVE YOU STUCK WITH FOR YEARS THAT STILL WORKS FOR YOU TODAY?
Real beauty starts with fresh thinking.

IF YOU COULD ELIMINATE ONE DESIGN/ARCHITECTURAL/ BUILDING TECHNIQUE OR STYLE FROM THE WORLD, WHAT WOULD IT BE?
Dome homes, because they look like measles on the landscape.

WHAT HAS HAD THE BIGGEST INFLUENCE ON YOUR CAREER?
Frank Lloyd Wright's Shiprock House in Phoenix. The burned-down house became my playground. The way the foundation was anchored into the desert reminded me of a ship navigating the sea. Standing on the deck of this house, aimed towards a nearby mountain, I learned how an architect could create great experiences, even in a ruin.

WHAT IS THE MOST UNUSUAL/EXPENSIVE/DIFFICULT DESIGN OR TECHNIQUE YOU'VE USED IN ONE OF YOUR PROJECTS?
Rammed-earth construction is expensive because it requires extensive detailing, numerous meetings with the Building Departments and lenders, and then considerable construction labor; yet it yields impressive results.

WHAT IS A SINGLE THING YOU WOULD DO TO BRING A DULL HOUSE TO LIFE?
I'd open it to nature and give it a strong organizing element like an axis to a significant view.

Quite simply, Ted Rexing believes everyone should have the opportunity to have a dream home. He is happy to help his clients achieve their dreams, either through his involvement in Habitat for Humanity, or through the unmatched services of his firm. The principal of ARTECH Architecture & Planning devotes his energy to bringing artistry and a soul-satisfying environment to every project he designs.

ARTECH ARCHITECTURE & PLANNING
TED REXING
2216 Warm Walnut
Las Vegas, NV 89134
702.645.5424
f: 702.869.4222

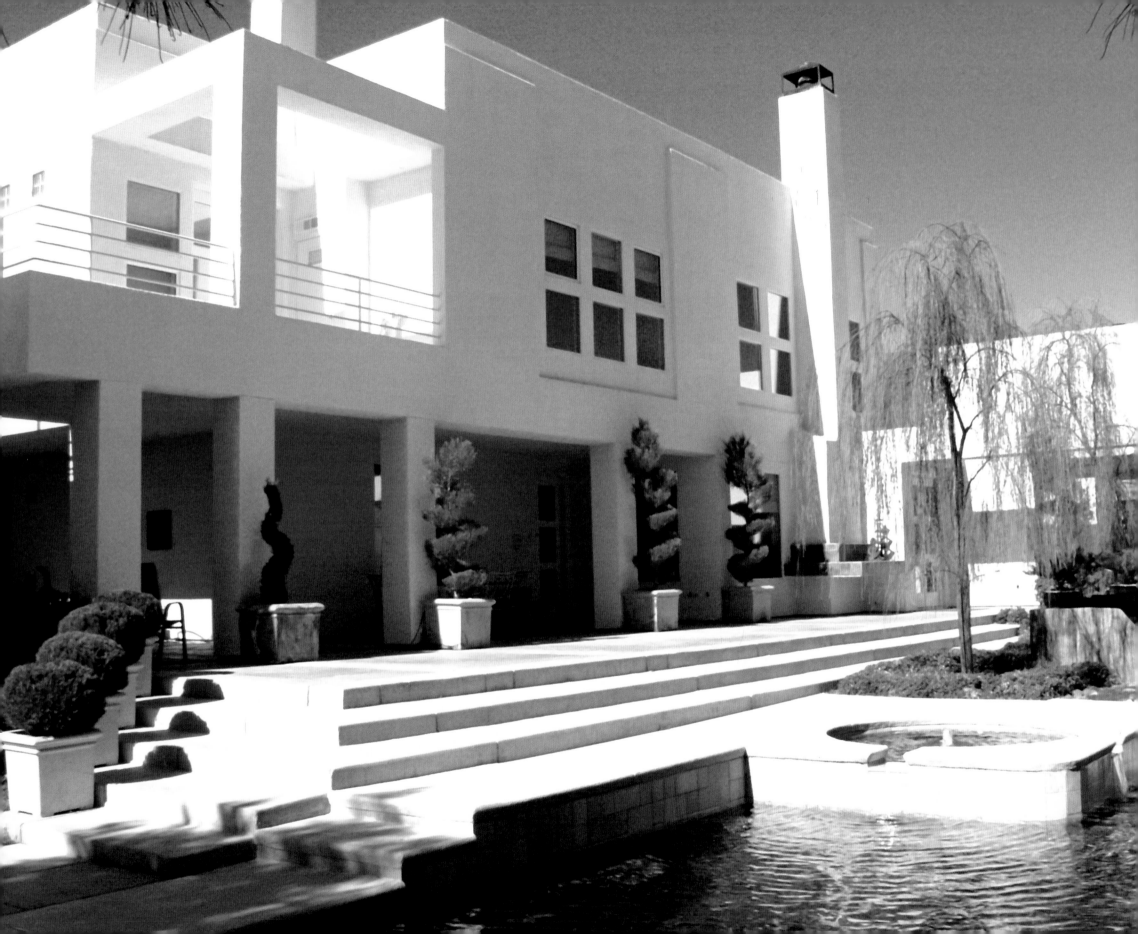

Bob Sherman

SHERMAN ARCHITECTURE

A 40-year veteran, Bob Sherman's illustrious career began in a most unlikely manner. Even with art influences within his family, as a young man growing up, Bob Sherman did not quite know what he wanted to do. He had always admired his best friend's father, a professor of architecture at the University of Oregon, and he had displayed an aptitude for engineering in high school. However, after stints pumping gas for race cars and fruitless time spent at a community college, Bob finally found a job that would open his eyes to the possibilities that lie ahead of him and find what would eventually "possess" him.

While working as a clerk for a large architectural/engineering firm, Bob was struck and impressed. He talked with the architects and engineers and soaked up every practical lesson they had to teach. For the next six years, Bob put himself through the University of Oregon while working full-time to support and finance his dream. During these years, determination and hard work were plentiful, but sleep was a seldom-had luxury. Upon graduation he joined with a senior partner, at 24 became licensed and six months later was made partner.

The bulk of his firm's work in Oregon consisted of municipal buildings including prisons, courthouses and numerous high schools. Bob soon found that one of these projects consumed three to four years of his life. He needed a change of scenery as he was "sick of the rain," and wanted to stretch his architectural interests as well.

ABOVE:
The gallery provides interesting access to bedrooms. Side wall recesses display wall art.
Photograph by Boyd Pomarius

FACING PAGE:
The rear and side yard pool terrace is viewed from the living room, great room, kitchen and game room of this contemporary design.
Photograph by Boyd Pomarius

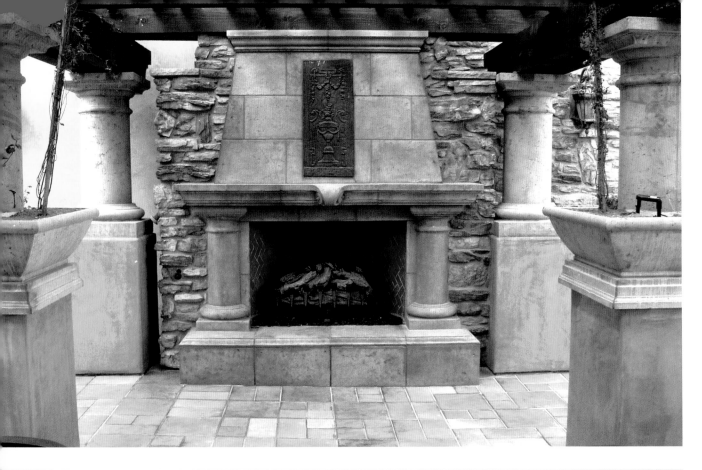

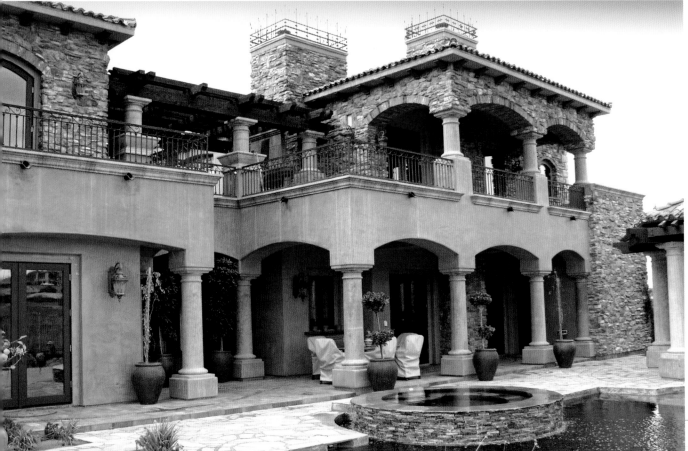

He landed a job as Vice President of Development for a prestigious development firm in sunny California. For six years, his life consisted of "airplanes and more airplanes" traveling to the various sites. Fortunately he was able to view and learn from some of the world's greatest architecture firsthand. From Hungary to South America, he studied it all. He spent a great deal of time in Las Vegas as his three biggest properties were there. As soon as the romance of traveling the world wore off, Bob found he was restless to return to his architectural roots.

Las Vegas was a natural choice as he had become quite familiar with the area by this time. His first build project in Las Vegas was his own home in 1991. Fifteen years later, Sherman Architecture is a thriving firm in one of the country's hotbeds of new construction. As one of Las Vegas' most respected architects, Bob has earned this admiration by doing things his own way.

His workday begins in the most creative hours of the day: the "blue hours" of the early morning beginning at about 3 a.m. Bob's commute is a coveted one, just a few steps to an office in his own backyard. There, in the quiet solitude of the morning, he welcomes his inspiration with no interruptions.

Bob works on eight to 10 projects a year, including a handful of commercial projects. More than most, he relies on his experience and strong understanding for what it takes to get something built. Beginning with pen and paper, Bob works closely with his clients one-on-one to sketch 3-D images based on intuitive perception and the client's desires and necessities. He works closely with them from start to finish, thereby ensuring total completion. He strives

TOP LEFT:
This upper-level fireplace retreat provides a casual outdoor living space accessible from the master suite and library.
Photograph by Boyd Pomarius

BOTTOM LEFT:
The rear yard provides covered outdoor living terraces from the great room, master suite and library in this "Tuscan" design.
Photograph by Boyd Pomarius

FACING PAGE LEFT:
The grand salon is viewed from the upper and lower galleries. Both galleries overlook landscaped courtyards.
Photograph by Boyd Pomarius

FACING PAGE RIGHT:
The entry vestibule is framed on both sides by the sweeping grand staircases.
Photograph by Boyd Pomarius

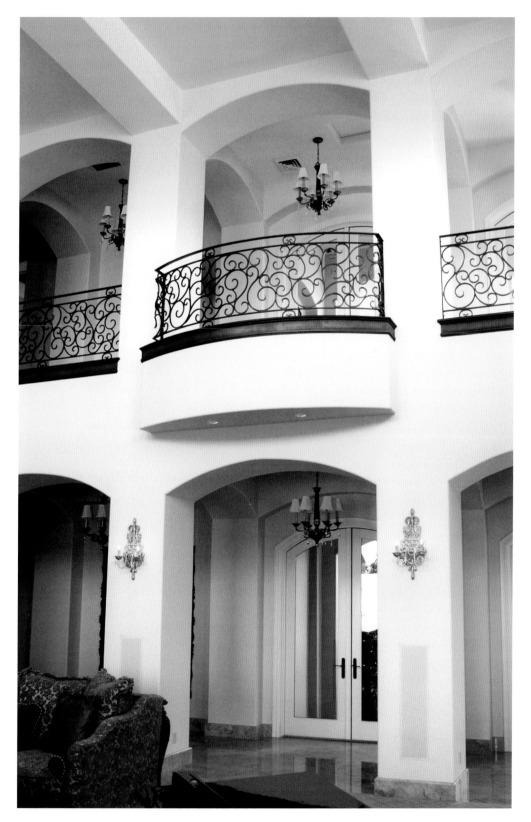

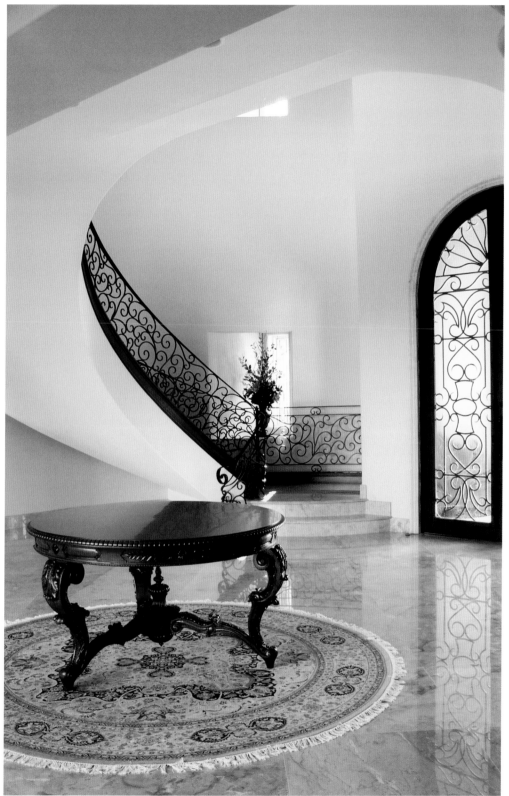

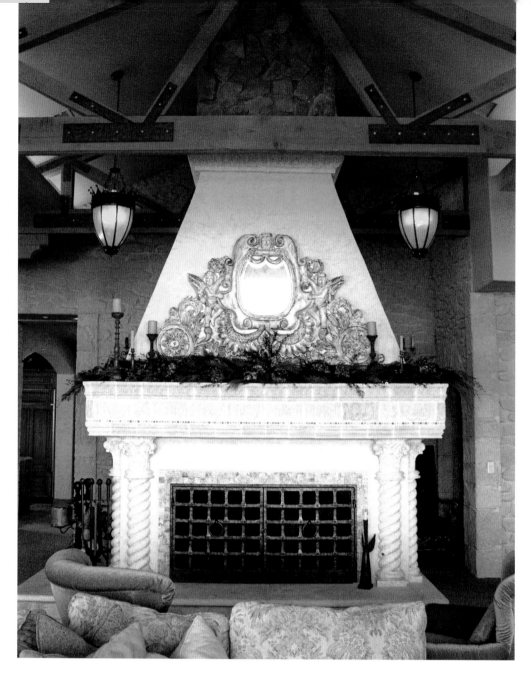

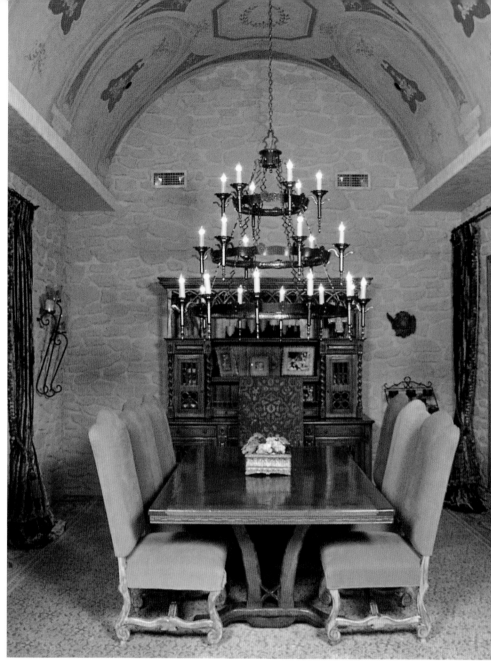

ABOVE LEFT:
The client desired a castle-like look throughout the interior. The great room fireplace and heavy timber roof trusses provide the desired image.
Photograph by Boyd Pomarius

ABOVE RIGHT:
The barrel-vaulted, decorative hand-painted ceiling reinforces the "castle" look. This formal dining room opens onto the entry courtyard.
Photograph by Boyd Pomarius

FACING PAGE:
This Spanish Eclectic home sits elegantly on its one-acre hillside site overlooking the city.
Photograph by Boyd Pomarius

ON WHAT PERSONAL INDULGENCES DO YOU SPEND THE MOST MONEY?
Travel, dining and books.

WHAT WOULD YOUR FRIENDS TELL US ABOUT YOU?
I am possessed with architectural design. They are correct and I thrive on design creativity.

WHAT SINGLE THING WOULD YOU DO TO BRING A DULL HOUSE TO LIFE?
Design exterior and interior elements that add shade/shadow and color, texture and visual interest.

WHAT DO YOU LIKE BEST ABOUT DOING BUSINESS IN YOUR LOCALE?
Economic growth and a large client base that desires more unique architecture.

to learn from every design he is exposed to and improve upon his designs with every project. His philosophy is to exceed the clients' expectations and they can tell you, he always does.

Always in design mode, he often sketches anywhere inspiration strikes. He keeps a black pen and three-by-five-inch index card in his pocket at all times. Although he does nearly every bit of the work himself, Bob relies on a team of about eight who then take his renderings and enter them into the CAD system. He has a relationship with two to three of the area's top builders whom he trusts to bring his renderings to fruition.

With building restrictions tightening, Bob continually encounters new challenges and the same ones that have always been present. For example, many communities restrict Tuscan-style homes from being built. This is often disappointing to many potential homeowners who had that style in mind. For Bob, it is all about guiding the client into accepting these slight changes while designing a residence they will appreciate and love even more than the one they had in mind. While budgets are always important to him, the occasional carte blanche project has its freedoms and personal advantages.

Many seasoned architects look to Sherman Architecture's designs—from classic to contemporary—as the bar by which to set their designs. One of the highest compliments he could receive, Bob simply enjoys his work and sharing his designs.

SHERMAN ARCHITECTURE
BOB SHERMAN, NCARB
7730 West Sahara Avenue, Suite 103
Las Vegas, NV 89117
702.365.9838
f: 702.877.1213

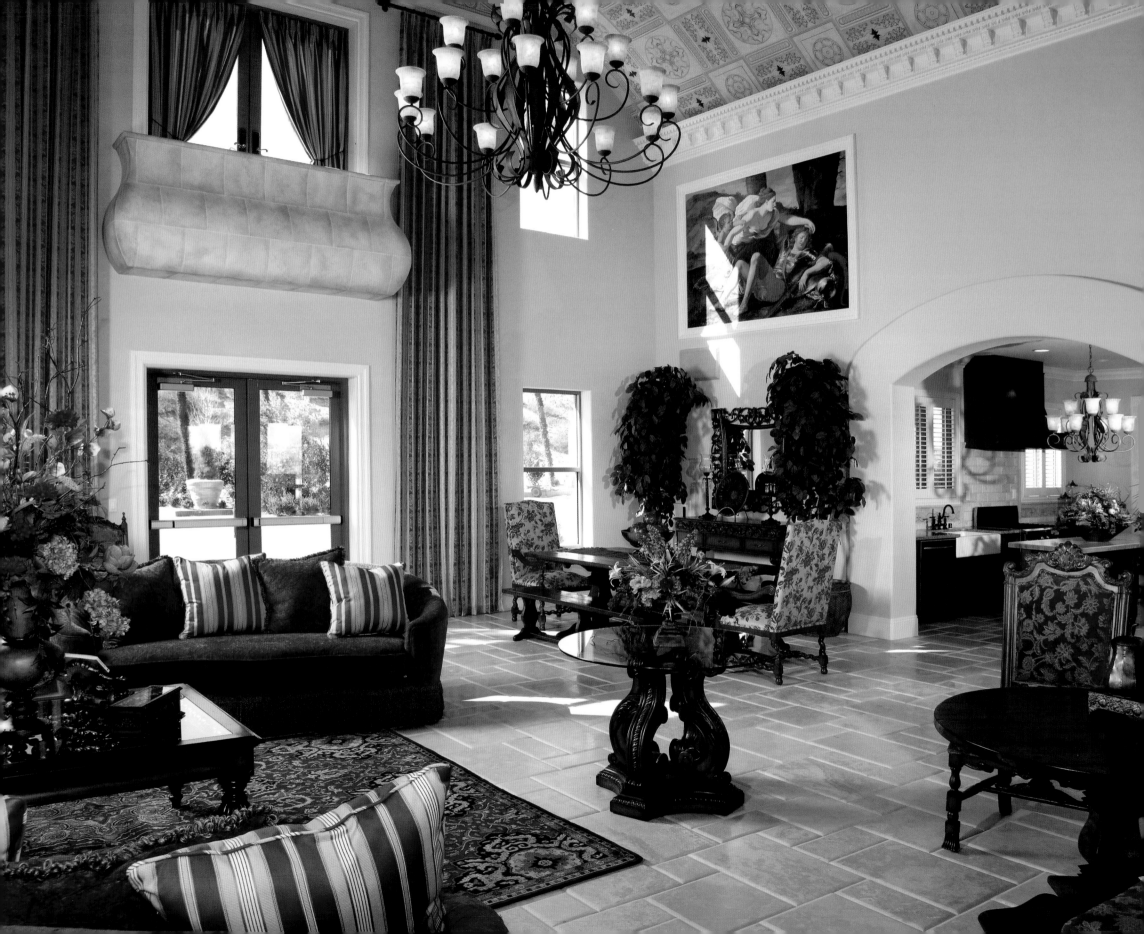

Kassie Smith
DESIGN CENTER WEST

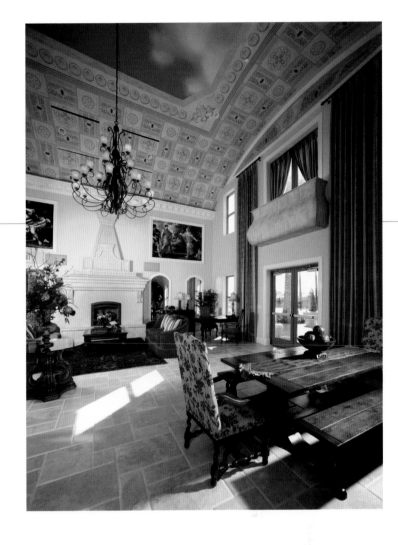

As one of the premier interior designers in Las Vegas, Kassie Smith has been changing the face of the industry throughout her 15-year career. Award-winning residential designs, commercial projects and show homes shine with her masterful touch. Also an energetic entrepreneur, Kassie has owned and operated three different furniture and interior design showrooms catering to both retail clientele and interior designers over the years. Her thriving full-service studio offers interior design, decorating, home design, commercial design and interior architectural consulting.

Known as the Nevada desert region's interior design specialist for custom home projects, her background is diverse and includes exemplary commercial and hospitality interior work: She has been a professional design consultant for the City of Henderson working on several important commercial design projects including the illustrious city hall expansion. With seven years of solid experience in the luxury resort market as well, Kassie has completed 82 "turnkey" private homes and several award-winning projects at the beautiful Lake Las Vegas Resort.

ABOVE:
Full view of the clubhouse interior showcases a dramatic fireplace flanked by gallery paintings. Upholstered furniture in fabrics of vibrant color and rich textures are accented by carved wood tables creating an aura of Spanish sophistication.
Photograph by Britt Pierson

FACING PAGE:
A grand Mediterranean-style clubhouse at Centex Destination Properties "V" in Lake Las Vegas Resort invites residents into comfortable conversation areas through exquisite art, fine custom furnishings, dramatic draperies and wrought-iron chandelier lighting fixtures.
Photograph by Britt Pierson

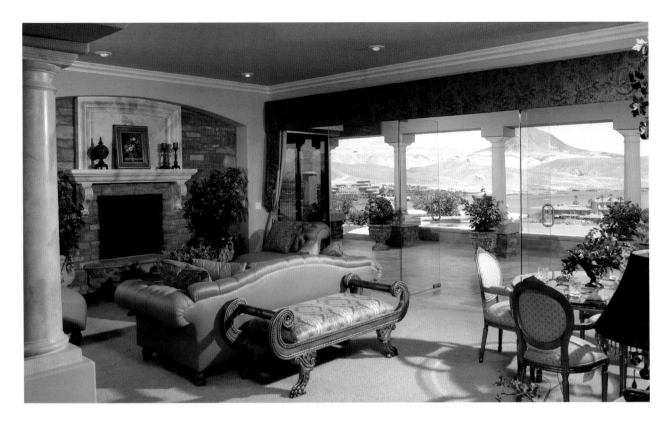

A key component of Kassie's success has been her signature flair for providing "turnkey" interior design services for high-end residential clients as well as developers. She is able to take an unfurnished house and turn it into a gorgeous home ready to move into in as little as six weeks; the only thing one needs to bring is their wardrobe. Kassie creates and oversees every design element and the personalized details of each project, leaving her clients to simply enjoy the new space. In the fast-paced world of development, she has worked diligently to fine-tune the design process and is always a step ahead in her forward-thinking attitude.

In addition to bringing her creative expertise to the Las Vegas market, Kassie also commits her time educating her clients and the public on interior design. All at once a published author, television personality and radio host, she has used these media outlets to reach a broad audience and bring her interior design advice to the masses. She even created her own segment called "Makeover Madness" for *The Home Show* in which she rejuvenated Las Vegas residences in desperate need of an interior facelift. In an effort to contribute to the education of future professional designers the world over, as well as current interior designers, Kassie is an invited guest speaker at universities and conventions, sharing her years of experience with fellow industry designers. Respected peers have taken notice of Kassie's devotion to her profession and elected her as the director of the Las Vegas chapter of the American Society of Interior Designers; she has proudly served a two-year term—truly honored to offer her leadership skills.

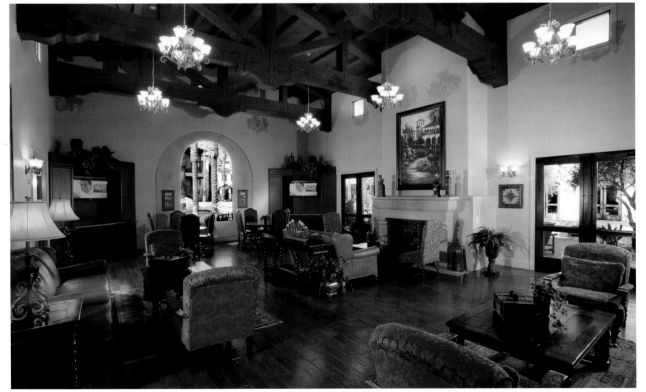

TOP LEFT:
This "turnkey" townhome located at Amstar Homes, "Mira Bella" in South Shore, Lake Las Vegas Resort, features a graceful, Italian-inspired formal living and dining space with unparalleled views.
Photograph courtesy of Design Center West

BOTTOM LEFT:
The Spanish-style clubhouse at the Legacy Villas Resort in La Quinta, California, is spacious yet warm and inviting with an understated, dramatic flair—a special place to relax and unwind.
Photograph by Sherrill and Associates

FACING PAGE:
This Spanish-style "turnkey" townhome possesses a rich color palette and sumptuous appeal with a traditional and elegant Spanish-style dining room evoking a very intimate feeling.
Photograph courtesy of Design Center West

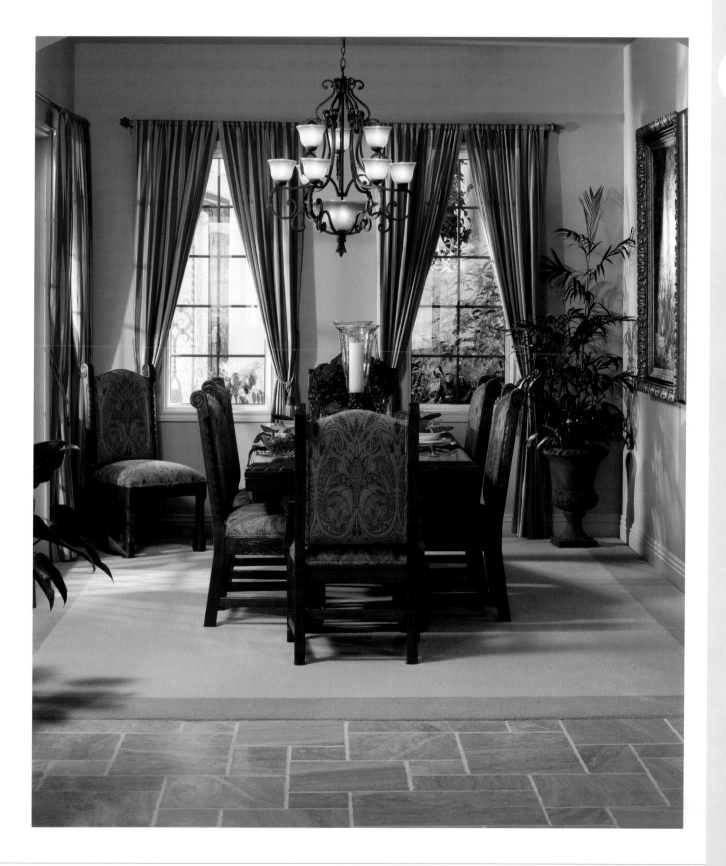

WHAT IS THE HIGHEST COMPLIMENT YOU'VE RECEIVED PROFESSIONALLY?

The positive reputation I have developed as a respected professional is the best compliment I could ever receive.

WHAT IS THE MOST UNIQUE/IMPRESSIVE/BEAUTIFUL HOME YOU'VE BEEN INVOLVED WITH? WHY?

An 18,000-square-foot home owned by a single gentleman. We traveled everywhere to find the most unique and original products. The home touted 45 plasma televisions!

WHAT IS THE MOST MEMORABLE PROJECT WITH WHICH YOU'VE BEEN INVOLVED?

I recently acted as a consultant for the City of Henderson working on several projects including the 214,000-square-foot city hall expansion project.

DESIGN CENTER WEST
KASSIE SMITH
6165 Annie Oakley
Las Vegas, NV 89120
702.897.1953
f: 702.616.1859
www.designcenterwest.com

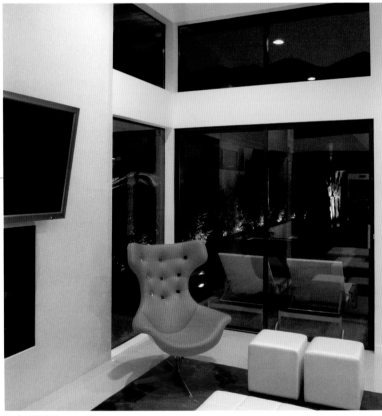

DesignARC LA, page 133

B³ Architects, page 119

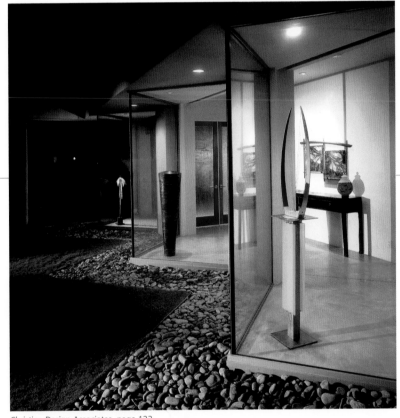

Christian Design Associates, page 123

CHAPTER TWO

PALM SPRINGS

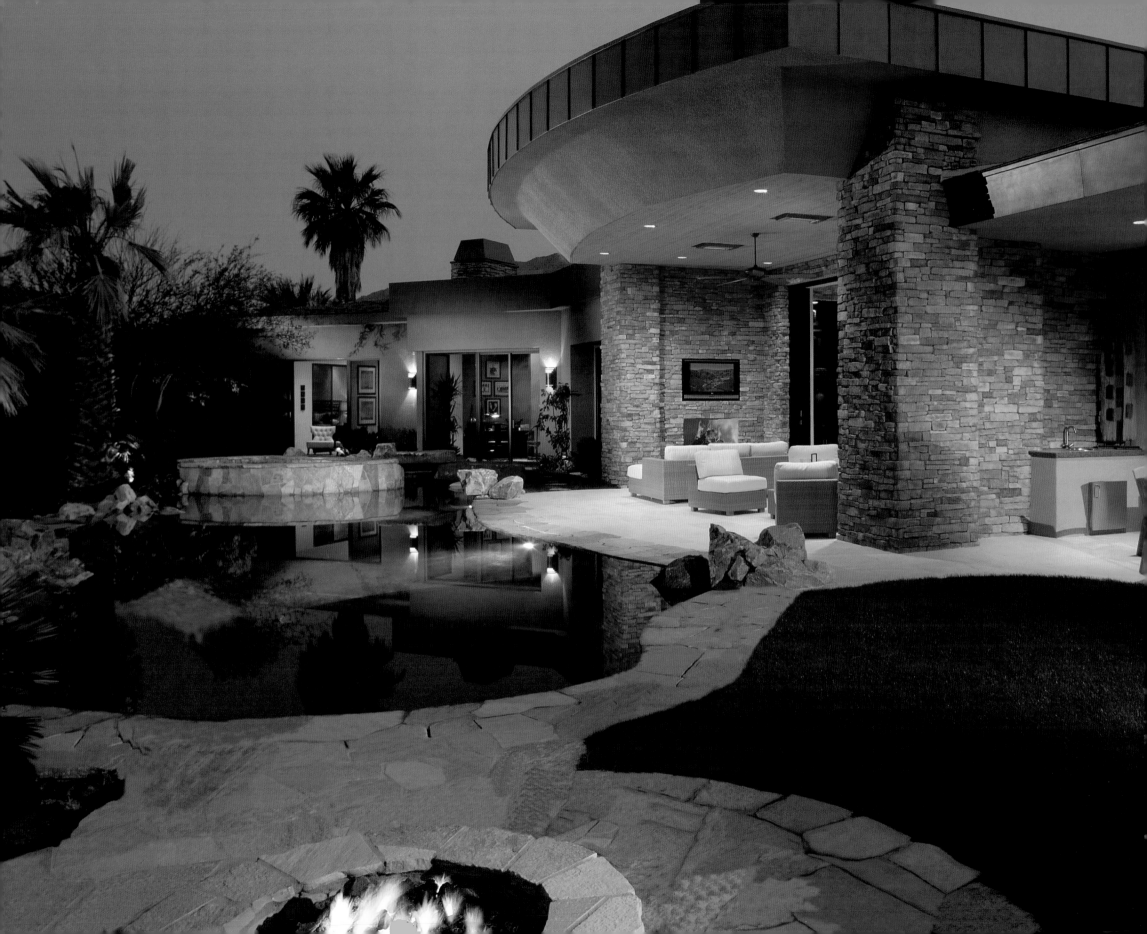

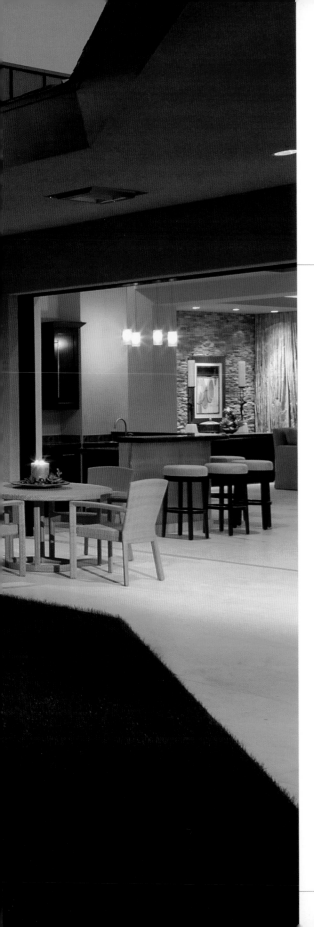

Carol Adolph
Mark Schneider

DUENDE DESIGNS, INC.
GRAYSTONE CONSTRUCTION COMPANY

Ideally the creation of a luxury custom home is the close collaboration between the builder and the interior designer. It is a fusion of concepts, craftsmanship and team effort. Grounded in this philosophy, Duende Designs, Inc. and Graystone Construction Company, together over the last few years, have created some of the most beautiful homes in the greater Palm Springs, Southern California, desert area.

The abundant sunshine and the goal to work in the luxury resort home market attracted Carol Adolph, interior designer, and Mark Schneider, custom home builder, to enjoy both professional careers and personal lifestyles in the Coachella Valley—each has celebrated 20-plus years of experience in their respective businesses.

Carol brought to the desert a wealth of experience from several years in her thriving Boston design firm. Following a calling to relocate to the California lifestyle, she expressed her enthusiasm in the name of her West Coast firm, "Duende," which when translated, means magnetic charm. A creative artist at heart, Carol is genuinely excited about a home's blank canvas as it awaits to be brought to life with warm colors, shapes, forms and the dance of light to portray a client's personality. Carol has the superb gift of interpreting individual lifestyles through her designs while incorporating comforts tailored to their

LEFT:
The modern architectural style of this residence offers the visitor both an intimate tropical oasis and expansive desert landscape.
Photograph by Ethan Kaminsky

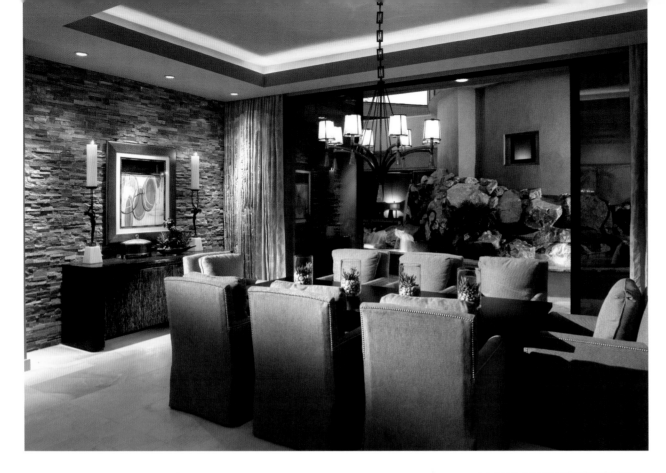

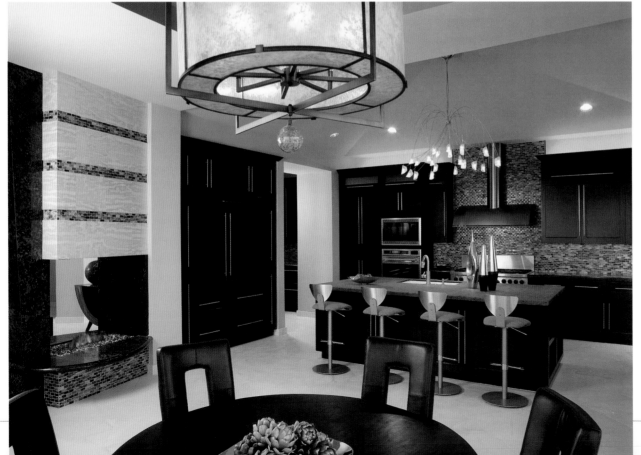

needs. Above all, she captures a client's inner spirit, as is manifested in the unfolding home of their dreams.

Mark and Carol's ambition, in every aspect of the process, is to achieve the design, quality and detail that make each home an award-winning showcase. A skillful collaborator, Mark works closely with renowned architects and expert tradesmen. Carol, his interior design partner, masterfully creates exquisite custom homes which have been featured in *Construction Today* and *Desert Homes* magazines. Mark's vast experience working for some of the most renowned companies in the country has honed his management skills to enable his firm to build residences with superior quality standards within shorter time frames and also deliver economic efficiencies.

The diverse styles they design, build, or remodel range from Tuscan to early Californian, Spanish Colonial Revival to desert modern and contemporary. These magnificent residences are located in some of the most prestigious golf club communities in the valley—The Tradition, The Hideaway, Big Horn, The Reserve, Andalusia and The Citrus, to name a few.

Carol and Mark believe ongoing communication and their synergistic relationship is the secret to success on all levels. Adhering to the highest quality standards, staying flexible and providing unwavering service beyond the client's expectations are the underlying principles behind each well-built and brilliantly designed private residence.

TOP LEFT:
The elegant yet casual dining room presents a unique experience with the beautiful sight and relaxing sounds of the outdoor waterfall in the courtyard.
Photograph by Ethan Kaminsky

BOTTOM LEFT:
The contemporary and transitional lighting treatments highlight the spacious kitchen which provides family and guests a dynamic gathering and entertaining area.
Photograph by Ethan Kaminsky

FACING PAGE TOP:
The custom paver stone circular driveway and handmade wrought-iron gate create a welcoming grand entrance to this Tuscan-style desert home.
Photograph by Ethan Kaminsky

FACING PAGE BOTTOM:
A magnificent view of the Santa Rosa Mountains can be enjoyed from the many inviting and plush seating areas of the great room, as well as the outdoor dining area.
Photograph by Ethan Kaminsky

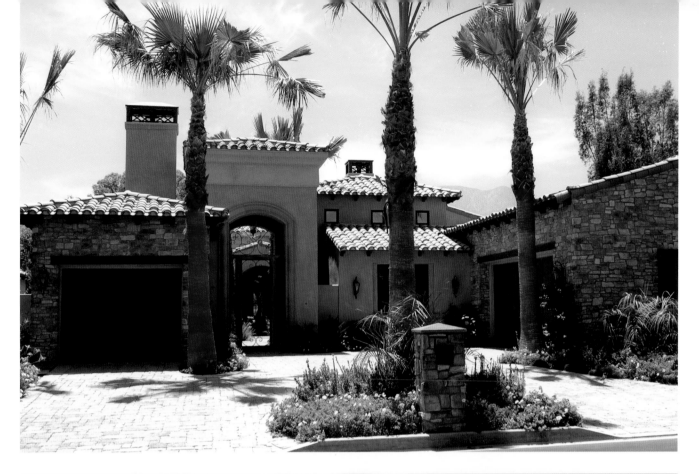

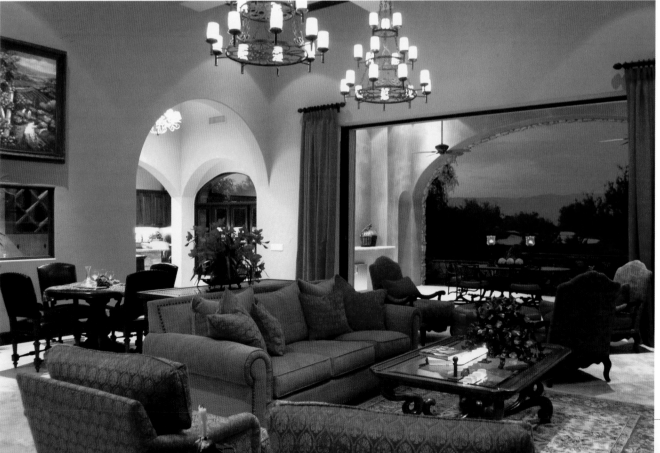

CAROL, WHAT IS THE BEST PART OF BEING AN INTERIOR DESIGNER?

Passionately using creative freedom—I'm stimulated visually by everything and keep pads of paper with me at all times to jot ideas. As a people-person, I love the client relationships, many of which become lifelong friendships.

WHAT ONE ELEMENT OF STYLE OR PHILOSOPHY HAVE YOU STUCK WITH FOR YEARS THAT STILL WORKS FOR YOU TODAY?

Carol: Keep things simple.
Mark: We don't vacillate on decisions or second guess our choices.

MARK, WHAT SEPARATES YOU FROM YOUR COMPETITION?

Working faster than our competition, we will never sacrifice luxury or high quality. Our building and interior design standards of excellence exceed our customers' expectations.

WHAT DO YOU LIKE MOST ABOUT DOING BUSINESS IN YOUR LOCALE?

Our clientele dictate the market by their lifestyle preferences in the context of the exclusive and dramatic desert valley.

DUENDE DESIGNS, INC.
CAROL ADOLPH, CID
79-770 Citrus
La Quinta, CA 92253
760.777.1422
f: 760.777.1899
www.duendedesign.com

GRAYSTONE CONSTRUCTION COMPANY
MARK SCHNEIDER
79405 Highway 111
Suite 9-414
La Quinta, CA 92253
760.564.6934
www.graystonecorp.com

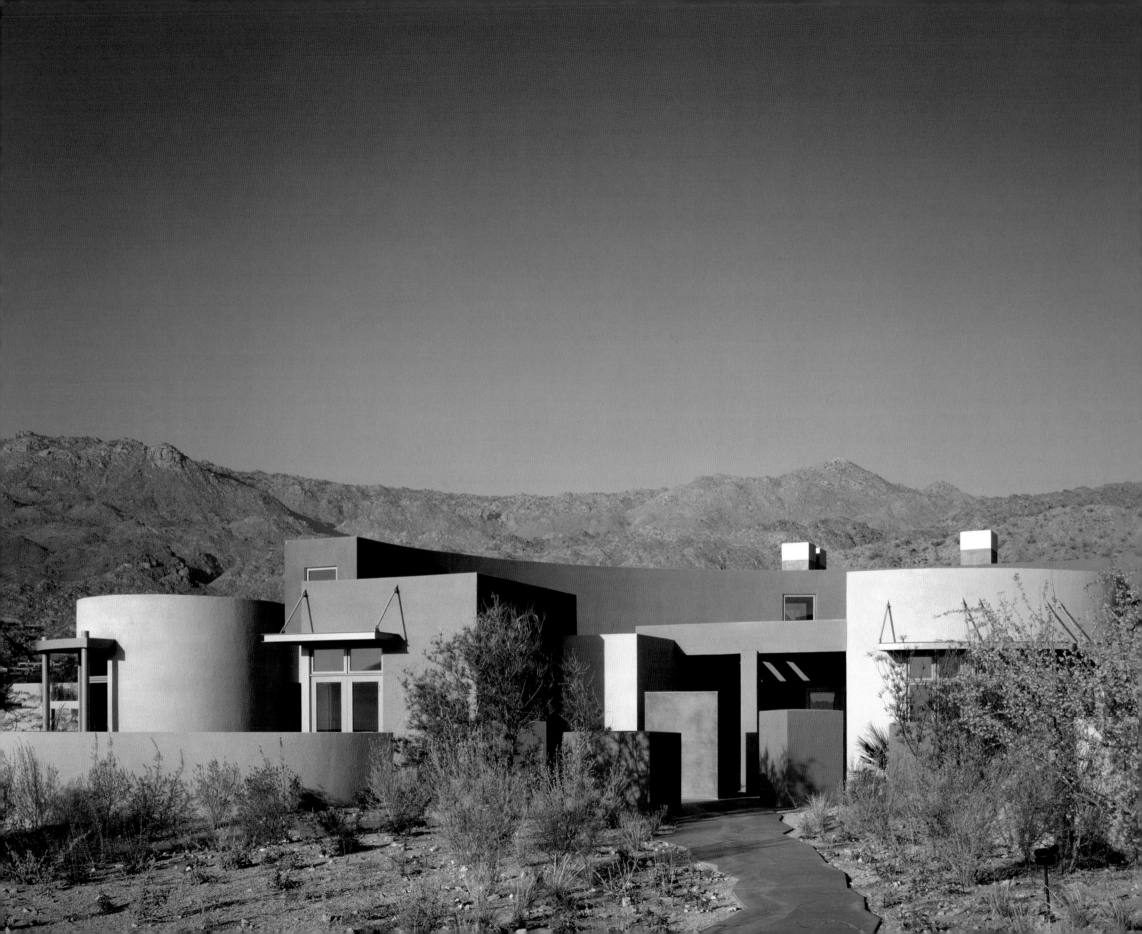

Barry A. Berkus

B³ ARCHITECTS
BERKUS DESIGN STUDIO

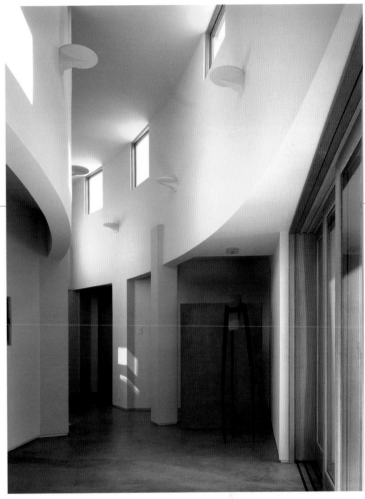

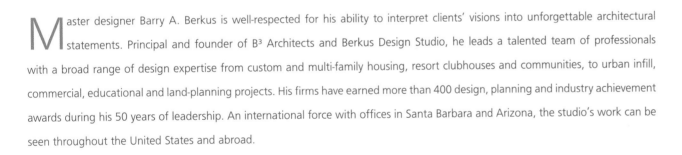

Master designer Barry A. Berkus is well-respected for his ability to interpret clients' visions into unforgettable architectural statements. Principal and founder of B³ Architects and Berkus Design Studio, he leads a talented team of professionals with a broad range of design expertise from custom and multi-family housing, resort clubhouses and communities, to urban infill, commercial, educational and land-planning projects. His firms have earned more than 400 design, planning and industry achievement awards during his 50 years of leadership. An international force with offices in Santa Barbara and Arizona, the studio's work can be seen throughout the United States and abroad.

The foundation of Barry's custom design work revolves around the refuge of home. In each architectural undertaking, he sees the potential to create a portrait uniquely designed to embrace those who reside within. The firm begins the design process by listening intently to clients and delving into their personal vision of home. Clients are then asked to write a personal account of their vision. Barry refers to this creative process as "soul stimulation," a process that allows the design to emerge in alignment with the client's aspirations and lifestyle.

Although not defined by a single architectural genre, there is something compellingly memorable about a Berkus design. Barry's work deliberately parallels art in its approach to compositional elements and the visual experience of sculptural form. He uses his

ABOVE:
The curvilinear gallery, acting as a main street connector to the destinations within, creates a central ribbon of circulation. Palm Desert, California.
Photograph by Farshid Assassi, Assassi Productions

FACING PAGE:
Color palette and geometric building forms blend this contemporary structure with its desert environs. Palm Desert, California.
Photograph by Farshid Assassi, Assassi Productions

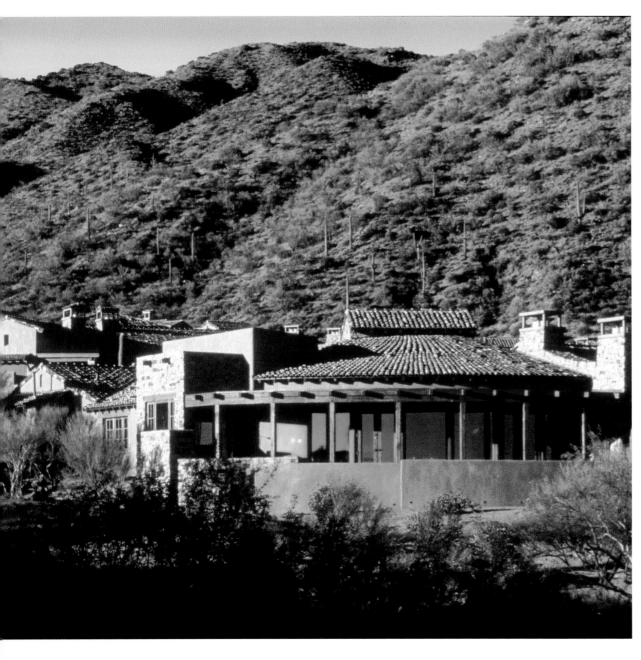

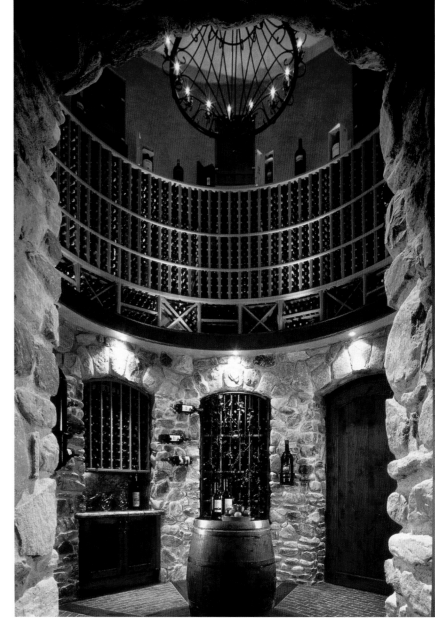

ABOVE LEFT:
Hillside villas blend seamlessly with the desert mountain terrain. Chiricahua Villas, Desert Mountain, Arizona.
Photograph by Lawrence Anderson, Lawrence Anderson Photography

ABOVE RIGHT:
The stone wine tower invites one to engage in the discovery of that within. Chiricahua Golf Clubhouse, Desert Mountain, Arizona.
Photograph by Mark Boisclair Photography, Inc

FACING PAGE:
The rotunda dining room acts as a magnet for social dialogue as well as an architectural hinge, unifying its adjacent forms. Scottsdale, Arizona.
Photograph by Peter Malinowski, InSite Architectural Photography

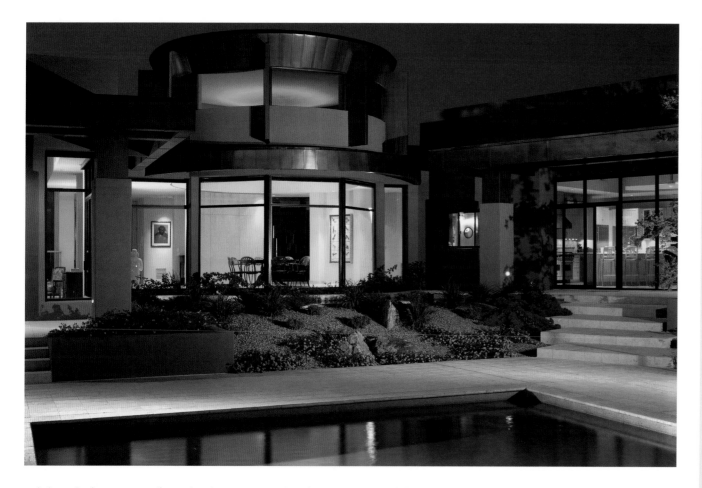

Q&A
more about barry ...

WHAT DO YOU LOVE MOST ABOUT BEING AN ARCHITECT?
I'm passionate about the creative process where ideas germinate and come to fruition—designing "art" for people to engage in, respond to and interpret. I am stimulated by learning, observing and creating architecture on a daily basis.

WHAT IS THE MOST IMPORTANT QUALITY OF RESIDENTIAL ARCHITECTURE?
Architecture should create memories; be a destination. For example, visiting a blue mosque in Turkey, quaint alleys in France or courtyards in Provence—they call to you, beckoning your return after visiting. A home should be able to do that.

WHAT IS ONE THING THAT MOST PEOPLE DON'T KNOW ABOUT YOU?
When riding my bike I have design solutions come to mind and new, exciting ideas surface. I'm a dreamer who is rewarded most by making other people's dreams come true.

artistic aptitude to create vibrant interior spaces, paying close attention to lighting, volume, massing and open space. Each element interacts with the changing patterns of light and dark throughout the day, resulting in a dynamic living environment.

In a time when entire regions seem to be sacrificing historical character to non-contextual design, it is rewarding to find an architectural practice with an unwavering commitment to acknowledging historical precedence. Abstracting from what has come before, the firm's body of work rethinks familiar traditions in a way that is meaningful to people today, enriching life's journey.

The Berkus custom residences featured on these pages pay tribute to the unique legacy of the desert region. Barry and his team of architects use authentic details and a material vocabulary that respects the context of place; modern aesthetics, clean lines and tactile finishes of adobe, massed composition of pueblo-style architecture, flat roofs with rounded corners, and other architectural detailing well-adapted to the desert climate.

His passion for building in harmony with the desert topography and nature—a complex environment filled with inspiration—is apparent in his work. The myriad moods and views of the desert landscape offer the perfect place for his contemporary and organic designs. His sensitivity to regional context, paired with his ability to turn dreams into reality through architecture, make Barry Berkus a true visionary.

B³ ARCHITECTS
BARRY A. BERKUS, AIA
2020 Alameda Padre Serra
Suite 133
Santa Barbara, CA 93103
805.966.1547
f: 805.966.1549
www.b3architects.com

BERKUS DESIGN STUDIO
Market Street at DC Ranch
Building C-110
20875 North Pima Road
Scottsdale, AZ 85255
480.473.8600
f: 480.473.2044
www.berkusdesignstudio.com

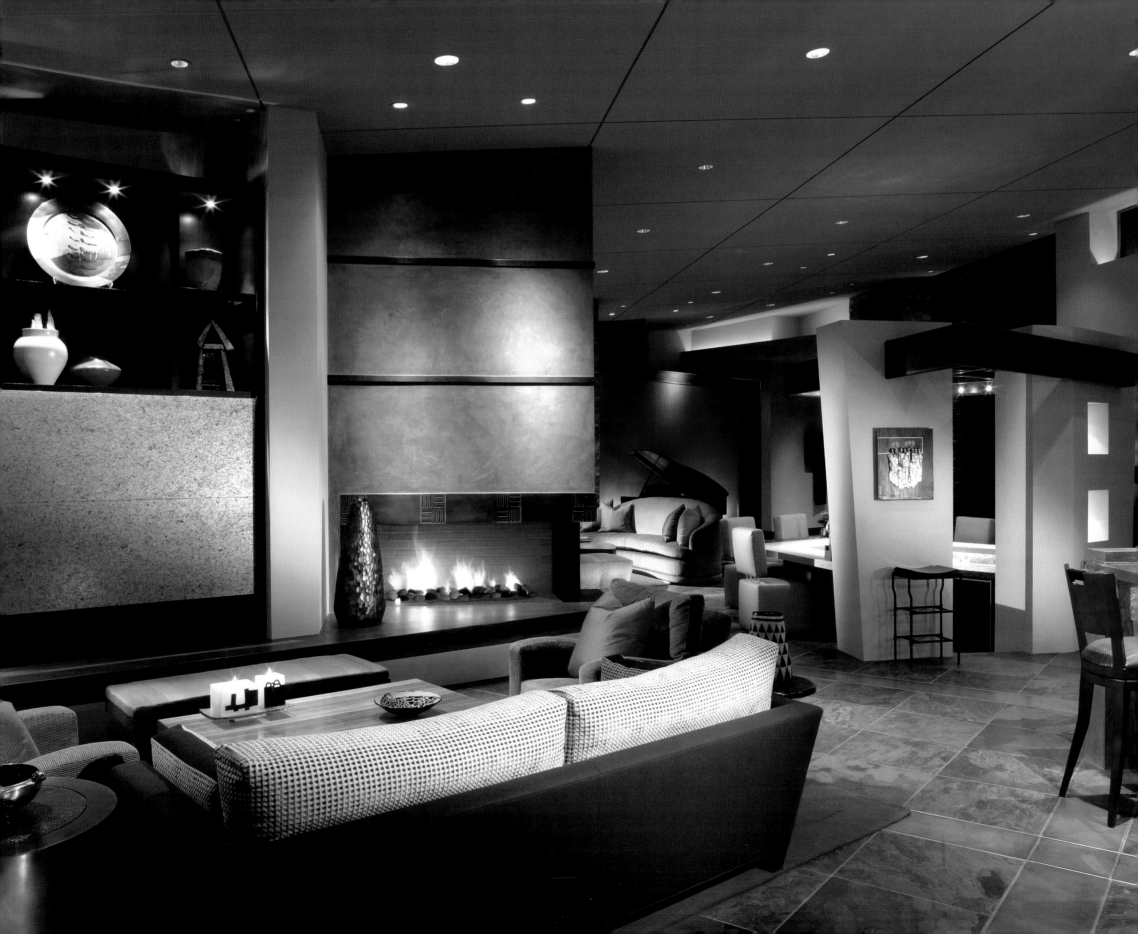

Jeanette Christian
CHRISTIAN DESIGN ASSOCIATES

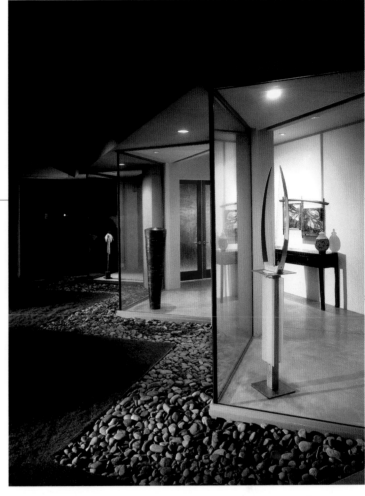

M ore than surface-deep or mere decoration, Jeanette Christian's custom residential interiors are an expression of timelessness. Since its inception, Christian Design Associates' guiding philosophy has been to provide classic designs that outlast ephemeral trends.

Each new project engagement begins with the question, "How do you want your home to feel?" And her clients appreciate the elegant, sophisticated and contemporary results. Often working in spacious vacation homes, Jeanette has mastered the art of transforming large floor plans into light and airy, yet warmly intimate spaces. She works from a varied palette, from artisan-inspired and organic designs to uncluttered, minimalist interiors.

More than 20 years ago, Jeanette apprenticed for legendary Palm Springs interior designer Joan Billings, honing her affinity for classical form under the guidance of her celebrated mentor. Now recognized as a distinguished designer by the National Council of Interior Design, with her own studio in Palm Desert, California, Jeanette seamlessly manages projects from concept to finishing touches, ensuring that the process is as tranquil and satisfying as the outcome.

ABOVE:
A hallway of glass, leading to the master bedroom, serves as an art gallery. The pebble buffer zone echoes the minimalist concept for this residence.
Photograph by Ethan Kaminsky

FACING PAGE:
Custom living room furniture is upholstered in warm, organic tones. Swivel occasional chairs provide convenient viewing of the flat-panel television, concealed behind a remote controlled panel of handmade rice paper encased in polished glass. A floating hearth transitions seamlessly from the firebox to the entertainment center. Bronze metal with artisan-inspired ornamentation accentuates the mantel facing. Twenty-four-inch squares of slate floor tiles, in groups of four, are bordered with nine-inch strips of concrete polymer, trimmed with zinc metal.
Photograph by Ethan Kaminsky

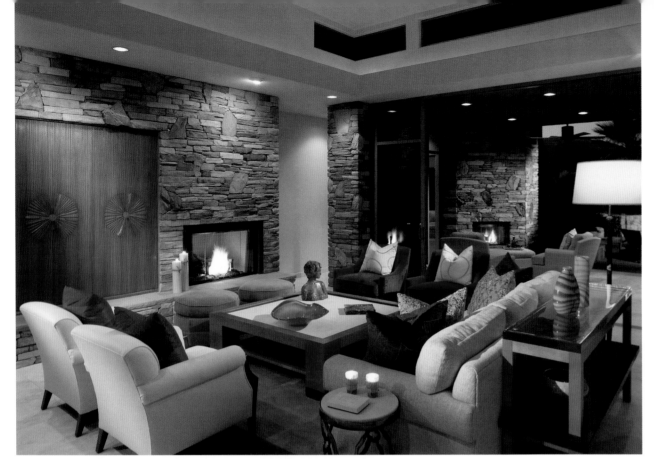

Predominantly designing for new residential projects, Jeanette collaborates with leading architects, contractors and carefully selected artisans to transform custom homes into comfortable and gracious living spaces.

Christian Design Associates' interiors grace many of the Coachella Valley's luxury golf resort communities, including Bighorn Golf Club, The Vintage Club and The Reserve. The firm has also completed projects in affluent enclaves of Chicago, Los Angeles, Montana and Cabo San Lucas, Mexico.

Today, most of Jeanette's new business comes from previous clients and their referrals—the highest compliment that can be paid for her work.

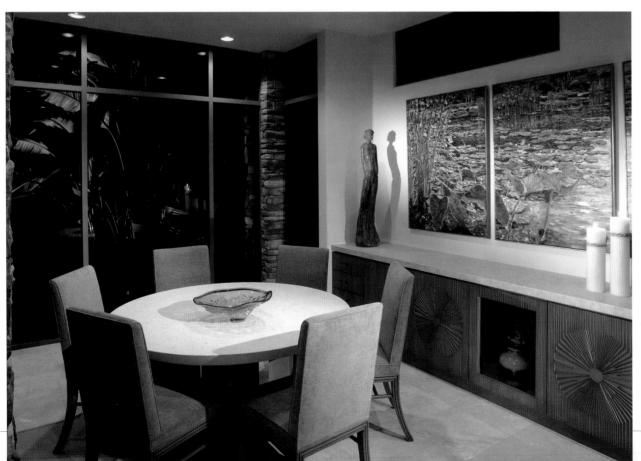

TOP LEFT:
Hand-carved doors conceal the entertainment center to create a more intimate space around the fireplace. Custom tables are made of cherry wood.
Photograph by Ethan Kaminsky

BOTTOM LEFT:
Soothing chenille fabric dining chairs and the cherry wood cabinet impart a sense of serenity. The sunburst design element is carried over from the adjacent living room cabinetry.
Photograph by Ethan Kaminsky

FACING PAGE TOP:
Jatoba (Brazilian cherry) wood surrounds the bed wall frame. Upholstered acoustic panels are covered in raw silk. Bedside lamps have aged white-gold bases and black silk shades.
Photograph by Ethan Kaminsky

FACING PAGE BOTTOM:
Honed marble flooring is framed with handset mosaic tiles. Colored concrete polymer with a zinc metal trim accents the tub face.
Photograph by Ethan Kaminsky

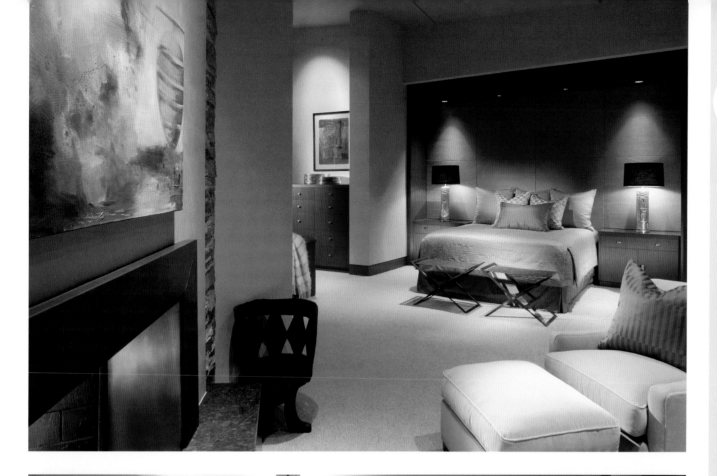

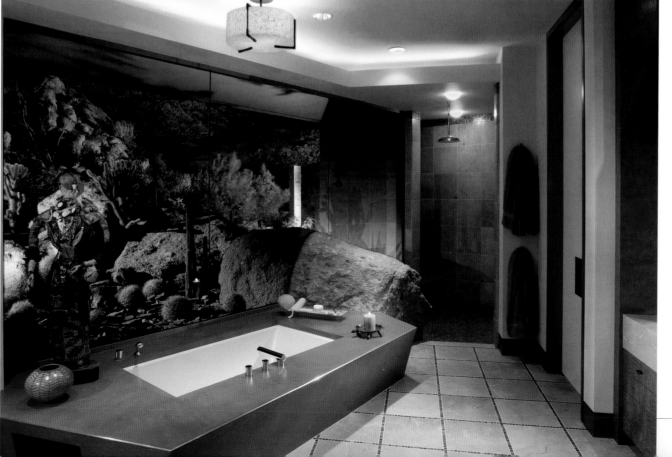

Q&A
more about jeanette ...

WHAT IS THE BEST PART OF BEING AN INTERIOR DESIGNER?
I love the whole process from first conceptual vision of the house to placement of the very last accessory. I think about projects from the inside out—including all of the architectural details, from fireplace to cabinetry and hardware—as a total cohesive space.

NAME ONE THING PEOPLE DON'T KNOW ABOUT YOU.
I am an avid hiker—I love the outdoors and I appreciate nature. My office space opens out into a courtyard so I can stay connected to the outdoors.

WHAT WOULD YOUR FRIENDS TELL US ABOUT YOU?
I enjoy cooking and entertaining friends in a casual, relaxed environment and I have a passion for music.

WHAT DO YOU LIKE MOST ABOUT DOING BUSINESS IN YOUR LOCALE?
I am delighted to work with people who come to the desert from all over the world. One wonderful client was from Japan, and although there was a bit of a language barrier, it was a fabulous custom interior design project experience.

CHRISTIAN DESIGN ASSOCIATES
JEANETTE CHRISTIAN, ASID, NCIDQ
73260 El Paseo, Suite 2-A
Palm Desert, CA 92260
760.776.8133
f: 760.776.1877
www.JeanetteChristian.com

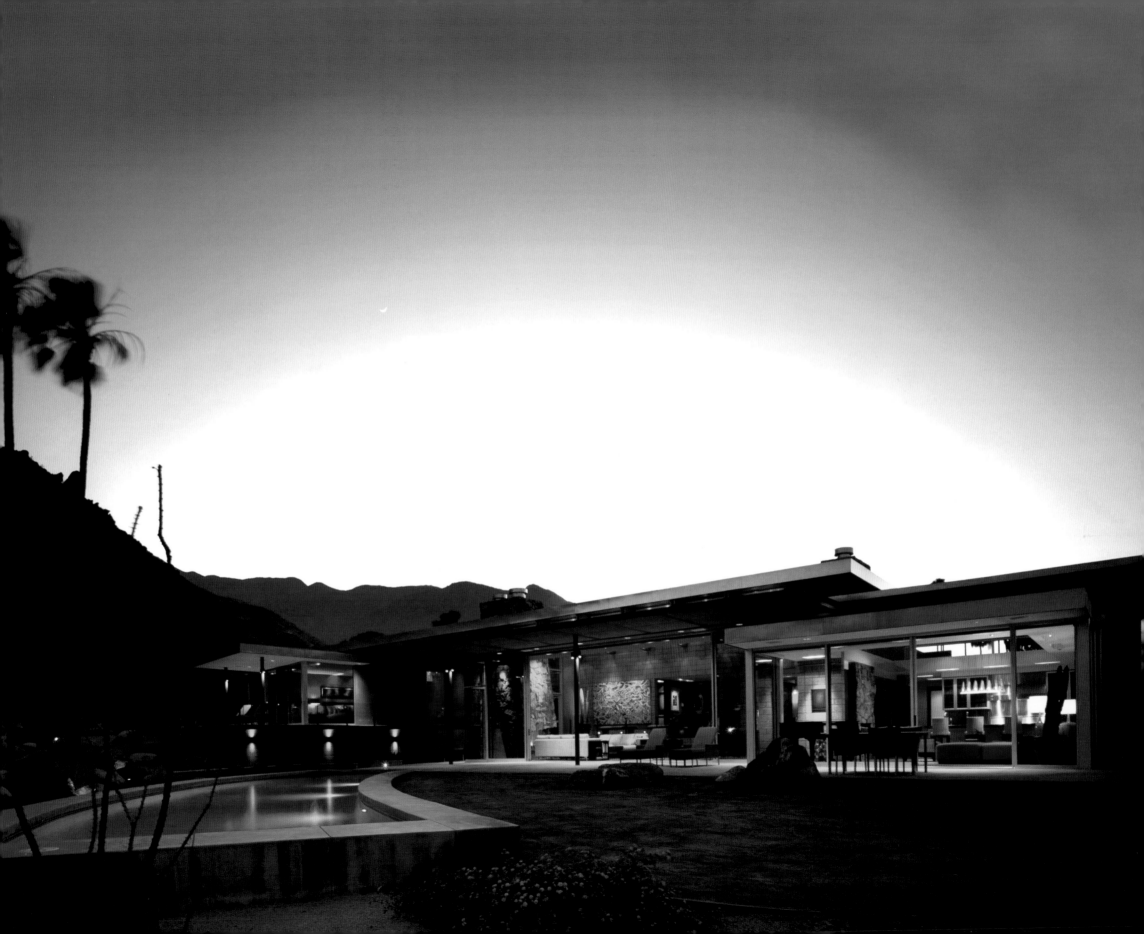

Ana Escalante
Sam Cardella
Mark Nichols
ESCALANTE ARCHITECTS

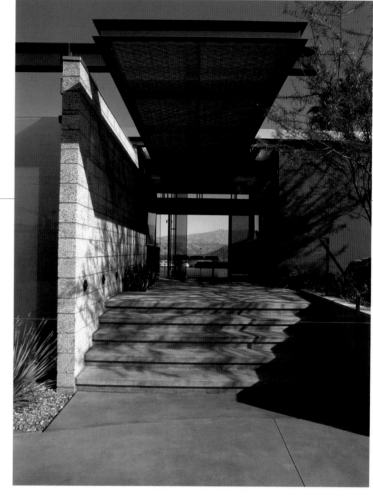

Imagine a definitive design style characterized by a technology-derived aesthetic, site specific solutions, clarity of ideas and systems integration. Enter the world of Ana Escalante, AIA—a passionate, courageous and committed architect born to design in the extreme climates. The desert and its unique climatology has always been a frontier for architectural experimentation and freedom where its raw beauty has been seductive to pioneering architects for generations. This is a place where Ana creates her modern form of architectural design characterized by non-standard solutions to unconventional and unique problems. She continues to celebrate the traditions of strong and locally unique architecture, and her designs contribute to the lineage of Neutra, Cody, Frey, Williams and Wexler.

In addition to her commitment to the design principles of these significant forebearers, Ana has been locally involved in design education, as well as community design and planning. Having moved to Palm Springs, she continues to teach at Cal Poly in Pomona. Ana has also lectured on her work and the architectural treasures of the Coachella Valley, including a 2005 public lecture at the Palm Springs Art Museum's Architecture and Design Council Lecture Series.

A native of El Salvador, Ana is a graduate of California State Polytechnic University and received a Master of Architecture degree in 1991. Her seven-person firm has become an institution in Palm Springs since she opened the practice more than 13 years ago.

ABOVE:
The perforated shade canopy and masonry wall accentuate the indoor/outdoor feeling while extending into the front entry and framing the desert view.
Photograph by David Glomb

FACING PAGE:
Glass facades—through which the home's spatial arrangement is seen—seamlessly capture the primal beauty of the desert landscape.
Photograph by David Glomb

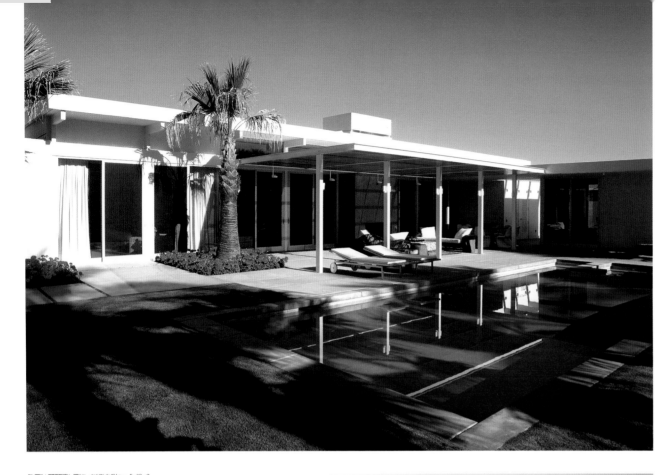

Only sound architectural projects stand the test of time because the nature of the desert is so unforgiving; the body of work created in the mind's eye of Ana and her associate architectural team exemplify this truth. With a tireless work ethic, Ana is an architect who follows her heart and intuition. Most of all she believes success in life is dependent on four qualities: courage to commit, personal sacrifice, the will to endure and belief in the self. The firm is built around this powerful philosophy.

This is also a place where a gifted interior designer, Sam Cardella, who often collaborates with Ana, creates simple and functional spaces. He is an interior designer with a clear Miesian influence apparent in his spare yet luxurious design aesthetic. He observes and refines every detail, line, form and shape; weaving all into an uplifting environment of sensuality, drama, understated elegance and distinction. Sam is a professional interior designer and liaison who has adeptly engaged Ana's architectural genius on behalf of his well-respected clients.

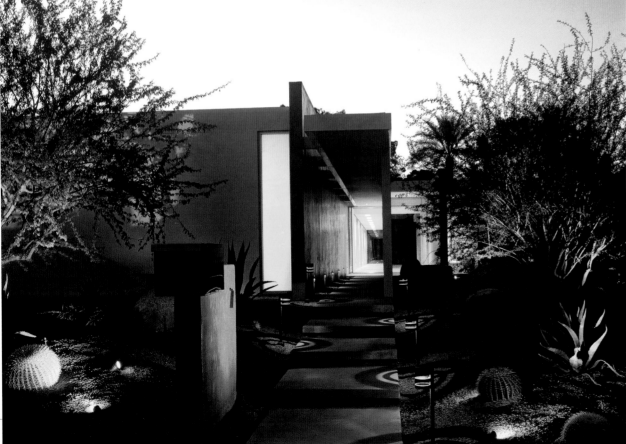

TOP LEFT:
This home is placed on the site to take advantage of the climatology of the region while preserving boundaries of the current energy codes. Light effects are enjoyed poolside and in the lounge area with fireplace. Interior design by Sam Cardella.
Photograph by David Glomb

BOTTOM LEFT:
An evening view of the street façade emphasizes the circulation spine around which the architectural spaces are woven, to create seamless indoor/outdoor relationships, claim the site views and water features. Landscape design by Marcello Vilano.
Photograph by David Glomb

FACING PAGE LEFT:
A daylight view of the minimalist dining area looks into the spacious main foyer and main hall connected to the guest wing. Interior design by Sam Cardella.
Photograph by David Glomb

FACING PAGE RIGHT:
For added privacy while entertaining, custom shoji sliding doors conceal the dining and great room area from the open kitchen plan creating an intimate ambience. Interior design by Sam Cardella.
Photograph by David Glomb

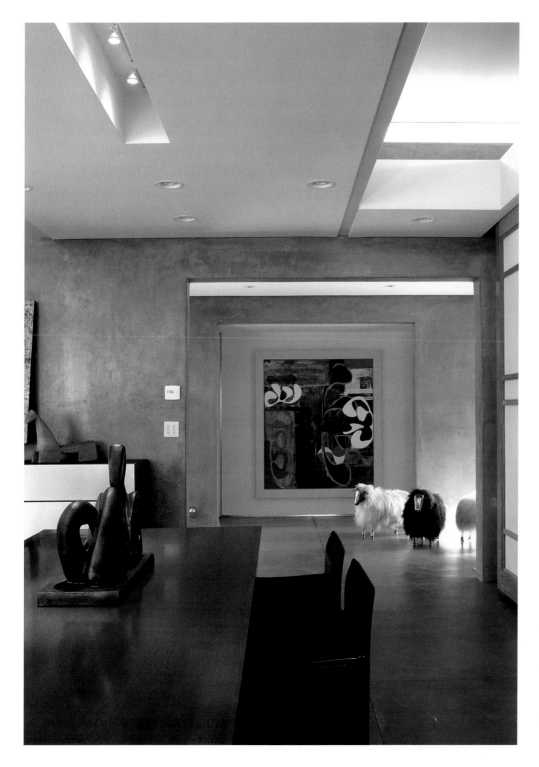

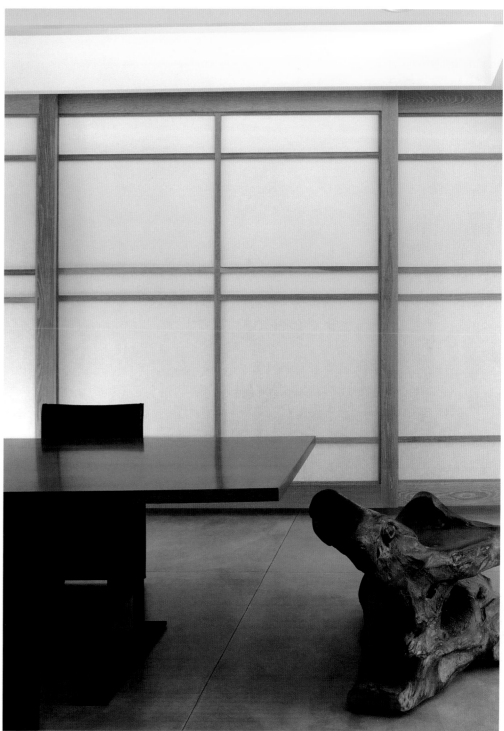

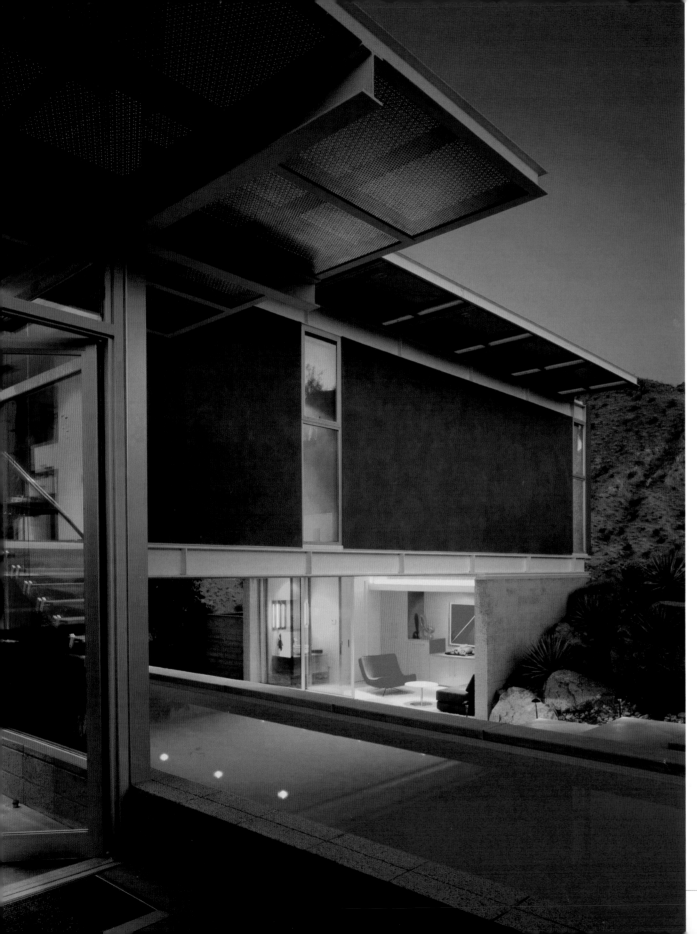

Ana also works with accomplished modern interior designer Mark Nichols who shares her progressive aesthetic sensibility—incorporating eco-friendly elements, soft color palettes, textures reflecting the region and natural influences which give a special quality to her geometric, airy, modernistic architecture. This Palm Springs alliance of Ana, Sam and Mark is a powerful creative union and a dynamic force in the desert's unique residential design market. The Escalante firm's brand of architecture is built on modern core principles; known for works of steel, glass and concrete masonry, these sculptural and often sustainable residential designs emphasize the indoor/outdoor relationship maximizing site views and bringing water features inside the space.

The Escalante team consists of Ana, principal and founder, two fellow architects and five architectural designers with diverse expertise. The firm collaborates with clients who are on the forefront of exploring new architectural ideas and provides professional design services ranging from residential to commercial projects, public, large-scale building design and campus planning. Ana was selected by AIA as one of the industry's top talents, and Top Ten Architects to Watch in California. Escalante Architects has been featured in *Architectural Record*, *CA-Modern*, *Metropolitan Homes*, *Palm Springs Life*, *Los Angeles Times* and *California Home & Design*, to name a few. Producing award-winning design work, the firm has reached a new pinnacle with architectural projects exhibited in the A + D Museum in Los Angeles under the New Blood/New Gen Exhibit, and Ana has lectured widely about her work.

LEFT:
This 3,500-square-foot residence is designed around a 25-meter lap pool sunken into the ground. The interior room features custom casework by Mark Nichols, fabricated by AGAN Woodcrafters using ABET LAMINATI decorative laminates. Designer furnishings by Ligne Roset and APT NY. Acrylic painting by Frank Sinatra.
Photograph by David Glomb

FACING PAGE TOP:
Windows allow a view of the pool showcasing the blue water to create an indoor/outdoor atmosphere. The custom sofa design is by Mark Nichols, fabricated by Berman-Rosetti. Custom casework by Mark Nichols of formaldehyde-free bamboo and fabricated by Desert Woodline.
Photograph by David Glomb

FACING PAGE BOTTOM:
This project carves back into the site, and hovers over it, in order to restore its original dramatic topographical mountain features. The Green-inspired serene bedroom uses formaldehyde-free bamboo flooring by Bamboo Mountain. Interior design by Mark Nichols. Oil painting by Kathryn Henneman.
Photograph by David Glomb

Highly regarded as a practicing architect, Ana is also a respected university professor at Cal Poly Pomona. She has been published, conducts lectures and proudly imparts her knowledge and experience with eager architecture students. Her article, "Indigenous Architecture in the Coachella Valley," a research paper funded by the College of the Desert Foundation, speaks of her incomparable understanding of architecture in relation to the unique desert region.

Beyond architecture, Ana is the secretary of Aim for the Restoration of Hope in Uganda, East Africa——a charity that cares for orphans and widows of the AIDS epidemic in the region. She lends her skills as an architect to building schools, clinics and other projects, in addition to her beloved fundraising efforts.

Driven by her pioneering spirit and design aesthetic, multi-dimensional Ana strives for holistic balance in all areas of life. She is an avid endurance runner who expends her boundless energy only to fill herself again with the next creative challenge.

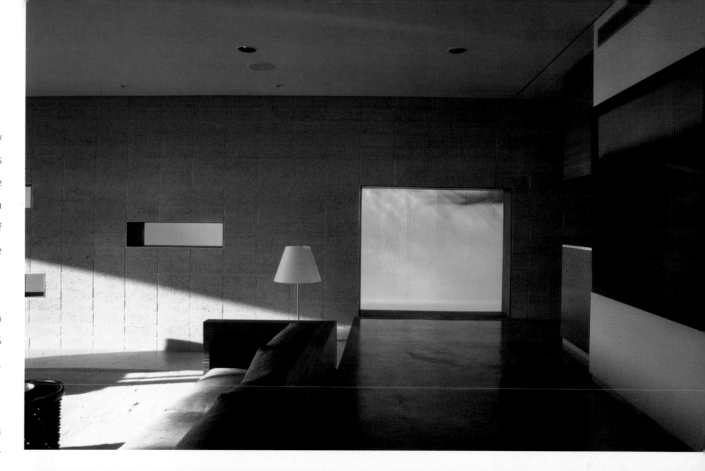

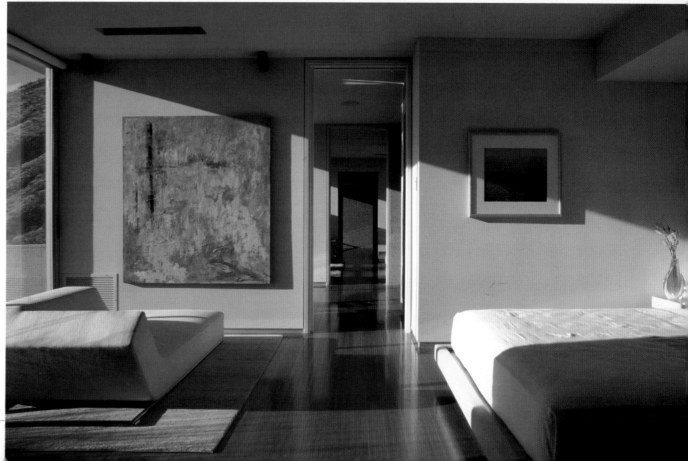

ESCALANTE ARCHITECTS
ANA ESCALANTE
121 South Palm Canyon Drive
Suite 222
Palm Springs, CA 92262
760.323.1925
f: 760.320.7897
www.escalantearchitects.com

CARDELLA DESIGN
SAM CARDELLA
760.324.7688
www.cardelladesign.com

MODERN INTERIORS
MARK NICHOLS
760.864.1747
www.marknicholsinteriors.com

Mark Kirkhart
Dion McCarthy
DESIGNARC LA

DesignARC was originally founded in Santa Barbara in 1976 as Design Works. In its 30 years of existence, the firm has developed into a leading architectural practice, with 40 professionals specializing in custom residential, commercial and institutional design throughout California, and with thriving studios in both Santa Barbara and Los Angeles. The Los Angeles office opened its doors in 1994, co-founded by principals Dion McCarthy and Mark Kirkhart.

Focusing its regional expertise on working within California's varied climate, the firm houses an eclectic practice, desiging an enviable range of projects of all scales and scopes. With the aim of producing a design firmly rooted to its place, the firm begins each new project with a comprehensive exploration of the site, often visiting it on numerous occasions, during different seasons and at various times of the day, to gain a thorough understanding of its unique qualities. According to Dion McCarthy, "Architecture emerges from a recognition of the site's inherent features through the lens of design. When we are able to better see the essential nature of the site because of our work, then we know we've been successful."

The many microclimates of California's desert, mountain and coastal regions have given distinct form to DesignARC's approach to design. Given the possibility of nearly year-round outdoor living in most parts of the state, a principal concern of the firm is creating

ABOVE:
Each two-story home in the multi-family development 48@Baristo embraces its exclusive outdoor courtyard and pool. Large expanses of glass are able to pocket away, creating a seamless relationship between interior and exterior.
Photograph by Benny Chan, Fotoworks

FACING PAGE:
An architecture of sharp geometries and incised lines resolutely affirms strong desert light. Apertures are cut into volumetric forms for specific mountain views.
Photograph by Benny Chan, Fotoworks

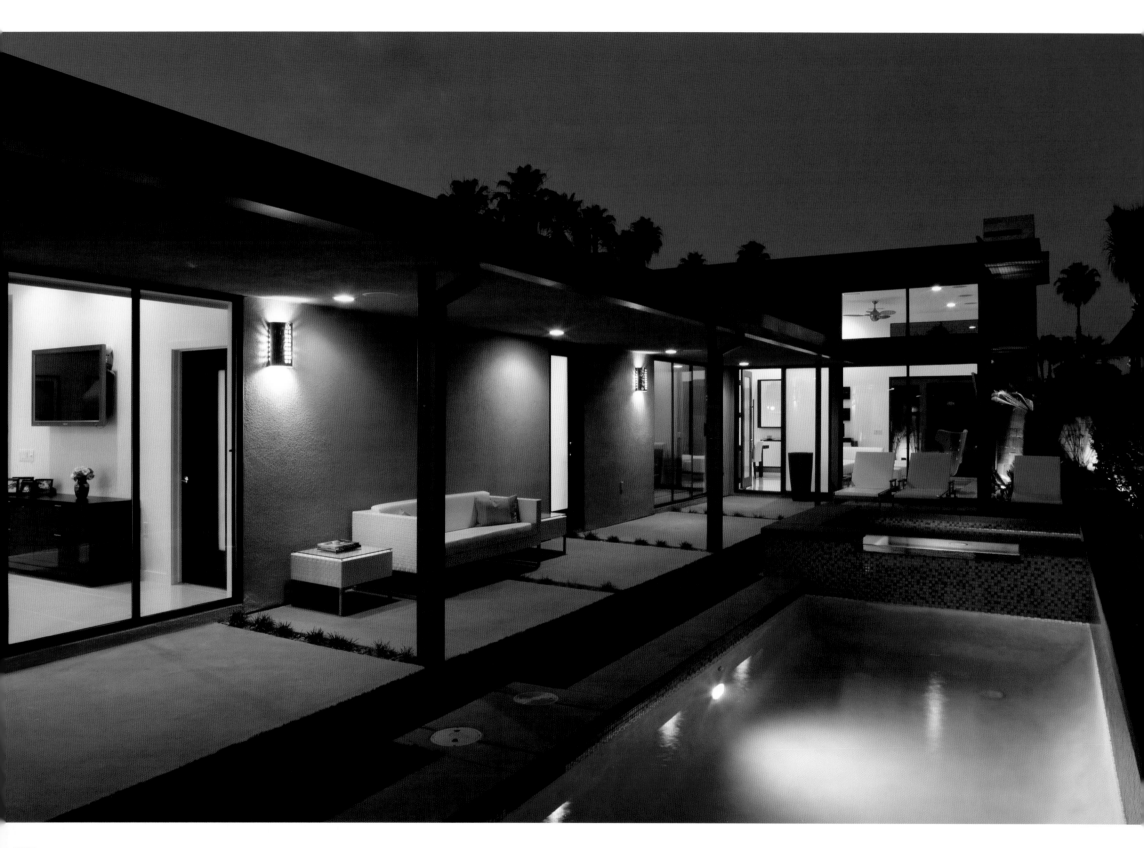

a strong relationship between the indoors and the outdoors. When working in desert climates, careful consideration is given to providing protection from the sun's intensity. Deep recesses, overhangs, clerestory windows and optimum building orientation combine to provide this protected environment, while also serving to frame the often breathtaking desert vistas. Another characteristic of DesignARC's desert design is the creation of private courtyards adjoining major living spaces, which provide an individual sense of shelter. When combined with public areas for relaxing and entertaining, these spaces offer privacy and refuge, as well as stimulation and excitement.

As a pioneer in the field of sustainable architecture, the firm utilizes a number of well-known Green strategies in all of its work, but the climatic extremes of the desert render these strategies a necessity. Accordingly, DesignARC works with passive solar elements such as thermal mass and thermal lag, large roof and window overhangs for shade, and appropriate landscape design to reduce energy usage. The firm also employs the latest building products, including toxin-free engineered materials, structural insulated panels, and low VOC paints and finishes, all of which reduce waste and add to the building's overall efficiency. By incorporating innovative sustainable design strategies on a number of high-profile projects, the firm aspires to educate the public about Green thinking, and to increase awareness of its environmental benefits. "Making Green ideas the heart of every project is based on our understanding

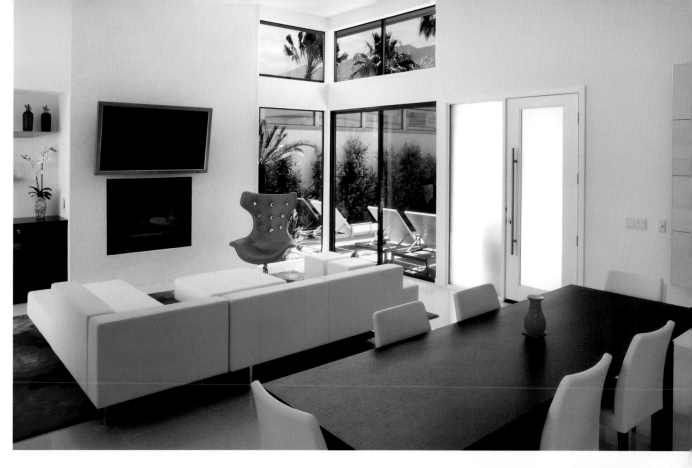

TOP RIGHT:
Part of an ongoing tradition of modern design in the City of Palm Springs, the Biltmore Colony homes strive to embody the essence of desert living, and a certain minimalist ideal.
Photograph by Ciro Coelho, Ciro Coelho Photography

BOTTOM RIGHT:
A neighborhood of 19 single-family homes located in the heart of Palm Springs, the Biltmore Colony takes its place among a rich architectural landscape of modern design.
Photograph by Ciro Coelho, Ciro Coelho Photography

FACING PAGE:
Dwellings in the desert have always sought to merge indoor and outdoor living. Here, all livable

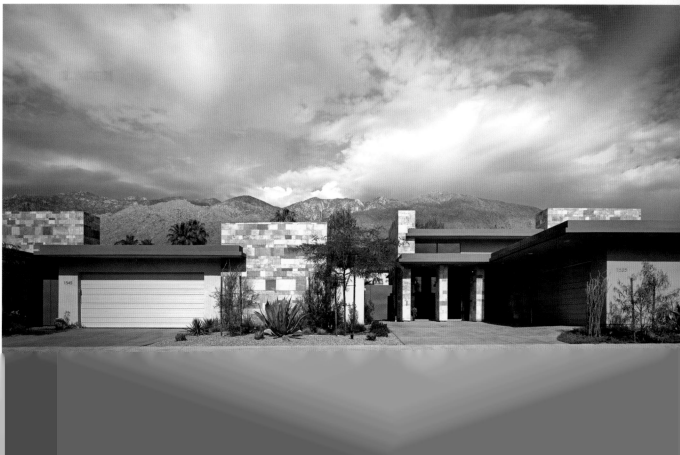

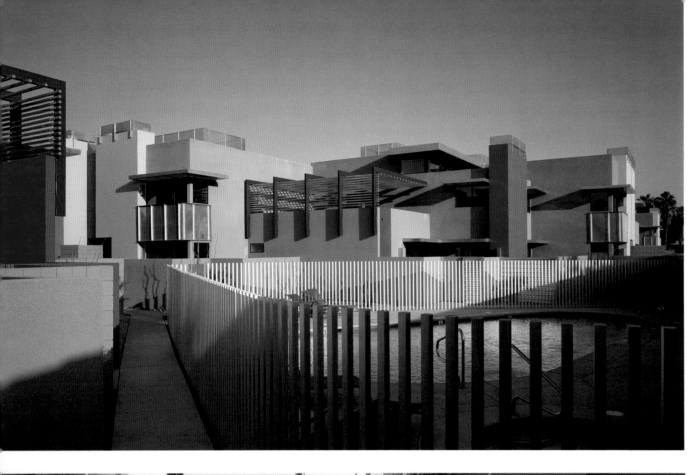

that energy is precious," explains Mark Kirkhart. The firm believes that all good design recognizes the wisdom of how the environment and design are related.

DesignARC has won numerous state and national awards, including "Green Awards," for its varied projects. Most recently, the firm earned a California AIA award for a suite of housing projects in Palm Springs on the theme of desert living. It is DesignARC's emphasis on understanding each project and the relation to its place, as well as using innovative and proven sustainable technologies, that has become a hallmark of the firm's success.

TOP LEFT:
At 48@Arenas, pools with spas punctuate the gaps between the multi-family buildings, allowing plentiful southern and western exposure for sunbathing. Color was chosen to echo the surrounding desert hues, and to complement this characteristically Californian landscape.
Photograph by Benny Chan, Fotoworks

BOTTOM LEFT:
Double-height living spaces and clerestory light monitors are prime amenities, allowing generous living spaces infused with natural light.
Photograph by Benny Chan, Fotoworks

FACING PAGE:
The ever-present sun and rugged terrain of Palm Springs has given distinctive form to the architecture, as well as life, in the desert. No matter the manifestation, a dwelling in the desert must embody progressive strategies—while working to preserve its modernist tradition.
Photograph by Benny Chan, Fotoworks

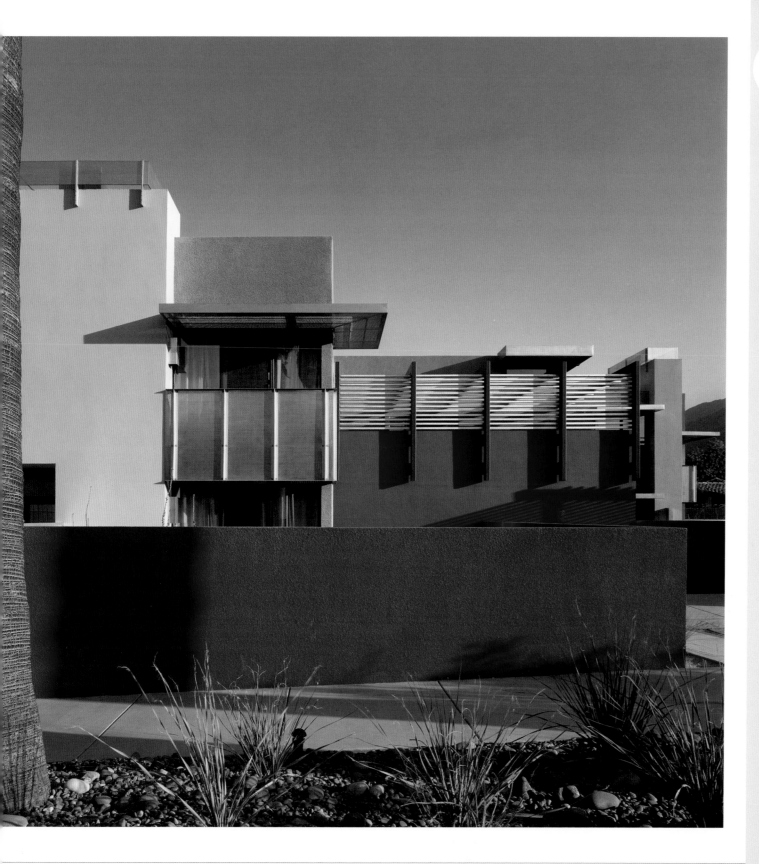

more about mark & dion ...

WHAT DO YOU LIKE MOST ABOUT DOING BUSINESS IN YOUR LOCALE?

Working within the nuanced climate of California's various deserts. We're doing housing projects in the low desert of Palm Springs, and several homes in the high desert above Joshua Tree National Park. Working in these very different deserts is both exciting and educational for us.

DION, WHO HAS HAD THE BIGGEST INFLUENCE ON YOUR CAREER?

While I've had the good fortune to study under several great teachers in school and also worked for a number of exemplary design firms, my partner and colleagues at DesignARC have had—and continue to have—the greatest influence on me.

MARK, WHAT SINGLE THING WOULD YOU DO TO BRING A DULL HOUSE TO LIFE?

I would try to establish an emphatic connection between the major indoor spaces of the house and the outdoors, via the creation of a series of courtyards and patios. Then I would throw a party in the house.

WHAT IS THE HIGHEST COMPLIMENT YOU'VE RECEIVED PROFESSIONALLY?

Probably when we were asked to design a second (and then a third) home for a client. We feel we've done something right if we're invited back for future work.

DESIGNARC LA
MARK KIRKHART, AIA
DION MCCARTHY, AIA
2558 Overland Avenue
Los Angeles, CA 90064
310.204.8950
f: 310.204.8959
www.designarc.net

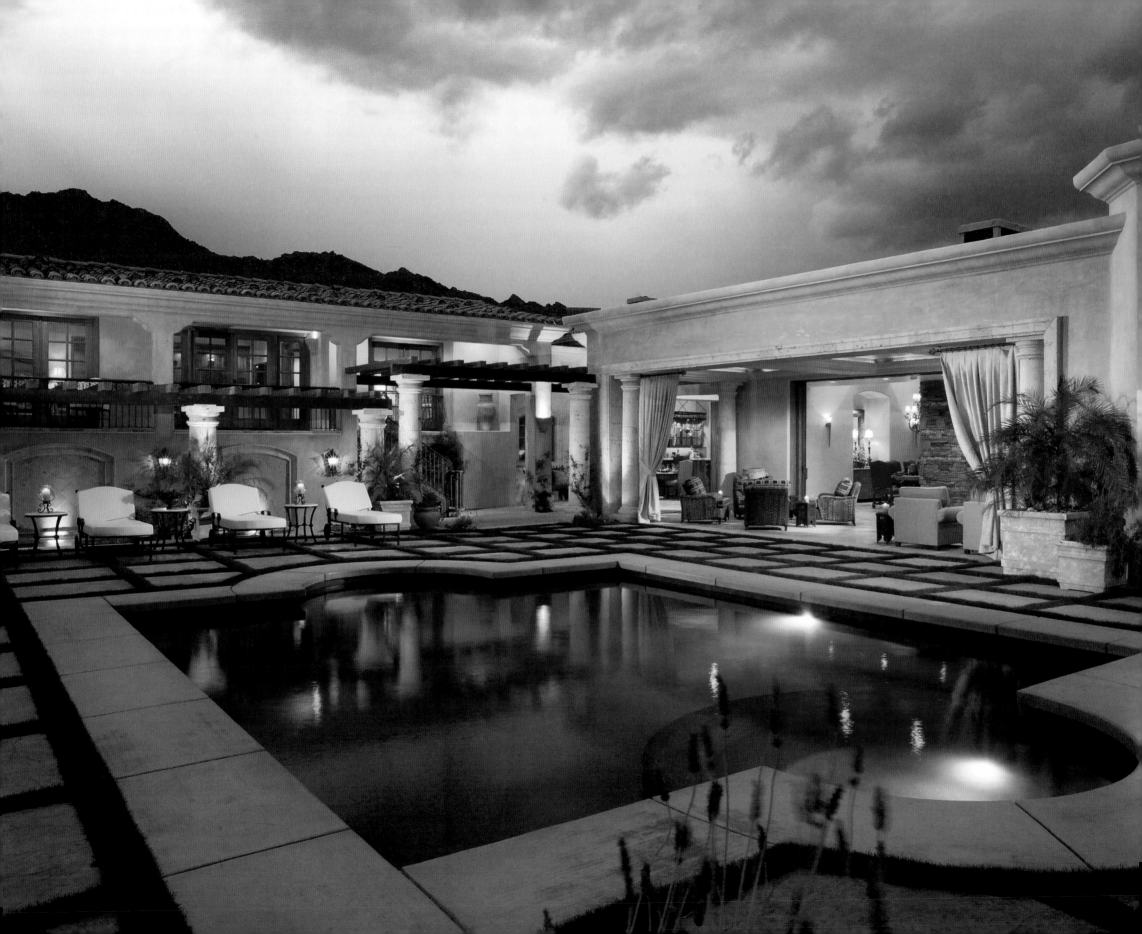

Bill Miller

WILLIAM MILLER DESIGN

Impeccable taste and attention to detail is the hallmark of William Miller Design but Bill Miller's signature "comfortable luxury" is the unwritten promise that clients have come to expect. The Coachella Valley's premier interior design firm was founded in 1995 with the mission of becoming one of the most creative and approachable residential and commercial interior design studios—the mission has been accomplished.

With an affinity for designing from the "inside out," Bill's philosophy is based on his formal education: He received his Bachelor of Science degree from Arizona State University studying both interior architecture and public relations. This highly inventive founder and principal applied his professional training and more than 25 years of practice to establish one of the desert's most coveted interior design firms.

Renowned for his soft-edged Contemporary and Mediterranean styles suited to Country Club Row's gated residential golf communities, Bill's interior designs boast a neutral palette of colors and textures. His discerning use of fine art and architectural details adds color and originality to each interior canvas. A collaborative designer, he begins the process meeting with the client, builder and architect so as to contribute to the level of details early on. The team works together throughout the project to create the

ABOVE:
Taking full architectural advantage of the beautiful climate, this dining room was designed to accommodate indoor/outdoor activity. Bighorn Golf Club, Palm Desert, California.
Photograph by Charles White

FACING PAGE:
The courtyard area of this Tuscan-style residence sets an amazing poolside ambience with luxurious indoor/outdoor living in Palm Desert, California.
Photograph by Ethan Kaminsky

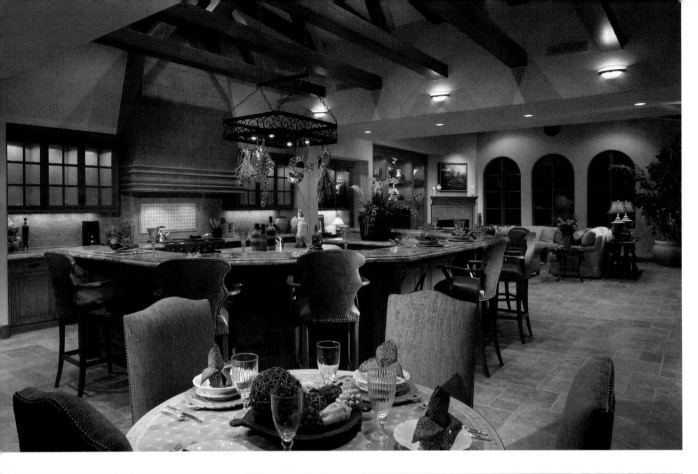

client's vision, be it a magnificent fireplace design or interesting wall niches, and also to implement custom work such as lighting design, milled cabinetry and placement of interior architecture throughout the project. Clients convey a positive experience because the results they envision become reality: "It is exactly what we wanted." Bill attributes this sure success to listening to dreams, needs and desires while leaving his own ego at the door.

Accessories and artwork speak to the personality of the home, reflecting those who live within—Bill's interiors meld architecture with possessions to paint a portrait of the residents. Born in the San Francisco Bay area, he has always had

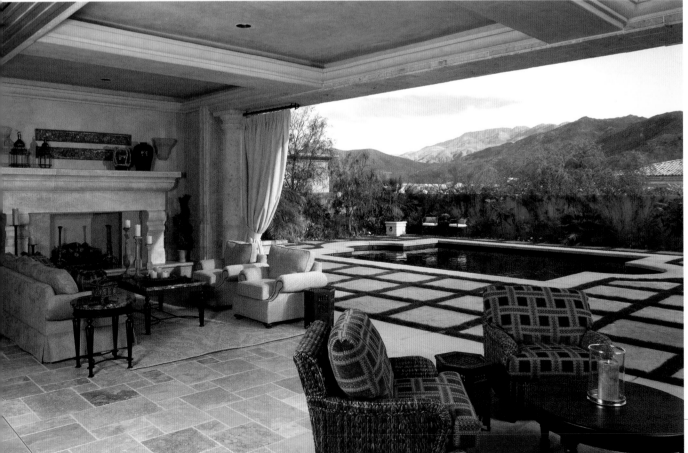

TOP LEFT:
Commanding wood ceiling beams enhance the character of this great room and custom kitchen.
Residence at Bighorn Golf Club, Palm Desert, California.
Photograph by Ethan Kaminsky

BOTTOM LEFT:
All the convenience and beauty of the indoors translates seamlessly to this outdoor living room area.
Custom residence at Bighorn Golf Club, Palm Desert, California.
Photograph by Ethan Kaminsky

FACING PAGE:
This outdoor dining room and living area boasts a dramatic view overlooking the 18th hole of the golf course at Bighorn, Palm Desert, California.
Photograph by Charles White

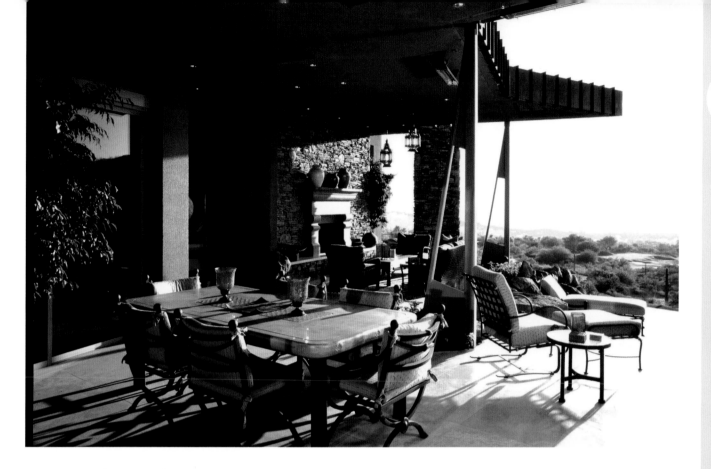

an appreciation for outdoor living and he works to utilize outdoor spaces to their best advantage in his designs. Television viewing areas with group seating, spacious entertaining spaces with fireplaces for dining al fresco; outdoor gourmet kitchens and barbecue areas are his specialty and a seamless extension of the living area.

A true consultant, Bill passionately gets involved in the exterior and material selection to ensure that the interior flows with the exterior architectural design on each new construction project, underscoring the team approach. His remarkable interiors have graced the pages of publications including *California Homes, Palm Springs Life, Boating International* as well as the coffee-table book entitled *Stone Style*, which demonstrates the beautiful, artistic use of stone in interior design.

Q&A more about bill ...

WHAT IS THE BEST PART OF BEING AN INTERIOR DESIGNER?
Keeping abreast of the newest materials, styles and trends: I travel to Italy and Europe for inspiration. The variety of clients makes every job unique and different, non-repetitious. I look forward to where the home will be located and the personal needs of each client. Creative, rewarding, difficult and challenging are words that describe my profession, and I love it all!

WHAT DESIGN PHILOSOPHY HAVE YOU STUCK WITH FOR YEARS THAT STILL WORKS FOR YOU TODAY?
My designs are classic and define "comfortable luxury." A home should be more than utilitarian, it should be approachable for everyone. My designs are sophisticated enough for a couple's intimate dinner party and, at the same time, are completely livable for active children, grandkids and visiting guests.

NAME ONE THING THAT PEOPLE DON'T KNOW ABOUT YOU.
I have an 18-pound pedigreed Maine coon cat named Spike and a new kitten—the oldest breed of cat originally from England.

WHAT DO YOU LIKE MOST ABOUT DOING BUSINESS IN YOUR LOCALE?
The California desert resort areas provide a perfect opportunity for creative expression—the ultimate creative freedom. Most homes are second and third residences where people enjoy playing golf and tennis. The clients are more relaxed at this phase of their lives so they are more open-minded about exploring design options.

WILLIAM MILLER DESIGN
BILL MILLER
42575 Melanie Place, Suite C
Palm Desert, CA 92211
760.836.9199
f: 760.836.3629
www.williammillerdesign.com

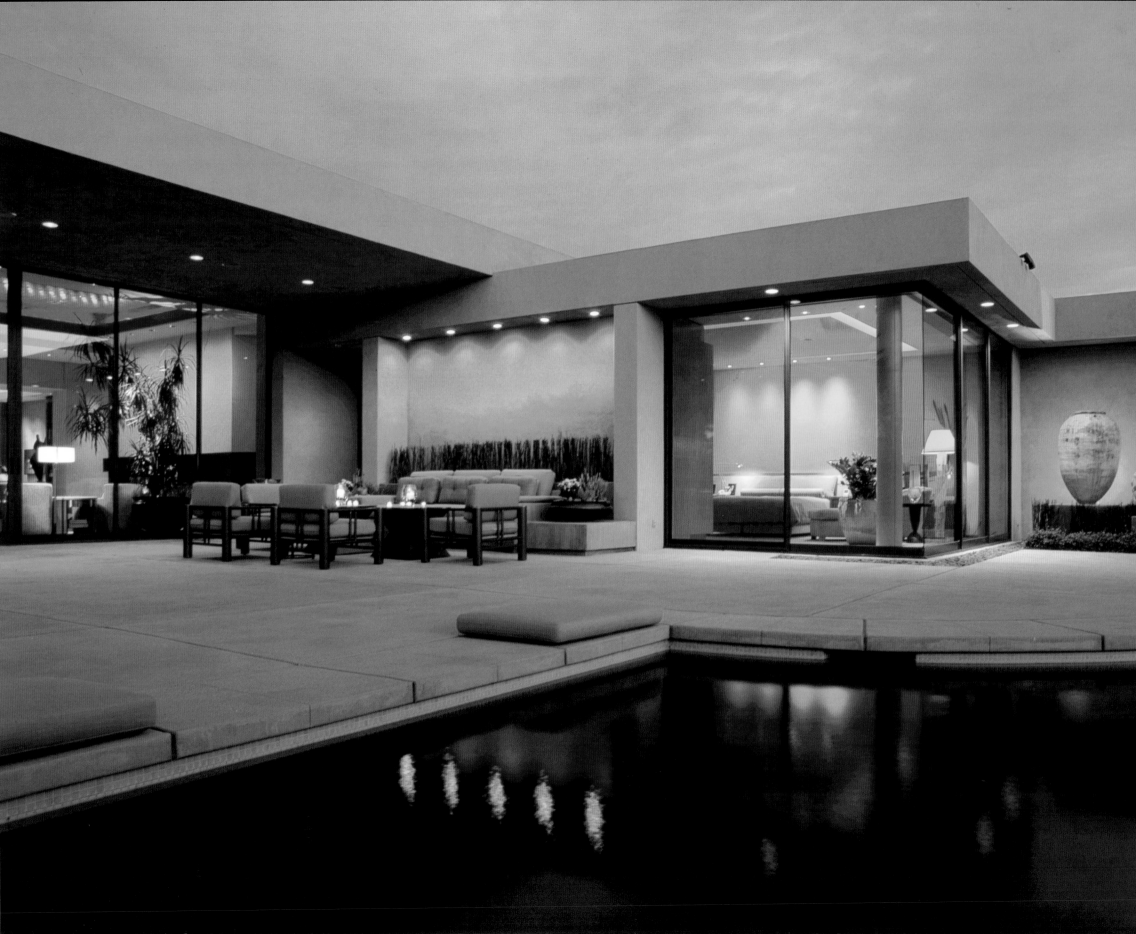

Randy Patton
PATTON DESIGN STUDIO

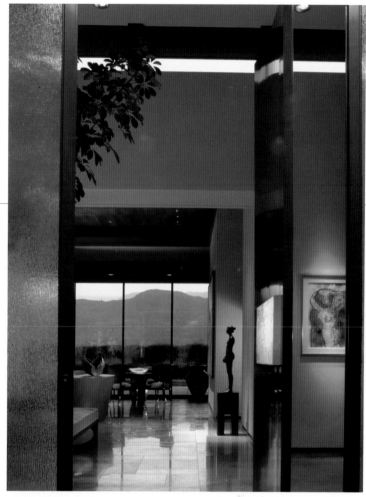

Gazing out of his window at indigenous swaying palms, Randy Patton houses his residential design studio in a 1937 ranch-style adobe home, a treasured relic of the past and one of the last standing desert ranch homes in the region. This inspiring work environment, with its rich, interesting history, is where Randy and his talented 12-person team of design associates and interior designers perform their magic.

Randy received his Bachelor of Architecture degree, graduating from the College of Design at Iowa State University in 1980. For more than 20 years he proudly worked as one of several on-staff designers for Steve Chase Associates in Palm Springs, and more recently founded his entrepreneurial namesake firm, Patton Design Studio, in 2002. Bringing a wealth of experience to the drawing board, Randy has a profoundly respectful attitude towards the associated architects on each project. His design philosophy is to honor an architect's vision for the project with the goal of working in unison with a strong architectural team, remaining faithful to the original architectural concept and program demands.

"We are more involved in space-planning and three-dimensional thinking than most interior design firms; we think and communicate three-dimensionally," says Randy. When he was a young boy, his keen interest in residential spaces and floor plans was obvious

ABOVE:
A large "slump" glass and metal-clad entry door pivots to reveal dramatic vistas of the Santa Jacinto Mountains beyond the living room and outdoor pool deck terrace. Sculpture by Robert Graham.
Photograph by David Glomb

FACING PAGE:
An exterior poolside view at dusk reflects the outdoor terrace lounge embraced by the contemporary master suite and living room. Architecture by Holden and Johnson Architects, Palm Desert and C2G Architects, Van Nuys, California.
Photograph by David Glomb

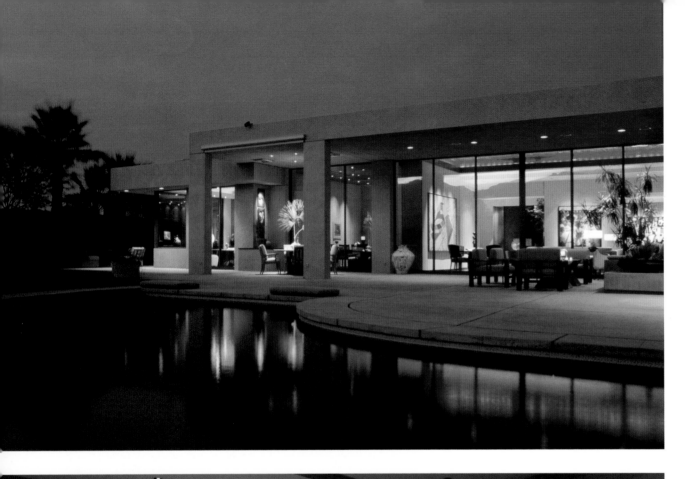

as he paged through *Better Homes and Gardens* magazine at every opportunity. His enthusiasm and growing interest in home interior architecture became his professional pursuit and today his projects are of great scale throughout southern California's most coveted gated and estate communities. National in scope, the studio's interior design expertise can be seen throughout Los Angeles, in Colorado and Chicago, as well as Florida and Las Vegas. From high-rise condominium developments to single-family luxury estates, each project is characterized by an appropriate use of materials and creative design solutions which "amplify" the architectural design.

A passion for the international style of architecture he experienced during his Midwest upbringing in Iowa made an imprint on his design aesthetic. In addition, Randy's formal education emphasized Modernism, and an enlightening 20-year professional relationship with Steve Chase gave him a deep understanding of fine textures, beautiful organic surfaces, textiles, discreet use of stone, marble and granite—refined, restrained design with no garish sense of waste or abandonment.

A true collaborative studio, he and his team work with artisans such as iron workers and specialty interior painters; they savor discovering new products and processes to create a commingled design composition. From landscape design to lighting fixtures, wall glazing techniques to art glass elements, the firm shops the market and does library research for each project uniquely; a time-consuming and rewarding process which produces stunning end results—the hallmark of the firm.

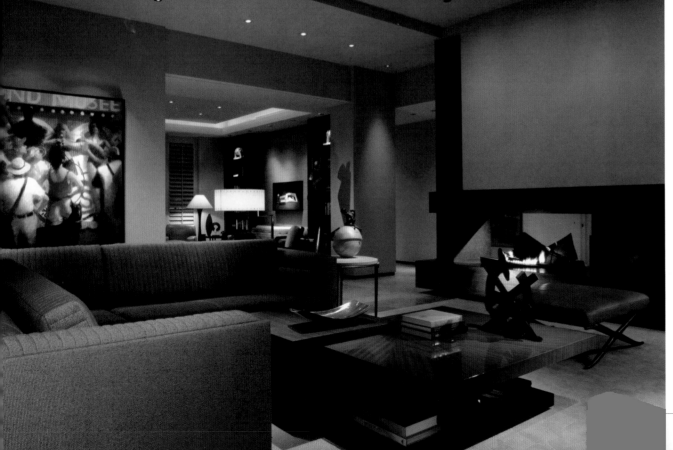

TOP LEFT:
Night skies showcase stunning illuminated views of interior spaces connected to the exterior's covered lounge and dining terraces separated by full-height, telescoping sliding glass doors.
Photograph by David Glomb

BOTTOM LEFT:
Living room lounge seating is anchored by a custom, cantilevered slab table design utilizing walnut, ebonized mahogany and woven metal mesh veneers. A custom bronze fire box "sculpture" with integral flame is beyond.
Photograph by David Glomb

FACING PAGE:
The gallery hall connecting a primary guest room and master suite displays skylights above, concealed by an architectural lens of walnut and black metal struts.
Photograph by David Glomb

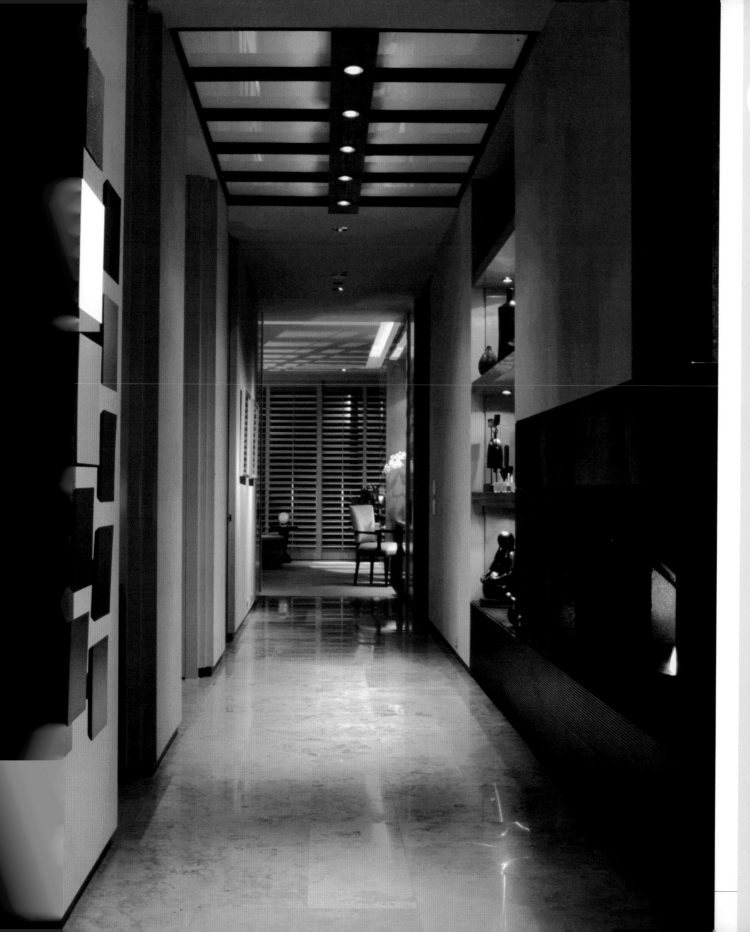

Q&A
more about randy ...

NAME ONE THING MOST PEOPLE DON'T KNOW ABOUT YOU.
I have a passion for the natural desert setting and do pro bono work for our area's zoological park and botanical gardens. I provide design work for the The Living Desert reserve in Palm Desert—it's such a magical place!

WHAT IS THE BEST THING ABOUT BEING A RESIDENTIAL DESIGNER?
Our clients come to us through referral and professional contacts. Together we have an understood performance criteria; they appreciate our portfolio of work before we even begin. Clients expect new, creative ideas and a custom approach, which is what we do best.

WHAT WOULD YOUR FRIENDS TELL US ABOUT YOU?
Although I appreciate living in the amazing geographic setting of the desert, I love snowy and chilly weather. I enjoy breezy Santa Barbara, San Francisco's climate and the damp coolness of Oregon's coast.

WHAT IS THE MOST UNUSUAL DESIGN TECHNIQUE YOU'VE USED IN ONE OF YOUR PROJECTS?
I have a passion for "slump glass," a molten glass poured into moulds to create counters, bar tops and architectural panels. Using the same sand casting process as bronze sculpture, this material is transparent, looks like lead crystal and can be manipulated to achieve effects such as a rough-hewn etched surface or artistic tinted "rivers" running through it.

PATTON DESIGN STUDIO
RANDY PATTON
7155 Highway 111
Rancho Mirage, CA 92270
760.776.5050

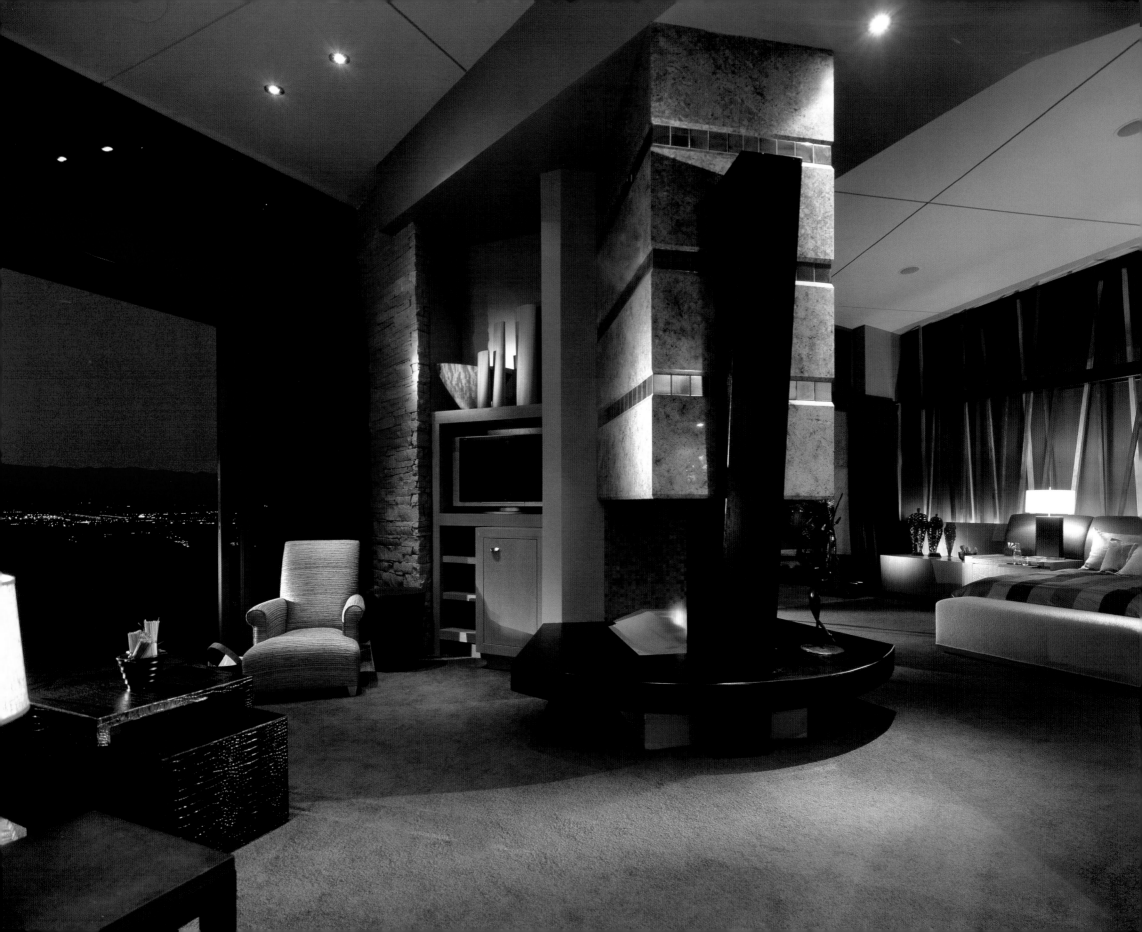

David Prest
John Vuksic

PREST • VUKSIC ARCHITECTS

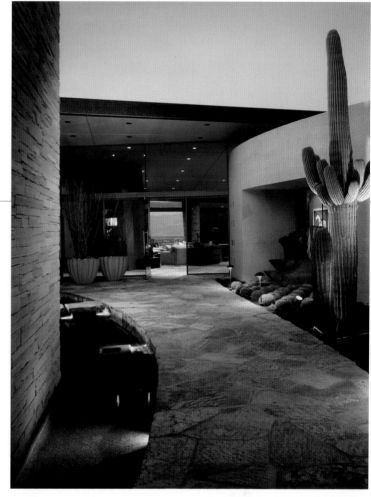

Taking a holistic approach to designing a custom home is paramount to the architectural team at Prest • Vuksic Architects as they examine each residential project overall in terms of the site, exterior elevation and interior design elements, thinking three-dimensionally and carefully planning every single detail throughout the residence. The ultimate goal is to make the entire house great, not just part of it, and raise it to the next level through strategic design. Perfectionists in a positive way, these visionary architects demand that each project entering their doors reflect the highest of architectural design standards.

Practicing for 30 years, David Prest and John Vuksic co-founded their Palm Desert architectural studio in 1997 after both had previous business partnerships and vast experience in commercial and residential work as members of other area firms. This dynamic design team creates nearly one dozen new custom homes annually, the vast majority second, third and fourth homes for their exclusively referral clientele. These commissioned private homes range in size from 5,000 square feet to 12,000 square feet and are vacation/retirement dwellings offering coveted desert living spaces during the winter months.

The alluring city of Palm Desert provides the perfect landscape for the fresh contemporary design aesthetic on which the firm has built its stellar reputation. Known for extraordinary works of steel, glass and stone, each home lends itself to the magical mountain

ABOVE:
An elegant entry courtyard precedes a home in Rancho Mirage, California, showcasing the use of steel, stone, plaster and glass.
Photograph by Taylor Sherrill

FACING PAGE:
This spacious master bedroom features a see-through, sculptural fireplace as the dramatic centerpiece.
Photograph by Taylor Sherrill

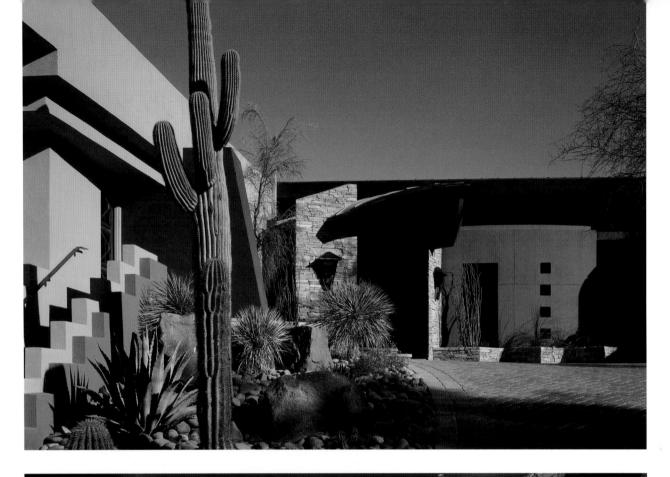

views and the indoor/outdoor lifestyle. The talented 13-person firm welcomes work in diverse classical styles including Spanish, Mediterranean and Tuscan influences. The studio's philosophy is simple yet profound: "Quality is more important than style. If you are going to do something, do it well." Their award-winning work confirms the truthfulness of this essential mantra.

Siting a house properly and designing the residence to take advantage of its unique location is key to Prest • Vuksic Architects' success. The multimillion-dollar homes created by the firm incorporate glass panels to permit sunlight to warm the space and deep overhangs to protect from the sun's intensity. High-performance air conditioning technology systems are integrated into the design to conserve energy, meeting California standards without sacrificing luxury or beauty. An established group of expert builders, tradespeople and interior designers collaborate on each project to achieve the finished vision. Gently letting go of each special residence as the new homeowner moves in, experiencing the joy of exceeding the clients' expectations and passionately anticipating the next home design—this creative team has truly mastered the art of dream-making.

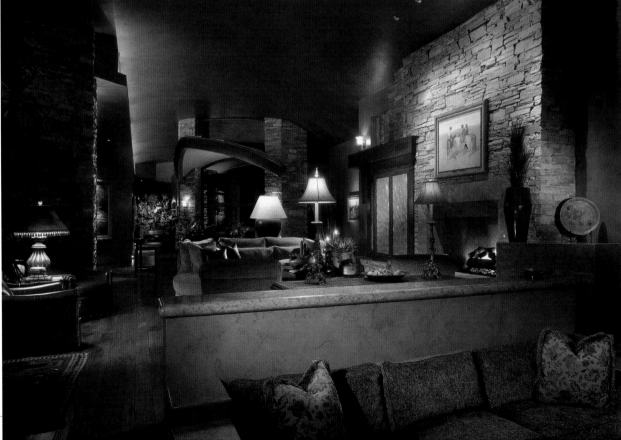

TOP LEFT:
The protective entry canopy feature is made of steel, stone and copper materials that mimic the desert palette on a home at Bighorn in Palm Desert, California.
Photograph by Ethan Kaminsky

BOTTOM LEFT:
Organic materials bring warmth to a clean, contemporary space.
Photograph by Ethan Kaminsky

FACING PAGE TOP:
This great room brings the outdoors in with expansive windows for breathtaking panoramic views and romantic stargazing at night.
Photograph by Taylor Sherrill

FACING PAGE BOTTOM:
An intimate retreat designed for reading and quiet reflection is off the main gallery of a private residence at Bighorn in Palm Desert, California.
Photograph by David Glomb

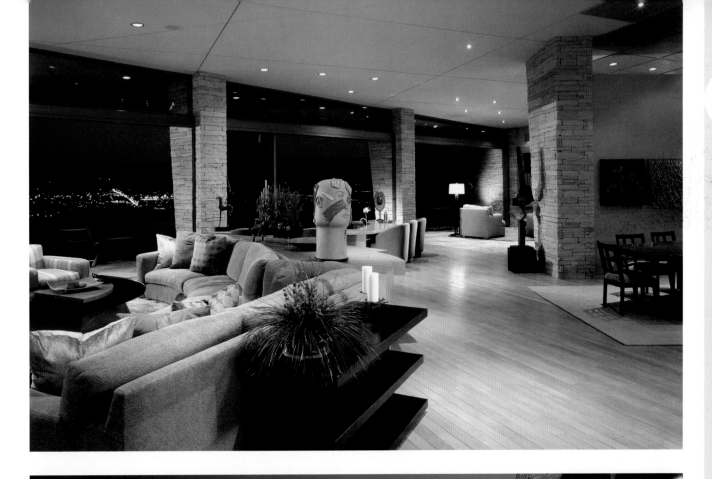

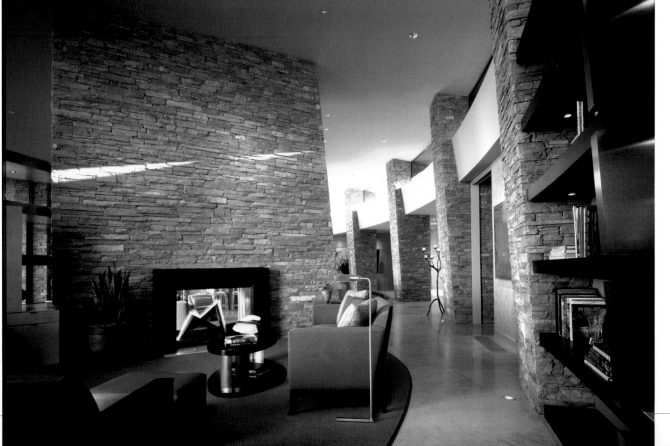

WHAT IS THE BEST PART OF BEING ARCHITECTS?

Doing contemporary work in a locale that we love. Every project is an opportunity to try new things on behalf of our clients.

WHAT IS THE HIGHEST COMPLIMENT YOU'VE RECEIVED PROFESSIONALLY?

When a client sees one of our homes in photographs and does a "double take," and also hearing their reaction upon completion that the home was more amazing than they had ever imagined it could be.

IF YOU COULD ELIMINATE ONE DESIGN TECHNIQUE WHAT WOULD IT BE?

Never overwhelm good architecture with too much interior design—keep it clean and simple to "complement" the space.

NAME ONE THING MOST PEOPLE DON'T KNOW ABOUT YOU.

David: I played professional baseball for three years in the San Francisco Giants organization.

John: I enjoy hiking and camping in remote locations.

WHAT PERSONAL INDULGENCE DO YOU SPEND THE MOST MONEY ON?

Golf! We enjoy doing business on the course as well.

WHAT SINGLE THING WOULD YOU DO TO BRING A DULL HOUSE TO LIFE?

Integrate more glass to allow natural light into the space.

PREST • VUKSIC ARCHITECTS
DAVID PREST, AIA
JOHN VUKSIC, AIA
44530 San Pablo Avenue, Suite 200
Palm Desert, CA 92260
760.779.5393
f: 760.779.5395
www.prestvuksicarchitects.com

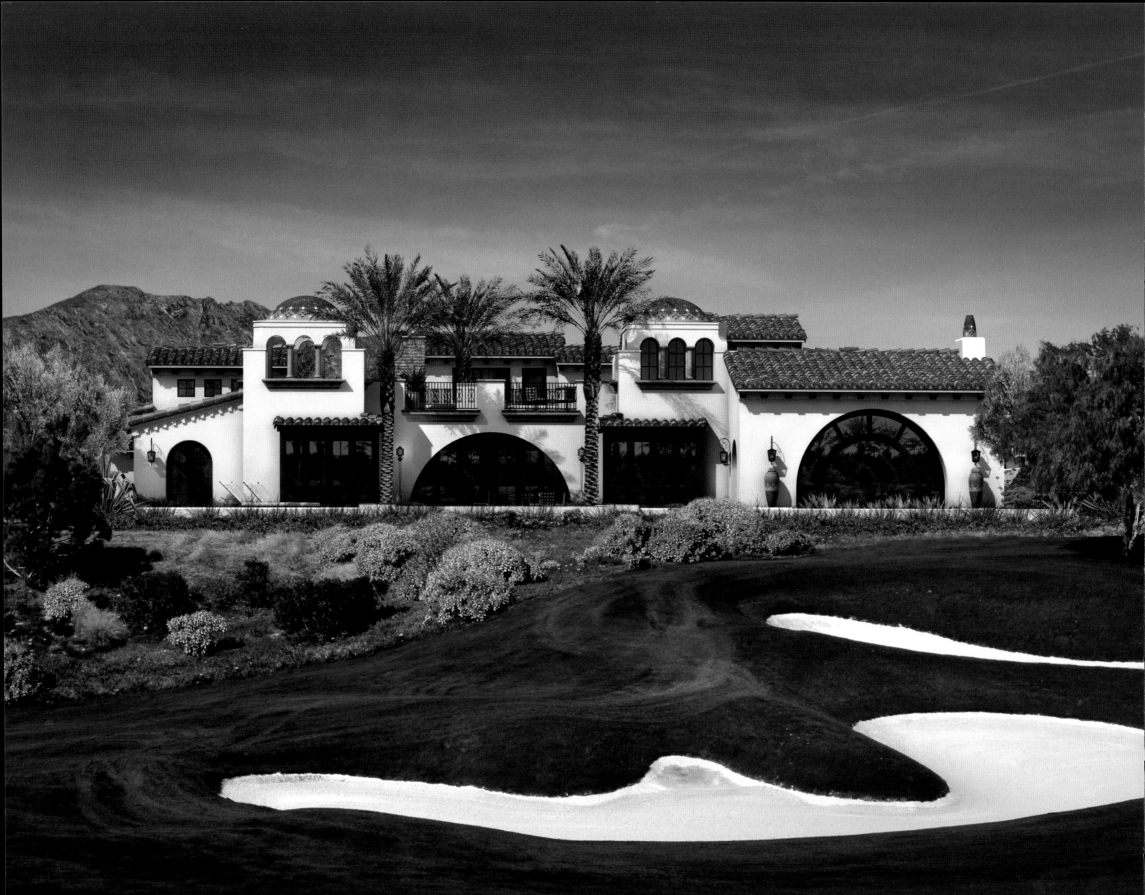

Frank Stolz

SOUTH COAST ARCHITECTS, INC.

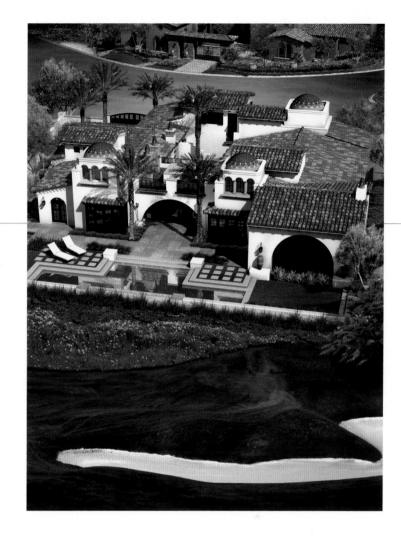

Imagine an exceedingly warm and approachable architect who makes people feel as much "at home" during the design process as they feel at home in their final space. Creating beautiful, luxury residences while nurturing a close relationship with each client is the abiding philosophy and hallmark of this award-winning architectural practice.

Known for stellar designs that shine along the southern California coastline and in elite communities on some of the desert's most sought-after real estate, South Coast Architects was the vision of Frank Stolz, who established the firm in 1992. Under his direction and with a tireless quest for creative excellence, it was destined to become a leading-edge, nationally recognized architectural studio. Today the firm is comprised of 15 talented, key professionals with well-rounded backgrounds in design, construction management and planning services, tailored to meet the needs of their clients with two thriving studios in Newport Beach and La Quinta.

Frank first practiced for 10 years in residential architecture with renowned firms throughout California upon earning his Bachelor of Architecture degree from the University of Idaho. With upwards of 23 years of residential experience to his credit and licensed in multiple states, he runs his own studio and designs a vast range of residences primarily in the Sunbelt including California, Arizona, Nevada and Florida, focusing on the western regions; the firm specializes in premier gated golf resort communities and

ABOVE:
An aerial view provides a glimpse of the colorfully tiled domes and grand archways of this Spanish Revival villa.
Illustration by Karl Hartmann-Hansen of Dimension Three

FACING PAGE:
A luxurious oasis in the desert, this Spanish Revival residence with its Moorish influences is sited on a prestigious golf course in La Quinta, California.
Illustration by Karl Hartmann-Hansen of Dimension Three

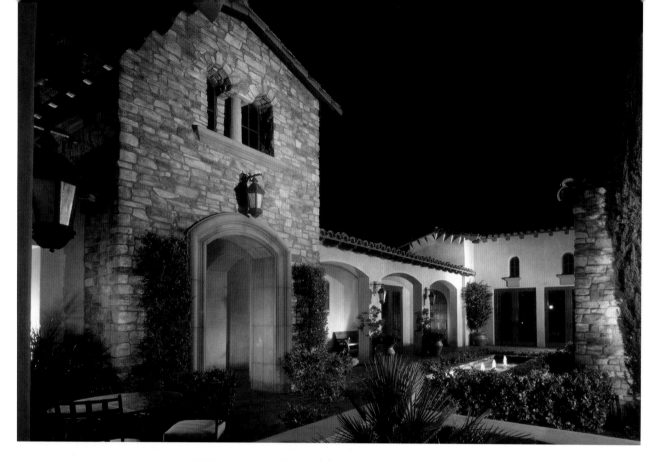

exclusive master-planned developments designing grand custom estates for single families as well as multi-family dwellings. South Coast Architects' diverse portfolio of residential work ranges from spacious contemporary designs to Old World architecture reminiscent of historical Spanish homes and Tuscan-inspired villas representing a purity of traditional style.

In the intense desert climate, second vacation homes are most prevalent for homeowners wanting a winter escape during the dreaded colder months of the year. Frank, who was born in Chicago, understands his clients' desire to have a home away from home, an oasis in the desert, a beautiful place to retreat and recharge. These palatial "destinations of leisure," as Frank explains, are designed to be in harmony aesthetically and functionally, and his ingenious creative solutions rival the work of his contemporaries.

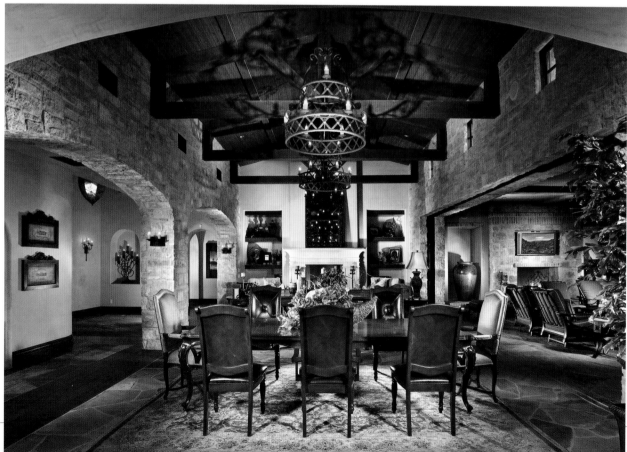

TOP LEFT:
This romantic Tuscan courtyard becomes the centerpiece of an Old World-style villa with a multitude of living spaces all leading to the interactive outdoor space.
Photograph by Lance Gordon Photography

BOTTOM LEFT:
This elegant great room, finished with rich stone walls, exposed wooden trusses and tongue-and-groove ceiling, extends to the covered outdoor entertaining area, maximizing the indoor/outdoor living effect—a must for desert dwellers.
Photograph by Lance Gordon Photography

FACING PAGE TOP LEFT:
The rear elevation of this Mediterranean-Spanish-style home displays sophisticated outdoor living at its finest, reflected elegantly in the turquoise swimming pool waters.
Photograph by Lance Gordon Photography

FACING PAGE BOTTOM LEFT:
This outdoor living space extends itself to an infinity-edge pool overlooking a breathtaking desert sunset.
Photograph by Lance Gordon Photography

FACING PAGE RIGHT:
Graceful classical columns punctuate this elegant Spanish-style living and dining space along with an arched brick façade, exposed wood trussed ceiling and a sculptural fireplace as the main attraction.
Photograph by Lance Gordon Photography

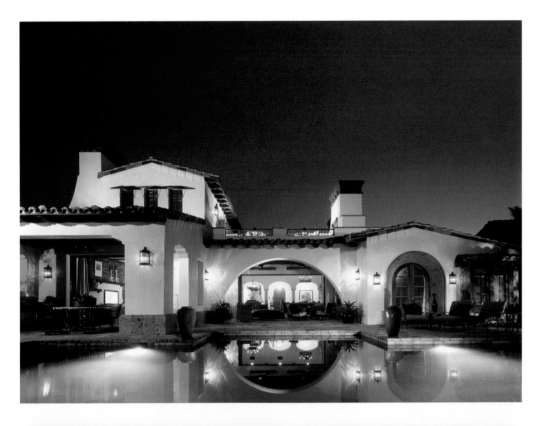

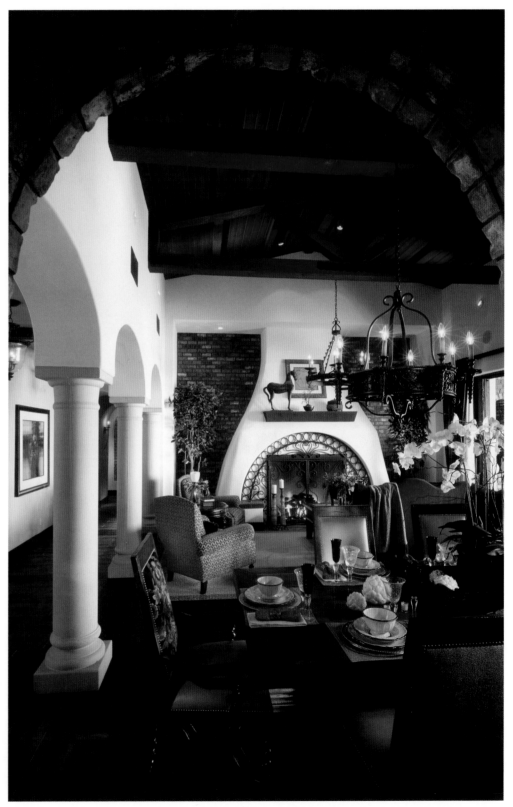

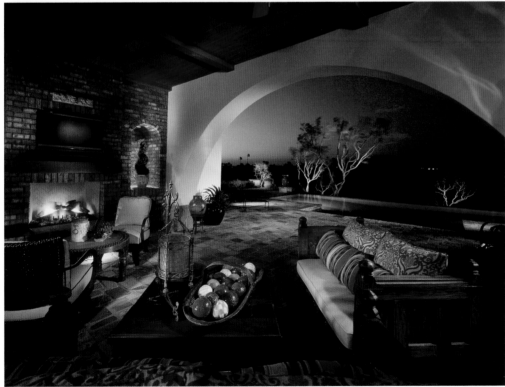

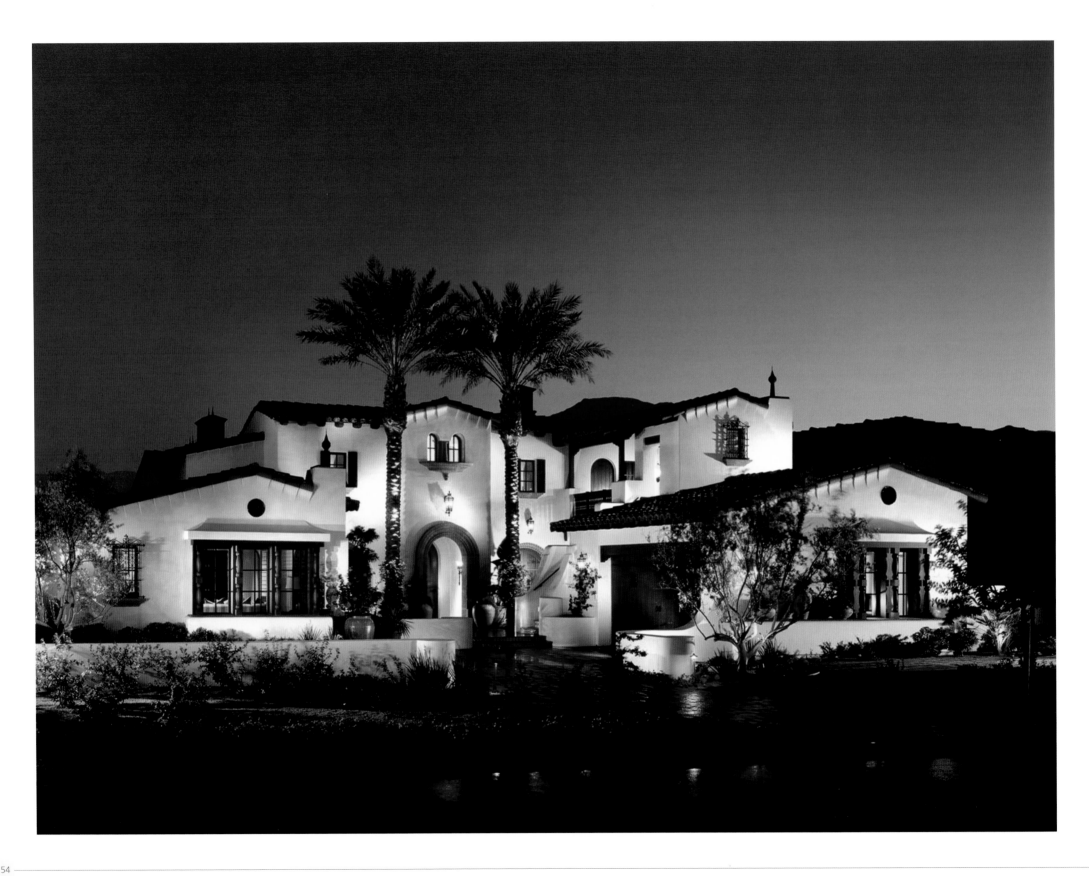

The firm's success as a whole comes from Frank's inner passion and commitment to the exciting field of architecture. Each custom home project is treated as though it is for a member of his own family, and history has shown that many clients become lifelong friends. An architectural problem-solving *firm* first and foremost, and not an architectural *business*, means that this creative studio carefully identifies each client's needs, listening attentively to their lifestyle requirements and aspirations, turning personal dreams into reality. Frank has a diverse list of clientele, each with unique and fascinating backgrounds, including high-profile clients. Respectful of the client relationship, the firm considers confidentiality to be of the utmost importance during the design and build process, instilling a mutual trust and a lasting bond. This "confidant" quality of the partnership allows for a working atmosphere of greater creative freedom and superior end results, a total experience that pleases each patron and rewards the architect on many levels.

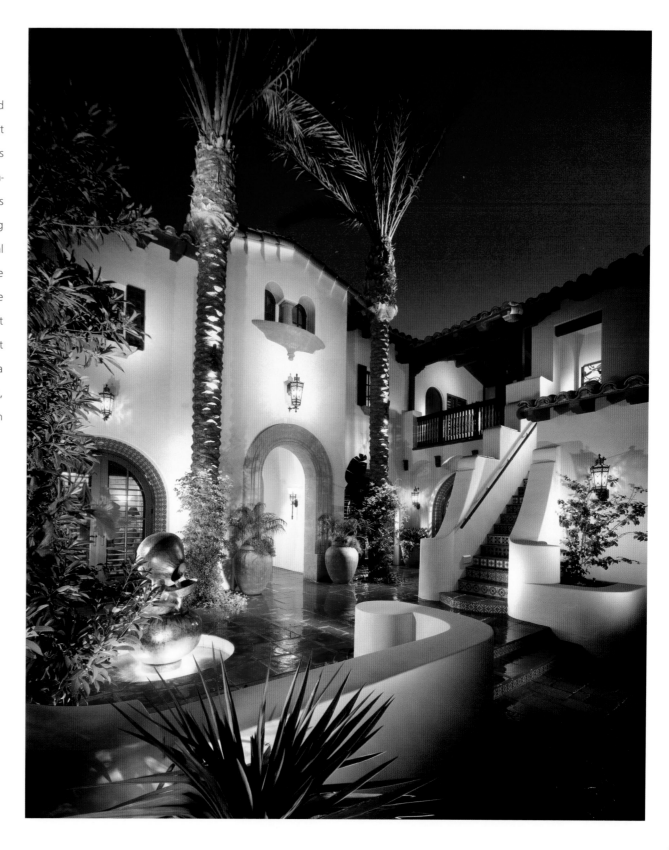

RIGHT:
This spectacular two-story Spanish villa creates a welcoming statement with an array of interior spaces interacting with the front-entry courtyard.
Photograph by Lance Gordon Photography

FACING PAGE:
This exquisitely detailed, classical front elevation is reminiscent of the Spanish Revival period which occurred throughout southern California during the 1920s.
Photograph by Lance Gordon Photography

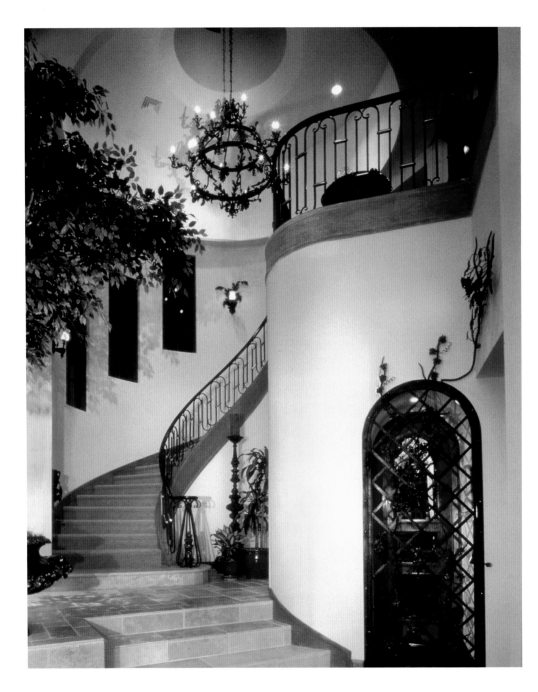

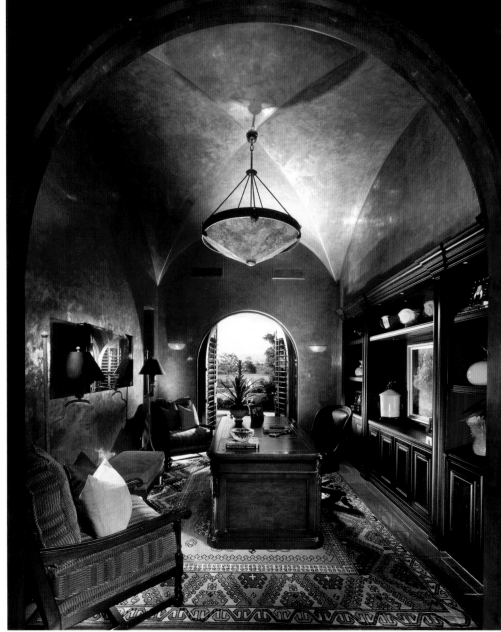

ABOVE LEFT:
This richly and elegantly designed curving staircase wraps over the wine cellar that is framed by a custom-crafted wrought iron arched door.
Photograph by Chawla Associates

ABOVE RIGHT:
A handsome office fit for a king, this room's groin-vaulted ceiling highlights the space and is artistically hand-finished in Venetian plaster.
Photograph by Lance Gordon Photography

FACING PAGE:
This magnificent Italianate estate is situated in an elite master-planned desert community on the periphery of Las Vegas.
Photograph by Chawla Associates

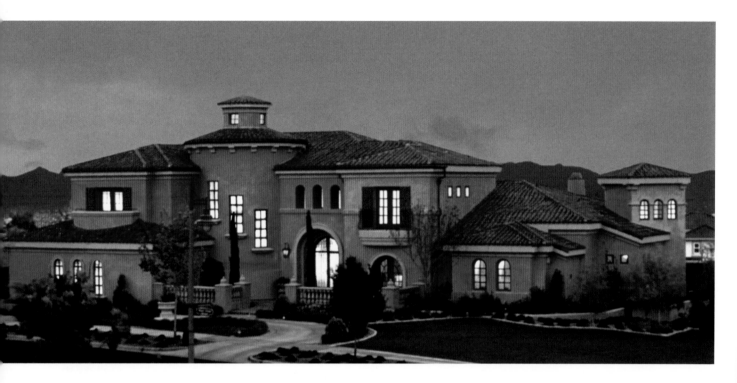

WHAT PHILOSOPHY HAVE YOU STUCK WITH FOR YEARS THAT STILL WORKS FOR YOU TODAY?

Commitment and listening to our clients. In return, this mutual trust allows me to create beautiful, elegant dream homes. I believe our success comes from an internal passion and commitment to architecture.

WHAT SEPARATES YOU FROM YOUR COMPETITION?

We are an architectural *firm* first and foremost, not an architectural *business*. Our mission is to create dream homes for each of our clients that exemplify architectural excellence. We put thoughtful consideration and energy into each project just as if we were designing our own home.

WHAT IS UNIQUE ABOUT YOUR FIRM?

South Coast Architects is a nationally recognized, award-winning firm. We function as an architectural studio with a staff size of 15 people. What makes SCA's practice unique is that our staff experiences all aspects of architecture; we get talented, dedicated candidates from all over the world seeking to join our firm for this reason.

From prestigious country club and golf resort communities of greater Palm Springs, Las Vegas and Scottsdale, South Coast Architects is a major performer in the custom, second-home market of America's western deserts. Offering a full array of architectural and planning services, its diversified and capable team has specialized experience in custom residences, resort and golf course projects. Throughout each project, the firm continually emphasizes a strong collaboration between the client and architect with a clear responsiveness to finances and schedules, while producing work of superior quality and enduring value.

With each project, South Coast Architects seeks to introduce new concepts, while developing solutions that are in harmony with aesthetic and functional considerations. Design excellence is the goal, and this is achieved while working as a team with each client constantly searching for alternatives and exploring options to help each project achieve its greatest potential. The firm has been recognized for over 20 Merit and Grand Awards at the prestigious annual Gold Nugget award ceremony. Along with that, the firm was selected as the Architect of the Year for its 1999 Western Idea House, a distinguished honor given by *Sunset Magazine. Professional Builder, Builder Magazine, California Builder* and *Custom Home* publications have also featured the firm's visually stunning residences that epitomize the word "custom."

Although awards are wonderful to receive, listening intently to understand the desires of its discerning clientele and developing a personal and professional trust is the foundation which allows the firm to create exquisite and elegant luxury homes. Remaining dedicated to and enjoying the artful process of designing dream homes in the deserts is the true reward for Frank and his illustrious firm.

SOUTH COAST ARCHITECTS, INC.
FRANK STOLZ, AIA, NCARB
13 Corporate Plaza
Suite 210
Newport Beach, CA 92660
949.720.7022
f: 949.720.2045
www.southcoastarchitects.com

79440 Corporate Centre Drive
Suite 115
La Quinta, CA 92253

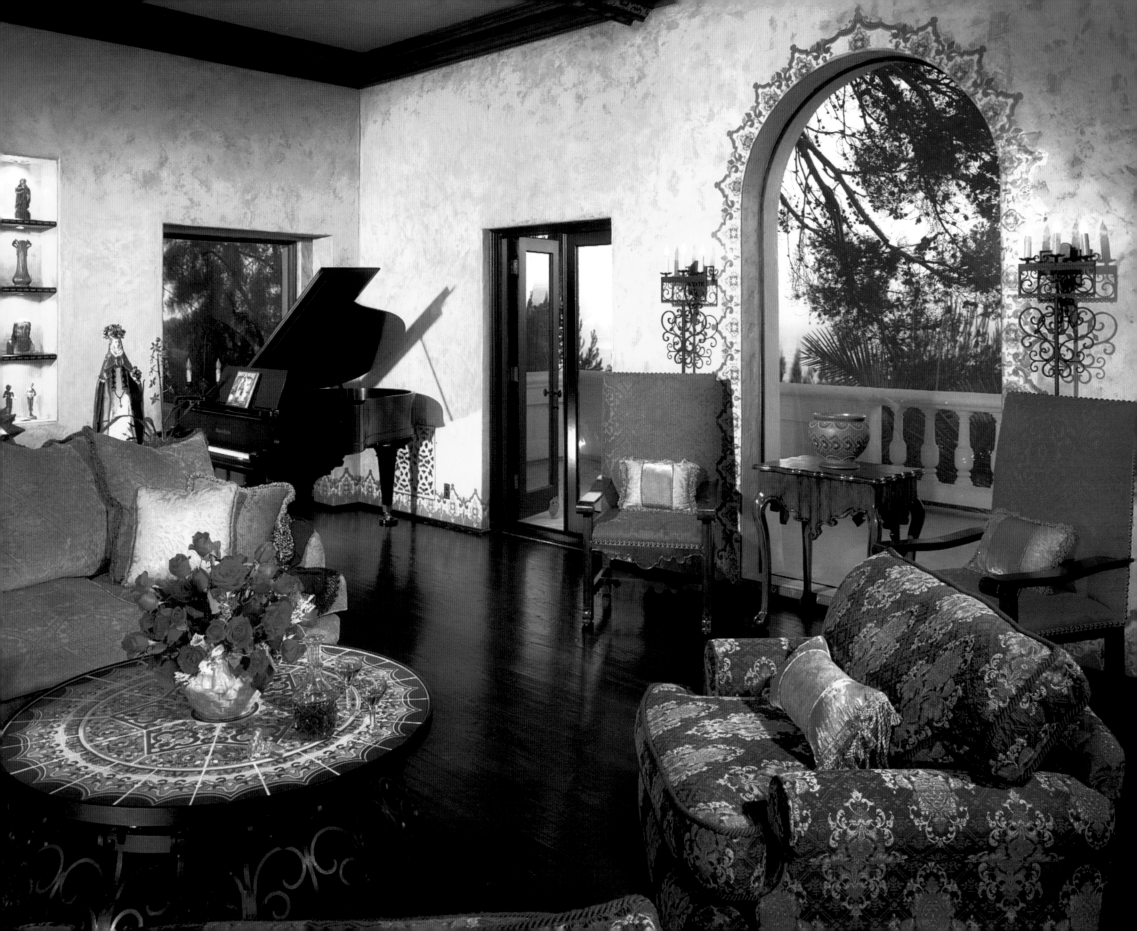

Jean Zinner
JAZ DESIGNS

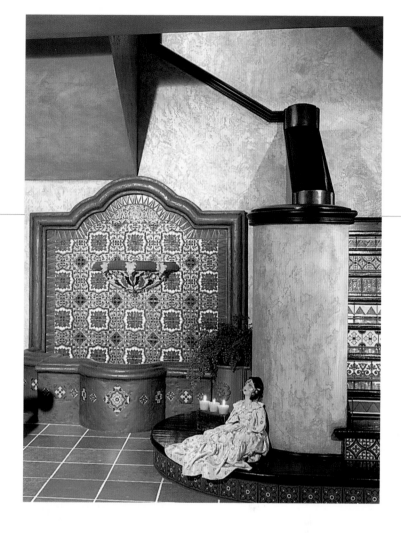

W hile studying interior design at UCLA, Jean Zinner was required to design and build a kite—but passing the course meant the kite had to fly! An interesting assignment to be sure, but only after starting her own firm did Jean fully appreciate the metaphor. She quickly realized that for her business to take off, her ideas, more than just being creative, had to fly with her clients. More than 26 years and thousands of rooms have proven that her ideas do fly. Jean's boundless energy, integrity, imagination, and creativity have translated into a thriving business and relationships that have spanned years and spawned multiple projects and many referrals.

A native Angelino with a background in fashion, photography and horticulture, Jean has a natural ability for creating environments that work well for her clients' tastes and lifestyles. Though her personal favorite style is Spanish Colonial, Jean's portfolio is as diverse as her clientele. European Traditional, American Classical, California Contemporary, and more are all represented in her body of work. An award-winning designer, she especially enjoys helping clients discover their style preferences. Starting with a free two-hour consultation, Jean guides them carefully through the process of building their dream, educating them on scale, color, texture and furniture selection, then interpreting their desires with flair and skill.

ABOVE:
The tumbled marble floor and rich Incan gold and terracotta colorations reminiscent of Cuzco with a Malibu Potteries fountain design have been custom-colorized to complement the Malibu tile risers.
Photograph by Martin Fine

FACING PAGE:
A reproduction of an authentic Malibu Potteries table forms the focal point of this hacienda-style living room. The Adamson House-inspired wall stenciling and 19th-century iron Mexican sconces complete the rich room.
Photograph by Martin Fine

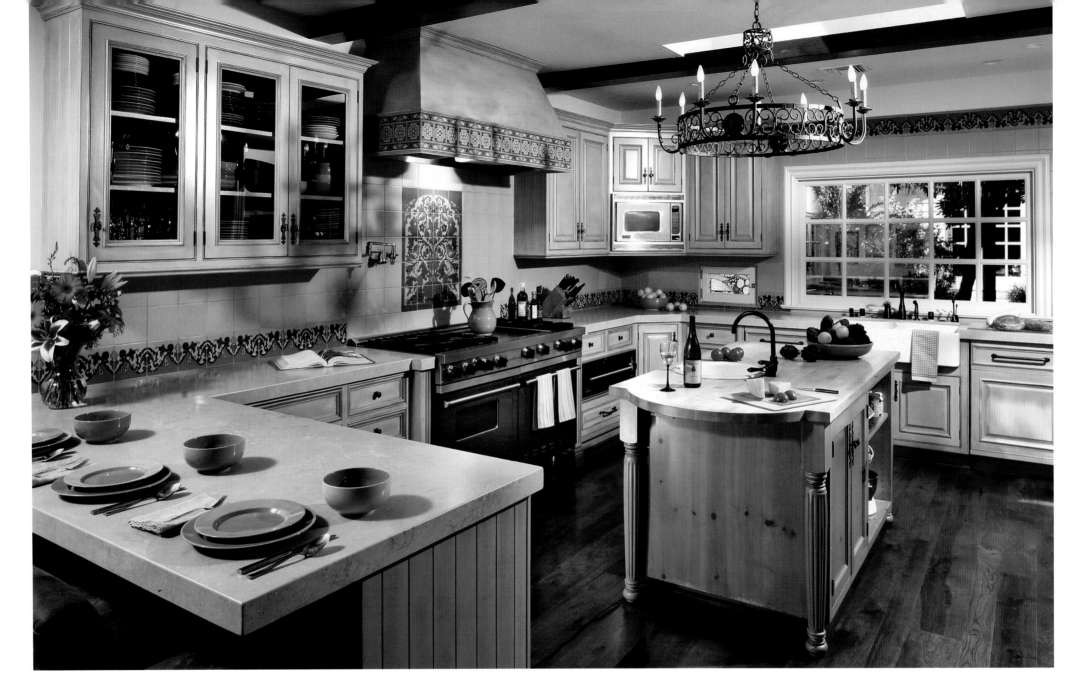

For Jean, membership in the American Society of Interior Designers means more than a few letters after her name. She has served on her chapter's board and she is a past chairperson for both the Student Affairs and Education Committee and the Nominating Committee. For her outstanding support of interior design education, Jean received the Dorothy Peterson Award, one of the most prestigious ASID honors.

Recently, Jean's work has appeared in the *Palisadian Post*, the *Los Angeles Times* and *Los Angeles Home & Decor* magazine.

ABOVE:
This kitchen's unique color palette features hand-glazed California and Malibu reproduction tile, limestone countertops and a wrought iron chandelier. An eclectic mix of woods includes painted poplar cabinets, a blue-stained knotty pine island and distressed pecan flooring.
Photograph by Martin Fine

FACING PAGE TOP:
The chocolate-stained distressed oak plank table—with matching console—is surrounded by six hand-carved walnut upholstered dining chairs. An iron and crystal Louis IV-style chandelier sets the mood with romantic lighting.
Photograph by Martin Fine

FACING PAGE BOTTOM:
Moroccan wall tile surrounds Spanish paver tile floors with a dark wax finish. Master bath cabinetry features recessed panel doors with a rope detail. Iron with crystal chandelier and sconces highlight gold-hue walls and arched detailing.
Photograph by Martin Fine

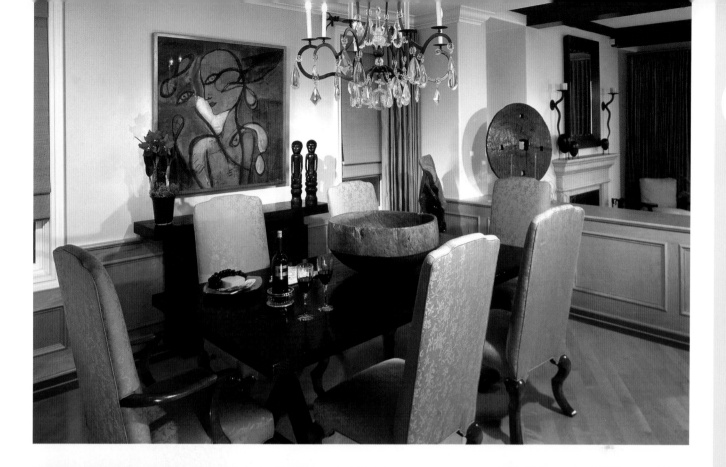

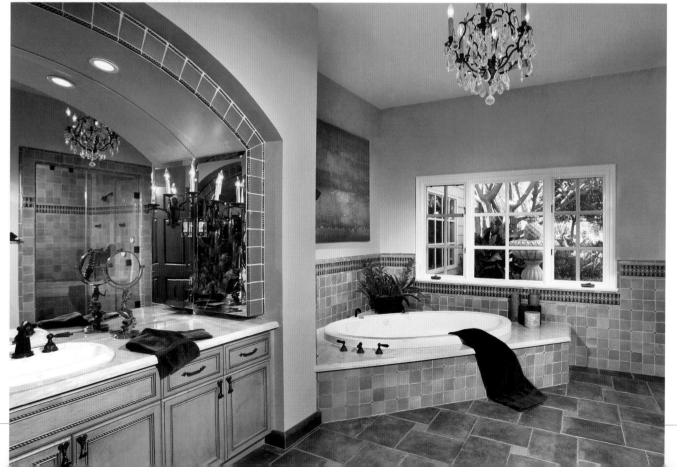

WHAT COLOR BEST DESCRIBES YOU AND WHY?

Light blues and teal suit me best. When I wear or work with these colors I always feel carefree, joyful and happy.

WHAT DO YOU LIKE BEST ABOUT BEING AN INTERIOR DESIGNER?

My clients' delight in the beautiful and unique environments I create for them. It is my favorite part of the job.

WHAT DO YOU LIKE MOST ABOUT DOING BUSINESS IN THE LOS ANGELES AREA?

I especially like the diversity of architecture within the Los Angeles area as well as the variety of easy access to myriad design resources, including the superior craftsmanship provided by my subcontractors.

JAZ DESIGNS
JEAN ZINNER, ASID, CID
2202 Hill Street
Santa Monica, CA 90405
310.450.2056
www.jazdesigns1.com

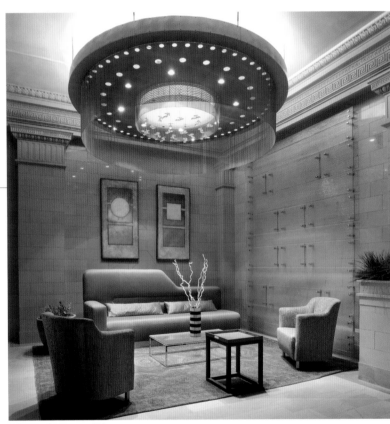

Rekow Designs, page 191

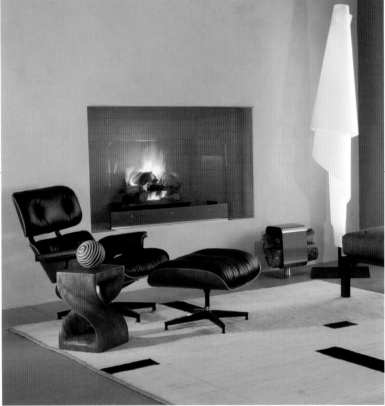

Kris Lajeskie Design Group, page 183

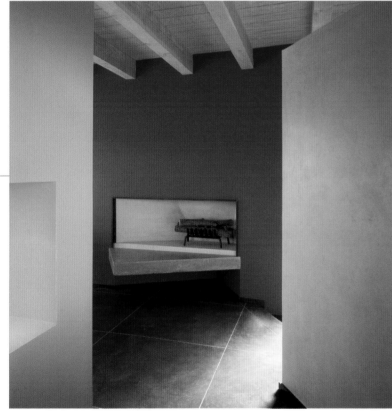

Archi-Scape, page 165

CHAPTER THREE

NEW MEXICO

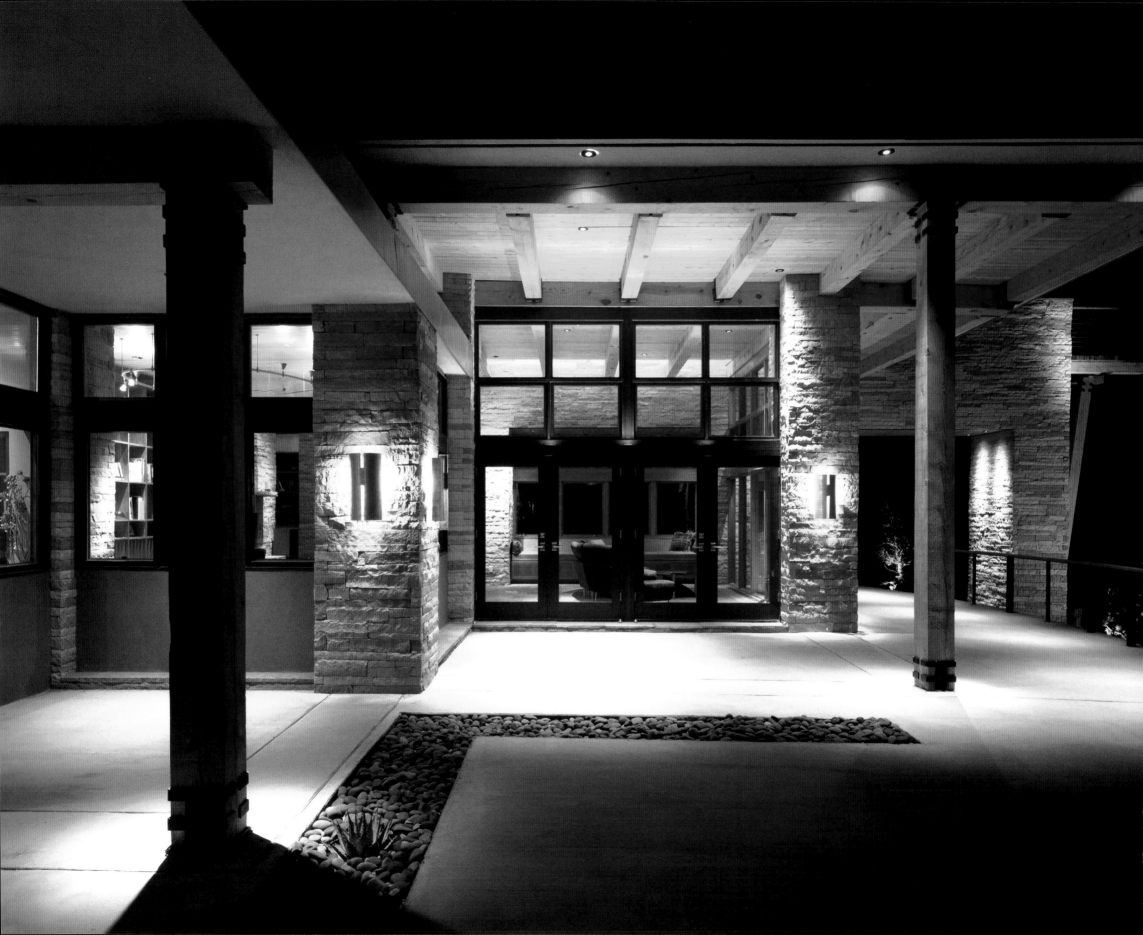

Aaron Bohrer
ARCHI-SCAPE
H-HAUS, LLC

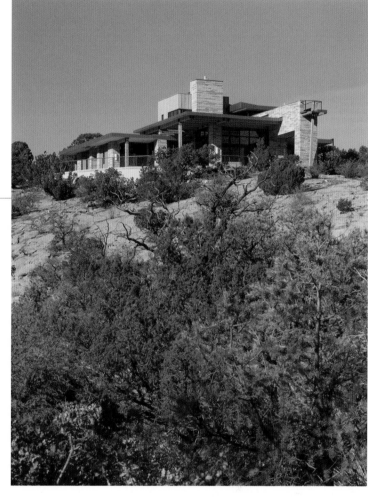

Having the fortuitous opportunity of working with the legendary architectural firm of I.M. Pei & Partners in New York City for two and a half years at the beginning of Aaron Bohrer's career, this urbane architect may seem better suited to design homes in the Big Apple. Working within the walls of this stellar firm marked only the start of his life's journey, followed by marriage to the love of his life and relocating to the mystical desert-mountain village of Santa Fe.

With more than 20 years of diverse architectural experience including commercial work and residential design, Aaron began professional training earning his Bachelor of Arts and Bachelor of Architecture degrees, then attended New York's Columbia University where he also earned his Master of Science degree in Advanced Architectural Design in 1993. Born and raised in North Dakota, his mother taught him the value of a fine education and merits of world travel to expand his horizons. Heeding her words, Aaron has evolved into a world-class architect on the forefront of the Green residential design movement.

His boutique design firm has three legs as an architectural entity strong in commercial and residential work, an established relationship with a developer of master-planned projects in Albuquerque and dedication to the growth of Santa Fe rich in its Pueblo and Territorial styles. Aaron speaks about Santa Fe as if it were a living, breathing being saying, "Its history is still palpable—you feel the

ABOVE:
This custom residence was designed to follow the horizontality of the mesas. An observation walk extends 50 feet allowing 180-degree views for nighttime stargazing.
Photograph by Robert Reck

FACING PAGE:
The Los Alamos residence's living room terrace extends from the space to the outdoors for a protected place to entertain guests or simply relax.
Photograph by Robert Reck

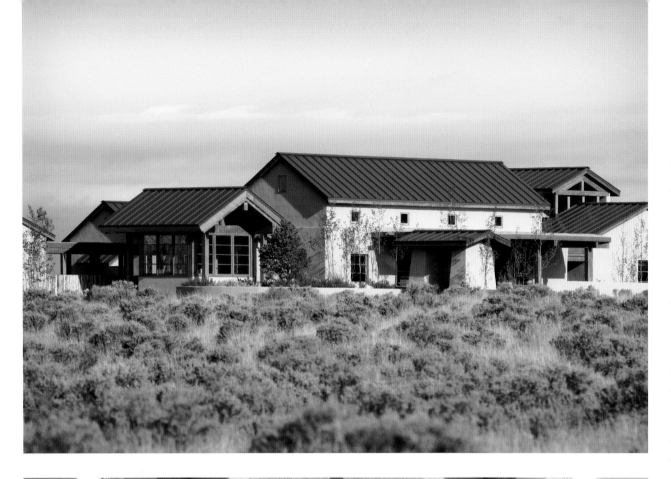

heartbeat here." He believes there are rich, contextual lessons to learn from its indigenous culture with Spanish influences. Santa Fe is a concentric-ring city with one central plaza likened to those found in European cities. It is a walking city, pedestrian-friendly with old trails.

Aaron professes an insightful philosophy: "The ultimate design luxury is space." New Mexico's vast spaces offer the opportunity to be inspired in his work. He has not come to terms with any one style, as he believes it is a language that evolves into being just as an artist's unique style evolves over years of practicing his talent. He looks at design as a problem to solve in a way that is spatially interesting—a relationship of spaces, indoors and outdoors, and a relationship of materials—finding a way to design that is consistent, rigorous and heightens the quality of the building.

As co-founder of H-Haus he merges Green design and modern living, bringing eco-friendly, intelligent home design for the 21st century to New Mexico. Portuguese architect Eduardo Souto Moura inspires much of Aaron's work, with a sensibility about designing for community; a modernism with reference to the past.

Passionate about civic involvement, Aaron is on the board of the Santa Fe Partners in Education and contributes his time to benefiting young students. Aspiring to teach later in life, he lives his words today: "Architecture is the craft of social and political art, the project of civilization, edifying people's hopes and aspirations, reinforcing a culture."

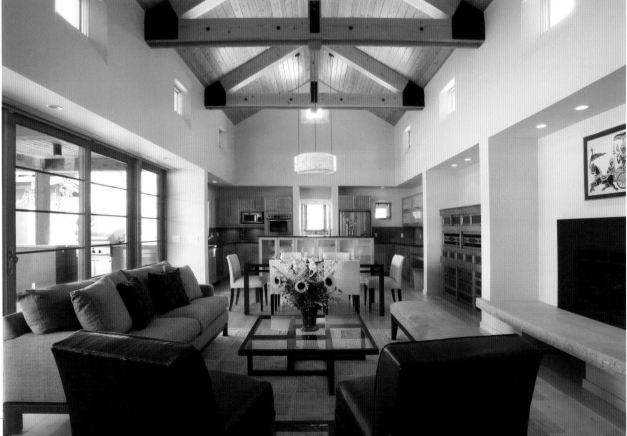

TOP LEFT:
A spacious home in Taos has uncommon architectural details, a blend of northern New Mexican and Asian styles.
Photograph by Robert Reck

BOTTOM LEFT:
Exposed roof trusses, wood ceilings and dropped soffits give this sun-drenched great room an intimate feeling.
Photograph by Robert Reck

FACING PAGE LEFT:
Perched atop the home is an open-air, summer sleeping loft used on warm desert nights.
Photograph by Robert Reck

FACING PAGE RIGHT:
A tranquil meditation garden in the zen style is visible from the master bedroom.
Photograph by Robert Reck

ARCHI-SCAPE
AARON BOHRER, AIA
1512 Pacheco
Suite A-202
Santa Fe, NM 87505
505.670.2375
f: 505.466.4552
www.archi-scape.com

H-HAUS, LLC
AARON BOHRER, AIA
ARUNAS REPECKA
www.h-haus.com

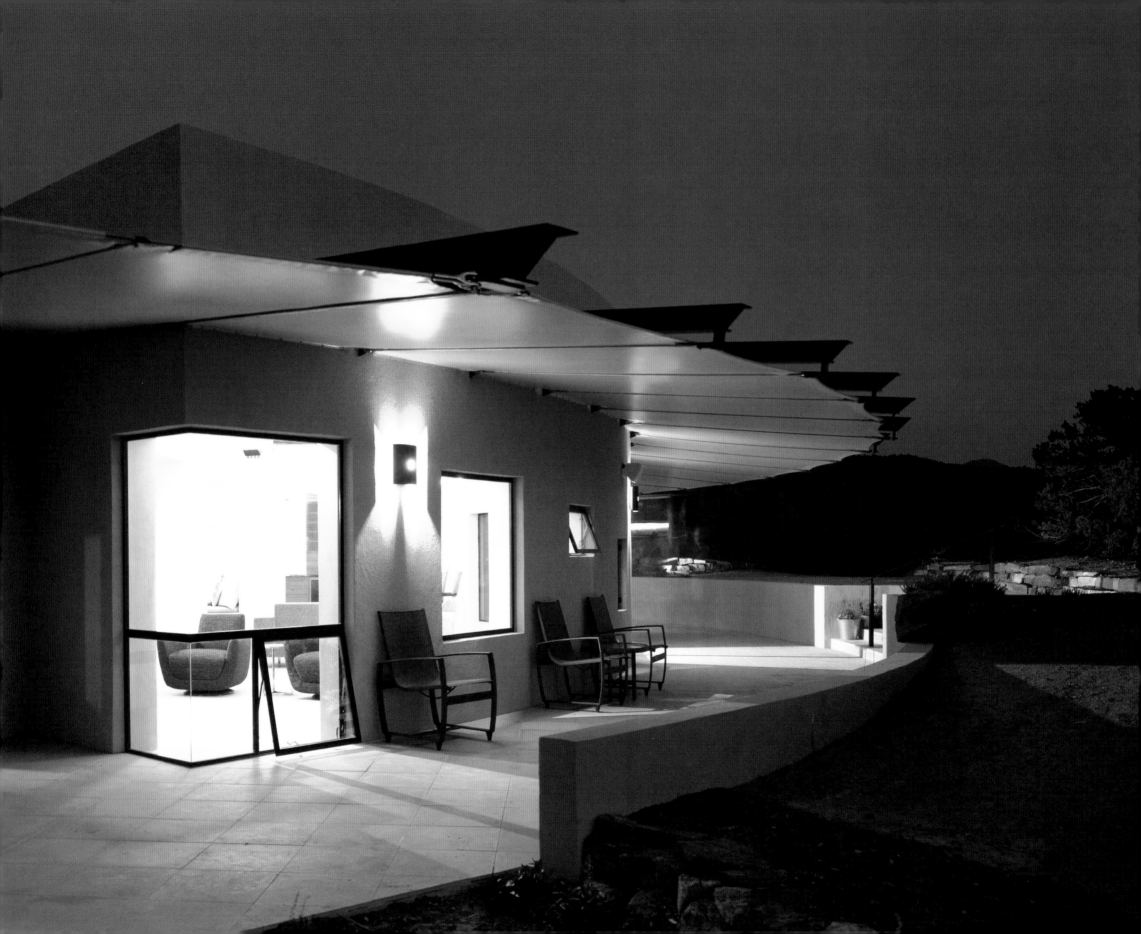

Jon Dick
ARCHAEO ARCHITECTS

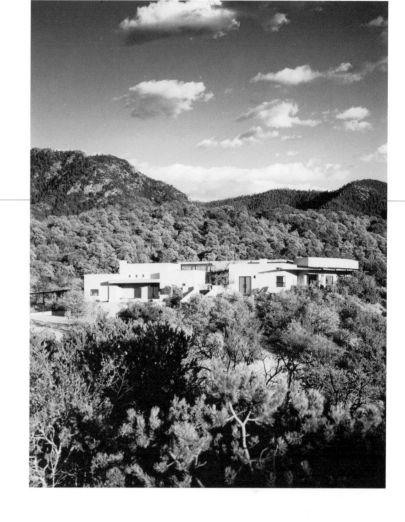

The unique alliterative name "Archaeo Architects" was thoughtfully selected for this Santa Fe firm by Jon Dick, founder and principal. In 1996, the boutique firm was born with a sincere reverence for what has come before. Inspired by ancient architecture and its lean simplicity, with a keen interest in early vernacular, this studio's designs seek to capture the elusive mystery of the "oneness" between site and structure.

Jon earned his undergraduate degree in architecture from the University of Idaho and his Master of Architecture degree from Cornell University. He was the proverbial urban dweller in Manhattan after graduate school and worked at some of the best architecture and interior design firms in the city. Through this process he discovered his true passion: custom residential design.

His roots brought him back to the West, where he was born and raised. Practicing in New Mexico, Nevada, Utah and Colorado he found inspiration in the open dramatic landscape that is the Southwest. His love for New Mexico clearly shows in his custom home designs, which are carefully integrated into the desert environment. The idea of "sculpting" light comes into play in all of Jon's work as this is a defining element he incorporates in every residential design—his mantra, "light creates form," describes his design philosophy as well.

ABOVE:
Discreetly tucked into western slopes of the Sangre de Cristo Mountains, the home captures 180-degree panoramic views of the Rio Grande valley.
Photograph by Robert Reck

FACING PAGE:
A twilight view of the living room terrace is shaded by a tension-structured canopy of fabric, steel beams and cables.
Photograph by Robert Reck

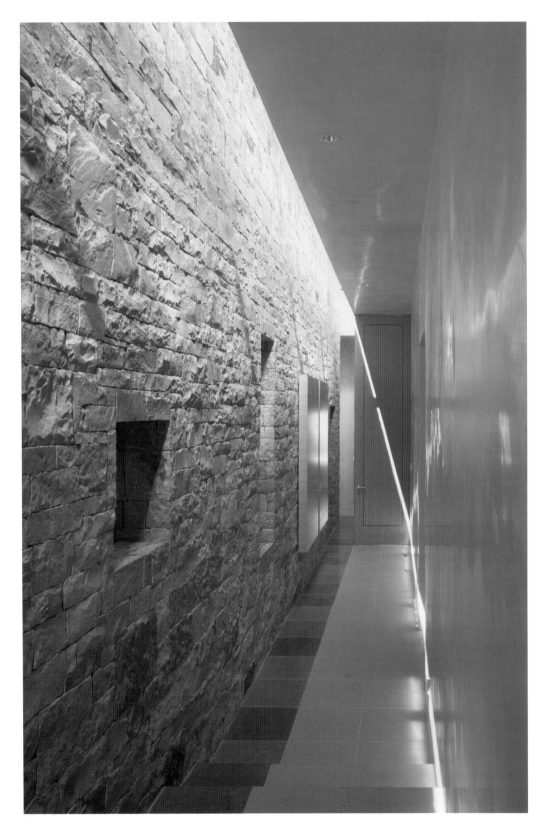

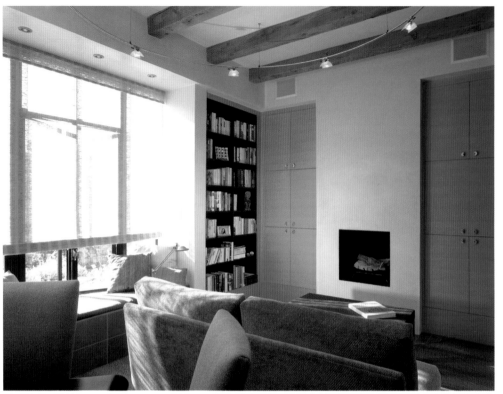

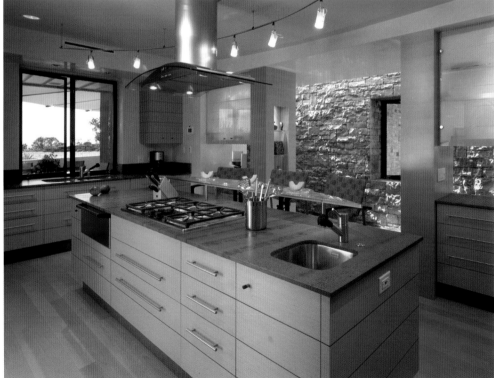

Jon conveys, "Our lives may have progressed but we have lost something. Staying in tune with ourselves and nature is important." Santa Fe is an old "walking city" based upon the Spanish "plaza" concept with winding streets and walkways. Not formulaic regarding any one style, Archaeo marries site, client, light and environment—creating a humane yet dramatic living space. Designing to embrace sensory aspects, Jon explores the "ambience" that a client wants to experience in a new home—from the natural sound of trickling water to the scent of native piñon trees. When Jon creates for his well-informed clientele it is as though his cutting-edge designs ascend from the ground. Authentic materials are masterfully assembled with superior craftsmanship, and the firm closely supervises the construction process to ensure the desired outcome.

One such custom project was designed for a 25-acre site. The firm and client had the opportunity to name the road leading to the residence: "Sendero de Luz," meaning "path of light," connoting an intangible aesthetic one can only see to appreciate. A central courtyard is the true axis of the home, relating to the arc of the sun with the home essentially wrapping around this sun-drenched focal point. The legendary Louis Kahn is one of Jon's greatest influences, and this desert home uses light as a form-defining element, the

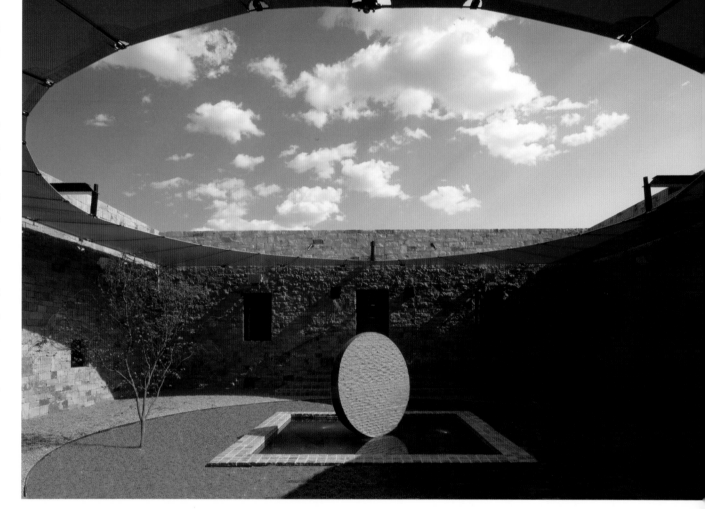

RIGHT:
A central zen courtyard features a circular canopy open to the sky while a circle of thyme encloses a reflecting pool as a singular Japanese maple contrasts with the walls of stone.
Photograph by Robert Reck

FACING PAGE LEFT:
A long narrow skylight flush against a stone wall allows a sliver of light to illuminate the hallway that leads to the guest suite.
Photograph by Robert Reck

FACING PAGE TOP RIGHT:
An intimate library with plaster walls, antique beams and suspended circular track lighting sets the focus on a window seat that looks out onto an enclosed garden.
Photograph by Robert Reck

FACING PAGE BOTTOM RIGHT:
European beech wood veneer kitchen cabinetry with ebony inlay is accentuated with sandblasted glass upper cabinet doors, a cantilevered glass breakfast bar and Kirkstone countertops from England.
Photograph by Robert Reck

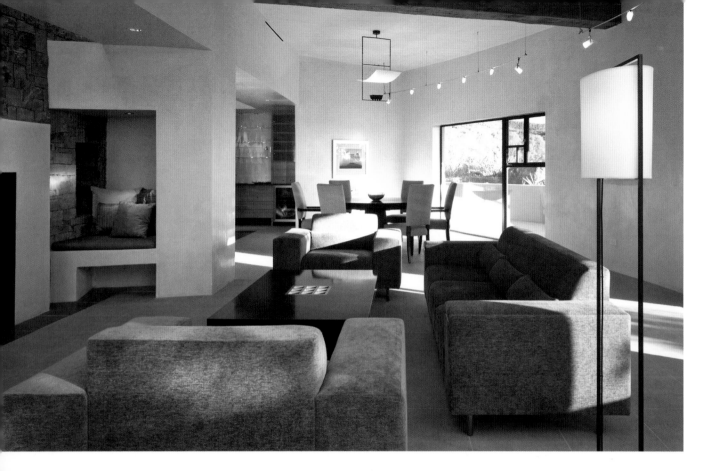

essence of his work. The utter simplicity of each design is difficult to execute and all-important details require meticulous craftsmanship. Integrated mechanical and electrical systems must be unobtrusive and virtually seamless to maintain a serene atmosphere in the space. Jon relishes design challenges. He notes that architecture continues to be a humbling profession but the possibilities are endless.

Immersed in custom residential design during the past eight years, the firm has received 16 local and state AIA awards as well as other notable accolades. Archaeo's work can be seen in *Western Interiors and Design, Fine Homebuilding, Phoenix Home & Garden, Santa Fean, Santa Fe Trend, Su Casa, Sources + Design* magazines and several books, including *The Simple Home* by Sarah Nettleton.

In a secluded studio along the Santa Fe River, one can find this quiet architect and his creative associates designing under the spell of Gregorian chant. His zen-like approach to design embodies knowing when to stop, celebrating restraint; he is an evolving modern-day minimalist who deeply respects the past.

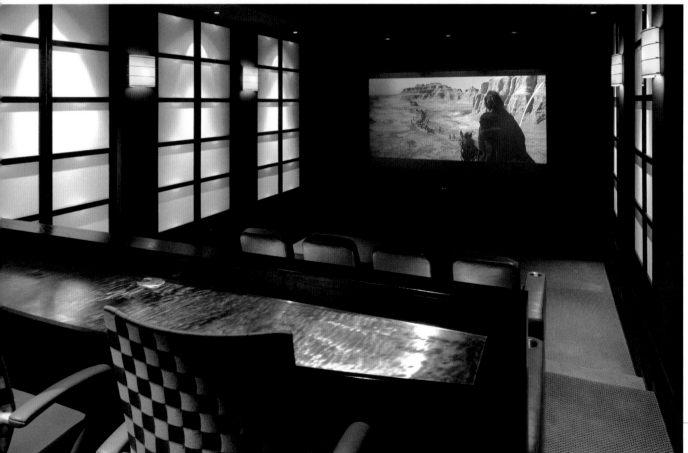

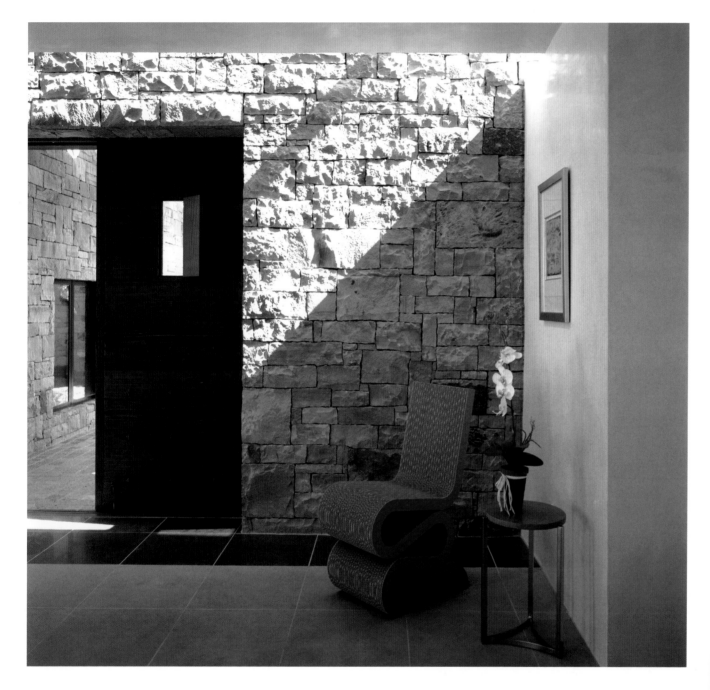

WHAT IS THE BEST PART OF BEING AN ARCHITECT?
Attempting to achieve a poetic expression through built work.

WHAT COLOR BEST DESCRIBES YOU AND WHY?
Cobalt blue. It is often the color of the sky directly overhead at dawn and twilight here in New Mexico—my two favorite times of the day.

WHAT IS THE HIGHEST COMPLIMENT YOU'VE RECEIVED PROFESSIONALLY?
Words from a new client upon approving the design: "Your architecture is art."

WHAT ONE ELEMENT OF STYLE HAVE YOU STUCK WITH FOR YEARS THAT STILL WORKS FOR YOU TODAY?
Light. It is a form-defining element.

WHAT BOOK ARE YOU READING RIGHT NOW?
Brunelleschi's Dome: How a Renaissance Genius Reinvented Architecture by Ross King.

WHAT IS THE MOST BEAUTIFUL HOME YOU'VE BEEN INVOLVED WITH AND WHY?
The one that presently exists in the dreams of my next client. The possibilities are endless.

HOW CAN WE TELL YOU LIVE IN THIS LOCALE?
I find solace in the open dramatic landscape that is the Southwest.

ABOVE:
A slice of the sun is cast down into the entry from a hidden skylight, washing a stone wall with light.
Photograph by Robert Reck

FACING PAGE TOP:
The outside Venetian plaster wall of the living/dining space curves out and away towards the view as the central cluster of furniture faces an inglenook and fireplace.
Photograph by Robert Reck

FACING PAGE BOTTOM:
The home theater features backlit shoji screens and rice paper sconces allowing for a variety of lighting options. Luxurious leather seats recline at the touch of a button.
Photograph by Robert Reck

ARCHAEO ARCHITECTS
JON DICK, AIA
1519 Upper Canyon Road
Studio A
Santa Fe, NM 87501
505.820.7200
f: 505.820.7400
www.archaeoarchitects.com

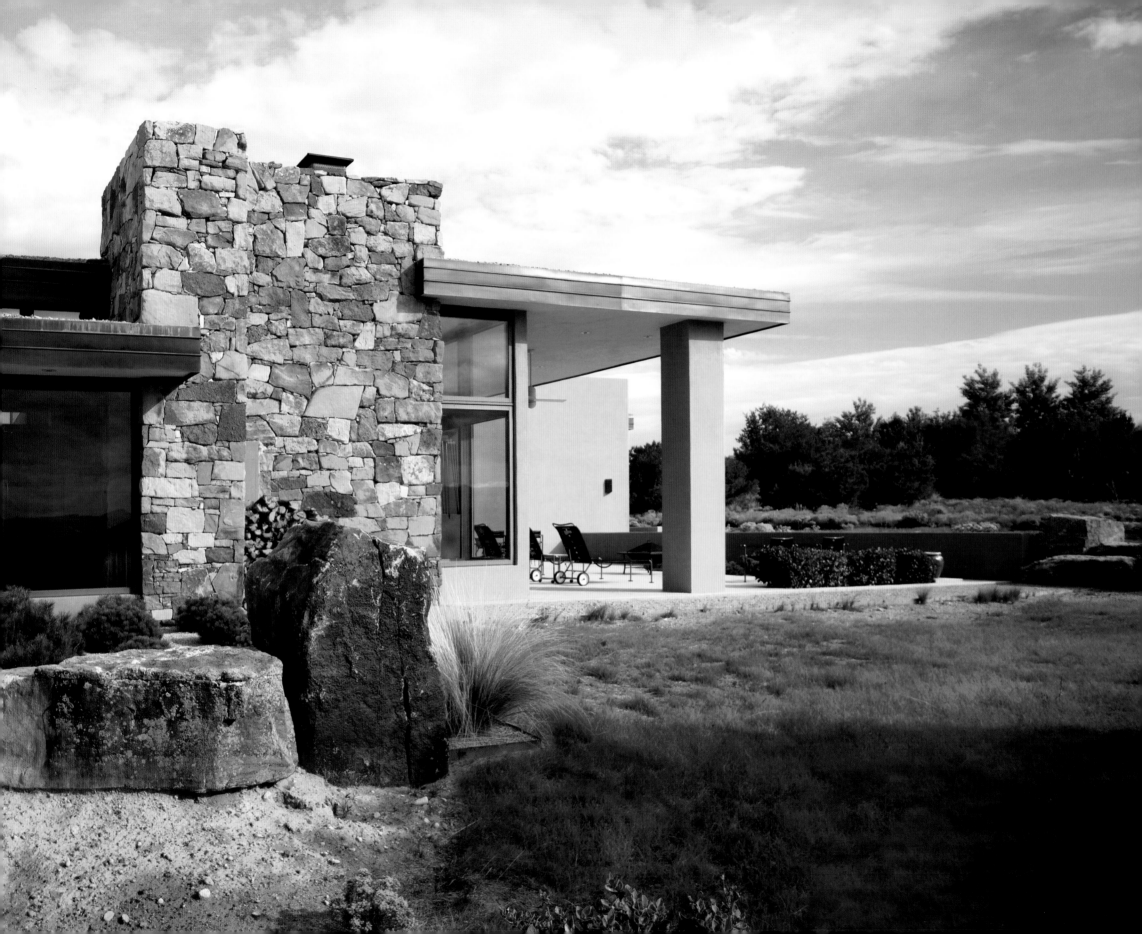

Craig Hoopes
HOOPES + ASSOCIATES

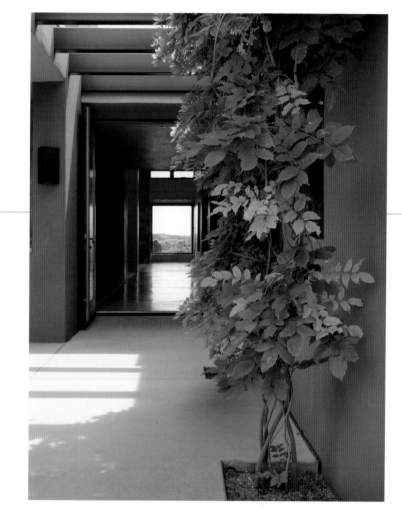

Designing for the desert is both a fine art and an exacting science. Craig Hoopes has a reputation as an avant-garde designer and architect specializing in custom residential dwellings, community theaters and ecclesiastic projects that are visually outstanding and fit seamlessly into the desert's beautiful yet fragile landscape. With more than 20 years of experience in both the high- and low-desert regions of America, he brings an unsurpassed sensitivity to his work.

With an advanced degree from Cornell University College of Architecture and having studied piano at the John Hopkins University conservatory of music, Craig took his architectural design knowledge and artistic sensibilities to a new height. A resident of Santa Fe since 1992, Craig moved from Baltimore and fell in love with the mountains. Inspired by the desert's unique magnificence, he discovered another opportunity to express himself creatively by opening an office first in Santa Fe, New Mexico, and most recently, in Palm Springs, California.

Drawing from the experience of living in two dramatically different regions of the country, having been raised on the East Coast in Maryland and becoming a resident of New Mexico, gave Craig an understanding of how climate influences architectural design. He is architecturally licensed in New Mexico, Hawaii, Colorado, Maryland and Texas and is NCARB certified.

ABOVE:
The interior and exterior open through portals (por-tals': New Mexican for covered patios). Polished concrete floors pick up light and bounce it into the house.
Photograph by Robert Reck

FACING PAGE:
The rear portal of the house looks out to the landscape and to the Sangre de Cristo Mountains beyond. The house has a simple palette: stone, stucco and glass.
Photograph by Robert Reck

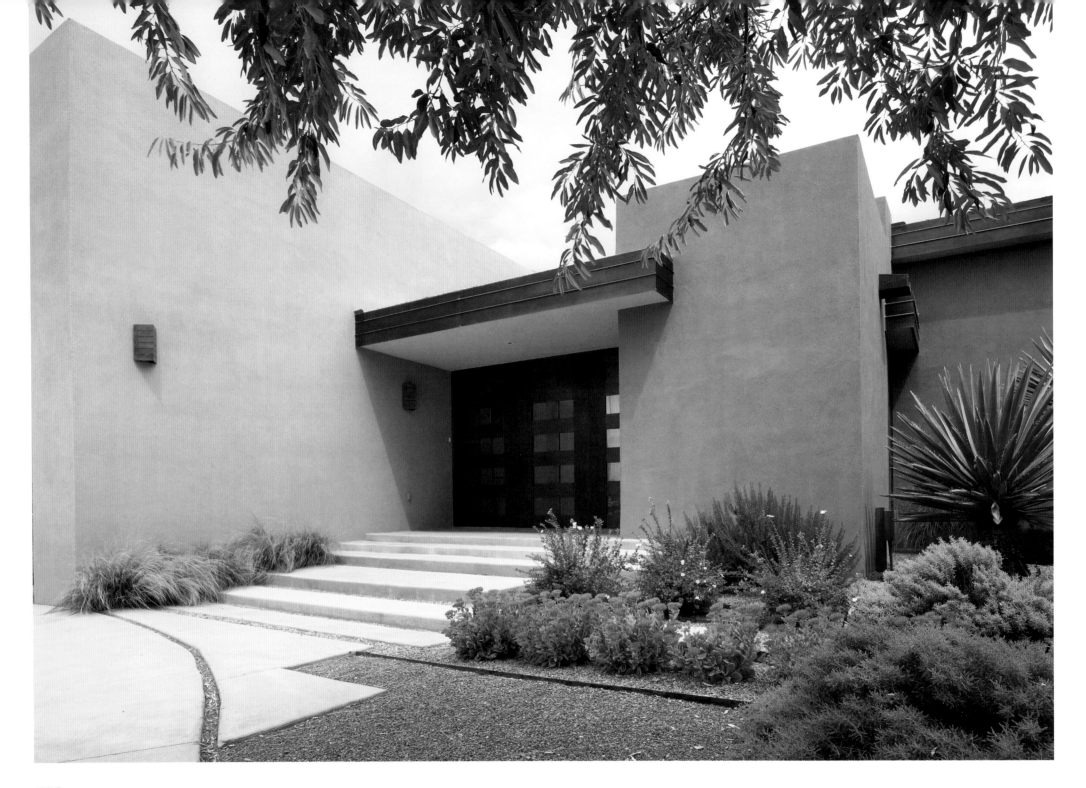

ABOVE:
The front of the residence is closed except where the lattice-like front door, clad in bronze, hints at the openness beyond. Subtle changes in stucco color allow the various masses to be played against each other. The landscaping design is by Edith Katz, ASLA.
Photograph by Robert Reck

Sensitivity to materials is important in the desert, and traditional adobe bricks act as a natural insulation of sorts to keep heat out by day and radiate heat at night, making it the perfect earthen material. Craig also often designs with concrete-filled walls to create "mass" so important for temperature control. An unseen advantage is that concrete is also a sustainable Green material derived from local sources which makes it ideal for use in the desert regions.

Craig's signature is creating homes possessing passive design elements to help minimize energy impact from the environment especially when it is 126 degrees during the day and 50 degrees at night. He integrates design elements like roof overhangs to help shade in the summer and have the dual purpose of saving heat in the winter. It is working with nature, not against it, that makes his designs so functional. His clients can expect year-round indoor/outdoor living in any one of his homes.

Far beyond functionality, Craig Hoopes expertly designs using Southwestern materials, applying modernist principles of form and minimalism to create strikingly beautiful homes and structures. His historic theater restorations, church spaces and renovations are must-sees on architectural tours as they are truly representative of his adept design and exquisite craftsmanship.

Craig's passionate respect for the environment ensures that his custom home designs utilize what nature so generously provides. Whether in the sun-

TOP RIGHT:
The formal living room opens to the dining room beyond. Light enters the living area through windows on three sides to maintain a balance, though changing, of light for the art collection. Interior finishes were designed by C. Scherer Byrd, ASID.
Photograph by Robert Reck

BOTTOM RIGHT:
The custom fireplace and media center doors of steel and maple are fit between slabs of golden oak limestone. Afternoon light spills into the space from the clerestory and the windows overlooking the zen garden.
Photograph by Robert Reck

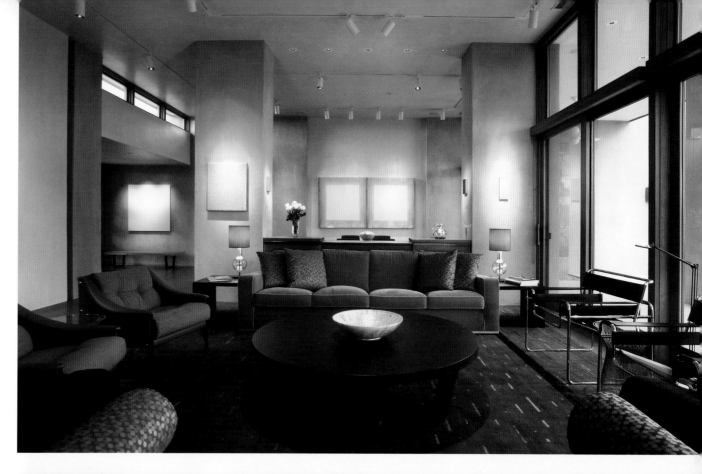

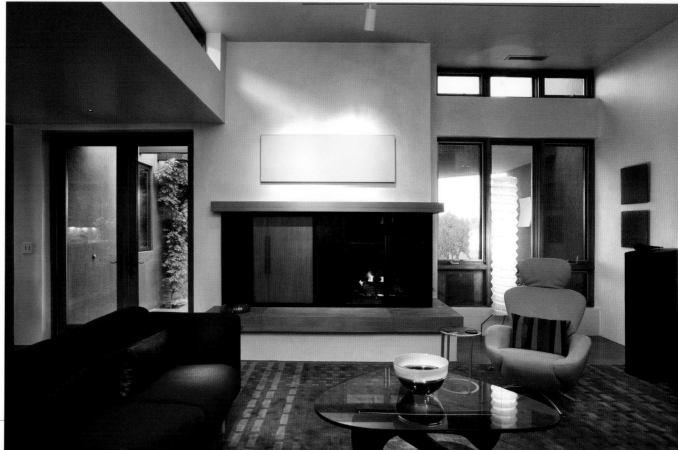

drenched low desert of Palm Springs or the high desert of Santa Fe at 7,000 feet above sea level, Hoopes & Associates is a friend of nature. Every house design has a solar energy aspect ranging from running the entire home to simple garden lighting.

Desert Living magazine has voted Hoopes & Associates one of the top 100 progressive architectural design firms. This professional recognition speaks volumes about the boutique firm and its remarkable desert projects. Craig thoroughly enjoys and maintains a close working relationship with each and every client, and his small firm allows for personalized attention and a hands-on approach to every design project.

As an architect and designer his ultimate goal is to define what shelter truly is via his work. He finds it to be a fine line drawn between an exterior and interior space and strives to make it invisible so one can experience the outside indoors and the protection of nature simultaneously. Whether developing compounds, individual spaces or institutional buildings, his designs evoke an aesthetic edge.

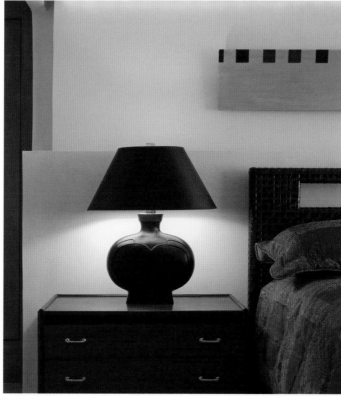

TOP RIGHT:
The living room fireplace glass screen slides into the stone fireplace mass when the fire is lit.
Photograph by Robert Reck

BOTTOM LEFT:
Throughout the house special art recesses are designed to light the owner's collection of color-field artwork.
Photograph by Robert Reck

BOTTOM RIGHT:
Maple return-air grilles align with wood stair treads. The contractor, Prull & Associates, had local craftsmen work on the various details.
Photograph by Robert Reck

FACING PAGE:
The zen garden is enclosed by monolithic stuccoed walls separated by steel fencing and gates.
Photograph by Robert Reck

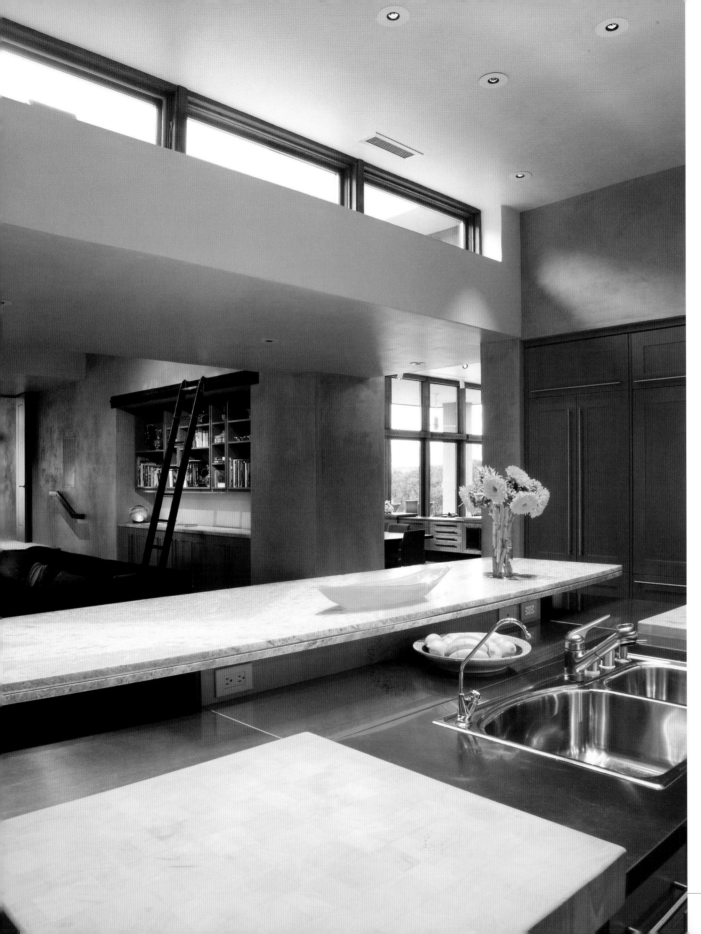

Understanding that living in the desert has both great beauty and danger due to the extreme environment, Craig believes that the unique desert experience gives a perspective that life is much bigger than we are. It is this spiritual philosophy that inspired him to collaborate with a local minister to write articles celebrating sacred architecture throughout America's Southwest.

Many of his clients share his reverence for nature and they gravitate to the desert as an oasis from urban life, a place to live as if an integral part of the landscape. Designing extremely habitable, enduring structures for its discerning clientele makes Hoopes & Associates' architectural team true masters of the desert.

LEFT:
The kitchen opens to the family room and beyond to the formal dining area allowing the owners a view of the mountains while preparing dinner. The clerestory, the reflection of the one in the family room, allows morning sunlight into the kitchen.
Photograph by Robert Reck

FACING PAGE TOP:
Custom cabinetry designed by C. Scherer Byrd, ASID, is seen throughout the house; here, the master dressing area is magnified by mirrors at each end.
Photograph by Robert Reck

FACING PAGE BOTTOM:
The grand scale of the rear portal allows for a variety of activities from romantic dinners for two to cocktails for 50.
Photograph by Robert Reck

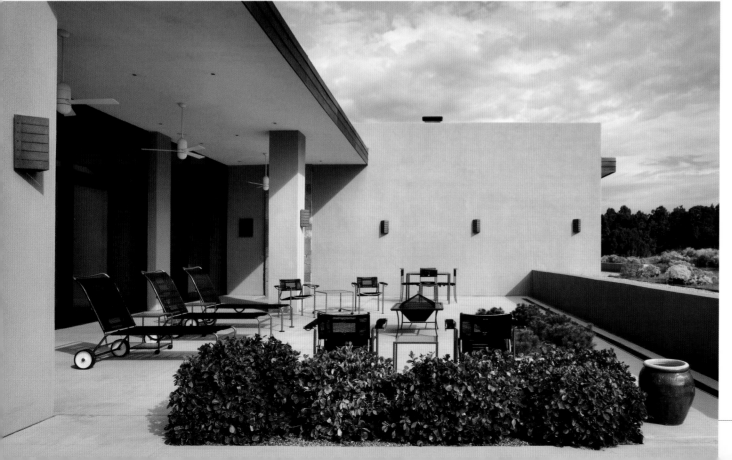

WHAT IS THE BEST PART OF BEING AN ARCHITECT?
Helping people realize their dreams.

WHAT IS THE HIGHEST COMPLIMENT YOU'VE RECEIVED PROFESSIONALLY?
Having clients return for their next project.

WHAT COLOR BEST DESCRIBES YOU AND WHY?
Yellow is my color because I'm a Leo. Need I say more?

WHAT ONE ELEMENT OF STYLE OR PHILOSOPHY HAVE YOU STUCK WITH FOR YEARS THAT STILL WORKS FOR YOU TODAY?
I believe that architecture is a "backdrop" for our lives, which allows me to be flexible in my design approach.

WHO HAS HAD THE BIGGEST INFLUENCE ON YOUR CAREER?
Most importantly, my parents. Also, Mark Beck, my first architect-employer, who taught me that anything can be built, as well as the work of Alvar Aalto, Le Corbusier and Louis Barragan.

WHAT BOOK ARE YOU READING RIGHT NOW?
Florence, The City and Its Architecture.

HOOPES + ASSOCIATES
CRAIG HOOPES, AIA
333 Montezuma Avenue
Suite 200
Santa Fe, NM 85701
505.986.1010
f: 505.986.9898
www.hoopesarchitects.com

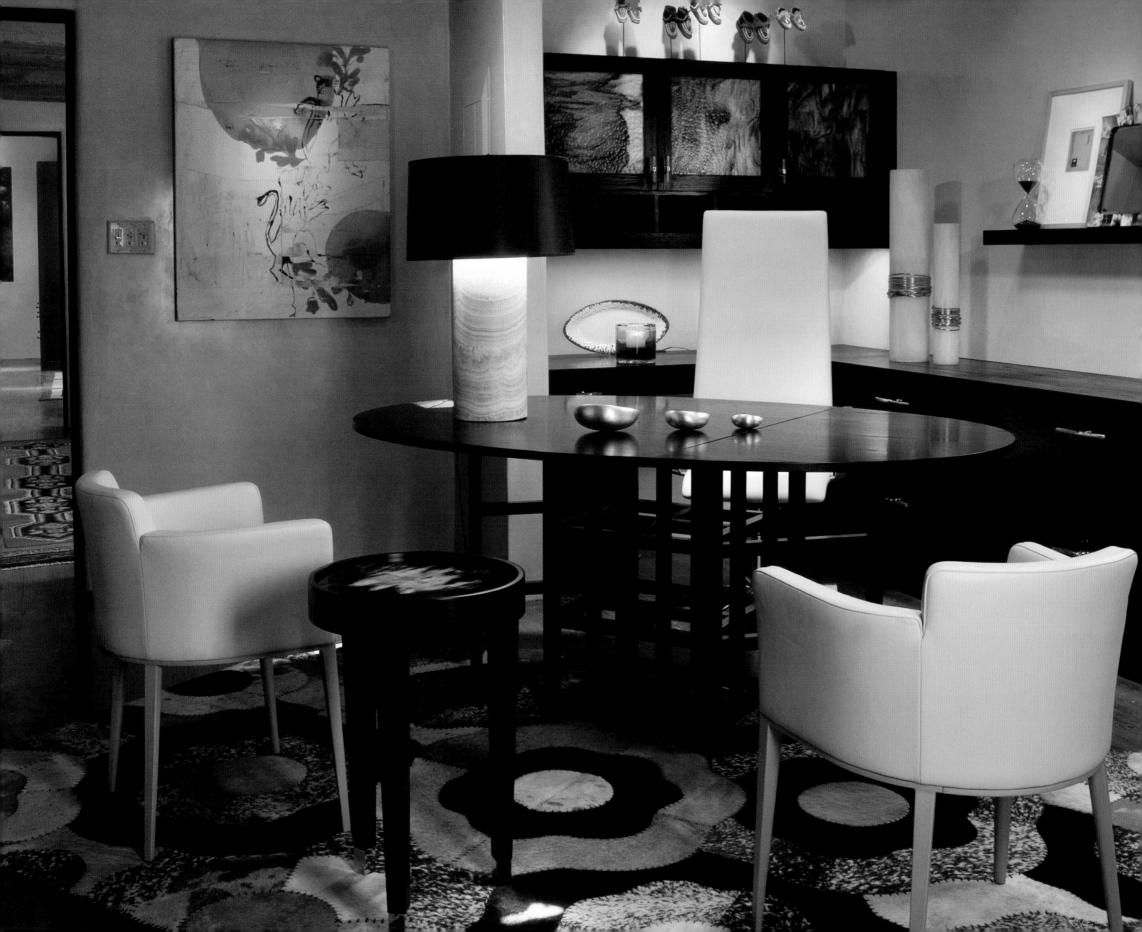

Kris Lajeskie
KRIS LAJESKIE DESIGN GROUP

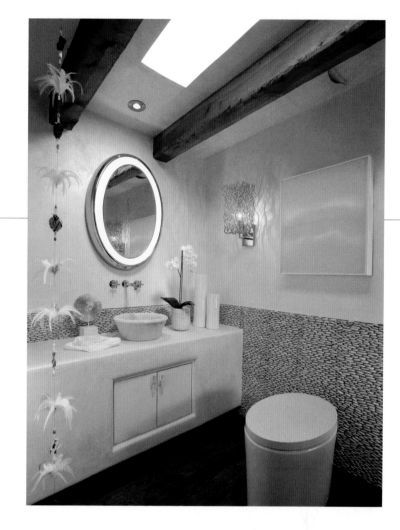

With heart and soul, Kris Lajeskie invigorates each interior design project by adding her signature organic style characterized by clean lines and the layering of sophisticated colors and textures.

Kris has a long-term connection to the Southwest—drawing from the intense natural beauty and light which inspires her work. She has also invested herself beyond regional lines and travels extensively to the most important design cities attending art and design fairs throughout the world. Kris collects treasures, finds new artisans and most importantly, learns from the great masters of design and architecture around the world, past and present. She articulates her work as a "fine balance between understanding the expectations of the client and their lifestyle, respect for the architecture and region," and infuses her unique vision to create an original and authentic interior. Extracting and discovering these essential components is the beginning and the most important first step in the creative process.

Kris is a phenomenon—a creative force in the industry with the vision, discipline and confidence to create what may not yet exist. Her forte is bringing talented artisans to each project from her cadre of expert international craftspeople and fabricators. From working with custom lighting designers in Italy to New Mexican furniture makers, her collaborative spirit allows her to create

ABOVE:
Washed in white: Powder room walls feature Venetian plaster mixed with sand and mica while stacked river stones create the wainscoting. The suspended custom art piece is made of feathers, precious stone and carved fetishes.
Photograph by Kate Russell

FACING PAGE:
A study in contrast: Custom woodwork stained in ebony features a classic Knoll dining table as office desk. Decorative accessories are made of horn, resin and alabaster; a Plains Indian collection of children's moccasins is highlighted.
Photograph by Kate Russell

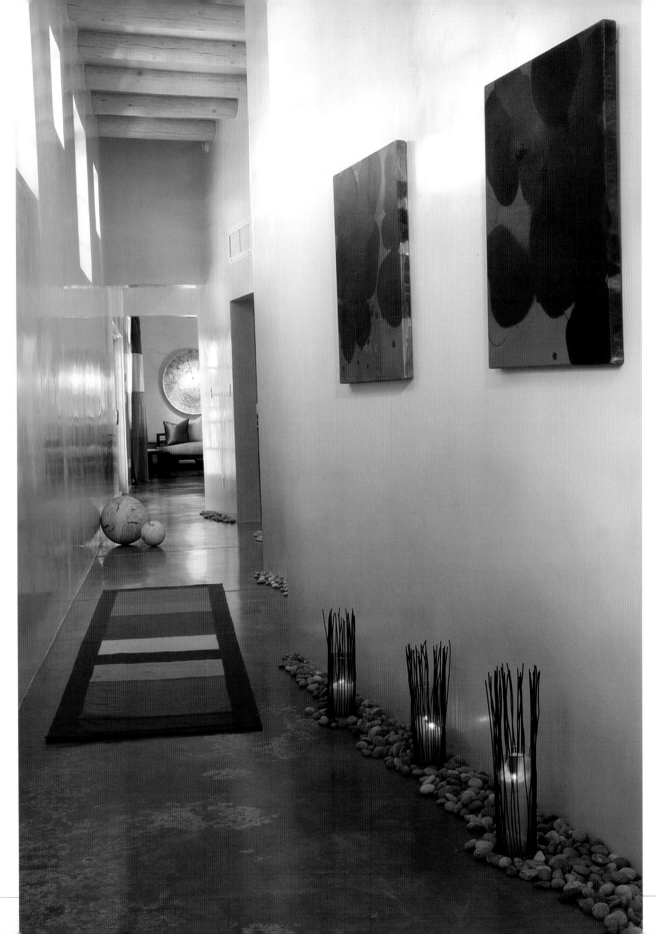

spectacular interiors for high-profile clientele throughout New Mexico, California, Arizona and Hawaii. 2007 marked the expansion of Kris' design studio to Manhattan, where she is focusing on creating avant-garde and contemporary residential interiors.

She abides by her studio's mission: "Bringing an international vision, an organic sensibility and the signature mark of master artisan collaboration to every creation." With studios in Santa Fe, Manhattan and a European collaboration with Milan, Kris is often en route to oversee any one of her projects—her entrepreneurial spirit and creativity is unmistakably the firm's hallmark.

After a demanding 12-year retail management career with Macy's, Kris moved to Santa Fe for solace and self-discovery. In 1998, she completed a four-year project: Rancho Alegre, a 26,000-square-foot residence on 200 acres. This private compound resembling a Spanish Colonial village provided her a first opportunity to design an all-encompassing project from its architectural details to interior design and exterior landscape. The collaborative effort with local master artisans helped revive precious "lost arts" intrinsic to Western, Native American and Spanish-Mexican cultures. The unique desert project became a beacon for her residential design work and shines in Santa Fe today. Kris is now dedicated to her most recent work commissioned by longstanding patron clients, creating residential and commercial interior design projects including upscale specialty retail stores and art galleries.

There are obvious design extensions in Kris' business, and her own line of custom furniture is now showcased in galleries and boutique retail stores. Several years ago, she made a pledge to live part-time in Italy and soon became enamored with the handmade lighting designed by Enzo Catellani. Kris has been importing and distributing the lighting of Catellani & Smith and takes pride in her role as "ambassador" for the United States. These lighting fixtures double as exquisite pieces of art and complement the interiors she creates.

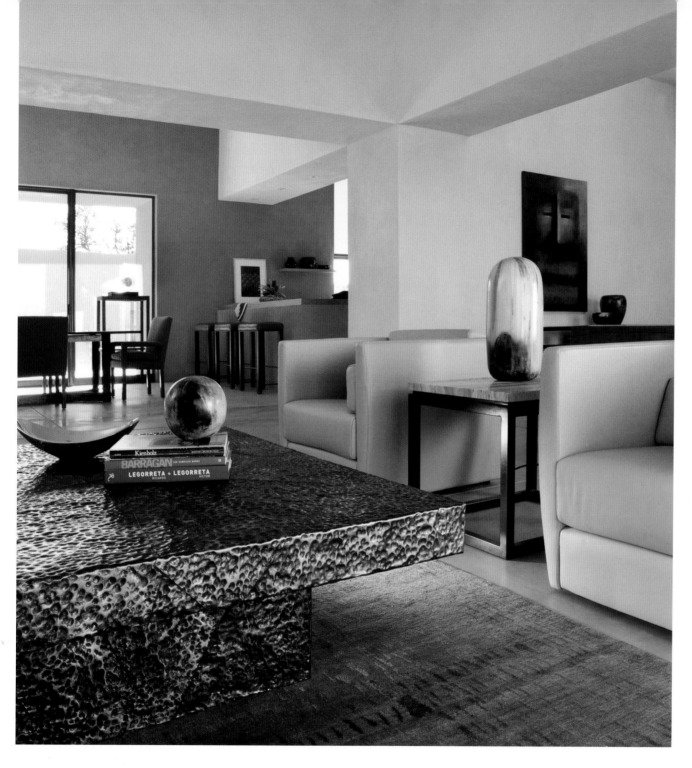

WHAT IS THE BEST PART OF BEING AN INTERIOR DESIGNER?
My life and work are one. Everywhere I go there is always a place, an object or person that informs my work. I also feel very fortunate to have this vision; to see and feel a complete creation in my mind's eye before the pen ever touches the paper!

HAS YOUR WORK EVER BEEN SHOWN ON NATIONAL TELEVISION?
My work has been featured on two shows for HGTV—my interior design proposal was the winning selection for "The Designers' Challenge," which was filmed in Santa Fe.

WHO HAS HAD THE BIGGEST INFLUENCE ON YOUR CAREER?
By far, my patron clients Ursula and Stephen Gebert. I have been designing for them for five years; they have a very developed eye for art and design, and most importantly, they have given me the freedom and license to truly create original designs and environments.

WHAT COLOR BEST DESCRIBES YOU AND WHY?
Copper patina. It speaks to my innate sense of beauty.

WHAT IS THE HIGHEST COMPLIMENT YOU'VE RECEIVED PROFESSIONALLY?
Those who know my work call me an "artist" first, then a designer.

KRIS LAJESKIE DESIGN GROUP
SANTA FE • NEW YORK • MILAN
KRIS LAJESKIE, ASID INDUSTRY PARTNER
PO Box 786
Santa Fe, NM 87504
505.986.1551
f: 505.983.0063
www.krislajeskiedesign.com

ABOVE:
Architect Ricardo Legoretto designed this personal residence in Santa Fe, New Mexico, which showcases custom furniture in organic materials. Clean lines create the platform for an extensive contemporary art collection.
Photograph by Kate Russell

FACING PAGE:
Private residence turned boutique hotel: Bright colors paired with natural elements create exciting, unexpected visuals upon entering the space. Original art by Dirk Debryker.
Photograph by Kate Russell

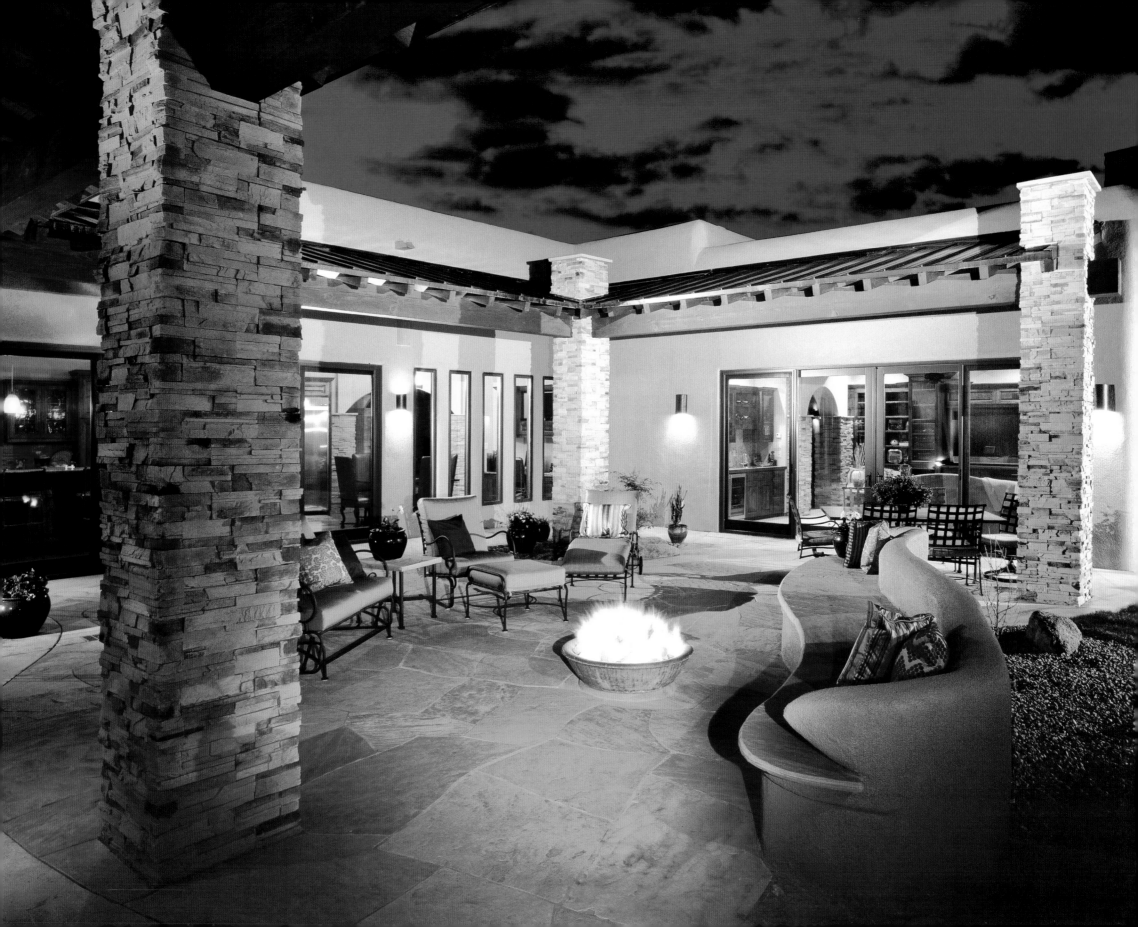

Jennifer Lopez
Tim Lopez
DWELL, INC.

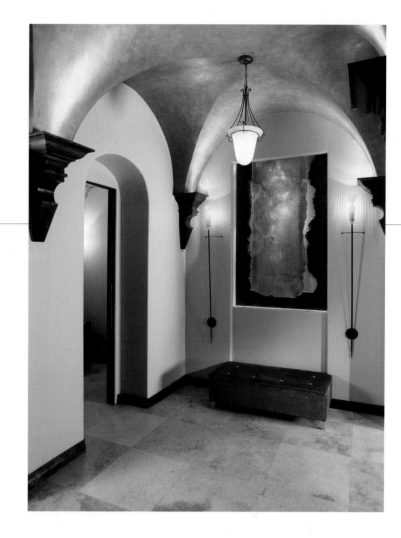

An energetic design-build partnership, Jennifer and Tim Lopez are changing the scape of Albuquerque one stunning custom home at a time. They have been building residences for their clients since 1997 and in 2005 founded Dwell, Inc., specializing in Contemporary custom homes for their discerning desert clients. Experienced residential designers, professionally certified contractors and real estate developers, they have a passion for creating high-end custom homes. Equal professional partners, Jennifer coordinates the creative design and construction aspects of the firm, while Tim manages the financial and development side.

One of the most respected builders in New Mexico, the firm has received numerous local awards and national recognition. Many of Dwell's designs have received attention for creative form and function, especially for use of new and innovative materials including eco-friendly homes. Jennifer, a talented artist, enjoys expressing her natural creativity through designing and building in a variety of architectural styles. She is also an experienced designer, planning room schemes and recommending color, textures, materials and finishes for interior spaces to bring warmth, elegance and livability to the residence.

ABOVE:
This unique entry sets precedence for the elements and style seen throughout the home. The illuminated custom-carved onyx and burl wood centerpiece draws attention into the home while the double-vaulted plaster ceiling surrounds the room with warmth.
Photograph by Paul Kohlman

FACING PAGE:
The natural beauty of the high desert is blended into a unique outdoor courtyard that flows into the home through expansive doors extending useful living space.
Photograph by Paul Kohlman

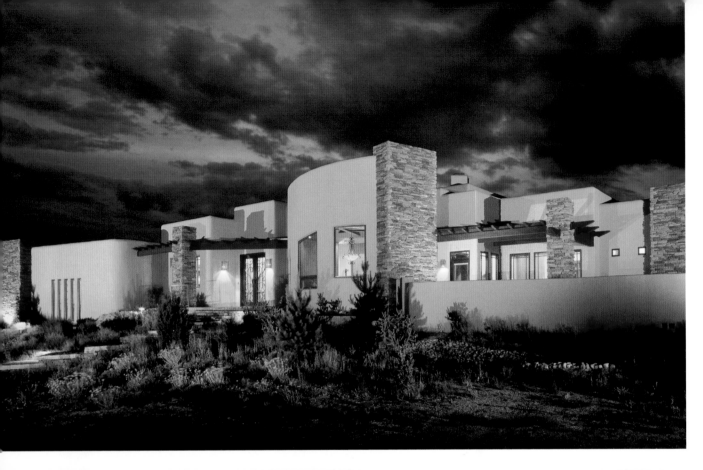

Creativity is the hallmark of a Dwell home, with one contemporary design featuring original mosaic work crafted by local artisans. It is the firm's thoughtful attention to detail and continuity of design elements that merits professional praise. The professionals' trained eye for the best materials and excellence in workmanship using superior subcontractors places them in the realm of elite designers building multimillion-dollar custom homes.

True perfectionists, they build custom residences that exude originality and consistently hit the mark exceeding the dreams and desires of their clientele, who are predominantly referrals. This dynamic team moves each project effortlessly through the construction process. Desert oasis-makers, Jennifer and Tim create vibrant and unique residences amidst vivid landscapes in the land that they love to call home.

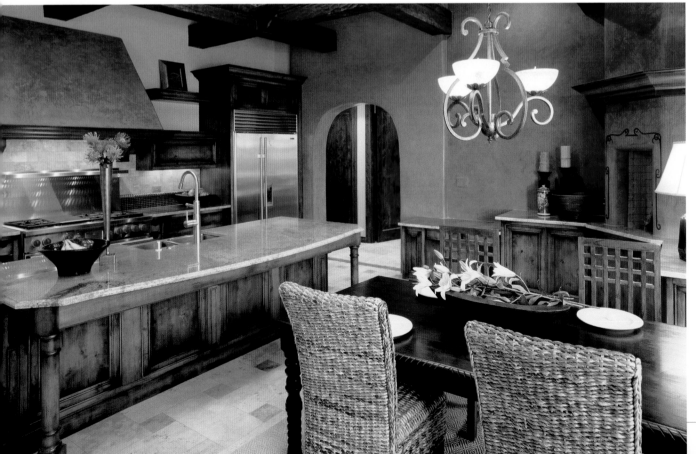

TOP LEFT:
Notice the massing and blended style of the home's front elevation accented by copper windows and natural stone columns.
Photograph by Paul Kohlman

BOTTOM LEFT:
Not just a kitchen—an inviting living space accented by a raised fireplace, warm-toned plaster walls, basket weave stone flooring and massive ceiling beams.
Photograph by Paul Kohlman

FACING PAGE:
A modern design of carved wooden beams nestled within a dome ceiling complements the dining table while elevated in a uniquely curved space to enhance an extraordinary dining experience.
Photograph by Paul Kohlman

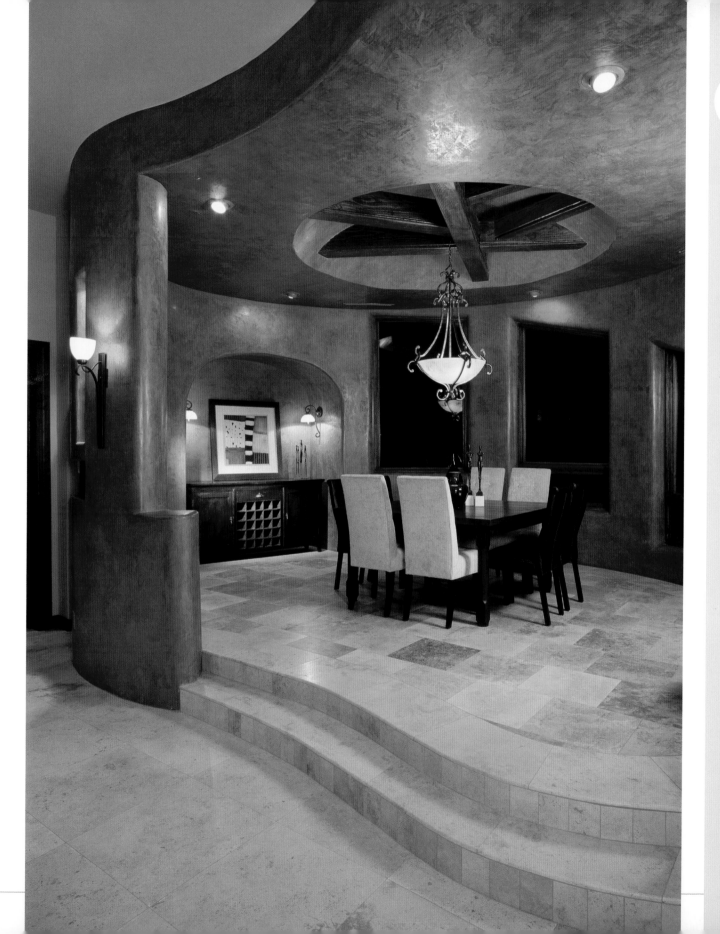

WHAT PERSONAL INDULGENCES DO YOU SPEND THE MOST MONEY ON?

Our Doberman pinschers named Ecco and Prada.

WHAT ONE PHILOSOPHY HAVE YOU STUCK WITH FOR YEARS THAT STILL WORKS FOR YOU TODAY?

Integrating homes into the natural environment, keeping the "view" uppermost in mind before any design plan or building begins.

JENNIFER, WHO HAS HAD THE BIGGEST INFLUENCE ON YOUR CAREER?

Tim and I have a mutual professional respect and are positively influenced by one another every day.

TIM, WHAT IS THE MOST UNUSUAL, EXPENSIVE AND DIFFICULT DESIGN OR TECHNIQUE YOU'VE USED IN ONE OF YOUR PROJECTS?

To enhance an exterior façade, Jen designed and engineered vertical, steel cages to hold beautiful natural rocks of exceptional weight. The prep work underground required special foundation support considerations, and this original Dwell design element makes an architectural statement while seamlessly integrating into the desert environment. It was a more creative approach than the usual tile or cultured stone.

DWELL, INC.
JENNIFER LOPEZ
TIM LOPEZ
10701 Montgomery, Suite C
Albuquerque, NM 87111
505.294.0354
f: 505.275.7063
www.jencohomes.com
www.dwellstructures.com

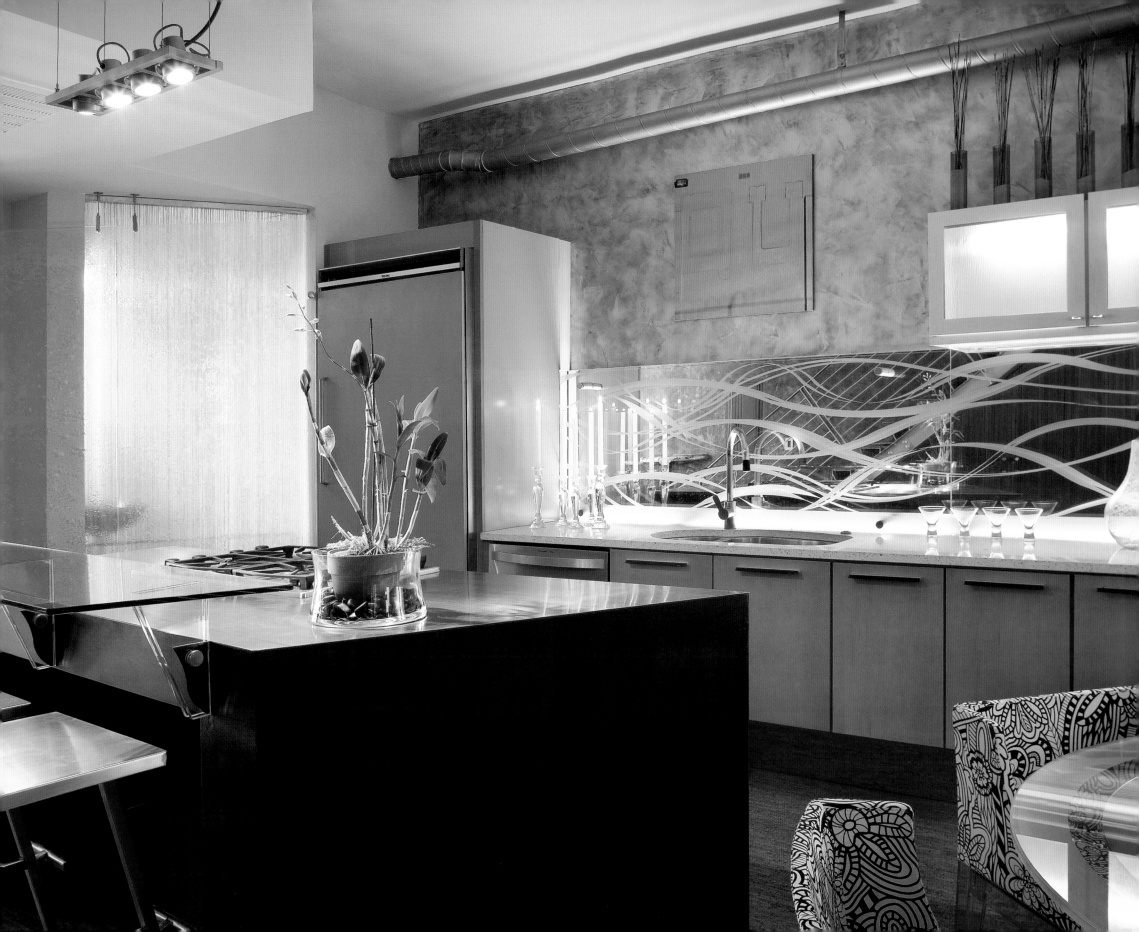

Beth Rekow
REKOW DESIGNS

E nlightened and evolved, the possibilities are limitless for an interior designer committed to the Green movement and innovation. Beth Rekow, founder of Rekow Designs, has a higher consciousness and genuine respect for how design can affect the way people participate in the environment. An artist by trade with a diverse academic background, she is a creative leader in the business of Green residential and commercial interior "architectural" design.

Living and designing in the moment, Beth has an unparalleled approach to each design project and is influencing the interior design field while making dreams come true for her clients. Since the early 1990s, her forward-thinking and professional commitment to engage all disciplines has set her firm apart. Beth's cross-disciplined approach and philosophy weaves her education in literature, art history, industrial design and construction design into her practice as she applies these ideas to her work.

Starting as a fine studio artist, Beth's oil paintings have been shown in galleries from Vancouver to Seattle, Los Angeles, Denver and Kansas City. Beyond painting, she is an accomplished furniture designer creating custom pieces for her creative and innovative clients. She has been in business since 1995 and is passionate about innovation and change in the built environment. Beth began designing interiors in 1996 and the spaces she works with are rooted in the process of building Green, creating a narrative specific

ABOVE:
The custom-cast glass wall of the master suite is a translucent backdrop to the lounge area. Hand-applied glass pebbles are adhered to the console and resin is poured over the top to create a continuous and flat surface. The chair and detailing are custom designed by Beth.
Photograph by Robert Reck

FACING PAGE:
This kitchen captures intimacy and strength without losing the attention to function. With a balance of elegant industrial detailing and dynamic lighting, the space will transition gracefully from any moment in the day or night. An oxidized steel island custom designed by Beth, with polished glass bar top, introduces the kitchen. The backsplash is designed with one layer of mirror and one layer of digitally etched glass with up-lighting sandwiched between the layers, washing the hand-plastered wall, plastered by Beth.
Photograph by Robert Reck

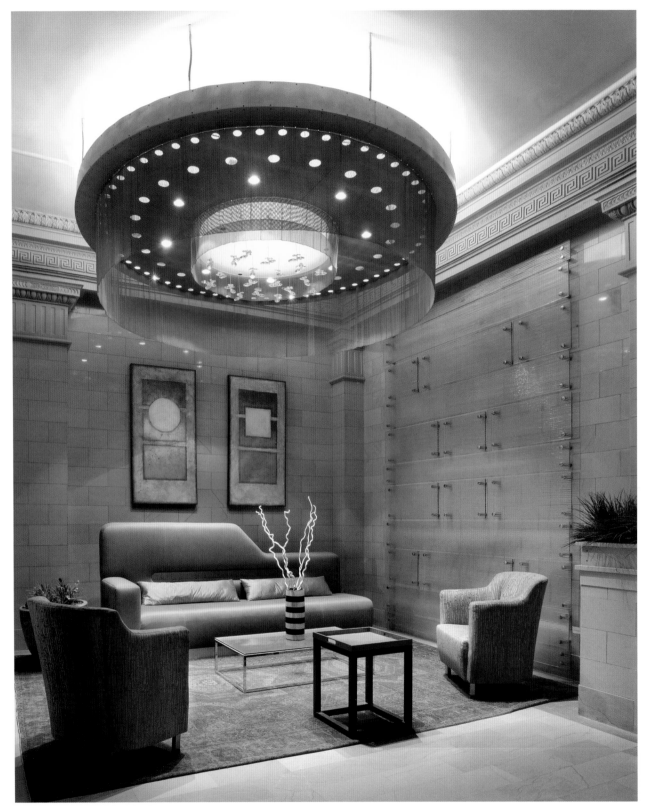

to each client/project, and resolving design questions with innovative solutions that lead to spaces with integrity, clarity and a sense of humor.

Her academic resume reads like a professor's curriculum vitae. She earned a bachelor's degree from Colorado College in both comparative literature and Spanish. Currently in graduate school at the University of New Mexico, Beth is working on her master's degree in architecture. She studied at the Colegio El Angel, Caracas, Venezuela, where she developed a deep understanding of the creative freedoms and opportunities in the United States. She also attended the University of Zagreb, Emily Carr School of Art and Design, Cornish College of the Arts, Western Washington University and the Art Academy in San Francisco. Her noteworthy design work has been published in *Trend, Night Club* and restaurant magazines, and a commercial project was awarded the "Downtown Albuquerque Best Commercial Interiors 2006."

Client-centered, she delves into their personal history and present status to best determine how they want to be living in the future. Her interiors are flexible so that they can be easily modified with the changing lives of her clients. The Banque project is one such space where a former 1923 bank building was transformed into luxury residential loft condominiums through Rekow Designs. Describing her style as "current," she works on single-family residential projects in Santa Fe and Albuquerque, New Mexico, as well as Boulder, Colorado, yet half of her work is light commercial, including upscale

LEFT:
This stately lobby is enshrined with original marble, dating back to 1923. This historic building was converted into contemporary residences with a delicate and strong sweep of original and innovative materials and furniture. The custom pieces are designed for the unusual proportions of this lobby, with cork and sustainable fabric that respond off of the cast glass wall-mounted to the marble. The custom chandelier is a 10-foot-diameter steel, Swarovski crystal and glass composition that illuminates and defines the space. The historic Turkish rug is a dynamic and humble piece from Packards West.
Photograph by Robert Reck

FACING PAGE:
The hand-carved Baltic birch headboard floats in front of silks from Belgium, France and Germany. All of the work is custom and inspired by studies of water and nature.
Photograph by Robert Reck

restaurants and night clubs. The firm is involved with a contemporary modular home business, H-Haus, a collaboration with endless opportunities and a rapid construction process. Beth has also designed a new line of furniture inspired by minimalist sophistication, modularity and sustainability, fabricated in America with parts from around the world.

With her sustainable work and cross-disciplinary understanding of the built environment, Beth Rekow is the progressive interior "architectural" designer to watch.

Q&A

more about beth ...

WHAT COLORS BEST DESCRIBE YOU?
Taupe and hot pink—for the moment. Warm, deep base tone in tandem with shocking, saturated intense pink. Go figure.

NAME ONE THING PEOPLE DON'T KNOW ABOUT YOU.
I was just voted the most valuable diver of the last 25 years for NCAA Division II.

WHAT BOOK ARE YOU READING NOW?
Cradle to Cradle by William McDonough and Michael Braungart. I find inspiration in this brilliant work as I see McDonough as one of the most evolved architects in the world today, in which recycling is the chief consideration, never wasting product or disposing of materials in a toxic way.

WHAT ONE ELEMENT OF STYLE OR PHILOSOPHY HAVE YOU STUCK WITH FOR YEARS THAT STILL WORKS FOR YOU TODAY?
Personal minimalism highly infused with an artistic sensibility and clarity of space.

WHAT SINGLE THING WOULD YOU DO TO BRING A DULL HOUSE TO LIFE?
Design appropriate and varying levels of lighting.

REKOW DESIGNS
BETH REKOW, IIDA, ASID, LEED
2209 Via Seville NW
Albuquerque, NM 87104
505.792.4780
f: 505.792.1659
www.rekowdesigns.com

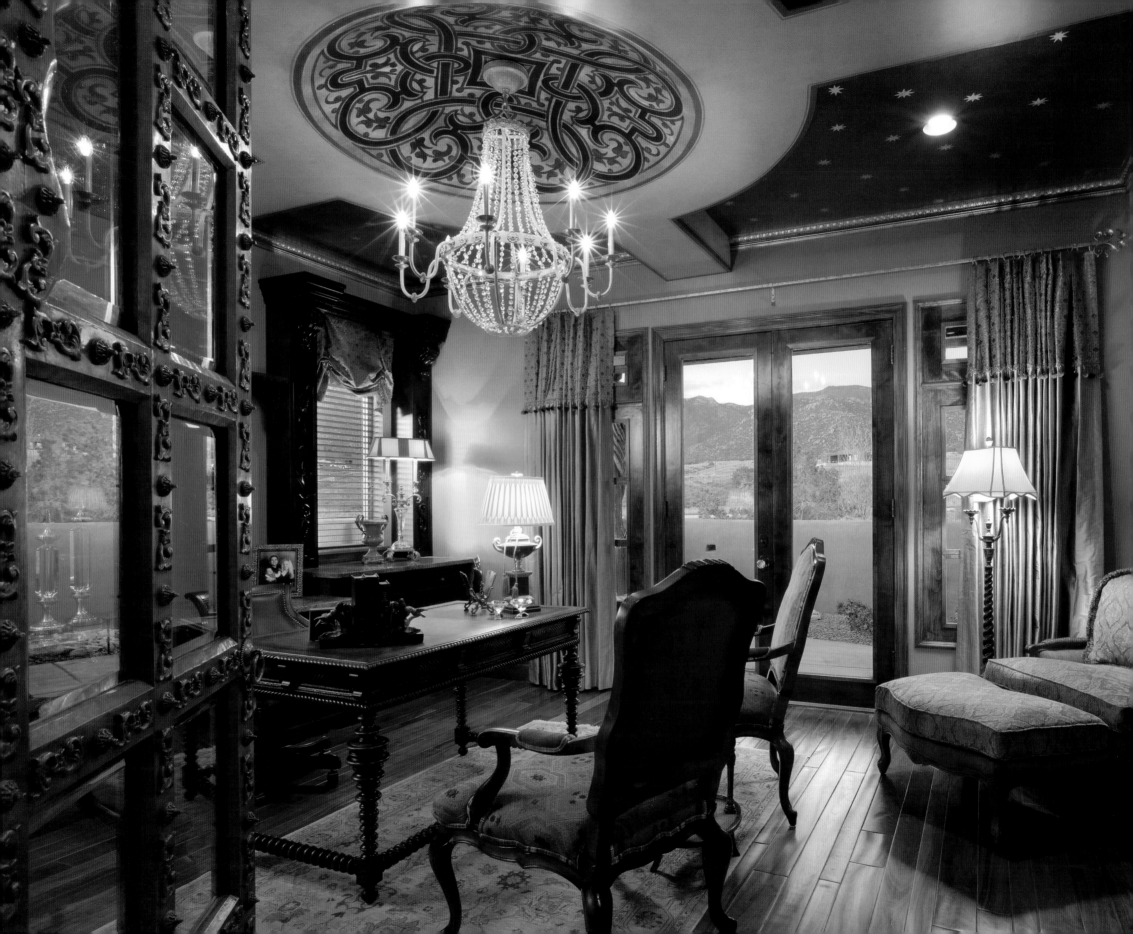

Moses T. Zabec

MOSES DESIGN GROUP
MOSES AT HOME

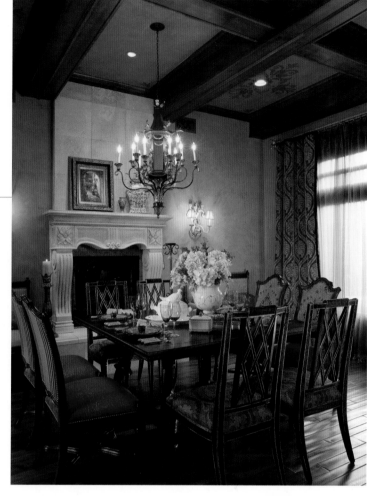

Seeing clients ecstatic over their very personal interior designs and watching their faces light up is what inspires and motivates Moses and Terri Zabec, co-founders of Albuquerque's renowned interior design studio and retail establishment. For more than 25 years, Moses' studio has been a household name among locals for offering complete residential and commercial interior design services, as well as distinctive furnishings and accessories in the associated Moses At Home retail store run by his wife, Terri. The well-appointed 4,200-square-foot home furnishings center celebrated 10 years in business and was recognized as a regional award-winner in the prestigious Dallas Market Center and ARTS competition, voted "Best Retail Store in the West."

The firm is known for creating exceptional interiors by providing space planning services, design consultation, furniture, flooring, lighting, accessories and paint and tile selections for its savvy clientele. The professionals work in contemporary, traditional, transitional and most notably, classic European interior design. Not defined by any one style, their work evokes a certain "feeling" in every project that is readily experienced by all who enter a Moses-designed space. From carefully chosen furniture down to the minute architectural details, the firm prides itself on giving its respected clients total design services.

ABOVE:
The imported stone fireplace along with the architectural detail and lighting sets the tone in this dining room, which captures the essence of blending eclectic European furnishings and style.
Photograph by Robert Reck

FACING PAGE:
Antique Indian brass doors open into this office to take you on a magical journey to another time and place.
Photograph by Robert Reck

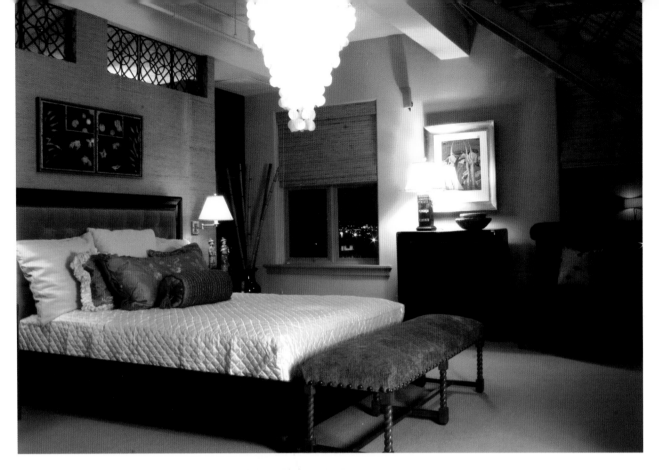

The 15-person studio has a team of five talented, professional interior designers. A most distinguishing honor was inclusion in the 1997 International Edition of Barrons *Who's Who in Interior Design* where Moses joined the elite one percent of practicing designers from more than 300,000 in the world. Sophisticated, elegant and upscale, cost-effective, clean and fresh; these are words used to describe their award-winning interiors from residential lofts to sprawling desert compounds. A true classicist, Moses' design philosophy is clear: "Whether contemporary or transitional, as long as design has a root in the classical it will always stand the test of time."

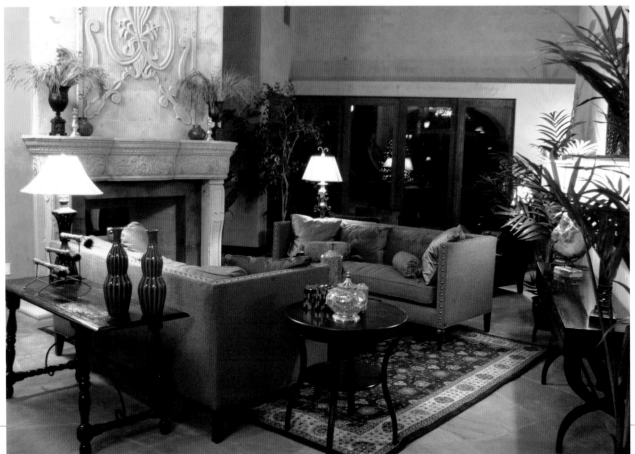

TOP LEFT:
A blending of transitional and contemporary styling, with hints of classical references, creates a fresh vision of the French pied-à-terre in this urban loft.
Photograph by Bob Mares

BOTTOM LEFT:
The clean lines of this living room's transitional furnishings and architectural elements—along with accents of rich red and icy aqua—provide a modern approach in this Mediterranean-style home.
Photograph by Bob Mares

FACING PAGE:
Truly a classical approach for this entry, imported furnishings and a 300-year-old rug set the tone for this well-appointed home.
Photograph by Robert Reck

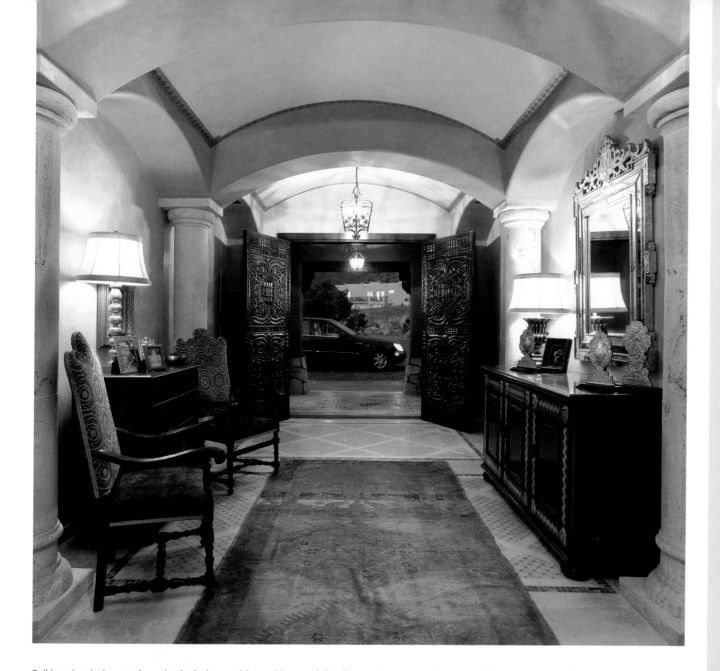

WHO IS YOUR FAVORITE DESIGNER?
The legendary American interior designer, Sister Parish.

WHO HAS HAD THE BIGGEST INFLUENCE ON YOUR CAREER?
The Florida architect, Addison Mizner. My interest is piqued lately on glorious San Miguel de Allende, north of Mexico City, because of the beautiful examples of Spanish architecture much like Albuquerque—it is like being in Spain with its rich cultural and art history.

NAME SOMETHING MOST PEOPLE DON'T KNOW ABOUT YOU.
My undergraduate degree was in sculpture and art education, which led to my interest in architecture and three-dimensional design. I was a middle and high school teacher for five years. I loved seeing children create art and achieve success! Then, I earned my master's degree in design from Pennsylvania's Edinboro University.

Full interior design services also include exquisite architectural detailing and custom cabinetry and furniture pieces. The firm has established resources to achieve most anything a client can imagine. Its slogan reads: "Style Your Life," and they do just that from a high desert Southwest adobe custom home to projects in San Francisco, Denver, San Diego, Tucson and Austin, Texas. The firm's magnificent interior designs have proudly earned numerous "Best of Show" awards in the annual Albuquerque Parade of Homes and continue to impress the most discerning homeowners.

MOSES DESIGN GROUP
MOSES AT HOME
MOSES T. ZABEC
TERRI ZABEC
8510 Montgomery Boulevard NE
Albuquerque, NM 87111
505.291.5400
f: 505.299.2232
www.mosesathome.com

PUBLISHING TEAM

Brian G. Carabet, Publisher
John A. Shand, Publisher
Phil Reavis, Executive Publisher
Martha Cox, Senior Associate Publisher
Karla Setser, Senior Associate Publisher
Carla Bowers, Associate Publisher
Beth Benton, Director of Development & Design
Julia Hoover, Director of Book Marketing & Distribution
Elizabeth Gionta, Editorial Development Specialist

Michele Cunningham-Scott, Art Director
Mary Elizabeth Acree, Graphic Designer
Jonathan Fehr, Graphic Designer
Emily Kattan, Graphic Designer
Ben Quintanilla, Graphic Designer

Rosalie Z. Wilson, Managing Editor
Katrina Autem, Editor
Lauren Castelli, Editor
Anita M. Kasmar, Editor
Ryan Parr, Editor
Daniel Reid, Editor

Kristy Randall, Managing Production Coordinator
Laura Greenwood, Production Coordinator
Jennifer Lenhart, Production Coordinator
Jessica Garrison, Traffic Coordinator

Carol Kendall, Administrative Manager
Beverly Smith, Administrative Assistant
Carissa Jackson, Administrative Assistant
Amanda Mathers, Sales Support Coordinator

PANACHE PARTNERS, LLC
CORPORATE OFFICE
13747 Montfort Drive, Suite 100
Dallas, TX 75240
972.661.9884
www.panache.com

Archi-Scape, page 165

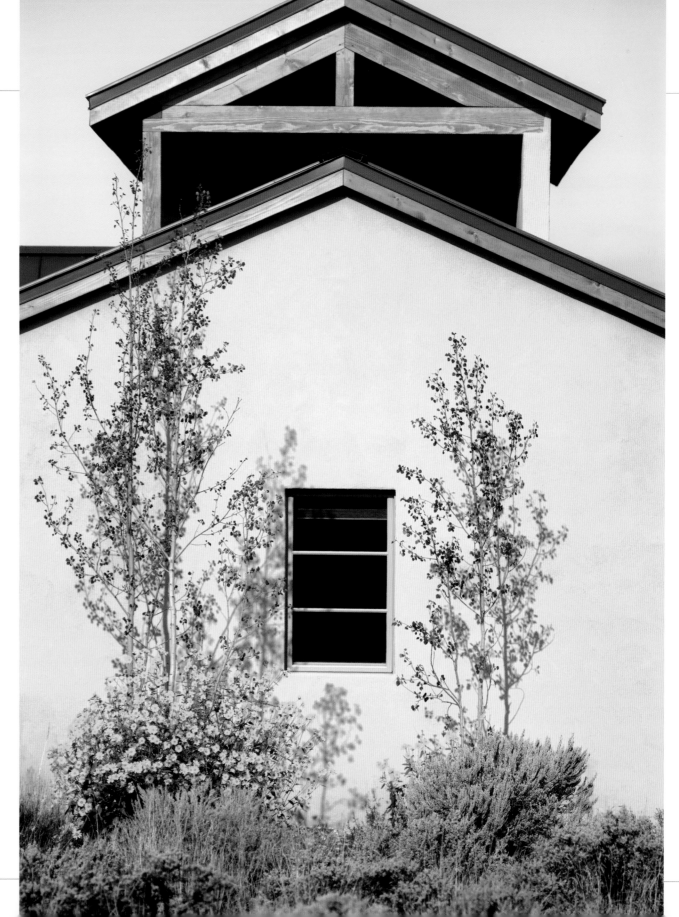

ARCHITECTURAL & DECORATIVE ARTS SOCIETY

IN LAS VEGAS — FOR LAS VEGAS

The Architectural & Decorative Arts Society (ADAS) was founded in 2006 by Carolyn Muse Grant, Alexandra Charbogne, president and CEO of Tribeca Designs, and Dina Remeta, president of Interior Design Concepts. These design industry achievers shared a dedicated effort to form a cohesive membership organization aligning the most talented architects, engineers, designers, vendors and the multitude of other remarkable creative professionals in Las Vegas. An incomparable world-class city, Las Vegas has a wealth of diverse talent, and the ADAS is an all-encompassing, lateral organization in support of the city's burgeoning architectural and design community. Carolyn Muse Grant is the founding president of ADAS and Executive Publisher and Editor of *Southern Nevada Home & Garden Magazine*.

ADAS is a non-profit professional organization committed to the creative, business and community development of the Las Vegas architectural and design industries. Each year ADAS recognizes remarkable industry achievement at the Annual Project Awards celebration, which distinguishes outstanding members in the hospitality, residential and contract design categories.

Membership in ADAS is open to any professional actively engaged in architecture, interior design, fine arts and crafts, graphic design, set design, building, development, manufacturing, sales, marketing, distribution, production, purchasing, management, operations, communications, legal services, accounting and education related to hospitality, contract and residential design.

ADAS has made a commitment to the southern Nevada community by adopting a charity organization or community project each year. This year it has selected Safe Nest, and a portion of proceeds from special events will help Safe Nest eradicate domestic violence. For more information, visit www.safenest.org. The Safe Nest 24-Hour Hotline is 1.800.486.7282

For more information and membership requirements contact:

ARCHITECTURAL & DECORATIVE ARTS SOCIETY
CAROLYN MUSE GRANT, PRESIDENT
Las Vegas, NV
702.236.9483
www.adaslv.com

Serving Families, Saving Lives since 1977

INDEX OF ARCHITECTS, DESIGNERS & BUILDERS

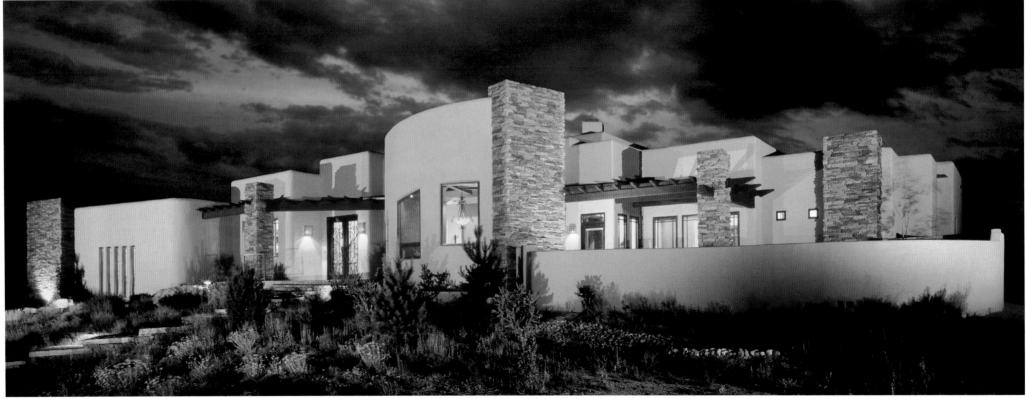

Dwell, Inc., page 187